THE ESSENTIAL LOUIS KAHN

THE ESSENTIAL LOUIS KAHN

PHOTOGRAPHS
CEMAL EMDEN

PRESTEL
Munich · London · New York

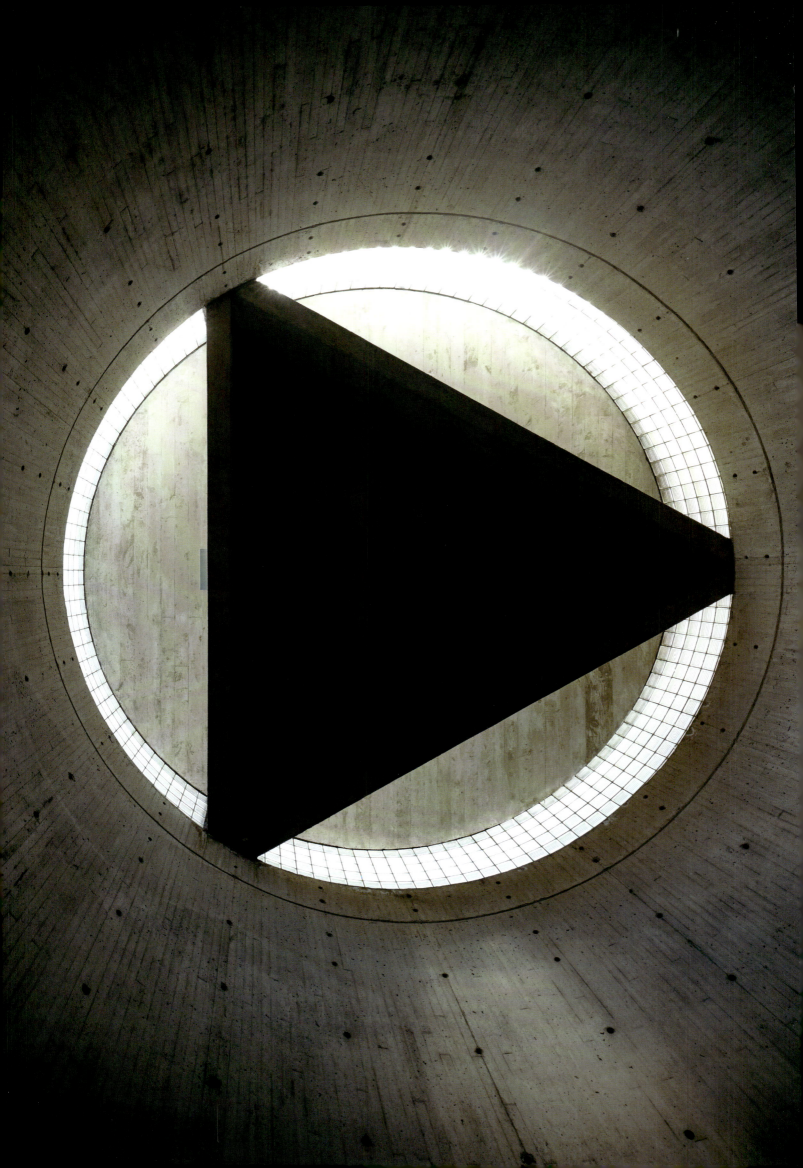

Contents

6 THE TENETS OF KAHN'S ARCHITECTURE JALE N. ERZEN

20 THE MASTERPIECES OF LOUIS KAHN CAROLINE MANIAQUE

23	Yale University Art Gallery	185	Phillips Exeter Academy Library
35	Trenton Bath House	199	Kimbell Art Museum
47	Alfred Newton Richards Medical Research Laboratories	219	Temple Beth-El
63	Tribune Review Publishing Company Building	227	Yale Center for British Art
71	Margaret Esherick House	243	Steven and Toby Korman House
83	First Unitarian Church of Rochester	259	Franklin D. Roosevelt Four Freedoms Park
97	Salk Institute for Biological Studies	271	RESIDENTIAL PROJECTS
113	Eleanor Donnelley Erdman Hall, Bryn Mawr College	274	Jesse and Ruth Oser House
127	Performing Arts Theater, United Arts Center	278	Samuel and Ruth Genel House
141	Indian Institute of Management	282	Bernard and Norma Shapiro House
159	Sher-e-Bangla Nagar	286	Fred E. and Elaine Cox Clever House
175	Ayub Central Hospital	290	Norman and Doris Fisher House

294 THE TIMES AND WORKS OF LOUIS KAHN AYŞE ZEKİYE ABALI

298 CHRONOLOGY AYŞE ZEKİYE ABALI

318 BIBLIOGRAPHY

Jale N. Erzen

THE TENETS OF KAHN'S ARCHITECTURE

Louis Kahn's work and writings will always be inexhaustible sources of knowledge and inspiration. Each time they are consulted, new meanings emerge, as though we are seeing or reading them for the first time. Over the years there has been much engaged and penetrating research into his output as well as his person, and this looks set to continue with fervour: in recent years, numerous books have appeared, each offering new information and insights. Today, in the context of our contemporary culture, the rich content of Kahn's work and thought continues to prompt new interpretations.

Given this plethora of analyses, tributes and ideas, one asks what kind of a contribution this publication can make. In putting this book together, our belief has been that, especially at a time when architecture caters so much to the 'marketplace',[1] new ways of thinking about Kahn and of viewing his work not only seem vital but are necessary in order to convey, for each new age, the importance of his universal understanding of architecture and its relation to basic social and institutional interests.

Though the mature period of Kahn's active career lasted more than two decades (1951–74, during which time he designed most of his major works), he realised relatively few buildings in these years. Furthermore, though many of his buildings are small by comparison with the huge structures commissioned from international firms today, they took many years to realise, with several completed only after his death; other projects were only partially realised or remained unbuilt. Yet appreciation for both Kahn's architecture and his profound personal philosophy has only increased.

Form and Design

Many articles had already been written on Kahn's work by the time Vincent Scully published his monograph in 1962, with the architect himself having also published several of his own, the first appearing in 1931. And each of the more than dozens of books that have appeared on Kahn's architecture and thought (beginning with Scully's) has tried to advance a different approach to this artist-architect whose work is inexhaustible in a single text, no matter how voluminous. With Kahn's work inviting such passionate engagement, each encounter with it acting as a new beginning and occasioning a new experience of his work, it seems clear that new interpretations will continue to emerge.[2]

Each of Kahn's buildings, irrespective of its function or use, differs distinctly from the others. In terms of how they relate to their environment, in terms of their structure and mass as well as how materials – even when similar – are applied, Kahn's buildings are individuals, each one holding out its own identity. Yet in all of them there are certain characteristic design decisions that make it possible to talk about an 'architecture of Louis Kahn'. In order to understand Kahn's body of work as a total creation, it is necessary to examine the different ways in which these characteristic qualities are applied and articulated in each project.

Appearing and Emerging

Why does Kahn's work captivate us, continually engaging us in the desire to view it again and again, to attempt to understand these often simple-looking but extremely complex structures? This is surely because each time we embark on an effort to interpret these forms and structures, new meanings emerge; new questions demand to be clarified. According to the American philosopher Joseph Margolis, artworks emerge into being not only as the artist creates them but also in the moment of their viewing and interpretation.[3] When seen in their physical reality, Kahn's buildings seem like apparitions from another world, as sublime structures that hold us in awe.[4] In each case, the relation to the site differs, being designed either to provide the best possible viewing vista or, if the building is in a crowded neighbourhood, to relate it to its environment. As the architect stated in his lecture on monumentality in 1944: 'The plan does not begin nor end with the space [the architect] has enveloped, but from the adjoining delicate ground sculpture it stretches beyond to the rolling contours and vegetation of the surrounding land and continues farther out to the distant hills.'[5]

Vincent Scully understood Kahn's relation to architecture as creating a complete world: 'We largely construct the settings of our actions and our works of art; the Greeks chose natural ones of special authority. In that sense, Kahn … was constructing a landscape "ageless and unwearied," physically expressive of Law.'[6] Indeed, each building uses shape and form in fascinating ways that relate to the landscape. The prismatic towers of the Richards Medical Research Laboratories (1957–60) at the University of Pennsylvania rise up into the sky. The building is situated on a lower level than the surrounding gardens so that as one approaches it from the street, one initially sees its base from a higher point, emphasising both its soaring elevation and its being grounded in the earth. The Erdman Hall dormitories (1960–65) at Bryn Mawr College, Pennsylvania, whose plan is made up of three diamonds intersecting at the corners, is by contrast situated on a raised plot and as such dominates the surrounding landscape. Its sectioned facades of concrete columns, glass and panels create an effect of accordion movement, like a dancer under the limelight moving across the terrain. Meanwhile, at the Sher-e-Bangla Nagar parliamentary complex (1962–83) in Dhaka, Bangladesh, the massive structures spread out alone amid a flat landscape and are reflected in the surface of the surrounding artificial lake. The buildings have an eerie, isolated appearance in the vast, otherwise empty environment, extending in groups of different colours, conferred by their materials: warm red brick; cool grey concrete with white marble.

The Kimbell Art Museum (1966–72) in Fort Worth, Texas, is an unusual sight: a structure comprising a series of parallel barrel vaults, sitting slightly raised within a garden of open lawn and edged on the entrance side by regularly planted trees. Its long portico, stretching out beneath an open end vault, is a meeting point between the world of nature – water, air, sunlight, greenery – and the world of culture with its spiritual light.

The library at Phillips Exeter Academy, New Hampshire (1967–72), is a striking presence that rises from the earth with no clear indication as to where to enter or what is housed within. The building acts like a key that unravels the secretive, introspective atmosphere of its interior – exemplary of Kahn's approach. As one penetrates the successive layers, one experiences a sequential procession from the purely physical to the spiritual. The Salk Institute complex in San Diego, California (1959–65), with its pair of long mirroring blocks, likewise gives the appearance of a closed, inward-looking whole, but this time embracing between its two wings a central plaza open to the sky and leading to the ocean.

With his museum projects at Yale – the two buildings bracketing his career, with the Yale University Art Gallery (1947–53) being his first public commission and the Yale Center for British Art (1969–77) being one of his last designs[7] – Kahn developed two differing solutions to relate his buildings to their wider context. For the gallery, he used a blind wall on the street facade, blank except for horizontal bands indicating its floors, thus visually extending the neo-Gothic stone elevation of the adjacent Old Yale Art Gallery building. In the later Center for British Art, situated opposite, he related the huge horizontal steel and concrete block to the pavement by incorporating glazed retail spaces beneath, which lead towards the open corner housing the entrance.

Structure and Monumentality

Each part serves to a maximum degree simultaneously as construction, as spatial definition, and as its own sculptural embellishment. WILLIAM H. JORDY[8]

Kahn's lifelong conviction about the priority of structure may have stemmed in large part from his Beaux-Arts education and the influence of his teacher Paul Philippe Cret. But unlike the French rationalists, for whom only structure dominated, Kahn's architecture was an integrated union of space and mass, solid and void. As Scully put it: 'He was seeking a truly classic wholeness of being.'[9]

This 'wholeness of being' was the source of the monumental character of Kahn's work, which derived its raison d'être and meaning from Kahn's belief in the institution and the city as aspirations of man, and its physicality from the system of structure and joint. His approach to tectonics, which he identified during his travels as the fundamental mode of expression in Roman, Greek and Egyptian monuments, as well as the ground for their condition of endurance, became in his designs the generator both of hierarchic space

and of light, achieved through the deployment of structural elements and techniques. The wall, the pier, the column and beam and the space frame, together creating an inseparable whole, were used differently in almost every building in accordance with the desired hierarchy of spaces, the need for specific light and the institutional function of the structure. The way they were used was always explicit: as Kahn had claimed, 'Space is architectural when the evidence of how it is made is seen and comprehended.'[10] However, in spite of their being interlocked, each element always retains its integrity and is experienced individually. The Exeter Library constitutes a perfect example of Kahn's ability to convey the inseparability of the structural elements and their simultaneous perception as discrete components. The exterior load-bearing walls, which appear as if autonomous, are tied to the whole structure at each floor by concrete beams, which in turn are integral to the central prismatic structure.

Both Kenneth Frampton and Vincent Scully have written about the affinities between Kahn and Frank Lloyd Wright (1867–1959). Scully's analysis emphasises how both Wright and Kahn contributed to a new beginning for American architecture within modernism and the International Style, identifying a 'close parallel … between Wright's works of 1902–6 and Kahn's of 1955–60' (although Scully claims that this was completely unconscious on Kahn's part).[11]

Both, that is, began their invention — Wright early in life, Kahn late — at a moment when the general architectural movement was toward clear geometric order ... In the nineties most architects soon came to conceive of such order in the usual Picturesque-Eclectic terms, and the movement as a whole turned into neo-Baroque formalism, overtly eclectic, overtly decorative. Wright conceived of order in intrinsic terms and rebuilt architecture from the ground up with it. In the fifties — after Mies — some of [Philip] Johnson's work ... and others has followed the first course, the neo-Baroque, decorative one. Kahn has followed the second: Wright's course. The first course heralded, in the nineties, the end of something; in the late fifties it would seem to have been doing the same. The impression becomes inescapable that in Kahn, as once in Wright, architecture began anew.[12]

For Frampton, Wright's influence on Kahn has not sufficiently been acknowledged. According to Frampton, although many architects were influenced by Wright, it was Kahn who best understood the hierarchic character of his spaces. Besides the obvious parallel between the hollow service towers in the Richards Laboratories and Wright's Larkin Building (1904–6, pulled down in 1964), Kahn's basic plan forms are cross-axial like several of Wright's buildings.

One of the important structural techniques employed by Kahn is his method of surrounding a core with a structural or, in some buildings, non-load-bearing enveloping shell a demonstration of his principle that 'A building is a world within a world.'[13] Throughout history, the architects of buildings that served spiritual or intellectual purposes, such as mosques, churches, libraries and schools, be it the works of the great Ottoman architect Sinan[14] or Byzantine and later Christian edifices, have tried to isolate the inner core, the main space of their buildings, by enveloping them within a second layer of spaces. Typically, such a second layer served as an isolating or protecting envelope. In

churches, the chapel naturally fulfilled this purpose. In Gothic examples as well as in classical Ottoman architecture, this second layer, made up of vaulted spaces, a row of columns or of chapels, was at the same time a structurally reinforcing necessity, with a series of columns acting to support the vaults, which worked as buttresses for the main hall. Kahn explained the logic of Gothic structures as 'a courageous theory of a stone-over-stone vault skeleton producing a downward and outward thrust, which forces were conducted to a column or a wall provided with the added characteristic of the buttress … The buttress allowed lighter walls between the thrust points and these curtain walls were logically developed for the use of large glass windows.'[15]

In many of Kahn's buildings, besides protecting the core, making it private and guarding its special atmosphere, the enveloping structure and its relationship to the core is decisive in the identity of the building. Often two or more separate kinds of structure are tied together (as in the Exeter Library), to allow for spaces of less specified use, as a mode of concealment for purely functional or mechanical components (air shafts, wiring, storage), or to create an ambulatory, a space of free movement. As has often been mentioned, such doublings of structure and space have also been a way of using and connecting different materials. This mechanism has been implemented in most of Kahn's buildings as an important ordering device, one that results in a structural complexity that defies definition through plan and section renderings.[16]

This method of enveloping the core with multiple layers of space is used to its utmost advantage and variety of uses in the Dhaka National Assembly building and its annexes and dependencies. The colossal mass of the main building is structured with an outer layering of cylindrical towers, open at the top and used as sources of light and air; while large courtyards and paths, related by walls pierced with circular openings, connect the different internal layers. This lamination around a central spiritual space, such as the assembly hall or the mosque attached to it, recalls Dante's description of the Empyrean heaven in Canto XXXI of his *Paradiso*, where space opens up like a rose with countless petals. The metaphor may not be so far off the mark, since in Islam the interiors of spiritual places are likened to paradise. For Kahn, who talked about man's creation as the work of God, this layering creates a sequential journey of discovery leading from the worldly to the spiritual: 'What man has made is the very, very manifestation of God.'[17]

At Exeter Library, the central cubic space that constitutes the core is surrounded by two other enveloping spaces that require different light intensities and serve specific purposes, such as for reading and for housing the bookshelves. The outermost layer of the building is composed of brick load-bearing walls; a second layer, a frame of reinforced concrete, supports the shelving; and a third layer surrounds the central gallery space, with enormous circular openings in the concrete walls on all four sides. Each intermediary space has specific functions, and the layered construction allows the light to enter each part differently.

In the First Unitarian Church of Rochester, New York (1959–62, 1965–69), the central space that constitutes the church is encircled by an ambulatory, encouraging free movement, with classroom partitions situated around the perimeter. As with the examples described

above, here too the layering of enveloping spaces made it possible for Kahn to relate different materials: concrete, brick, travertine and wood. The inner walls are of precast concrete brick, while the exterior walls are of brick and the doors and window frames are in wood. Textures and colours create a variety of sensuous impressions as we gaze at different parts of the building. It is interesting to note that among Kahn's first sketches for the church is a diagram that seems to be a precursor of the plan of the National Assembly in Dhaka, with an octagonal core surrounded by satellite spaces.[18]

Without giving further examples, it suffices to say that these principles of layering hold true in most Khan buildings with similar structural, functional and atmospheric intentions, including the Indian Institute of Management in Ahmedabad (1962–74); the Arts United Center in Fort Wayne, Indiana (1973); the Salk Institute; and the Richards Laboratories.

Another important structural device used by Kahn is the space frame, which functions as both space maker and light giver. In almost all works by Kahn the ceiling is treated as an integral element, being articulated to transmit light in the particular ways that are appropriate for the space it covers, and also acting, in the context of the space frame, to create space. Indeed, of all architects it is perhaps Kahn who best understood how to utilise space frame and folded plate structures to their utmost advantage.

Yale University Art Gallery was the first building where the ceiling became a major feature for Kahn, its triangulated waffle slab creating a dynamic effect and reflecting light from its three-dimensional surfaces into the space beneath. The most extravagant – as well the most historically referential – of all his ceiling articulations, however, was executed at the parliament building in Dhaka. Here, in the main amphitheatre, Kahn elected not to use a conventional dome[19] but instead came up with a design that clearly recalls the ceiling of the prayer hall at the Selimiye Mosque in Edirne, Turkey, the masterpiece of the Ottoman architect Sinan, completed in 1574. It is fascinating to note that these late buildings by two genius architects – working almost exactly four centuries apart – both have octagonal bases and a roof that permits light to infuse through openings around its sides. In Kahn's case, an inset parabolic shell of folded concrete plates is tied to the base at the eight corners, leaving eight intermediary arches of light between the umbrella-like roof and the base. What results from this unusual design is a cosmic formation, reminding one that historically, in Islam, general assemblies had a religious significance.

Another atypical ceiling form is used in the Unitarian Church, where the four folded plates, attached to each other along their inner sides to form a cross, leave rectangular openings in the four corners of the space, allowing light to filter in via the four cubic light towers at the corners of the building. The folded plates are supported along the interior wall by slim structures comprising a cross-beam bracketed by columns at the edges. Frampton said of this design: 'The full spirituality of this church as an institution is expressed in the roof section, from which a mysterious light enters into the four cubic corners of the meeting room, highlighting the flying beams that serve to sustain the stability of this quadripartite shell form.'[20]

One of the architect's latest projects was the Yale Center for British Art, which also implemented a system of natural lighting in the ceiling: the roof is partitioned into sixty squares, each one formed of a truncated concrete pyramid inset with glazing. Both the exterior elevations and the interior spaces consist of repeated square or rectangular formations that connect groups of gallery spaces. Thus the building as a whole is experienced as a unified prism, divided proportionally according to function and the need for light.

At Exeter Library, the centralised plan comprises three concentric volumes, each requiring light in different intensities. At the top of the central space, the exterior frame walls do not meet, so as to leave a gap for natural light to enter. Two thick, deep concrete beams extend diagonally from the corners and cross at the centre, structurally tying together the four concrete walls of the square central atrium while allowing light to pass through.

Geometry

The basic forms of Kahn's buildings are often composed of interlocked structural layers of basic Platonic geometries, although, as Frampton took care to emphasise, 'Kahn rarely used the primary forms in isolation, but always as the elemental parts of more complex assemblies.'[21] Kahn, coming from a Beaux-Arts education at the University of Pennsylvania with the French-born architect Paul Philippe Cret as his mentor, inevitably tended towards the basic spherical and prismatic forms used by Enlightenment architects.[22] In spite of his metaphysical understanding of architecture's meaning, Kahn tried to create clearly legible constructions (though these were nevertheless complex and not easy to understand from a plan).

These basic geometric forms had their origins in nature and could be interpreted as relating to the human and its orientation in the world, for example the square or cross signifying the four cardinal points; or relating to cosmic forms, as in the circle, or the Trinity in the form of the triangle.[23] Although Kahn did not talk about their significance, he used them in both structural ways and as the basic forms of his buildings; these are imposing shapes that confer a sense of strength and monumentality without necessarily having a functional role. Essential geometries appear both as spatial volumes and as planes: the prismatic enclosures of the Trenton Bath House (1954–59) or the spherical towers of the Dhaka National Assembly, for example, are juxtaposed with openings and partitions that incorporate rectangles, circles or triangles in planar form. The interplay of hard geometric lines and the generous curves of the circle as apertures in walls or ceilings, found in so many of Kahn's buildings, brings an awareness and sense of shelter to the fore for users of his spaces. Furthermore, many of Kahn's buildings present voids, holes and shadow play not only on their surfaces but in the form of hollow tubes or prisms to enclose services, contributing to the structural system. Kahn, who had expressed his admiration for Amsterdam, would have been aware of Piet Mondrian's artwork and Gerrit Rietveld's architecture, and his equal regard for both voids and articulated volumes, as well as for blind surfaces, might also be interpreted as an architectural correspondence with the principles of De Stijl.

The square and the circle, and the way their uses and relationships alternate in different buildings, become legible indications of how the structure is ordered. Such forms are often sensed and seen in the most emblematic structural aspects. In Kahn's work, prismatic volumes of various dimensions, both as structural elements and in the buildings' fundamental massing, are striking forms that work to express the identity of a building in the first instance and render it monumental, regardless of size.

Ruins and Beginnings

I might say that everything must begin with poetry. LOUIS KAHN[24]

While Kahn's interest in basic geometries may have had its origins in his Beaux-Arts education, he became consciously attracted to them during his visits to historic sites in Europe and Egypt. His drawings and paintings from his trips to Europe in 1928 and 1951 evidence his emotional fascination with such forms, as well as how he viewed ruins, voids, volumes, shadows and light analytically, seeing in them the possibilities of monumental form. In these sketches, one can sense the significance of the relation of light to silence, a notion fundamental to Kahn's understanding of architecture. Many of the archaic forms found in these ruins, such as at Paestum in Greece or the pyramids in Egypt, became sources of his modern, 'original' vocabulary, and they can be interpreted as his basic references when he talked about 'beginnings'. As he stated in 1973, 'that which made a thing become manifest for the first time is our great, great moment of creative happening.'[5]

As Frampton affirmed in several texts,[26] Kahn's work was both progressive and anti-progressive, but an understanding of his architecture as belonging to a specific movement or era did not mean much for Kahn. For him, every work of art was a first and a beginning: 'The beginning is a wonderful time because nothing could take hold unless that beginning, when it does take hold, is true, thoroughly and deeply, to the nature of man … So the beginning is true to man.'[27]

But even beyond Kahn's travel sketches, references to ancient architectures – and in particular the way such buildings openly reveal their structure – can be identified in much of his built work, as the historic examples, notable for their timelessness, that inspired the simplicity and austerity of his forms. With closer scrutiny, we can identify sources such as the second-century Baths of Caracalla in Rome, echoed in the form of the Kimbell Art Museum's vaults, or medieval Scottish stone castles in the rising masses of Erdman Hall and Exeter Library.[28] Hadrian's Villa at Tivoli had been an inspiration for many architects from the time of Borromini onwards; and Rome and its ancient architecture – revised in a historicised and surrealistic interpretation in the drawings of Piranesi in the eighteenth century – and the Pantheon in particular, symbolising the unity of sacred forces and the rhythm of the sun's light, were definitive sources of inspiration for Kahn whose influence can be traced in many of his buildings. Without decoration and without reference to function, Roman ruins, with their massive arches

and walls, could be appreciated as pure geometric volumes in which the aesthetic effect is generated by the structure. The Trenton Bath House, with its precise Greek cross plan as well as its voluminous piers topped with pure pyramidal forms, harks back both to Palladian plans and ancient Egyptian pyramids. The ambulatory spaces of free movement present in many of Kahn's buildings, often separating the outer and inner walls or the layering between a building's core and its enveloping structure, and which also provide air circulation or space for services, remind one particularly of the Teatro Marittimo at Hadrian's Villa. This principle of ambulatory space is applied most effectively in the Institute of Management at Ahmedabad, where they are placed between the exterior walls and the interior spaces; the National Assembly in Dhaka, where they encircle the core; and at the First Unitarian Church, between the interior and the surrounding spatial units.

By refining the memory of these classical models, which had assumed an almost magical timelessness for Kahn, the architect perfected most of his architectural elements as Platonic forms that embodied absolute beginnings and pre-existing ideals – immeasurable essences with an eternal existence. As Kahn explained, taking Baroque music as his example, 'Somehow the toccata and fugue did not disappear, because they are the most unmeasurable and therefore the closest to that which cannot disappear. The more deeply a thing is engaged in the unmeasurable, the more deeply lasting is its value.'[29]

Silence and Light

For Kahn, beauty – in its essential form, discussed simply and without adjectives – was found in silence and inner light. His emblematic lecture on this subject, 'Silence and Light', given at ETH Zurich in 1969, began with the affirmation that if we see well, we also hear; that 'The senses can really be considered one thing.'[30] According to Kahn, in thought, 'all the various ways of expression come to the fore.'[31] For Kahn, since architecture means capturing an ideal that has always existed, the physical forms of expression spring from a single, unique beginning and become separated as built form according to human desires, creating the social institutions that are the origins of architectural typologies. It is in this way also that architecture can essentially be traced to the senses. Again using a metaphor from music – an important touchstone for the architect – Kahn explained: 'When I see a plan, I must see the plan as if it were a symphony, of the realm of spaces in the construction of light.'[32]

As discussed above, Kahn conceived the construction of many of his buildings in terms of the reception and control of light, a critical element in modulating the visual and tactile qualities of architecture, conferring transparency, softness, warmth and colour. For Kahn, light is 'the giver of all presences, is the maker of material', and is given by the possibilities of structure.[33] Simultaneously, just as buildings and spaces have their own particular light, they also have their sound. However, 'silence', in Kahn's conception, cannot be easily defined or described: it 'is not very, very quiet',[34] is not a lack of sound, but rather refers to the dissolving of materiality in light. It is akin to pure

colour, having no reference to materiality but evoking a kind of intangibility of matter and form. One might liken Kahn's silence to Kazimir Malevich's *White on White* of 1918 or the monochrome paintings of the 1960s, which possess a silent quality that reveals an immaterial or spiritual presence. It is this essence that Kahn sought in relating silence to light. Though he designed the main structure of his buildings around the light that is given by the sky and the sun, within each building this light not only changes character but assumes a unique nature, one that belongs only to that given space.

Architecture as Philosophy

Kahn might be described as a philosopher who gave his words and beliefs physical form. Those of his buildings that stand alone in the landscape – with the exception of the museums at Yale – seem as though sprung from the earth, as if they emerged from the ground in their awesome physical wholeness. For Kahn, who wrote and talked about architecture as human consciousness and conscience,[35] his architecture was an extension of his thought. As he succinctly expressed it, 'The whole reality isn't there without the reality of belief',[36] and thus he transmuted words and thought into built form; one might even say that architecture was the necessary medium through which he was able to convey his convictions. This is perhaps also why many of his projects took so much time to be finalised – he was seeking, besides functional and cultural appropriateness, the proper physical counterpart to his ideas. And, like a philosopher, these ideas were primarily rooted in the question of humanness and how humans build communities and habitats. But because Kahn never claimed to be a philosopher and was surrounded mostly by architects, students and urbanists, his discourse was not considered 'philosophy' (even if it was accepted as 'philosophical'). Kahn always based his criteria for architecture on its social and spiritual content, and as such achieved an understanding of the human that had been lacking in much philosophical writing – as Margolis has noted, many philosophers tried to understand how we can know the world, without trying to understand humanity.[37] In this sense, Kahn's discourse disclosed more about humanity than much directly philosophical writing.

In reading Kahn and apprehending his work, it becomes clear that designing buildings was for him the means to fulfil the necessity of realising the metaphysical in actual and communal form. From his beginnings in the early 1930s through to his mature period, he was constantly concerned with issues of human need and aspiration. Struggling to achieve success in making his convictions about habitation and urban problems understood, he insistently worked on and reworked projects dealing with these concerns, coming up with numerous alternatives for public housing and urban planning projects that emphasised circulation and proper urban living. It is evident from the unusually creative urban planning sketches he made for central Philadelphia (including the Center City plan, the Triangle Redevelopment Plan and the Viaduct Architecture plan), and from the many ingenious design projects of later years, such as for the US Embassy in Luanda, Angola, that most of the time Kahn's genius exceeded what could be understood in his time. Like Michelangelo, Sinan and a few other great architects,

his passion was beyond verbal interpretation. Though his many lectures and writings go some way to articulating his ideas, Kahn's metaphysical position can only be penetrated through an understanding of his work.

Viewing Architecture as Art

In the context of the themes and preoccupations outlined above, this book offers a means of approaching Kahn's work through images that are both aesthetic and that present qualities that reveal what Kahn meant by 'just simple beauty' in architecture.[38] For Kahn, as for Cemal Emden, who is also an architect and whose photographs form the core of this book, the special quality and iridescence of light, its colour, reflection and angle, are what make each view unique. And, as Kahn's drawings and paintings of landscapes and architecture attest, a precise viewing position was essential in order to render the uniqueness of the space as experienced. Each of the photographs contained here fulfil this idea of precision and will remain as unique memories of Kahn's work.

Accompanying the visual presentations, Caroline Maniaque's descriptions of Kahn's individual buildings provide a comprehensive and clear understanding of their structure, materials and form, as well as, often, the history of their construction and the intentions of the architect, accompanied by illuminating quotations from Kahn himself. Maniaque, who has previously written on Kahn's residential projects, has an eye both for the specifics of form and design in each building and for identifying the general principles of Kahn's architecture as they apply to each particular case. Her texts summarise the literature on Kahn's work in lucid and economical fashion and are both pleasurable and informative to read.

1 Kahn talked about architecture as not belonging to the 'marketplace'. See Louis Kahn, 'Silence and Light II' [1969], in *Louis Kahn: Essential Texts*, ed. Robert Twombly (New York: W. W. Norton & Co., 2003), p. 240. Note that Kahn presented two talks with the same title, the first in 1968, published as 'Silence and Light I', ibid., pp. 228–35. In 1969 he also gave a talk with the same title at ETH Zurich; this has also been published in *Louis I. Kahn: Silence and Light* (Zurich: Park Books, 2013), with accompanying audio CD.

2 In the last few years, in Turkey alone, two new books have appeared: *Re/Framing Louis Kahn*, ed. Müge Cengizkan (Istanbul: Pera Museum, 2017); and Cengiz Yetken, *Louis Kahn Stüdyo ve Atölyesinde Birlikte Üretmek* [Louis Kahn: Creating Together in his Studio and Workshop] (Istanbul: Yem Yayinlari, 2020).

3 Margolis famously spoke of artworks as 'physically embodied and culturally emergent entities'. See Joseph Margolis, *What, After All, Is a Work of Art?* (Philadelphia, PA: Pennsylvania State University Press, 1999), p. 68. He continues: 'such entities and properties emerge in a *sui generis* way in the cultural space of human life' (p. 98).

4 This is the case especially with the Exeter Library, which appears almost out of nowhere on the flat terrain.

5 Louis Kahn, 'Monumentality' [1944], in *Essential Texts*, p. 28.

6 Vincent Scully, *Louis I. Kahn* (New York: George Braziller, 1962), p. 21.

7 During his last years Kahn worked on several projects at the same time.

8 William H. Jordy, 'Medical Research Building for Pennsylvania University, Philadelphia', *Architectural Review*, 129:2 (February 1961), p. 103.

9 Scully, *Louis I. Kahn*, p. 23.

10 Louis I. Kahn in Walter McQuade, 'Architect Louis Kahn and His Strong-boned Structures', *Architectural Forum* (October 1957), p. 142, quoted in Kenneth Frampton, *Studies in Tectonic Culture: The Poetics of Construction in Nineteenth and Twentieth Century Architecture*, ed. John Cava (Cambridge, MA: MIT Press, 1995), p. 228.

11 Scully, *Louis I. Kahn*, p. 24. He continues: 'It should only be pointed out that anything of the kind has been wholly unconscious on Kahn's part.'

12 Ibid., pp. 24–25.

13 Louis I. Kahn, *Conversations with Students*, ed. Dung Ngo, Architecture at Rice 26, 7th edn (Princeton, NJ: Princeton Architectural Press, 2017), p. 28.

14 As architect and civil engineer to several Ottoman sultans, including Suleiman the Magnificent, Sinan (c. 1500–1585) built most of the imperial mosques in Istanbul, as well as the Selimiye Mosque in Edirne.

15 Kahn, 'Monumentality', pp. 21–31.

16 This aspect of Kahn's work is mentioned several times by Frampton in his 1995 *Studies in Tectonic Culture*, in relation to both the Yale Art Gallery (pp. 221–22) and the triple structural forms of the Exeter Library and the Bangladesh National Assembly (pp. 232–33). In Romaldo Giurgola and Jaimini Mehta, *Louis I. Kahn: Architect* (Boulder, CO: Westview Press, 1975), the authors discuss the Exeter Library and the Yale Center for British Art in this regard (pp. 91 and 99).

17 Kahn, 'Silence and Light II', p. 251.

18 David D. Brownlee and David G. De Long, *Louis I. Kahn: In the Realm of Architecture* (New York: Rizzoli, 1992), p. 67, fig. 102.

19 His first design for the roof of the National Assembly involved a dome.

20 Frampton, *Studies in Tectonic Culture*, p. 235.

21 Ibid., p. 233.

22 Kenneth Frampton, 'Louis Kahn and the French Connection', in *Louis Kahn: The Power of Architecture*, ed. Mateo Kries, Jochen Eisenbrand and Stanislaus von Moos (Weil am Rhein: Vitra Design Museum, 2012), pp. 115–31.

23 In Islamic geometric decoration, the square within the circle symbolised man's position in the universe. See Keith Critchlow, *Islamic Patterns* (London: Thames & Hudson, 1976). Critchlow's book gives extensive explanation of the cosmic symbolism of geometric forms.

24 Kahn, 'Silence and Light I', p. 235.

25 Louis Kahn, 'Lecture at Pratt Institute' [1973], in *Essential Texts*, p. 278.

26 Frampton claims: 'Thus Kahn's work presents us with two complementary yet utterly opposed principles. The first is categorically anti-progressive and asserts the presence of a collective abstract architectural memory in which all valid compositional types are eternally present in their disjunctive purity. The second principle is vehemently progressive and pursues the renovation of architectural form on the basis of advanced technique.' Frampton, 'Louis Kahn and the French Connection', p. 127. In his other writings on Kahn, for example in *Modern Architecture: A Critical History* (London: Thames & Hudson, 1980) and *Studies in Tectonic Culture*, Frampton emphasises Kahn's historicism and classicism by pointing to his use of 'primordial' and 'archetypal' forms, alongside his preference for modern materials such as tubular steel and concrete, even in his early work.

27 Louis Kahn, 'Law and Rule in Architecture II' [1962], in *Essential Texts*, p. 141.

28 'He did make a flying visit to Scotland to see castles in March 1961 when he was called to London by another job in the midst of the Erdman design.' Brownlee and De Long, *In the Realm of Architecture*, p. 102.
29 Kahn, 'Lecture at Pratt', p. 269.
30 Kahn, 'Silence and Light II', p. 235.
31 Ibid., p. 236.
32 Ibid.
33 Ibid.
34 Ibid.
35 Kahn talked about the role of conscience in several of his lectures; see *Essential Texts*, pp. 153, 167, 247.
36 Louis Kahn, 'Lecture at Yale University' [1963], in *Essential Texts*, p. 166.
37 Joseph Margolis, *Towards a Metaphysics of Culture* (New York: Routledge, 2013).
38 Kahn, 'Lecture at Pratt', p. 269.

CAROLINE MANIAQUE

THE MASTERPIECES OF LOUIS KAHN

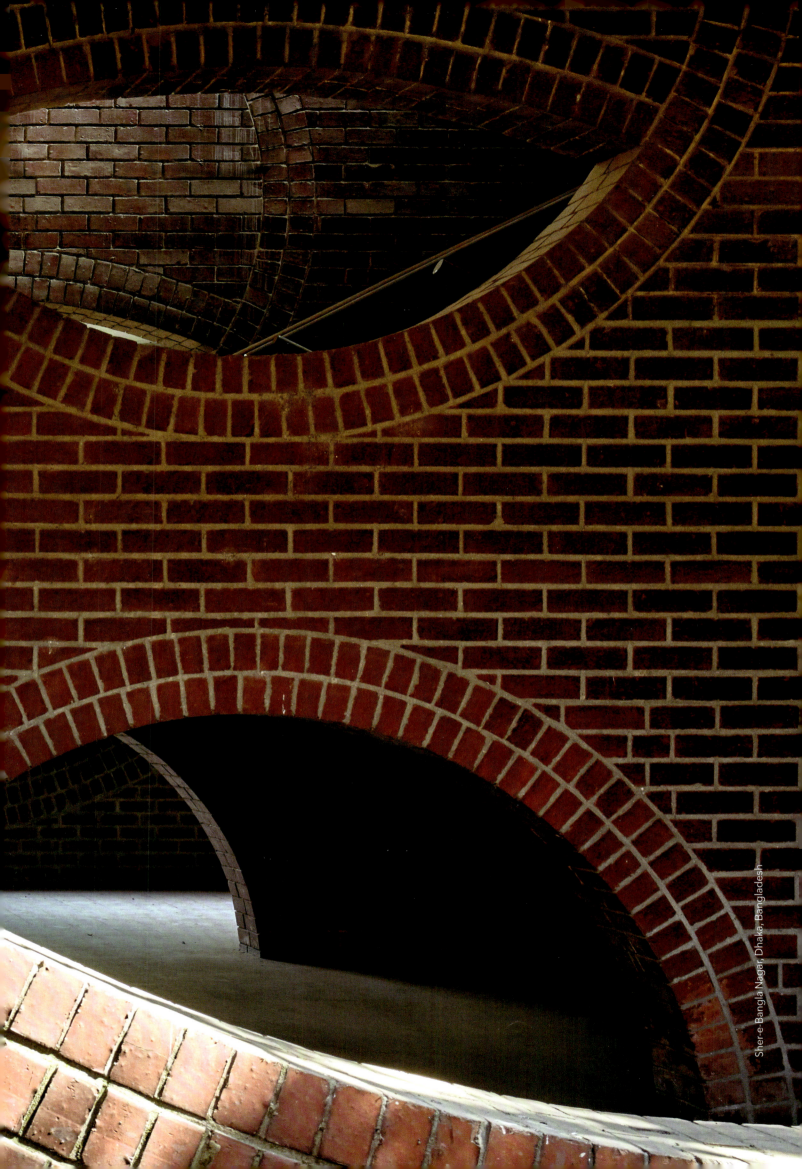
Sher-e-Bangla Nagar, Dhaka, Bangladesh

The formwork was made from floor to floor, and this line was accented in the design; because what we tried to do in the expression of the building was to show in every way how it was built.

Louis Kahn, 'This Business of Architecture', 1955[1]

New Haven, Connecticut
1951–53

YALE UNIVERSITY
ART GALLERY

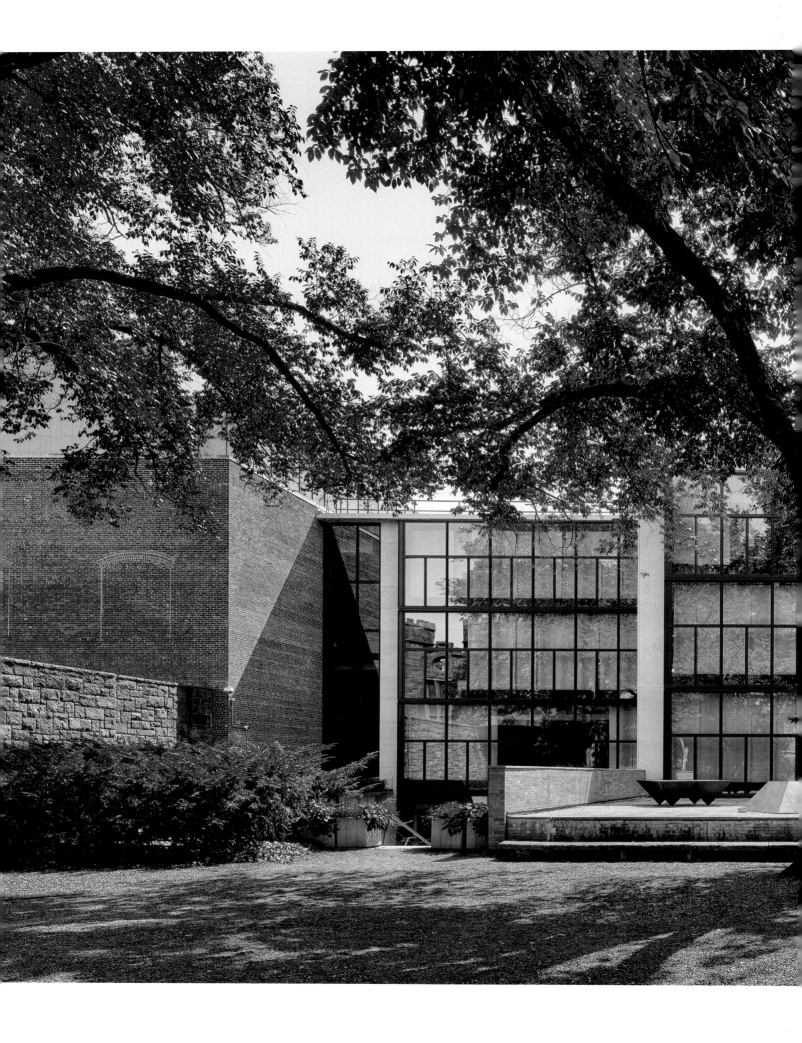

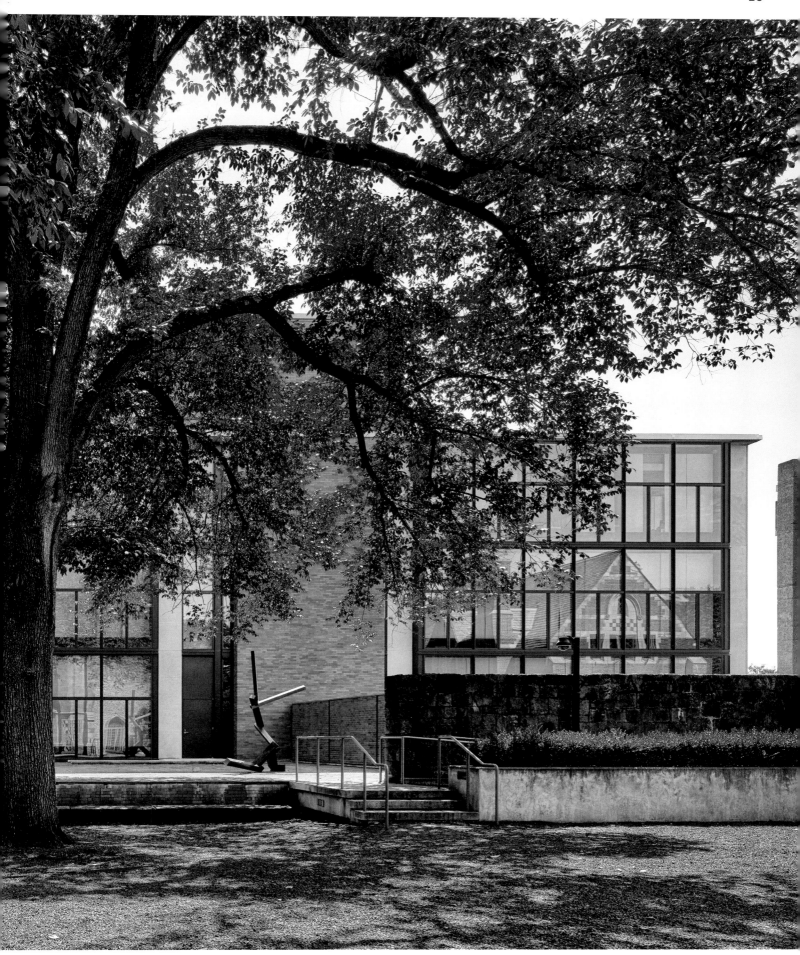

In 1951, a few weeks after returning from a stay in Rome, Kahn presented his first sketches for an extension project for Yale University Art Gallery. The gallery's collection had been significantly enriched thanks to a donation made in 1941 by the artist and patron Katherine Dreier, comprising works that she had collected since 1920, when she had co-founded the Société Anonyme with Marcel Duchamp and Man Ray.

Located on the outskirts both of the city of New Haven and the Yale University campus, the site perhaps suggested to Kahn the idea of a 'frontier', a notion he gave built form in the continuous wall that encompasses the museum, creating a terraced courtyard within its boundary. To the south, along Chapel Street, two blind stretches of wall in brick are interrupted only by four horizontal bands of white stone, indicating the levels of the floors inside the building and also serving as a water outlet. These bare walls, connected directly to the pavement, give a certain austerity to the building and with their rough texture contrast with the International Style buildings of the same period, characterised by load-bearing frameworks, curtain walls and the use of pilotis.

Kahn played on the duality between transparency and opacity by creating glazed facades reminiscent of those of Ludwig Mies van der Rohe to the west and north. The space created by the gap between the two brick walls is glazed too and houses the entrance to the museum, reached by external steps set back from the street. The project required an uninterrupted interior space so as to allow the layout to be modified, and Kahn used a system inspired by the lightweight, three-dimensional structures of architect-engineer Buckminster Fuller. The increased span provided by the concrete tetrahedral ceiling structure constituted a remarkable technical feat that undeniably contributed to Kahn's fame as an architect. Kahn spoke of it as a 'breathing ceiling',[2] because it housed the ventilation devices as well as pipes and cables, thus freeing up space in the exhibition areas beneath. The massive appearance of the interior and the monumental look conferred by the structural slab, the concrete cylinder housing the staircase and the raw surface finish of the materials used (imperfections were emphasised for their aesthetic value) made this museum, according to Reyner Banham in an article published in the *Architectural Review* in December 1955, the 'best American example of neo-brutalist architecture'.[3]

1 Louis I. Kahn, 'This Business of Architecture', lecture at Tulane University, New Orleans, 1955, in *Louis I. Kahn: Writings, Lectures, Interviews*, ed. Alessandra Latour (New York: Rizzoli, 1991), p. 62.
2 Patricia Cummings Loud, *The Art Museums of Louis I. Kahn* (Durham, NC: Duke University Press, 1989), p. 206.
3 Reyner Banham, 'The New Brutalism', *Architectural Review*, 708 (December 1955), p. 357.

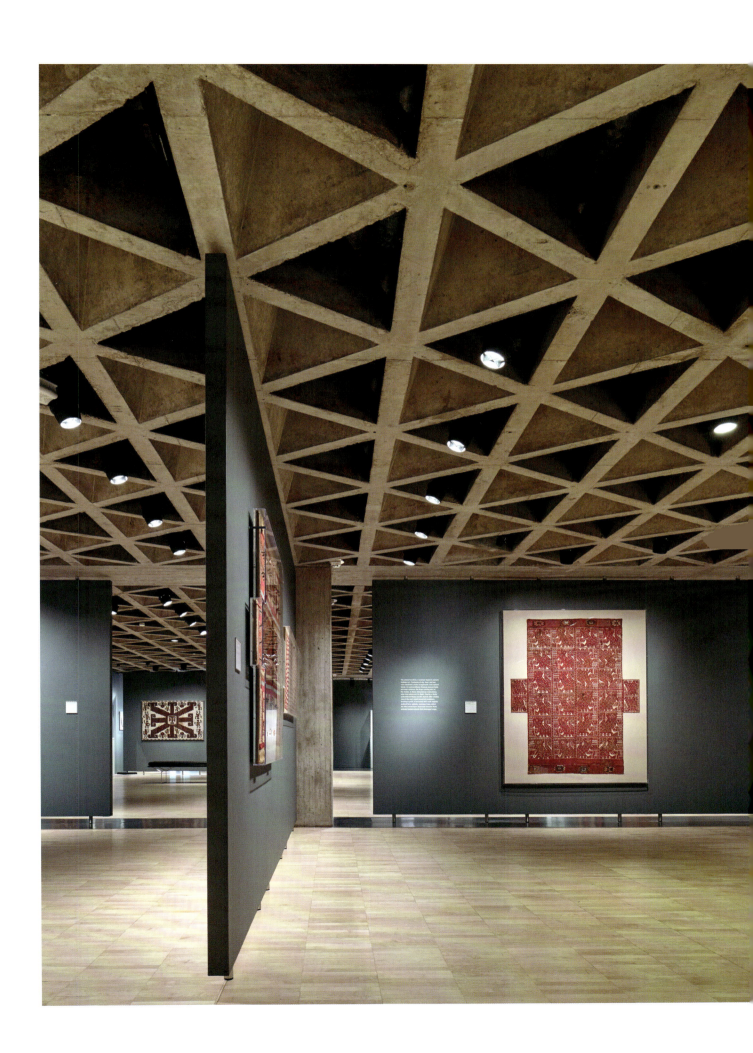

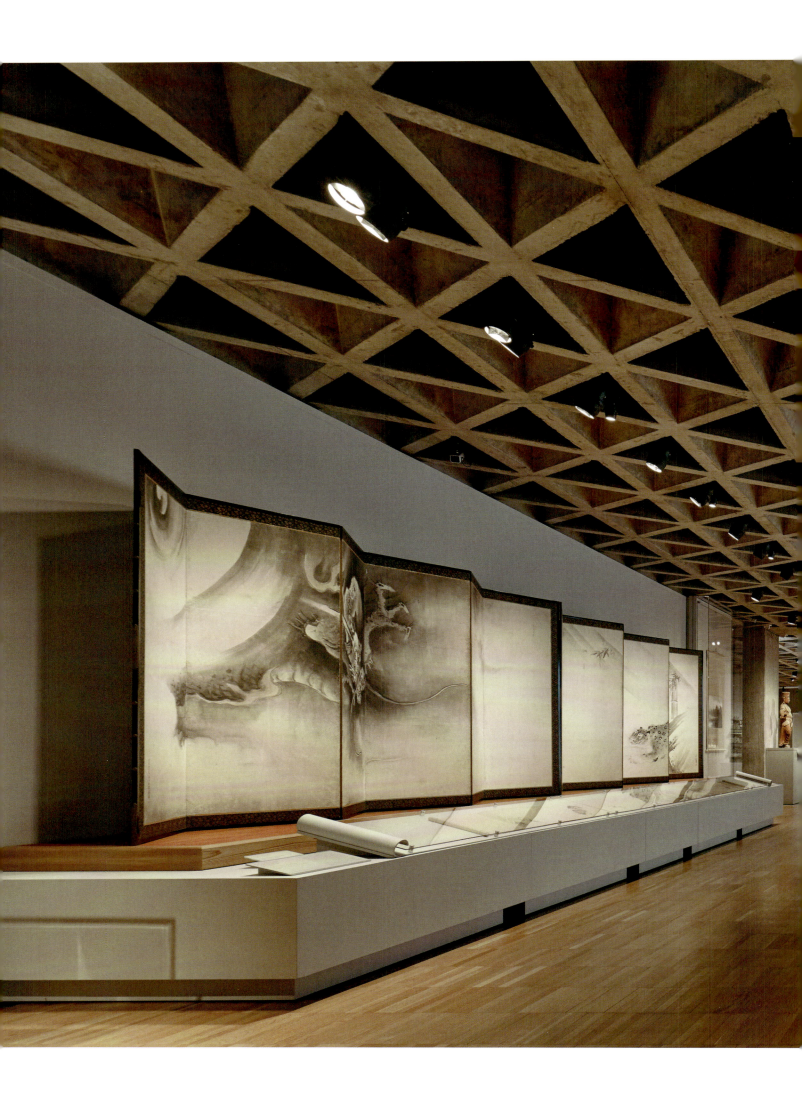

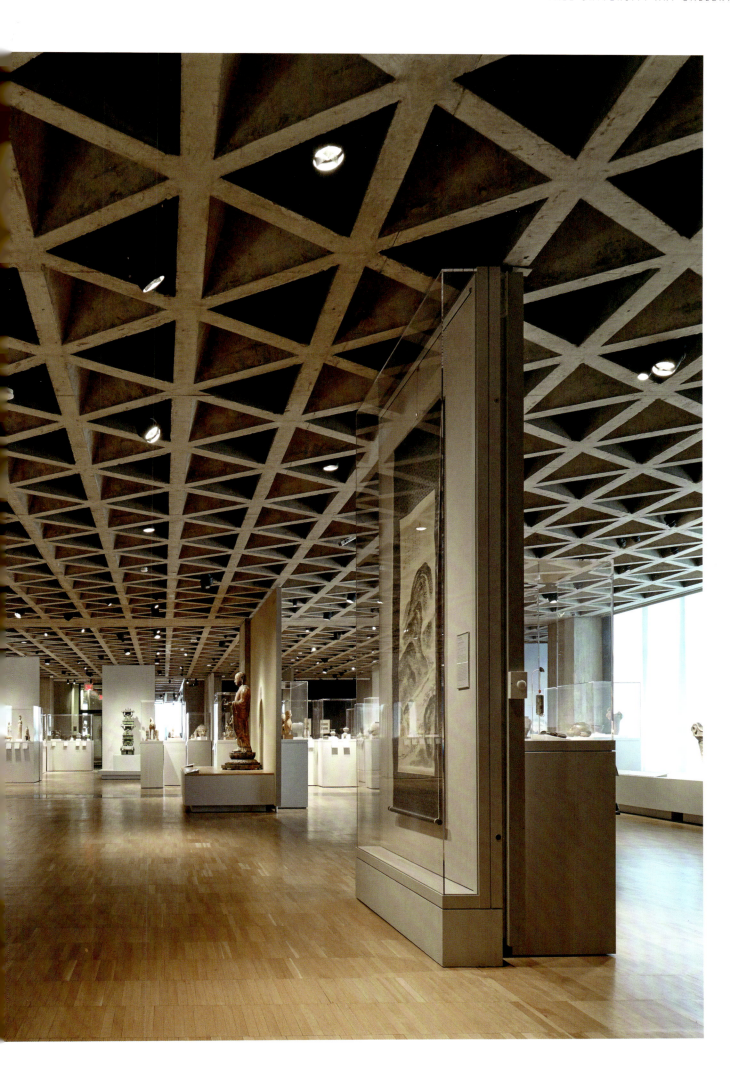

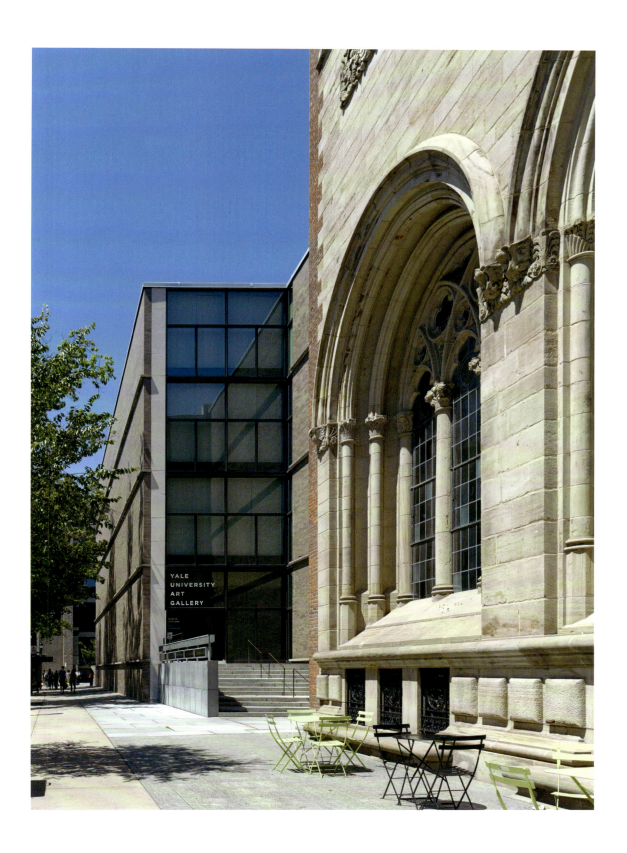

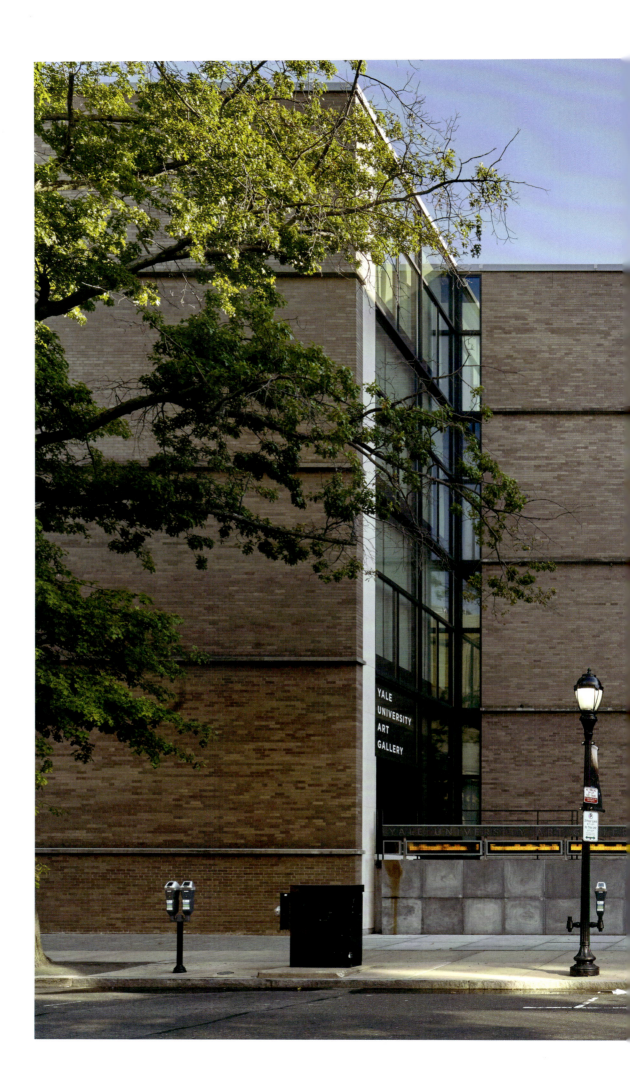

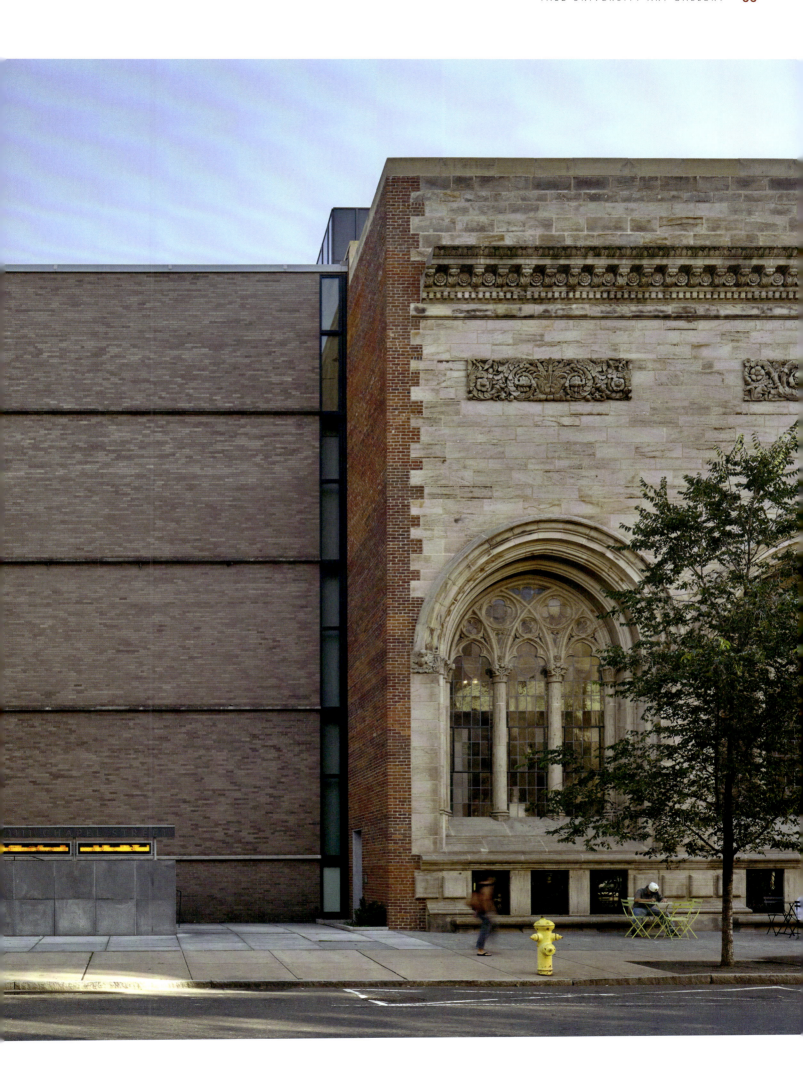

Design is form-making in order

Form emerges out of a system of construction

Growth is a construction

In order is creative force

In design is the means — where with what when with how much

Louis Kahn, 'Order Is', 1955[1]

Ewing Township,
New Jersey
1954—59

TRENTON
BATH HOUSE

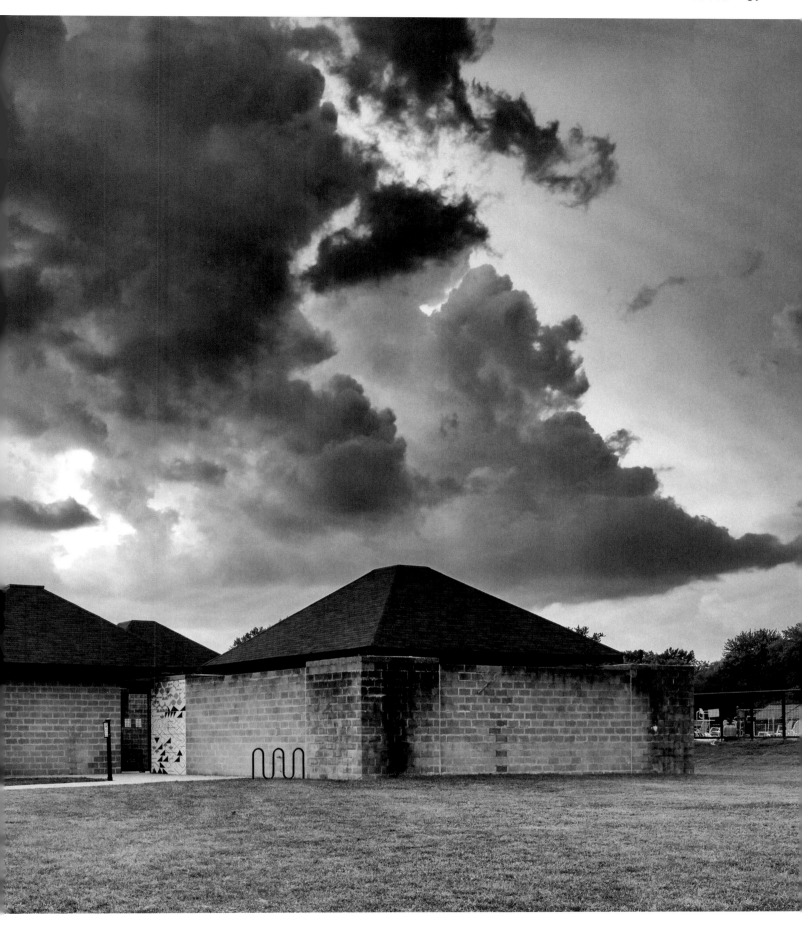

This modest building played a crucial role in the affirmation of Kahn's principles. It houses the changing rooms and showers that serve an adjacent open-air swimming pool. Initially, the architect was to create a cultural centre for the Jewish community in Trenton, but in the end only the annexes (the bath house, swimming pool and playground) were built. The plan of the bath house is in the shape of a Greek cross: four small square pavilions face one another around a square courtyard-atrium, which was originally ornamented with a stone circle on the ground (no longer visible today). Each pavilion is topped by a slightly floating roof in the shape of a truncated pyramid, supported at each corner by a pillar. Kahn decided to augment and hollow out these corner pillars to create interior spaces that would be used to house toilets, storage spaces, administrative offices, a water filtering station and a double-door entrance. Thus these initially purely structural elements underwent a metamorphosis, ultimately fulfilling multiple functions.

Although no openings are discernible from the outside, each pavilion benefits internally from an oculus at the top of the roof, bringing in light from above, and from the light that passes through the gap between the top of the wall and the edge of the roof. Each pavilion is organised according to a hierarchy that is established from the centre to the periphery. The central core comprises what Kahn called the 'served space' (those spaces in a building that are actively used), while the large corner pillars as well as the space between them are the 'servant spaces' (those that serve the utilised areas – staircases but also ventilation and other systems), with all the elements that allow this small building to function situated within: showers, washbasins or the steps leading to the pool. The corner pillars became the prototype for the 'hollow column' principle that would define many of Kahn's later projects, fulfilling both a structural function and offering a solution to the problems of limited space: 'The hollow columns which I invented for it, which were containers, became the servant areas and all other spaces became open, served by these hollow columns. From this came a generative force which is recognizable in every building which I've done since.'[2]

The Greek cross plan that organises and differentiates the spaces, the multifunctionality of the structural elements, and the composition of the building using simple geometric volumes are all features that were introduced by Kahn in this project but which would later be found in many of the buildings he designed.

1 Louis I. Kahn, 'Order Is', *Perspecta*, 3 (1955), p. 59.
2 Louis I. Kahn in Richard Saul Wurman, ed., *What Will Be Has Always Been: The Words of Louis I. Kahn* (New York: Access Press/Rizzoli, 1986), p. 130.

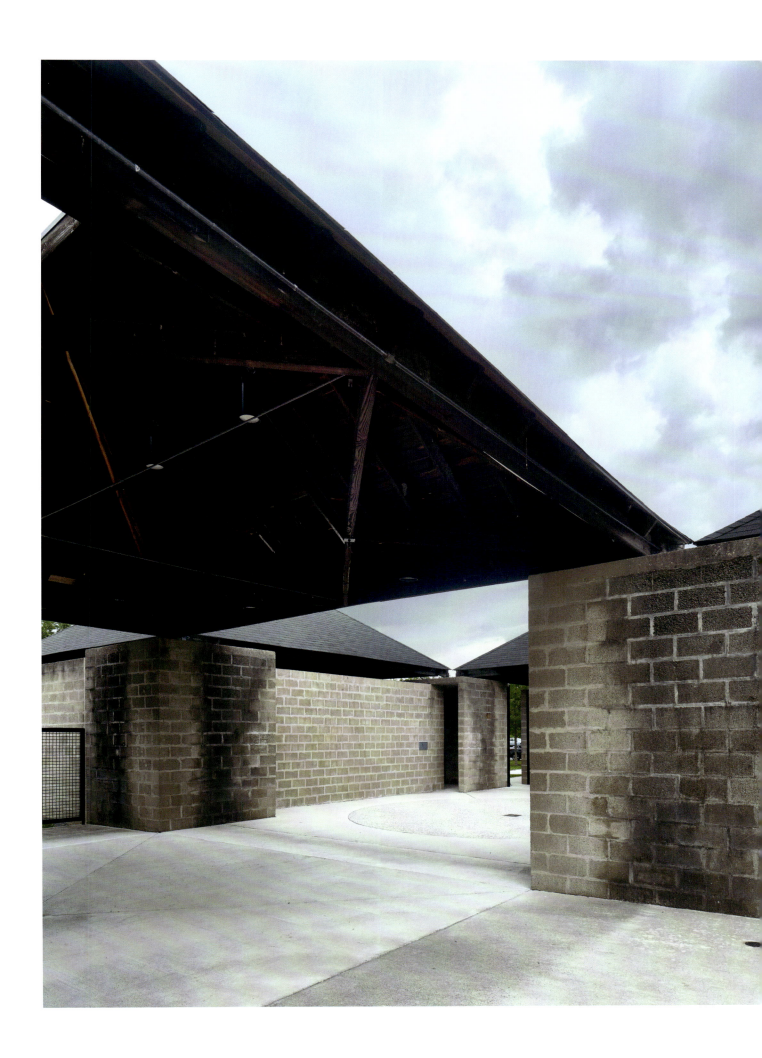

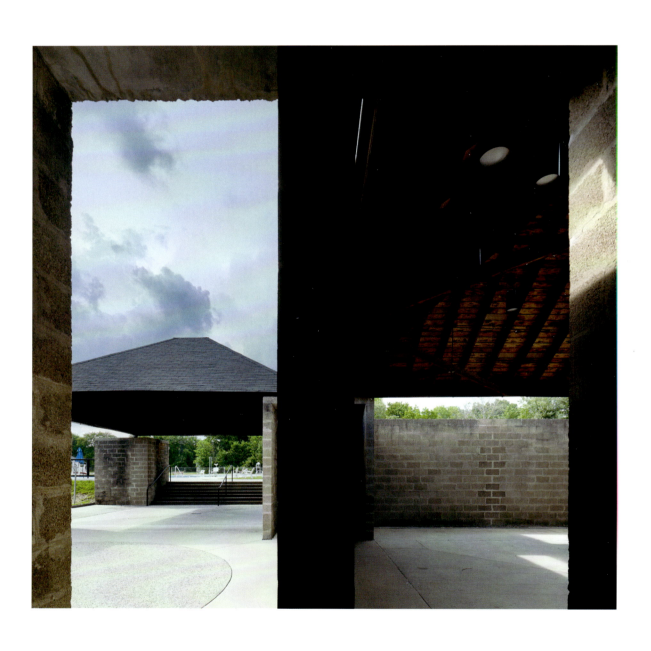

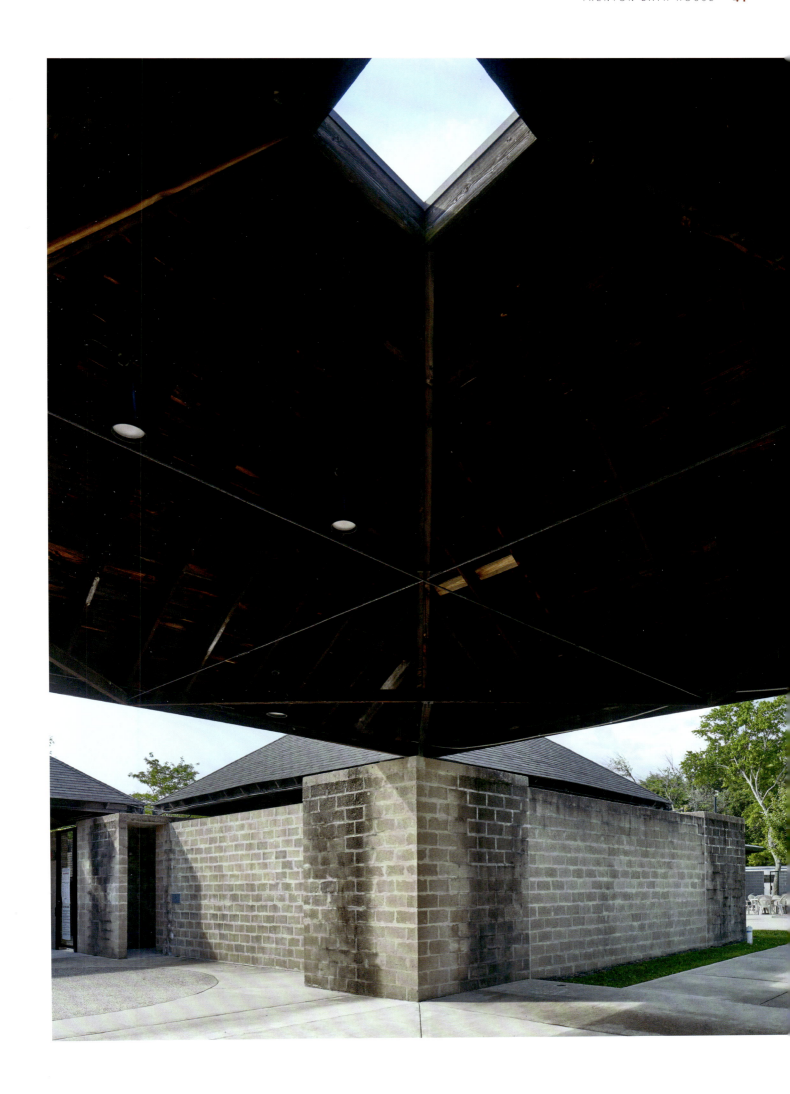

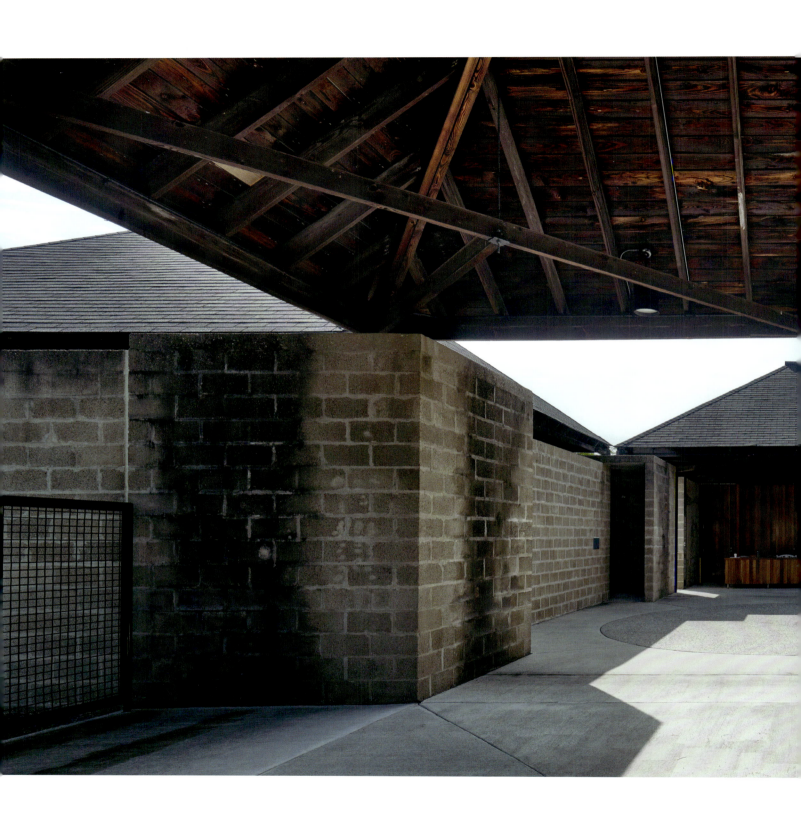

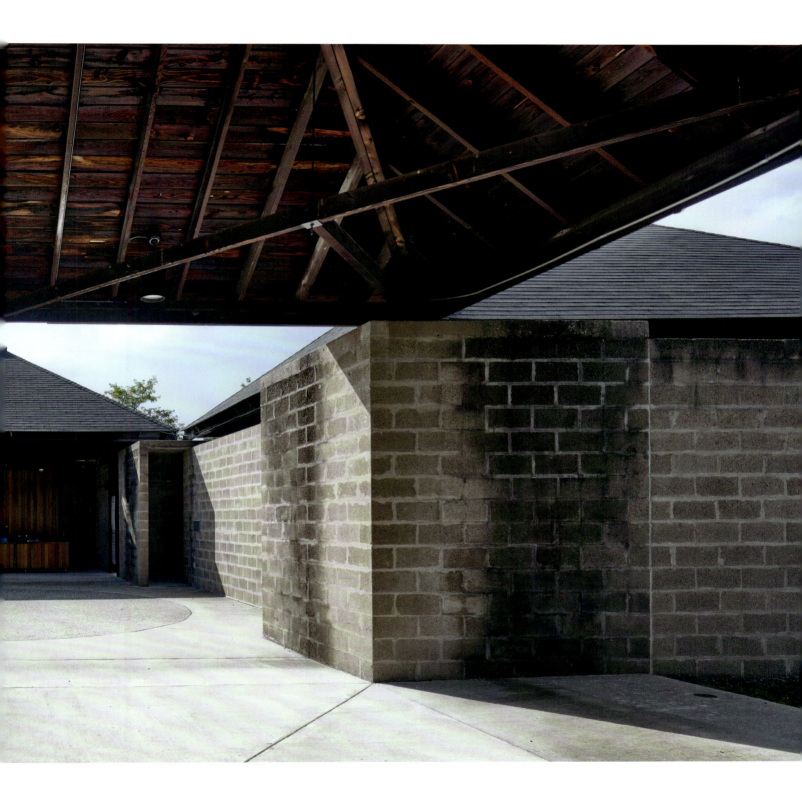

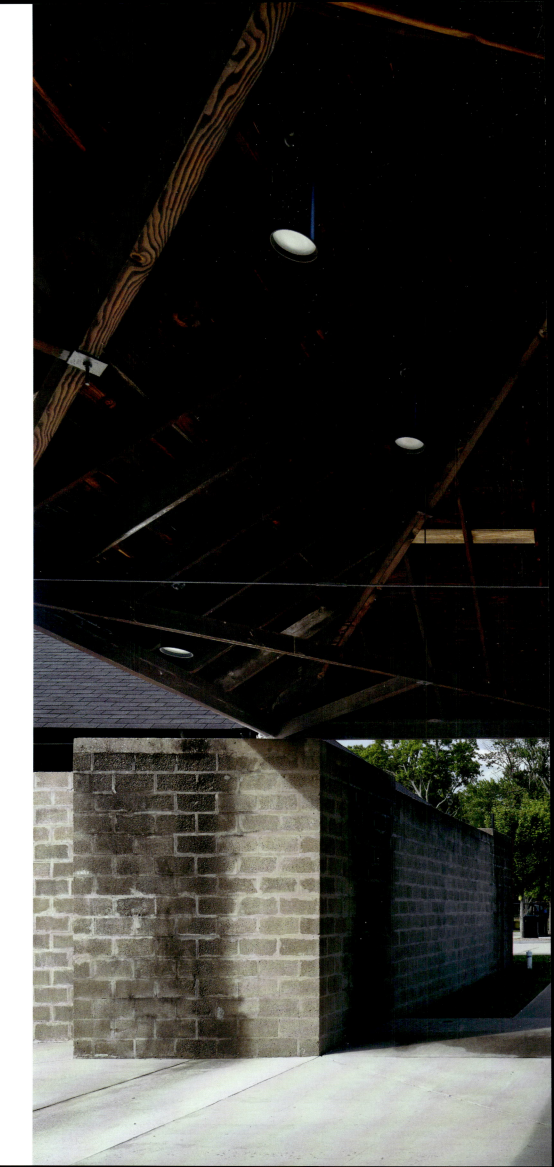

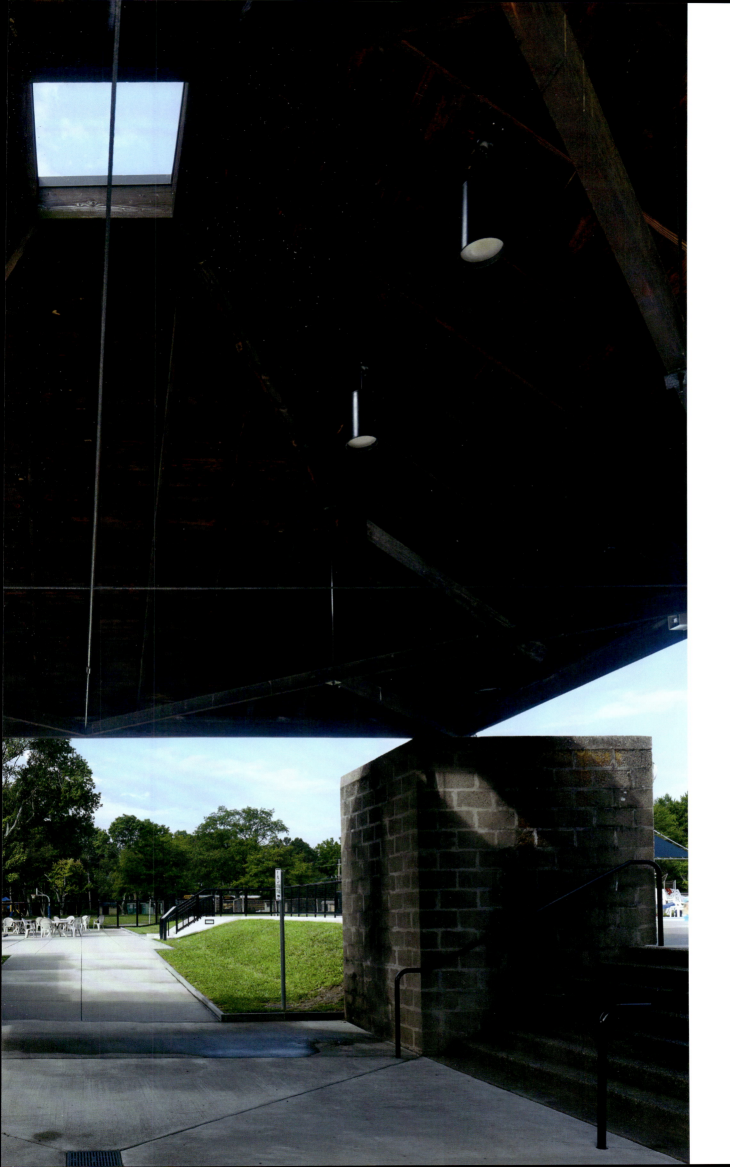

[For this building] I developed characteristics ... where you can get darkness and light, not by pulling shades, but simply characterizing the building so that there are natural places where darkness exists, and natural places where light exists.

Louis Kahn, 'New Frontiers in Architecture', 1959[1]

University of Pennsylvania,
Philadelphia, Pennsylvania
1957–60

ALFRED NEWTON RICHARDS MEDICAL RESEARCH LABORATORIES

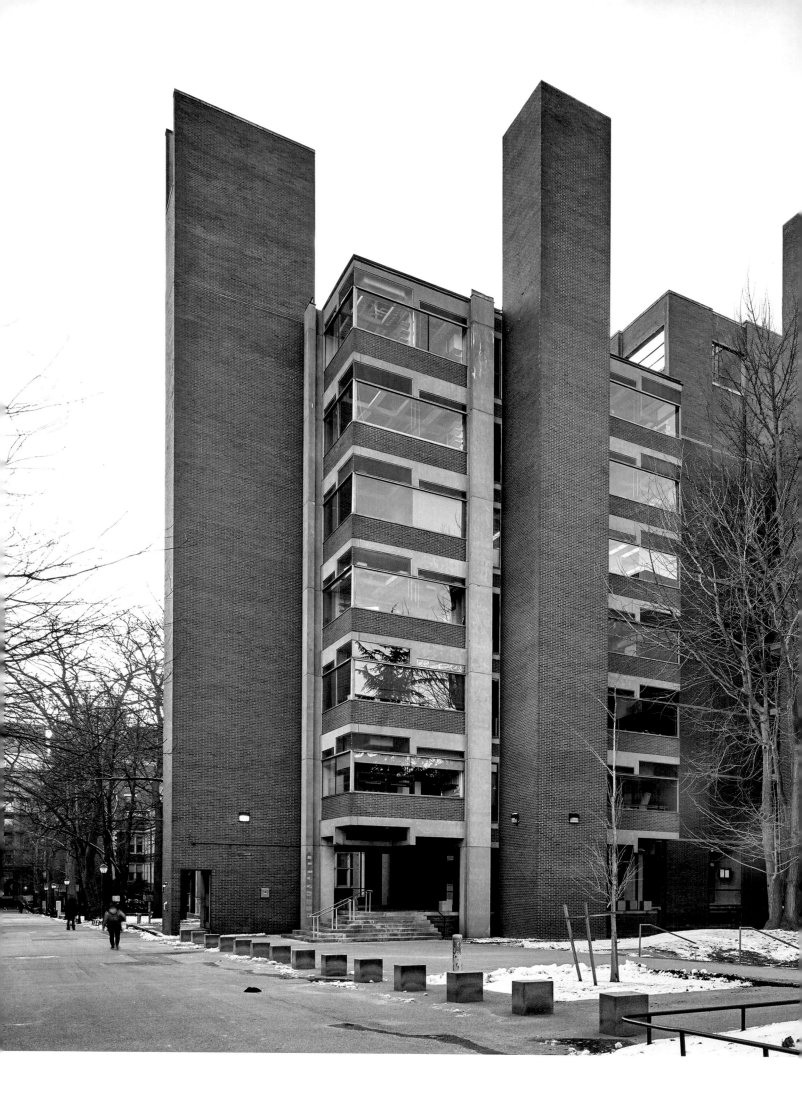

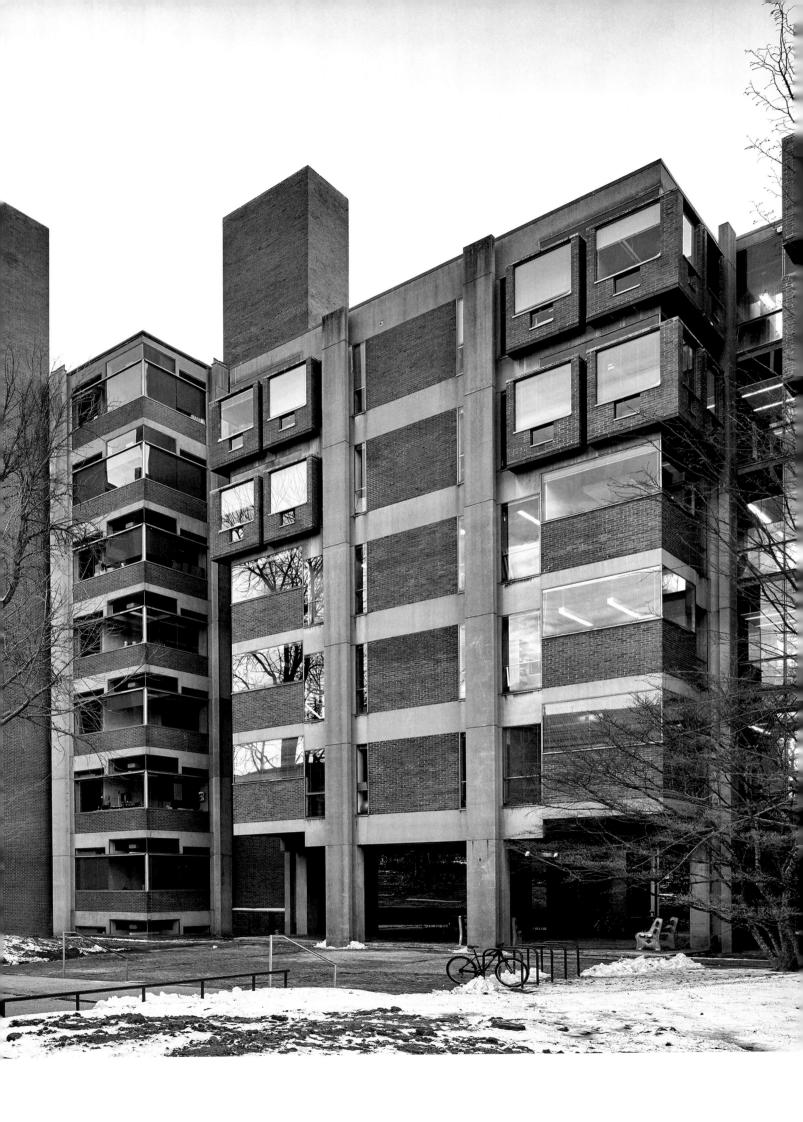

ALFRED NEWTON RICHARDS MEDICAL RESEARCH LABORATORIES

The construction of the Alfred Newton Richards Medical Research Laboratories at the University of Pennsylvania coincided with the arrival of Kahn as professor at the School of Architecture at this same university. For this project, the architect developed principles he had already used, on a smaller scale, for the baths in Trenton. He worked starting with one basic module, the square, and one basic notion, the hierarchy of space. Kahn imagined the research laboratories as a set of identical spaces served by an extensive network of fluids:

The Medical Research Building ... is conceived in recognition of the realizations that science laboratories are studios and that the air to breathe should be away from the air to throw away. The normal plan of laboratories ... places the work areas off one side of a public corridor [with] the other side provided with the stairs, elevators, animal quarters, ducts and other services ... The only distinction between one man's space of work from the other is the difference in the numbers on the doors.[2]

Rather than one vast, uninterrupted volume, Kahn thus conceived a juxtaposition of separate towers within which the laboratories themselves would be distinct from areas such as the stairs and conduits. The laboratories are situated over seven floors and are arranged on each level inside a square of 12 by 12 metres. 'I always start with a square, no matter what the problem is',[3] Kahn liked to say. The glass walls, placed on a brick base, are inserted into a prefabricated concrete frame that Kahn developed with the engineer August Komendant, who specialised in this type of structure. This frame, apparent both inside and outside, is conspicuous as soon as one enters the building: the ground floor of the tower comprises an open space – the entrance – without any partitions. This further highlights the structure and the dimensions of the square, the underlying module, and makes it possible to understand how the building was built. Indeed, Kahn was very attached to this type of honesty, to the frankness of the structure. He tried always to make it easy to distinguish the elements that support the building (here the prefabricated concrete frame and the posts) from the elements that are used to fill in the frame (the brick). This concern for transparency in the building process was also later exhibited in many other projects, such as the Kimbell Art Museum or the Yale Center for British Art.

Soaring up to the sky, slender concrete towers covered with brick flank the laboratories. They indicate from the outside what Kahn called the separation of functions. These windowless towers, the servant spaces, contain the ventilation systems, the technical conduits as well as the staircases and the storeroom, and are easily distinguished from the laboratories, the served spaces, with their glass facades.

1 Louis I. Kahn, 'New Frontiers in Architecture: CIAM in Otterlo 1959', talk at the conclusion of the Otterlo Congress, in *Louis I. Kahn: Writings, Lectures, Interviews,* ed. Alessandra Latour (New York: Rizzoli, 1991), p. 92.
2 Louis I. Kahn, 'Form and Design', *Architectural Design*, 31 (April 1961), p. 151, quoted in David B. Brownlee and David G. De Long, *Louis I. Kahn: In the Realm of Architecture* (New York: Rizzoli, 1991), p. 90.
3 Louis I. Kahn in Heinz Ronner, Sharad Jhaveri and Alessandro Vasella, eds, *Louis I. Kahn: Complete Works, 1935–74*, 2nd edn (Basel and Boston, MA: Birkhäuser Verlag, 1987), p. 98.

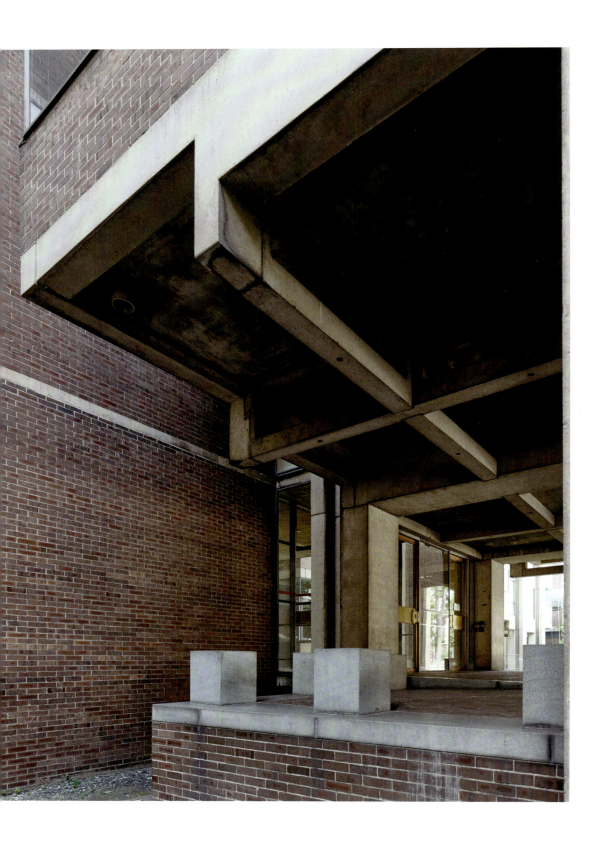

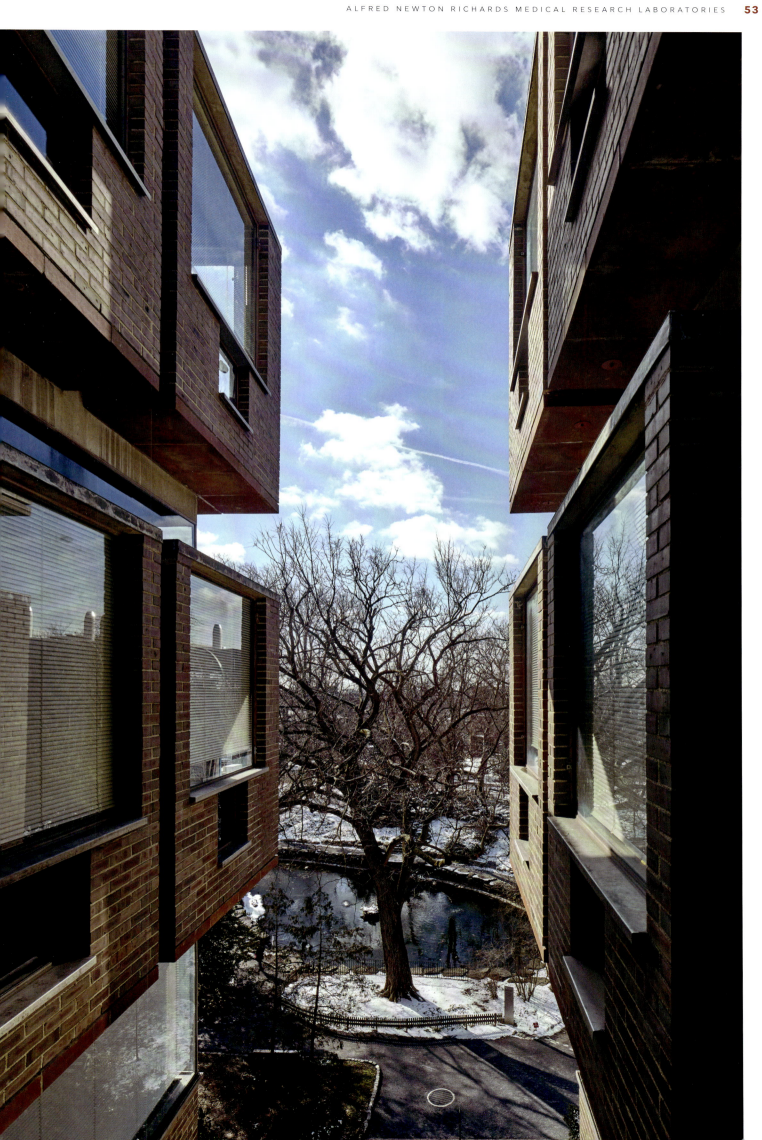

ALFRED NEWTON RICHARDS MEDICAL RESEARCH LABORATORIES 55

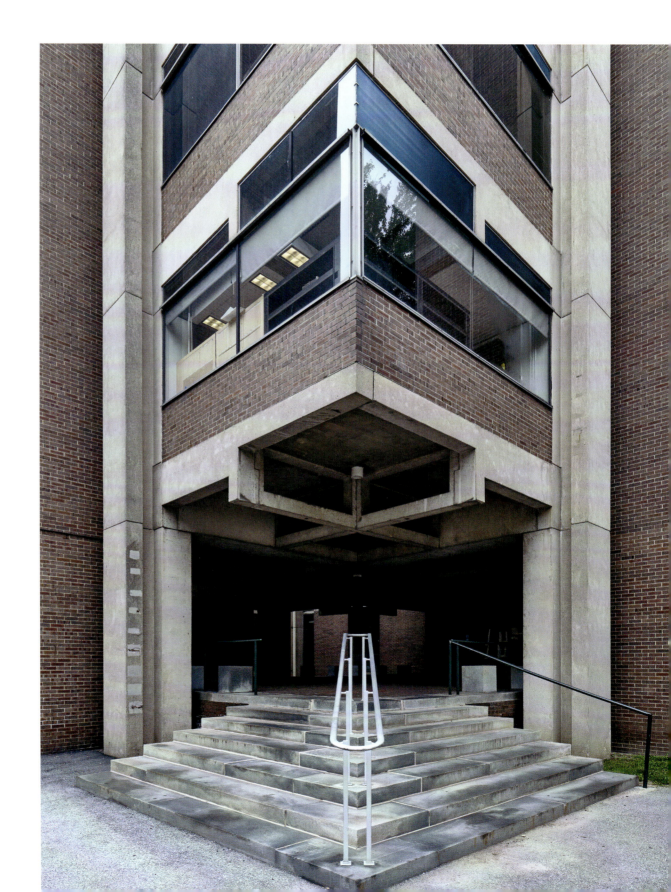

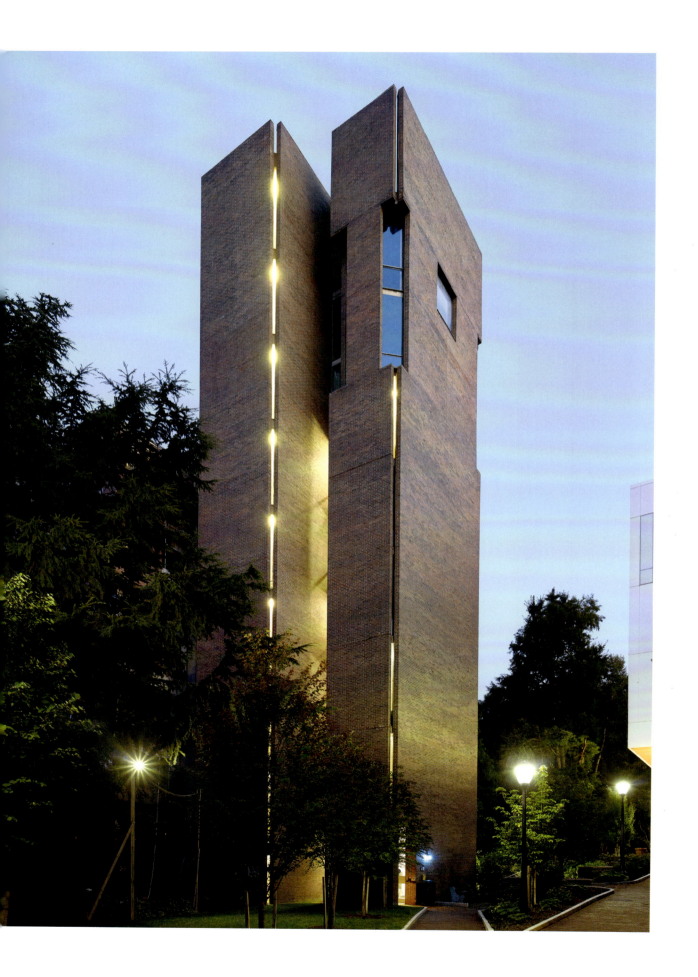

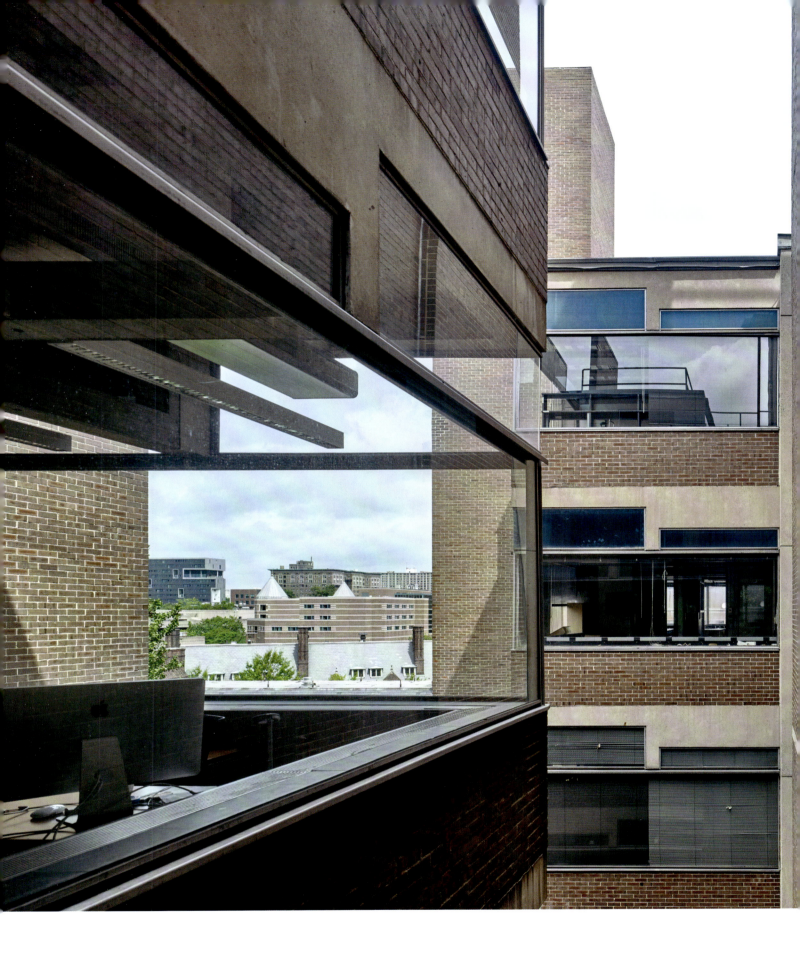

ALFRED NEWTON RICHARDS MEDICAL RESEARCH LABORATORIES

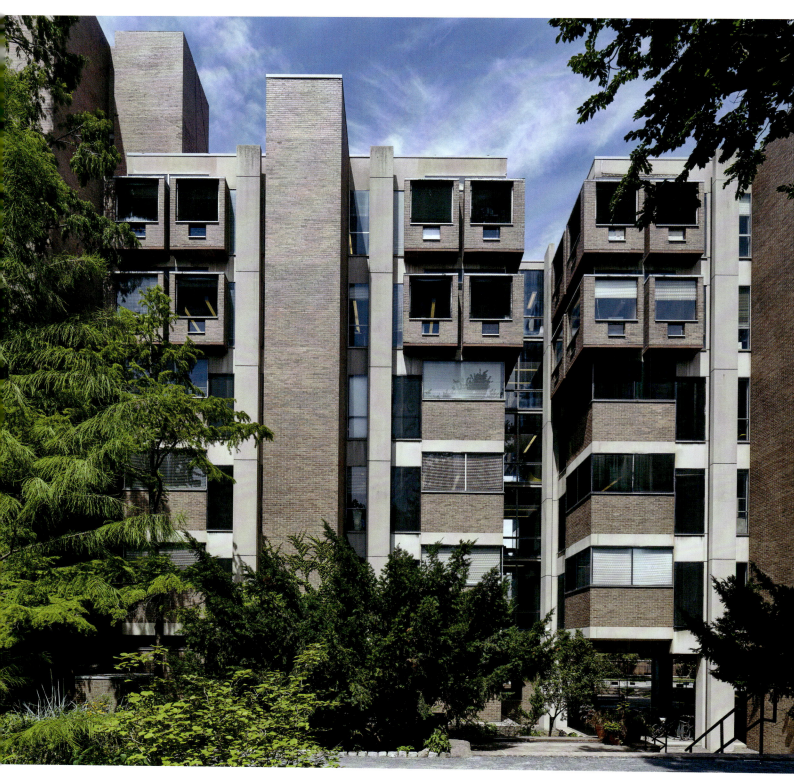

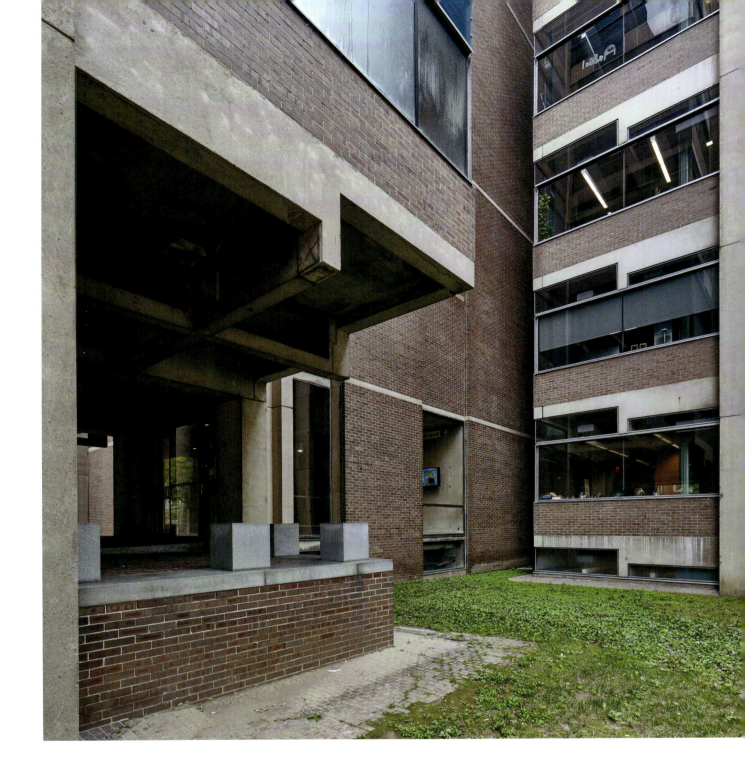

ALFRED NEWTON RICHARDS MEDICAL RESEARCH LABORATORIES

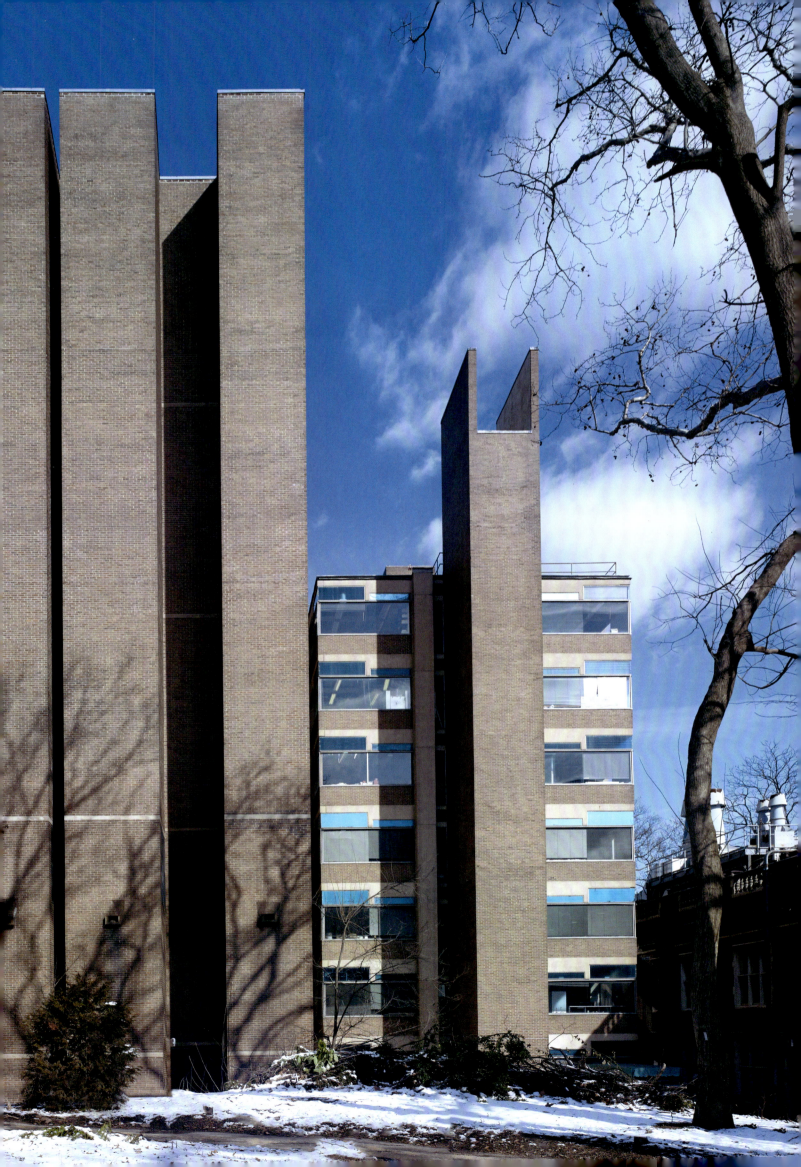

It is the glory of the joint which is the beginning of ornament. The more a man knows the joint, the more he wants to show it. The more he wants to show the joint, the more he wants to show the distance. And if he wants to have it show the distance, he wants to exaggerate and caricature things which ordinarily are small. The beginning of ornament lies also in the challenge against the elements.

Louis Kahn, 'New Frontiers in Architecture', 1959[1]

Greensburg, Pennsylvania
1958–62

TRIBUNE REVIEW PUBLISHING COMPANY BUILDING

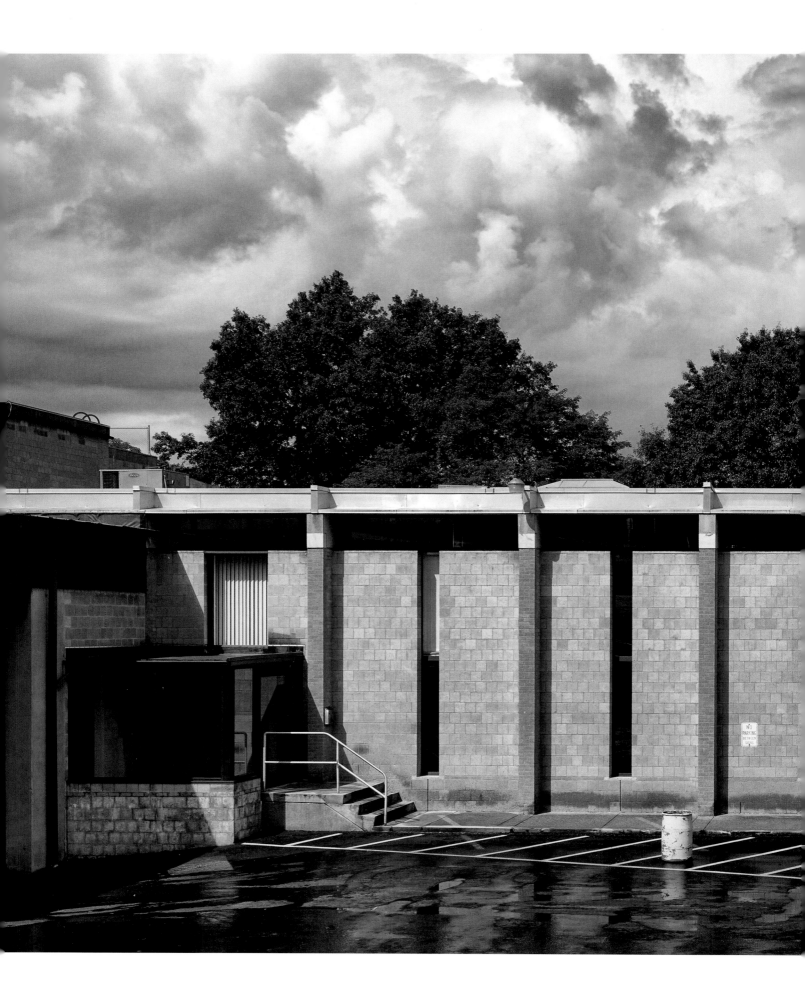

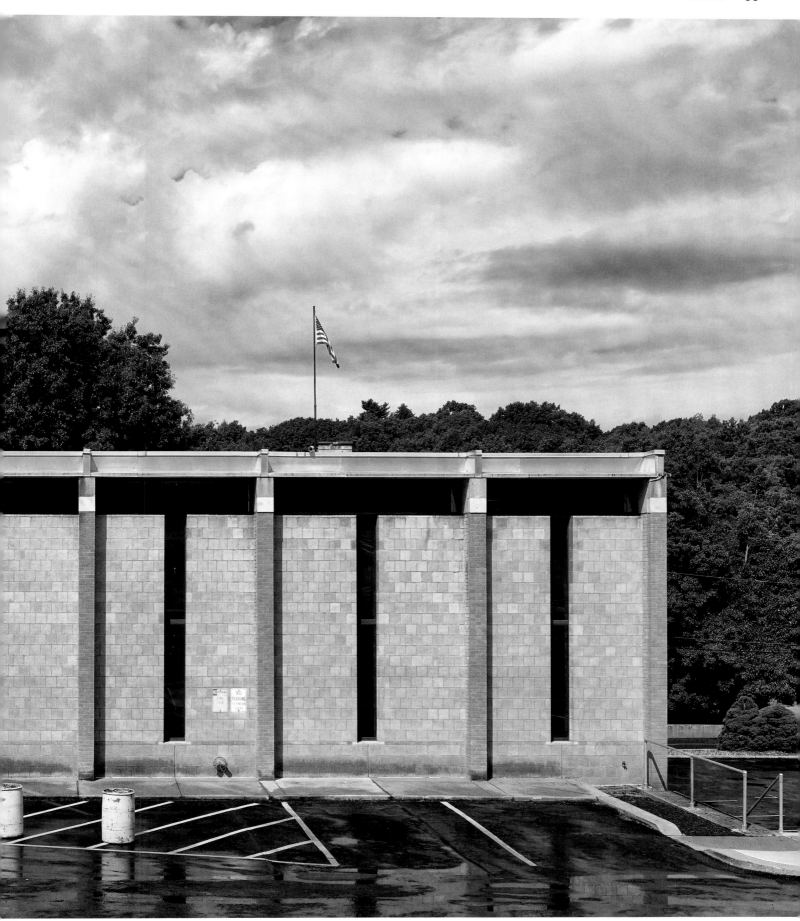

During the course of 1958, Kahn came into contact with the head of the Tribune Review Publishing Company regarding a commission for the newspaper's headquarters in Greenburg, Pennsylvania. The resulting building represents a great example of Kahn's achievements in the use of exposed precast concrete. Architectural historian Roberto Gargiani has remarked that 'Every part of the structure, from the pillar to the wall panel, reveals the different logics of the constructive processes of concrete in its textures and measurements, and every part of every piece is selected in keeping with its particular role in the overall structure.'[2]

Kahn's treatment of the facade in this project reflects a new concern in his work: that of controlling the impact of harsh external light in the interior. Kahn's scheme involved incorporating windows while retaining a maximum of usable wall space. These are composed of two sections: above, a large, wide pane; below, at human height, a vertical slit. Almost identical windows were used in the Esherick House in Philadelphia, and a variation of the distinctively shaped opening, with an arched upper section, appears in Kahn's drawings for the Fleisher House (1959, unbuilt) in Elkins Park, Pennsylvania.[3]

1. Louis I. Kahn, 'New Frontiers in Architecture: CIAM in Otterlo 1959', talk at the conclusion of the Otterlo Congress, in *Louis I. Kahn: Writings, Lectures, Interviews*, ed. Alessandra Latour (New York: Rizzoli, 1991), p. 98.
2. Roberto Gargiani, *Louis I. Kahn: Exposed Concrete and Hollow Stones, 1949–1959* (Oxford, Routledge, 2014), p. 186.
3. Alexandra Tyng, *Beginnings: Louis I. Kahn's Philosophy of Architecture* (New York: John Wiley & Sons, 1984), p. 145.

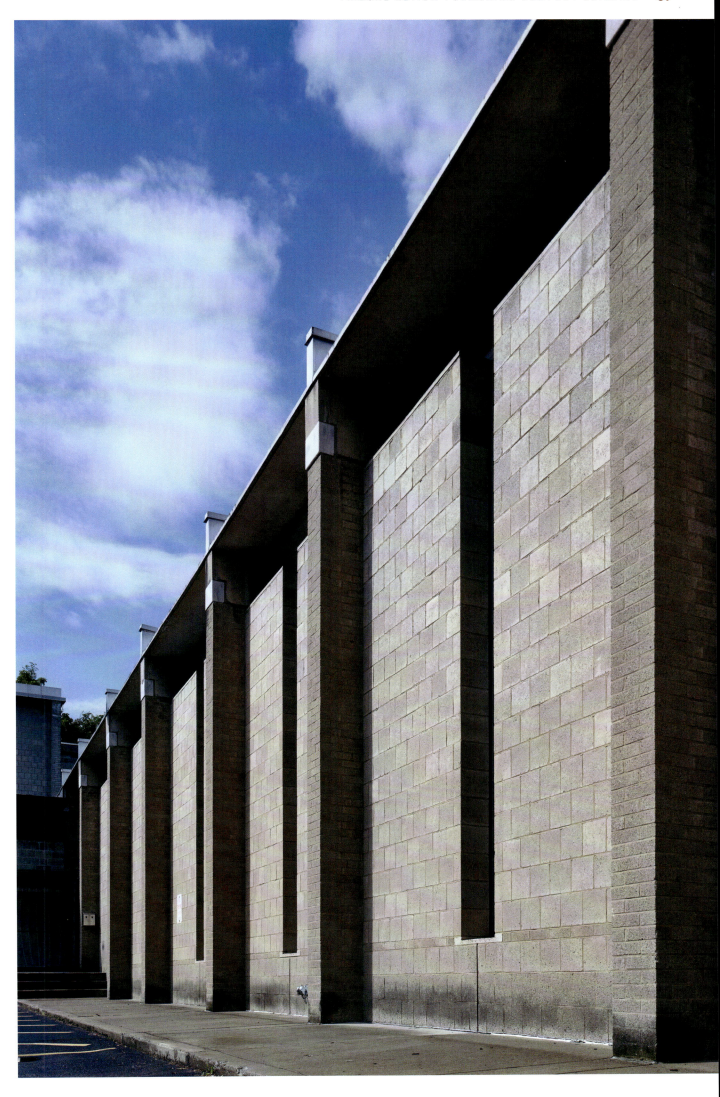

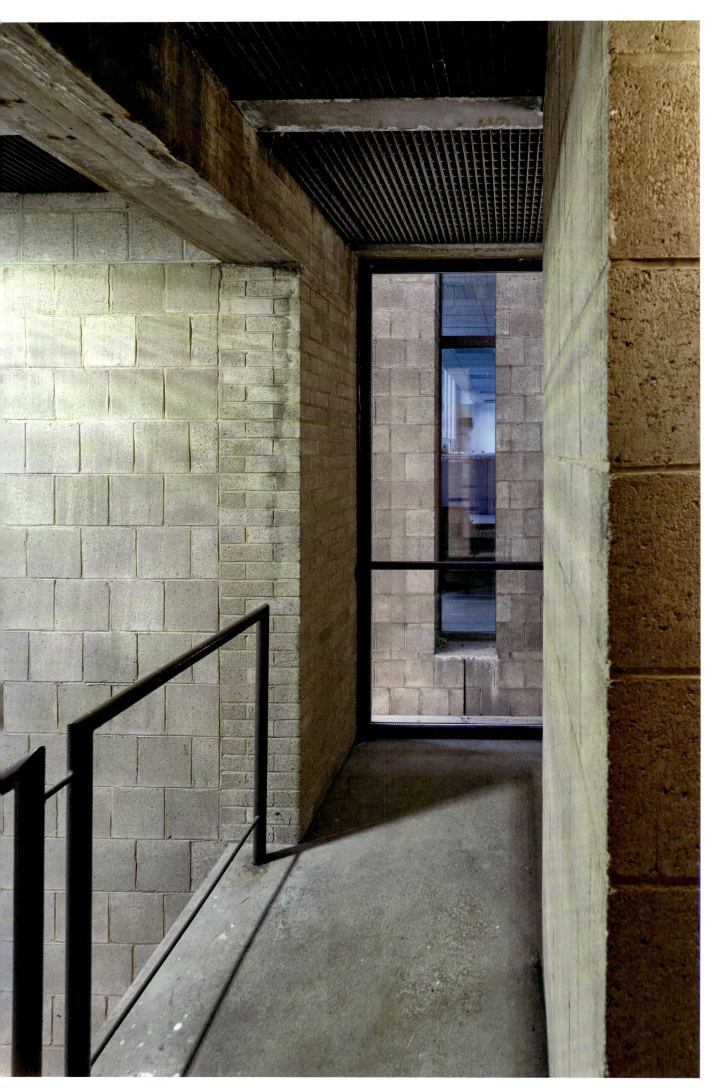

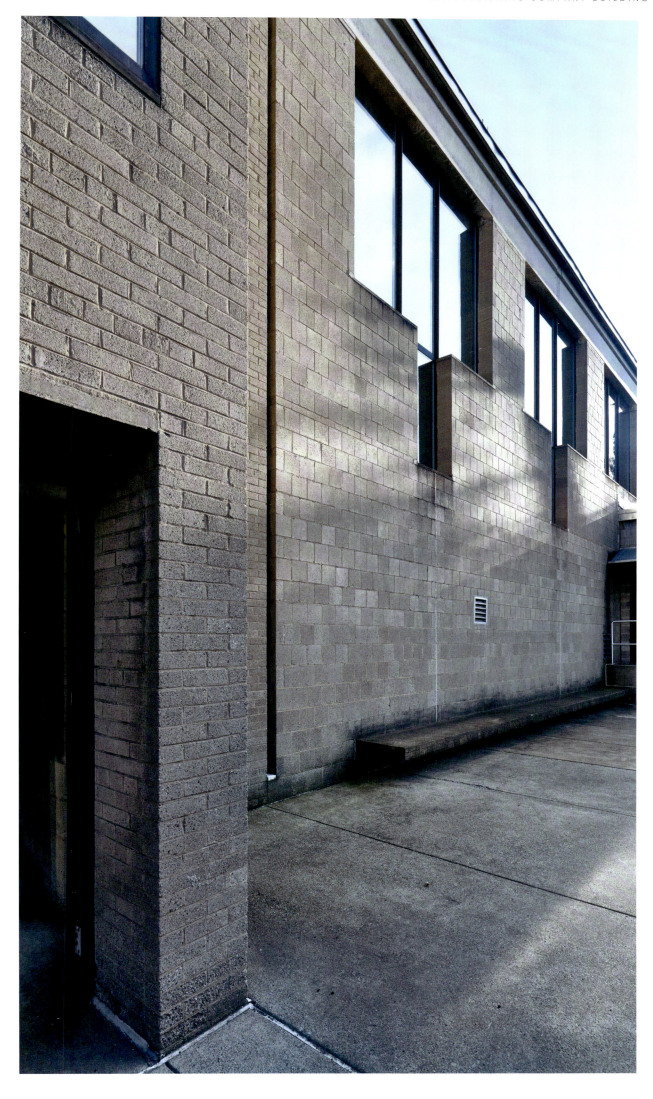

A craftsman never wants to cover his work. In a good drawer the detailing is not hidden, the joint is the beginning of ornament. The joint is where ornament begins. The less the craftsman enters into something, the more there is a modification of the craft.

Louis Kahn, 'An Architect Speaks His Mind', 1972[1]

Philadelphia, Pennyslvania
1959–61

MARGARET ESHERICK HOUSE

The plan of the Esherick House can be described as a single rectangular unit organised in bands. Kahn located the servant spaces (kitchen, toilets, cupboards and closets, shelves, fireplace, corridors) at the periphery and along a central band perpendicular to the street. The served spaces sit within this periphery.

The 'keyhole' or T-shaped opening on the right of the entrance facade is integrated within a wooden frame. The wide upper section of the window captures the light, while the narrow lower section affords a more discreet survey of the outside. The fixed window on the left is part of a larger system incorporating adjustable shutters and operable windows. The Esherick House, like the Unitarian Church at Rochester, forms part of Kahn's ongoing inquiry into light modulation systems; both additionally include window seats or bookcases built directly into the walls, augmenting their thickness and accenting the relation to the exterior.

1 Beverly Russell, 'An Architect Speaks His Mind' (interview with Louis Kahn), *House and Garden*, 142:4 (October 1972), p. 124.

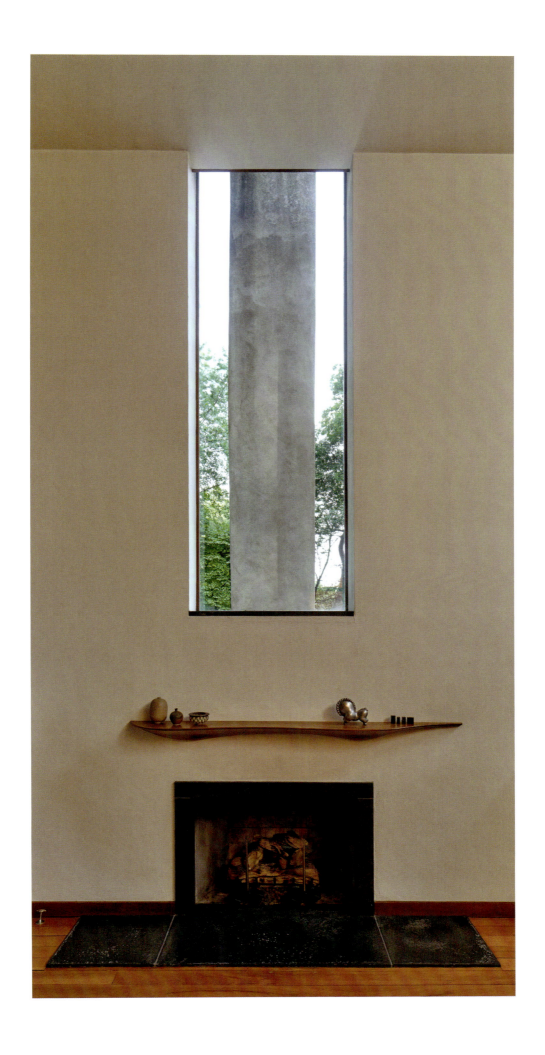

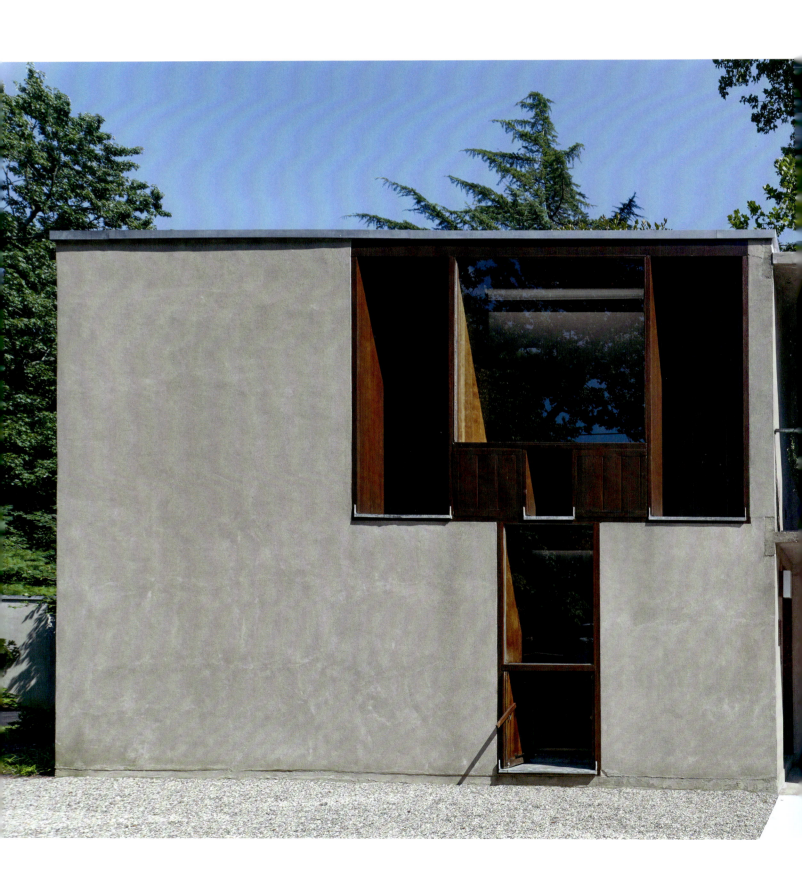

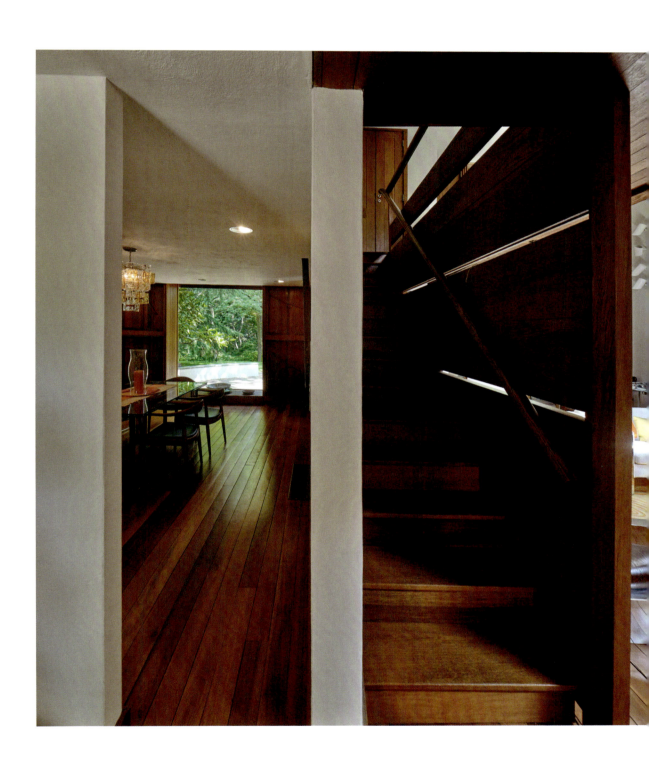

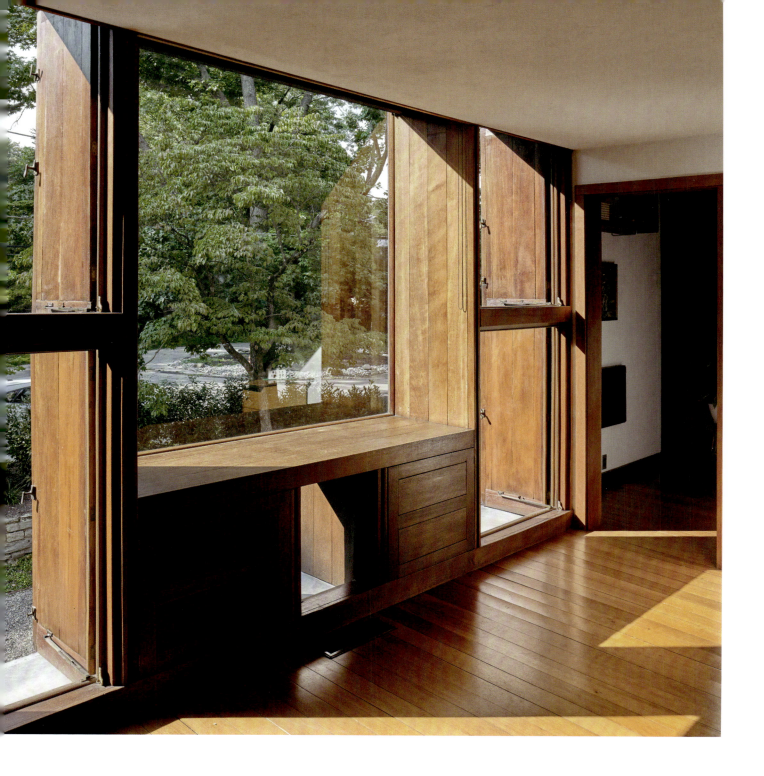

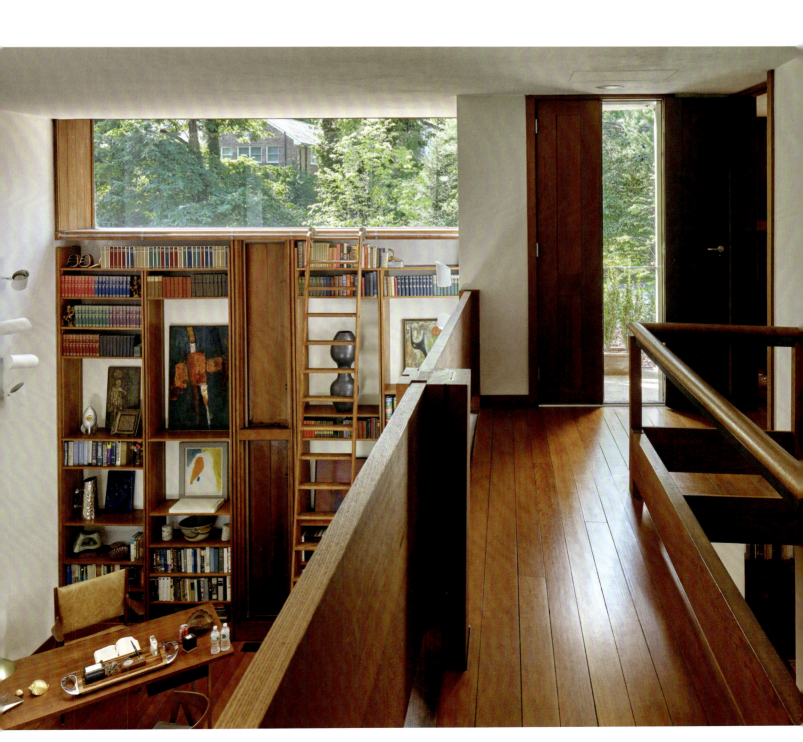

There, again, light, light, light: that's the Unitarian church, Rochester. All these undulations are, in a way, to modify light, and to get niches for sitting [in the school], and everything that changes your feeling when you enter, and that changes your feeling when you come to where you were.

Louis Kahn, 'Thoughts on Architecture and Personal Expression', 1966[1]

Rochester, New York
1959–62, 1965–69

FIRST UNITARIAN CHURCH OF ROCHESTER

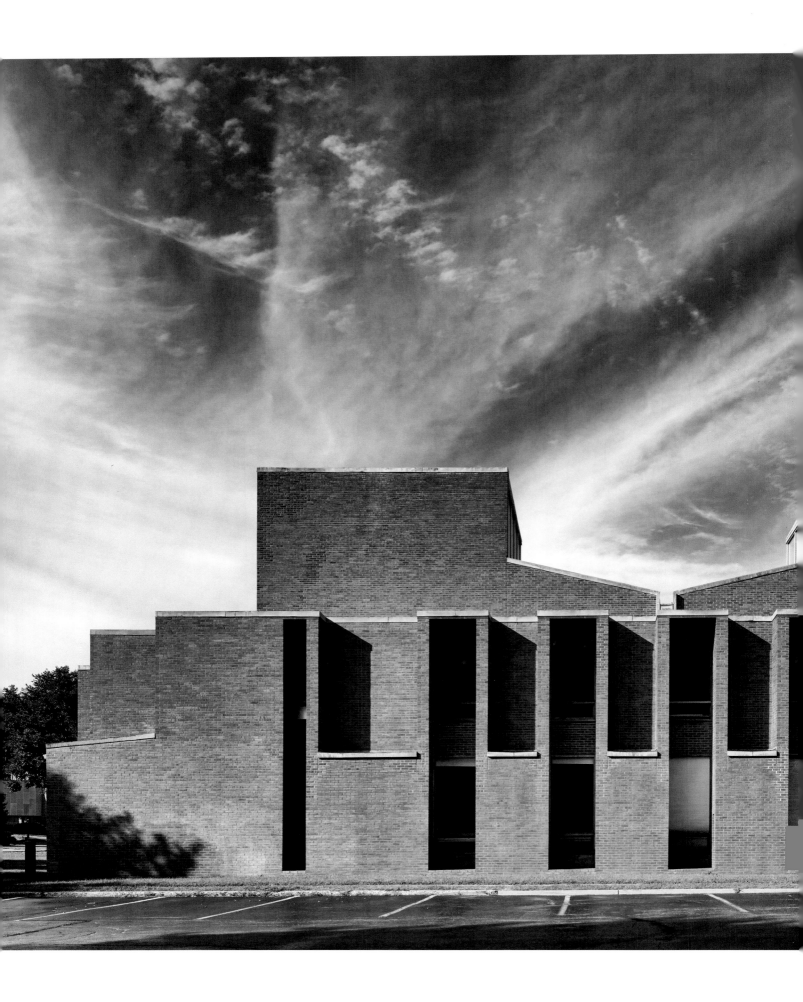

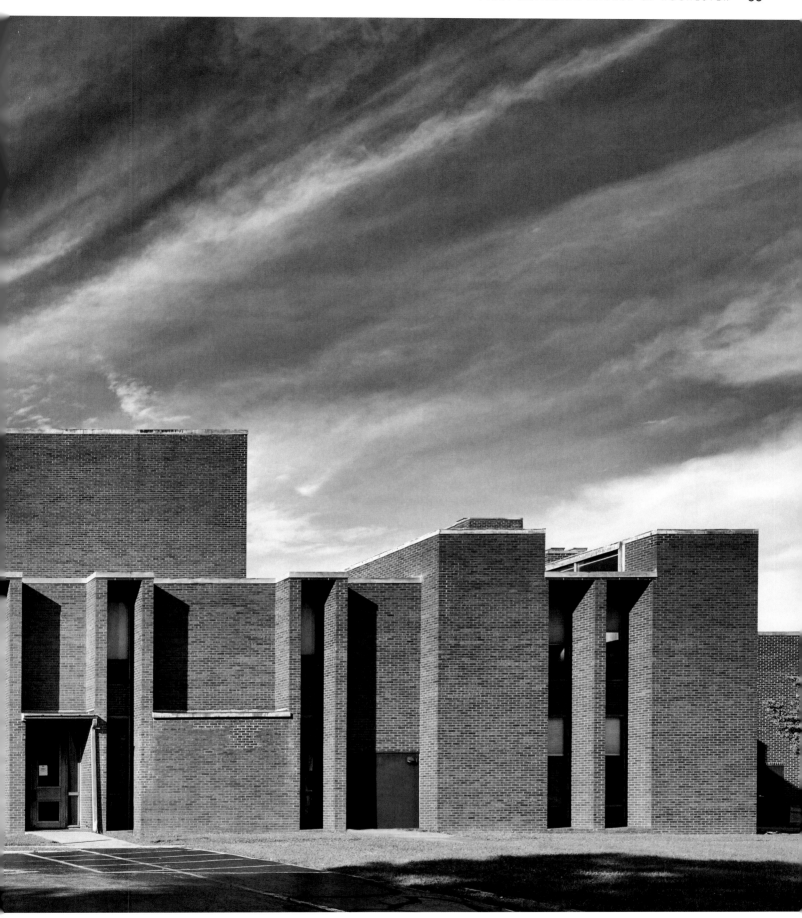

Before beginning the drawings for this religious building, for which he received the commission in 1959, Kahn carried out research into Unitarianism, a theological movement believing in one united Christian God rather than in the Trinity. He also conducted research into ecumenical institutions, which welcome people from different Christian denominations.

The First Unitarian Church was a double project: a place of worship and a school. In order to present his architectural vision to his clients, Kahn produced a series of plans. His proposals ranged from a spatial composition consisting of two squares in juxtaposition, separated by a corridor, with the school on one side and the church on the other (a layout reminiscent of Frank Lloyd Wright's Unity Temple at Oak Park, Illinois, built between 1904 and 1906), to a centralised spatial composition with the sanctuary in the centre and the school on the periphery. It was this latter solution, of a building encircling another building, that was chosen, and Kahn would go on to employ similar configurations in almost all of his subsequent projects, including the Erdman Hall dormitories at Bryn Mawr College, the National Assembly building in Dhaka and the Exeter Library in New Hampshire.

In Rochester, the school is differentiated from the church through the use of lighting and materials. Side glazing was used to light the meeting rooms and classrooms, whereas light from above, being more conducive to meditation, was used in the sanctuary: emerging from the outer wall are four square towers whose partially glazed walls capture the light and redistribute it inside the church. An interior structure of concrete distinguished the place of worship in the centre from the educational spaces, built in brick. Like a rampart protecting the assembly space, the thick wall that surrounds the church forms a kind of quadrilateral along which the classrooms and meeting rooms are arranged. The plate glass windows are narrow and high and housed in deep, vertical embrasures like a kind of crenellation, making them relatively inconspicuous. The surrounding brick walls extend out, interrupted only by the alternating patterns of light and shadow. In 1962, Robert Le Ricolais, a French engineer and, like Kahn, a teacher at the University of Pennsylvania, wrote of this rampart wall: 'Just as a river has two banks, for Louis Kahn a wall is not a single plane separating two spaces, but a double skin with an interstitial space, sometimes solid, sometimes empty, as the case may be.'[2]

At the Unitarian Church, Kahn created his first significant interior space. The assembly space, or sanctuary, situated in the centre of the building and encircled by two floors of classrooms and meeting rooms, is a simple, vast room with square proportions. The only light that enters comes from above, from the sky. The light towers, which are hardly noticeable when one is inside but which are clearly visible from without, are placed at the four corners of the room. Through these towers, a diffuse light enters and spreads across the sanctuary. The grey concrete walls, lit by this silvery, ethereal light, thus seem less imposing; indeed the corners of the room seem to lose their materiality in comparison with the striking concrete ceiling, cast in the shape of a Greek cross. The space seems to widen or narrow according to the intensity of the sunlight.

1 Louis I. Kahn, 'Thoughts on Architecture and Personal Expression: An Informal Presentation to Students at Berkeley' [1966], *Perspecta*, 28 (1997), p. 32.

2 Robert Le Ricolais, 'Propos sur Louis Kahn', *L'Architecture d'aujourd'hui*, 105 (December 1962–January 1963), p. 2, author's translation.

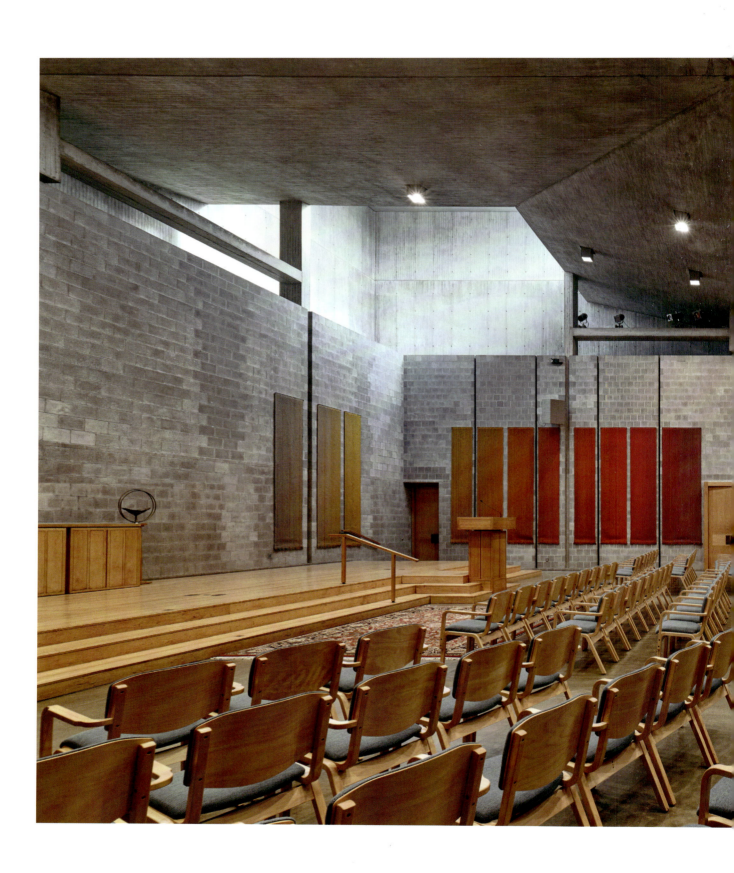

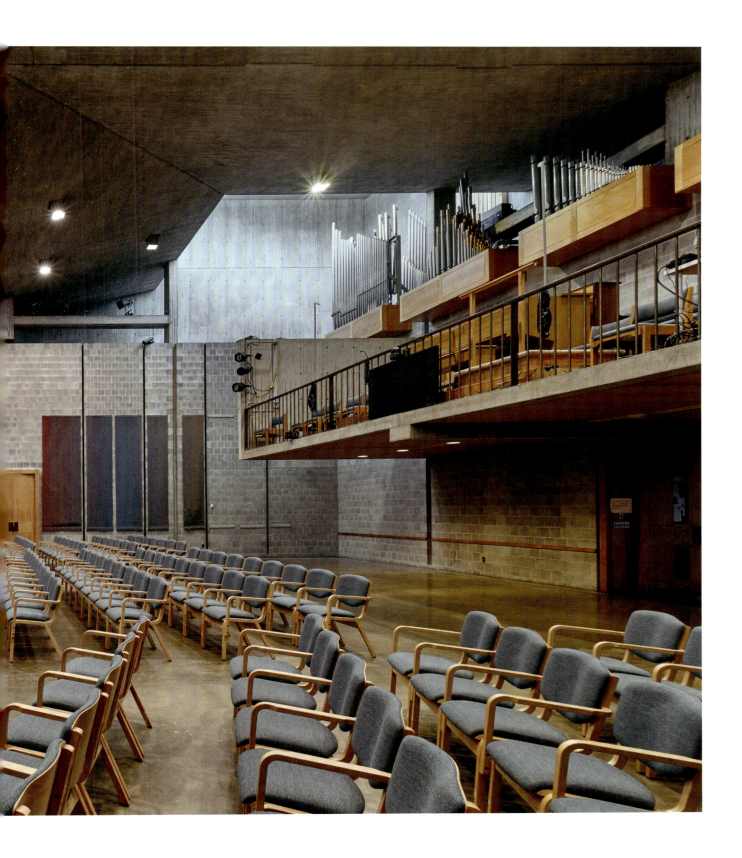

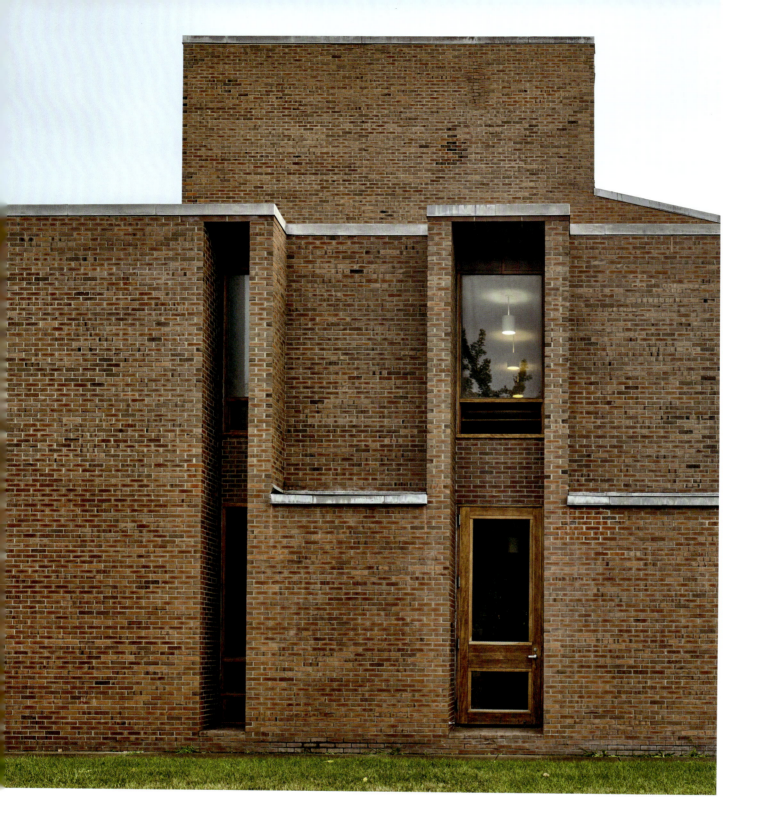

FIRST UNITARIAN CHURCH OF ROCHESTER

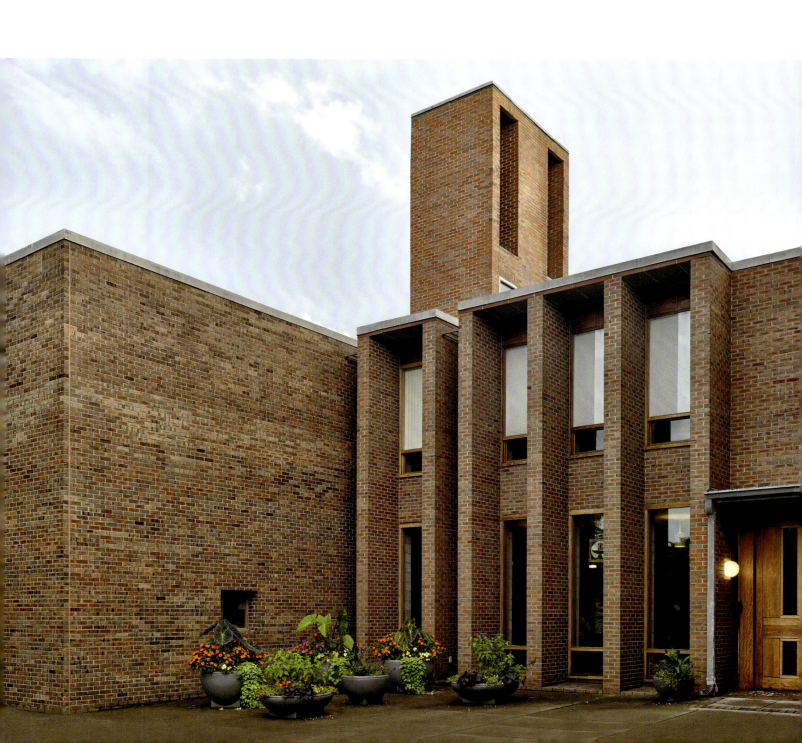

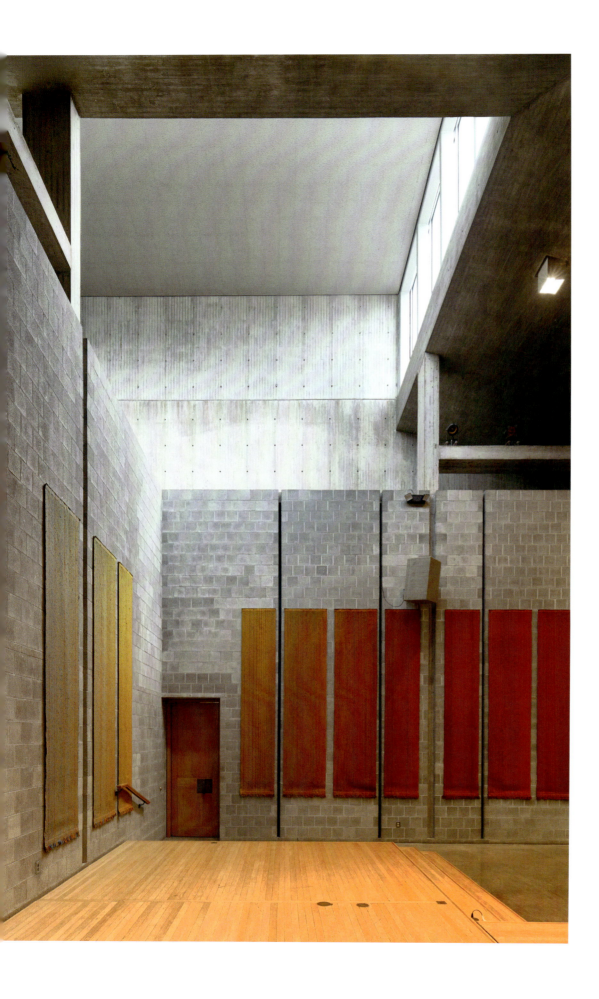

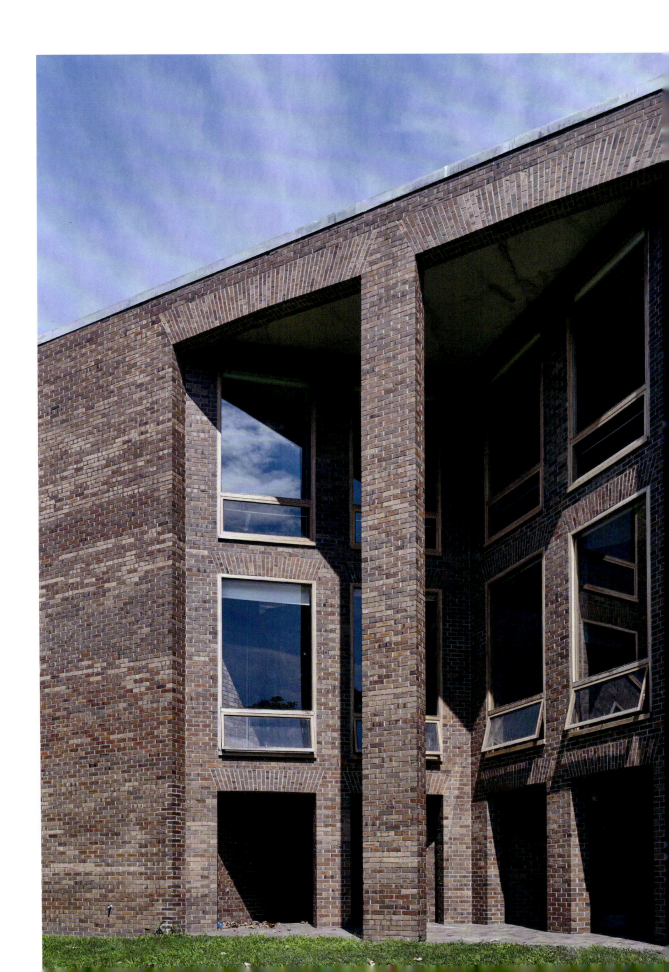

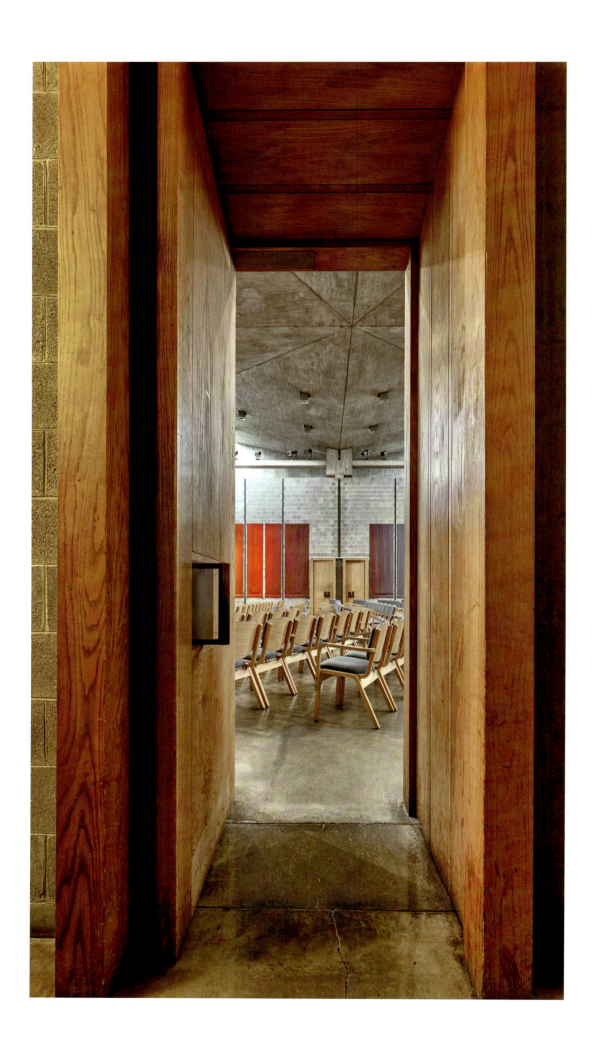

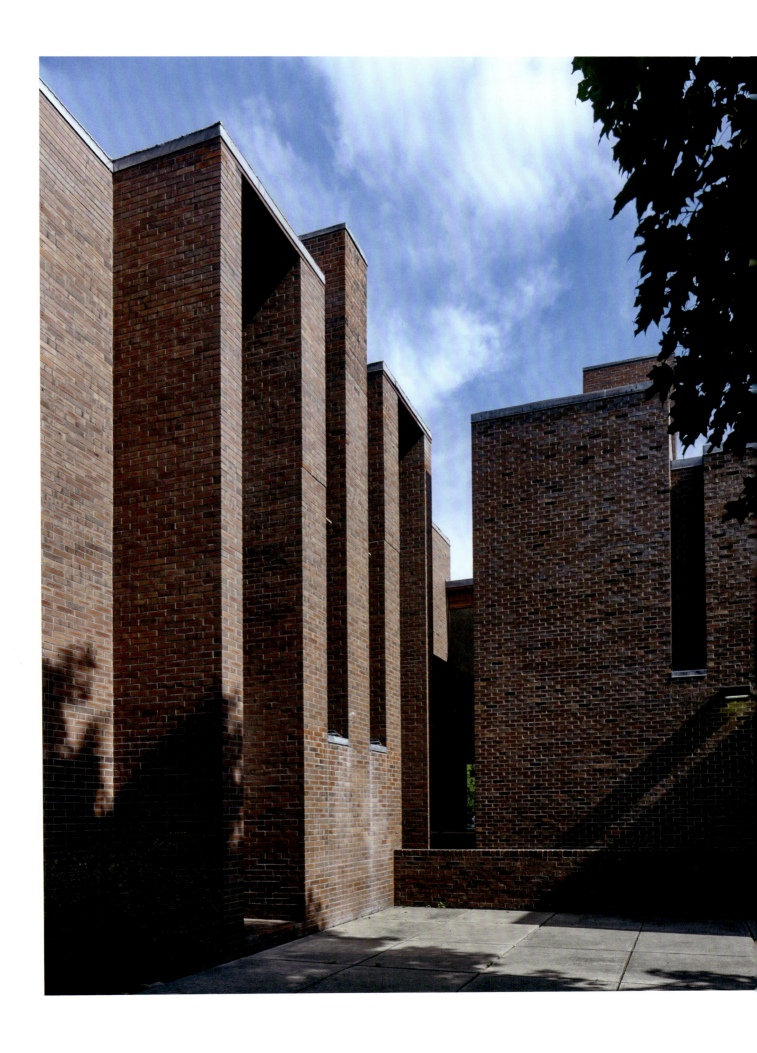

In the San Diego project, the rainwater, scarce as it is, is gathered in a cistern and then sent up to a higher point where it is distributed by gravity, and these pools are linear and shaded by trees so that evaporation does not too quickly occur.

Louis Kahn, 'Law and Rule in Architecture', 1962[1]

La Jolla, San Diego, California
1959–65

SALK INSTITUTE
FOR BIOLOGICAL
STUDIES

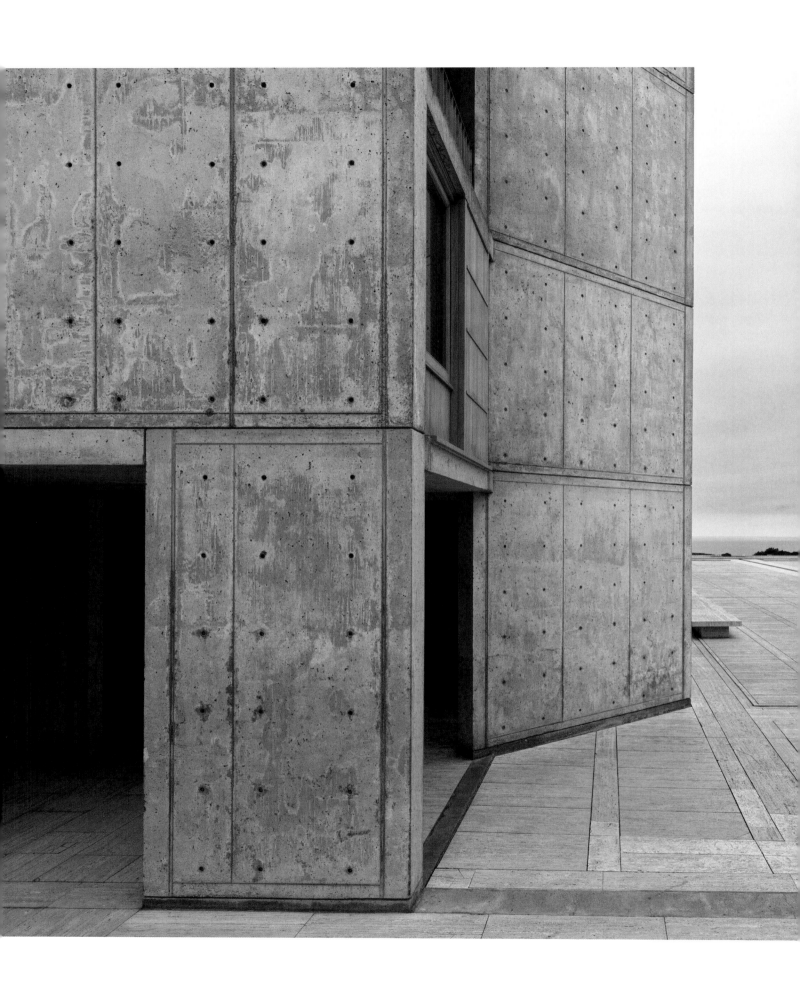

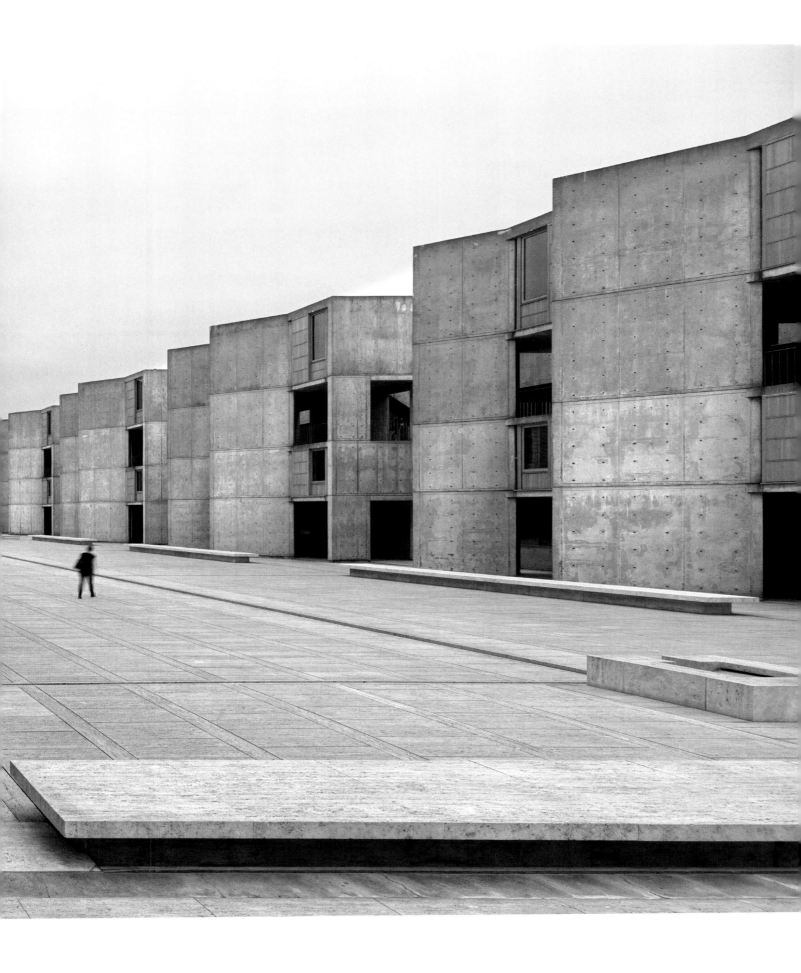

Situated on the edge of a canyon, the Salk Institute, a medical research laboratory, has a commanding position over the La Jolla plateau, with cliffs overlooking the Pacific Ocean near San Diego, California.

For this building, Kahn had many productive discussions with the virologist Jonas Salk, who had developed the first effective polio vaccine a few years earlier and now planned to establish a research institute. Together they visited the Richards Medical Research Laboratories at the University of Pennsylvania, using Kahn's earlier building as a point of reference for their new project. But Salk's intention was more ambitious; he is quoted by Kahn as saying that he wished to invite Picasso to the laboratories.[2] Kahn imagined three different spaces for the scientific community at the new institute: the work areas, with laboratories and offices for the researchers; a public pavilion for conferences and cultural events; and a residential space. For financial reasons, only the laboratories were completed, in 1965.

On a vast travertine platform, two groups of buildings face the ocean: two continuous wings containing the laboratories, each with five pavilions punctuating the open central area that separates them. The central plaza is a great achievement. Like a vast sundial, it emphasises the presence of the light. A narrow waterway runs through the middle towards the sea. The perpetual movement of the line of the water, running through an elegant travertine channel, suggests continuity and eternity. The water then breaks into a succession of waterfalls flowing into a series of ornamental pools below the level of the platform. All of these elements are reminiscent of the layout of the Mughal gardens that Kahn had had the opportunity to visit during his travels to India.

1 Louis I. Kahn, 'Law and Rule in Architecture', lecture at RIBA, London, 14 March 1962, Louis I. Kahn Collection, Architectural Archives, University of Pennsylvania and the Pennsylvania Historical Society and Museum Commission, Philadelphia.

2 Kahn repeated this anecdote several times; see for example Louis I. Kahn, 'White Light, Black Shadow', in *Louis I. Kahn: Conversations with Students*, ed. Dung Ngo, Architecture at Rice 26, 2nd edn (New York: Princeton Architectural Press, 2000), p. 25.

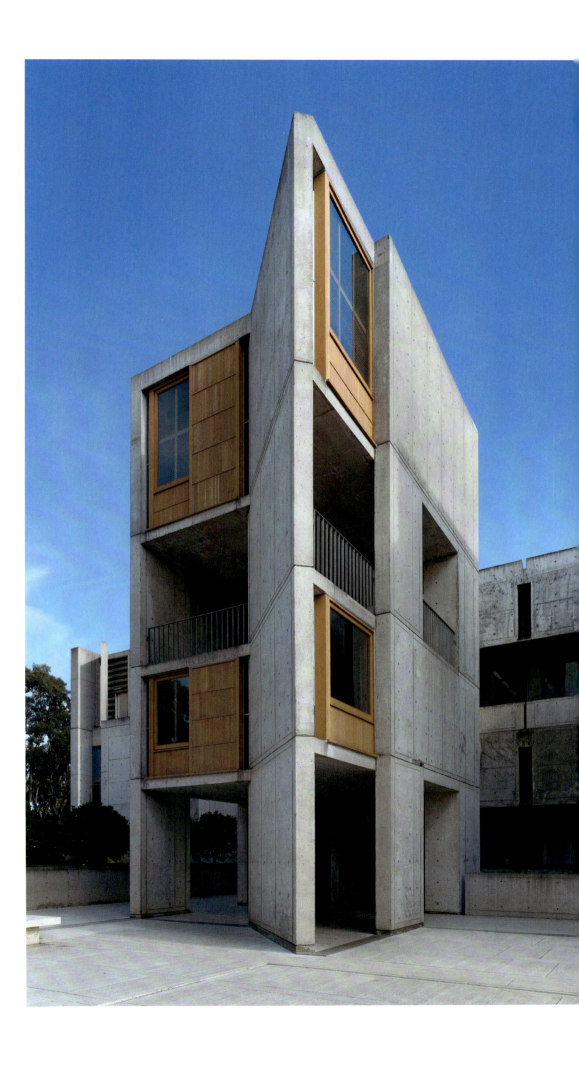

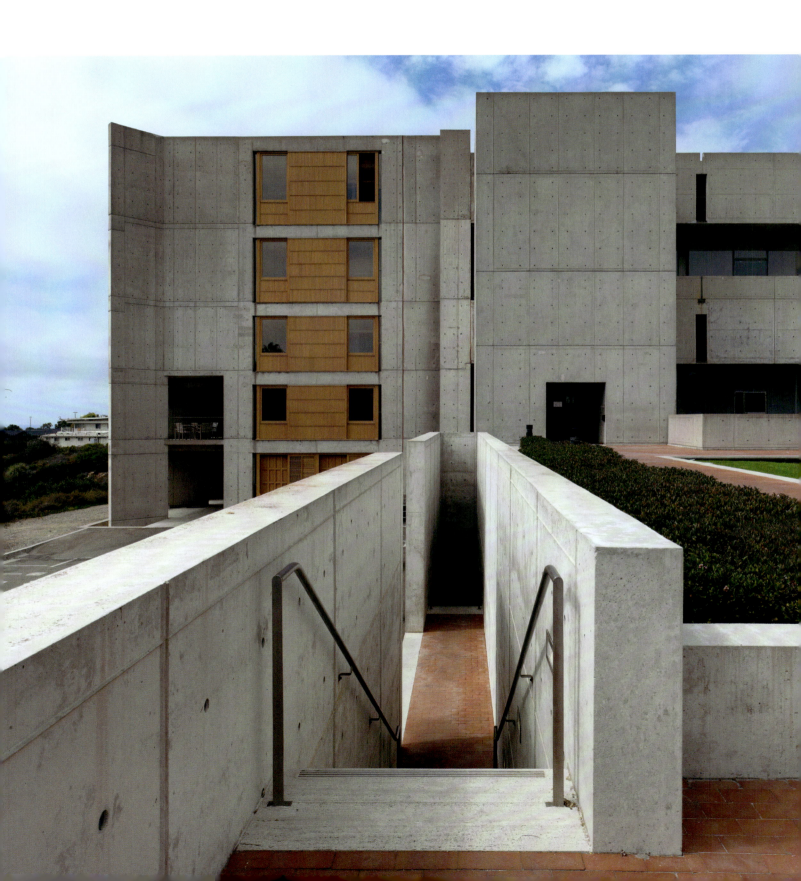

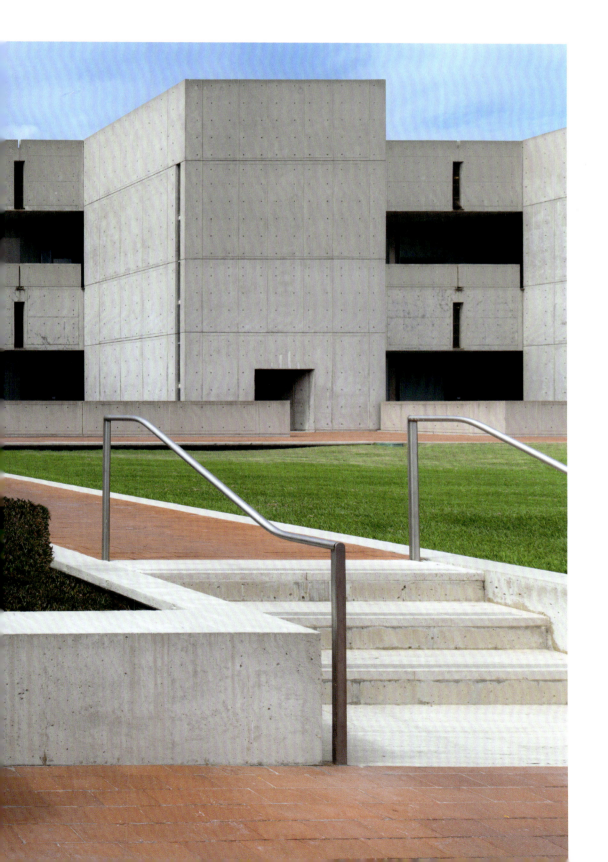

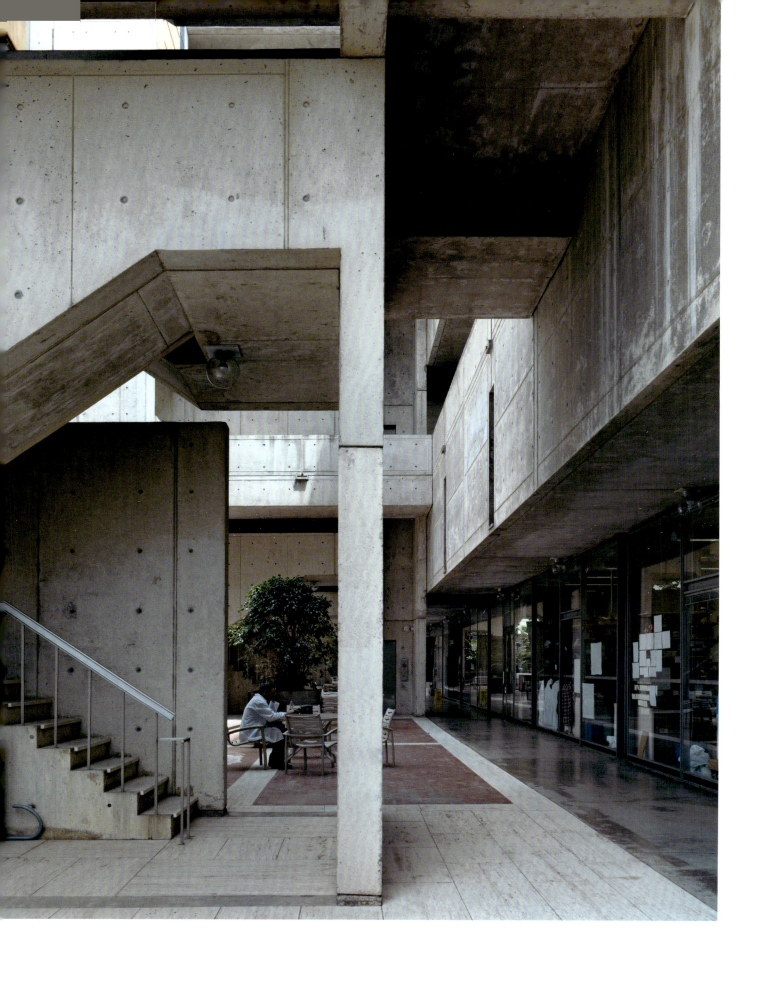

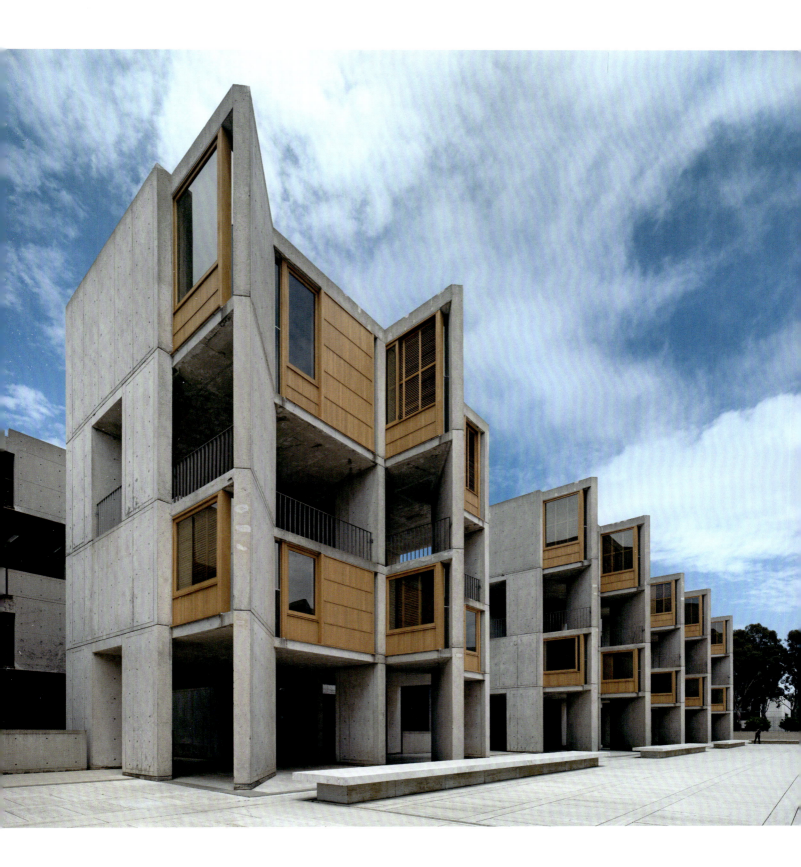

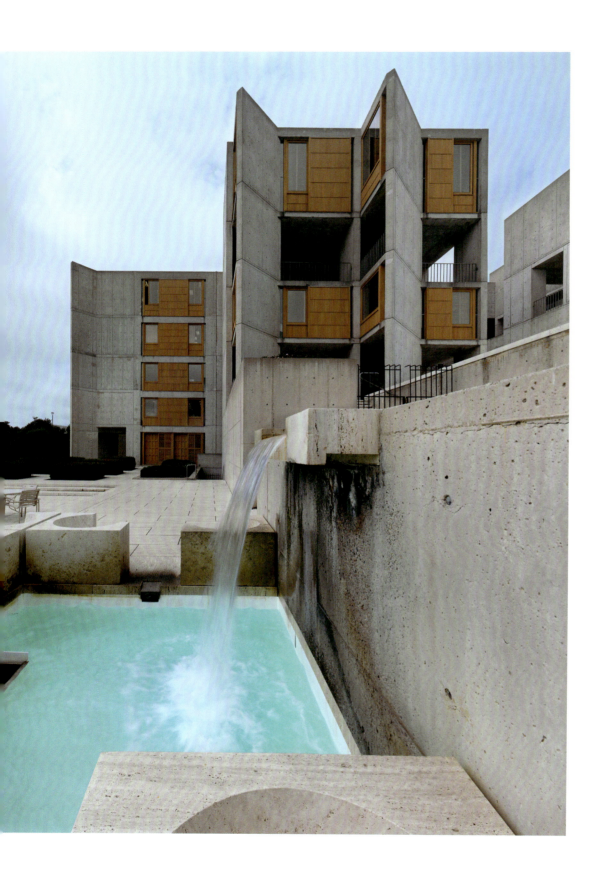

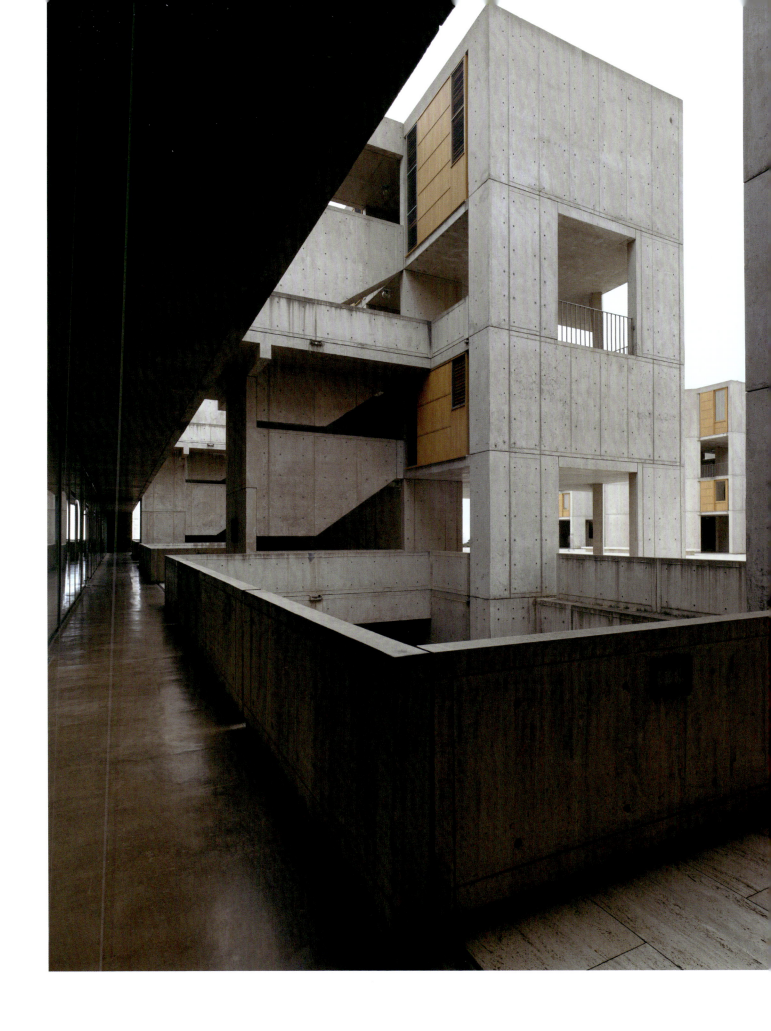

SALK INSTITUTE FOR BIOLOGICAL STUDIES

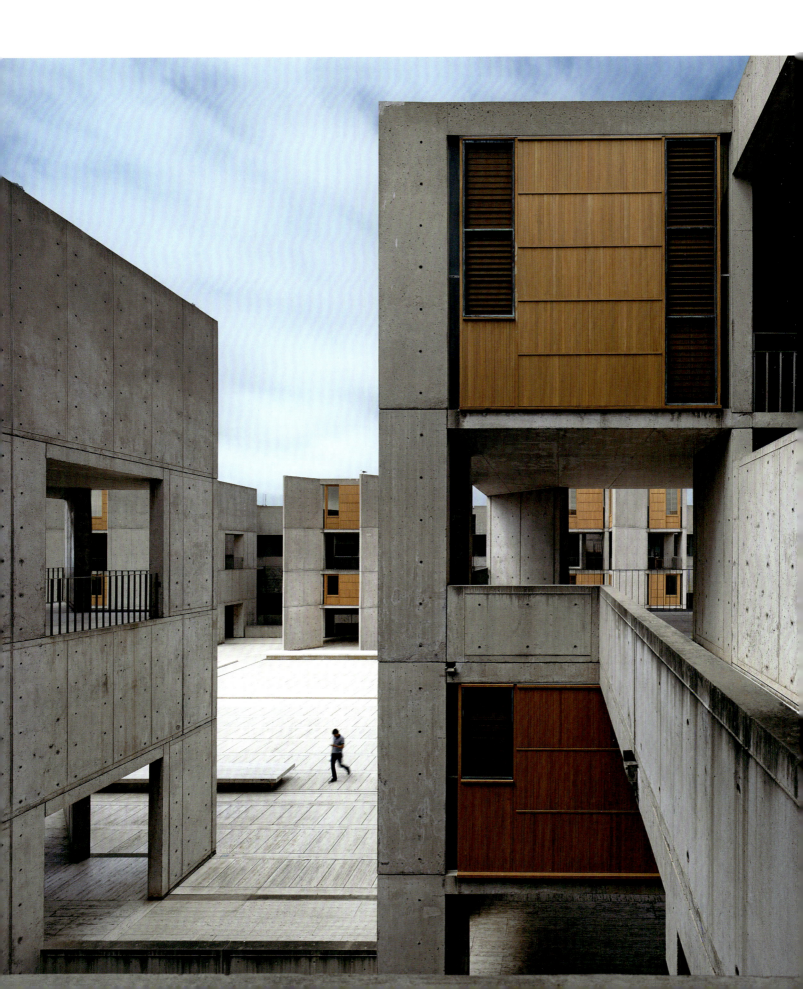

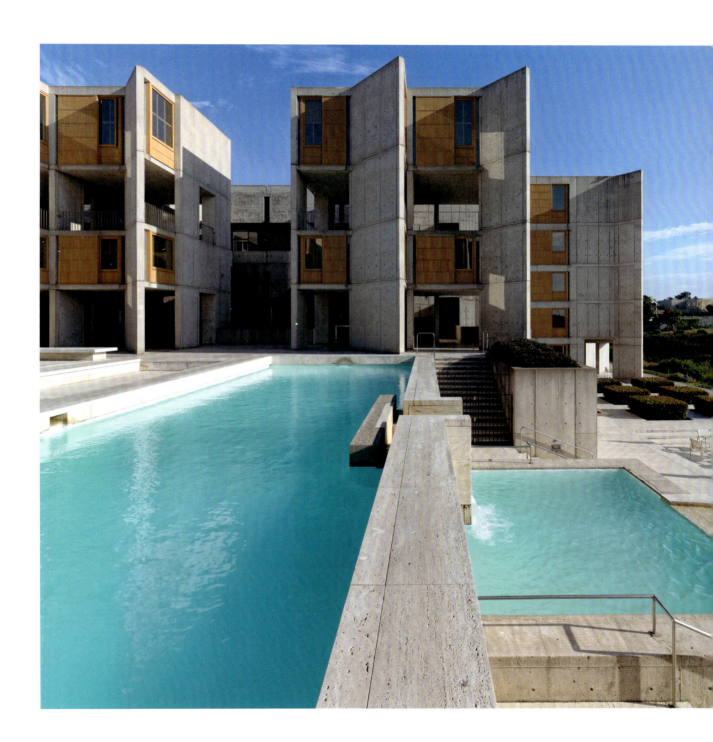

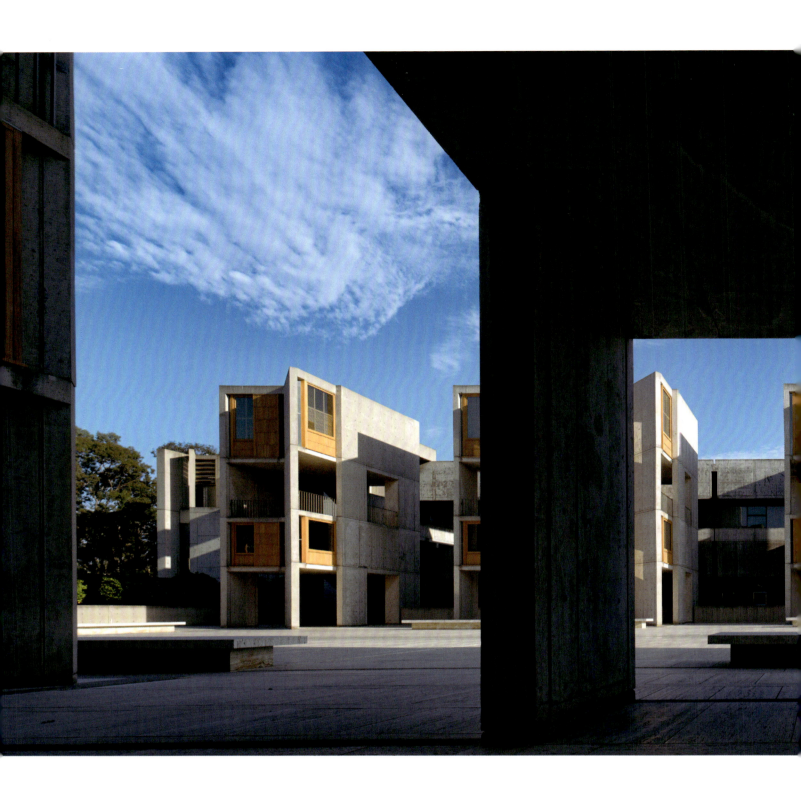

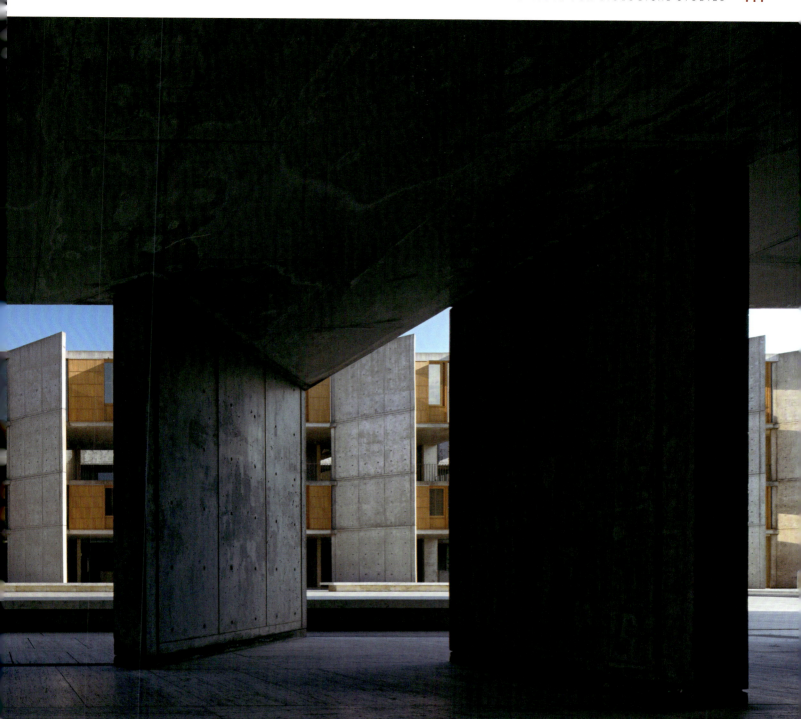

In a dormitory I'm doing for Bryn Mawr College, I had a feeling that the dining room, living room, reception rooms and entrance were different, in every respect, from the sleeping quarters. And I kept the sleeping quarters apart from these rooms, believing that I was expressing that one was different from another. But I discovered my mistake. I realized that a person sleeping in a room felt well about his house if he knew the dining room was downstairs. The same way with the entrances to the building. The sense of hospitality, or reception, of getting together must be part of the fabric of the house itself. I changed, much to my delight, the whole conception, and I made these spaces part of the fabric of the other spaces.

Louis Kahn, 'A Statement', 1962[1]

Bryn Mawr, Pennsylvania
1960–65

ELEANOR DONNELLEY ERDMAN HALL, BRYN MAWR COLLEGE

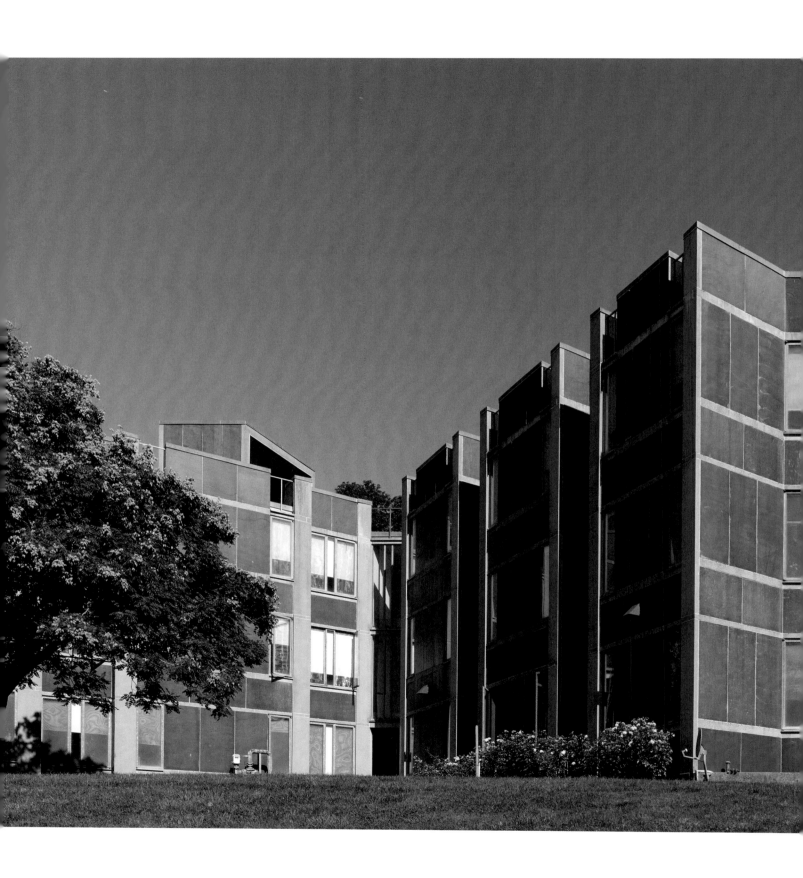

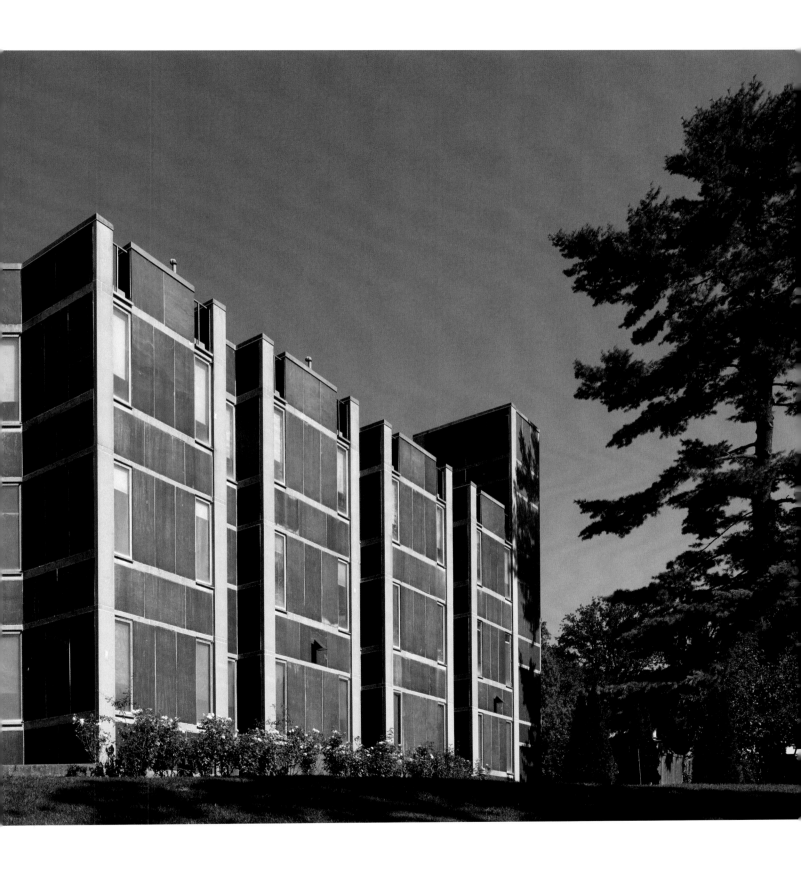

Geometric order and structural expression were again the leitmotifs at this hall of residence for young female students in Bryn Mawr, near Philadelphia, which Kahn designed between 1960 and 1965. How was it possible to connect the three communnal spaces of the programme – the refectory, the entrance hall and the living room – without using corridors? What was the best way to connect these shared spaces with the private space of the students' individual rooms? What was the best position for the building in relation to the rest of the campus? These connections and junctions between the different interior spaces (both shared and private) and the exterior were the most important elements in the final result.

Kahn created a plan for a building consisting of three squares rotated and connected along their diagonals. Each block consists of a central collective space surrounded by individual rooms, creating a plan in a nested square formation. The exterior facades are composed of vertical concrete structures with alternating protruding and receding elements and are covered with grey-blue slate panels. According to Kahn, the layout of the dormitory halls was a reference to castles in England and Scotland:[2] inside, the separation of the central space and the secondary spaces is reminiscent of Comlongon Castle near Dumfries, for example, which Kahn had looked at, where the kitchens, chimneys and stairs were inserted into the broad walls, thus freeing the central space.

1 Louis I. Kahn, 'A Statement', paper delivered at the International Design Conference, Aspen, Colorado, 1962, in *Louis I. Kahn: Writings, Lectures, Interviews,* ed. Alessandra Latour (New York: Rizzoli, 1991), pp. 150–51.
2 See Kahn's sketches of British castle floor plans in David B. Brownlee and David G. De Long, *Louis I. Kahn: In the Realm of Architecture* (New York: Rizzoli, 1991), p. 68.

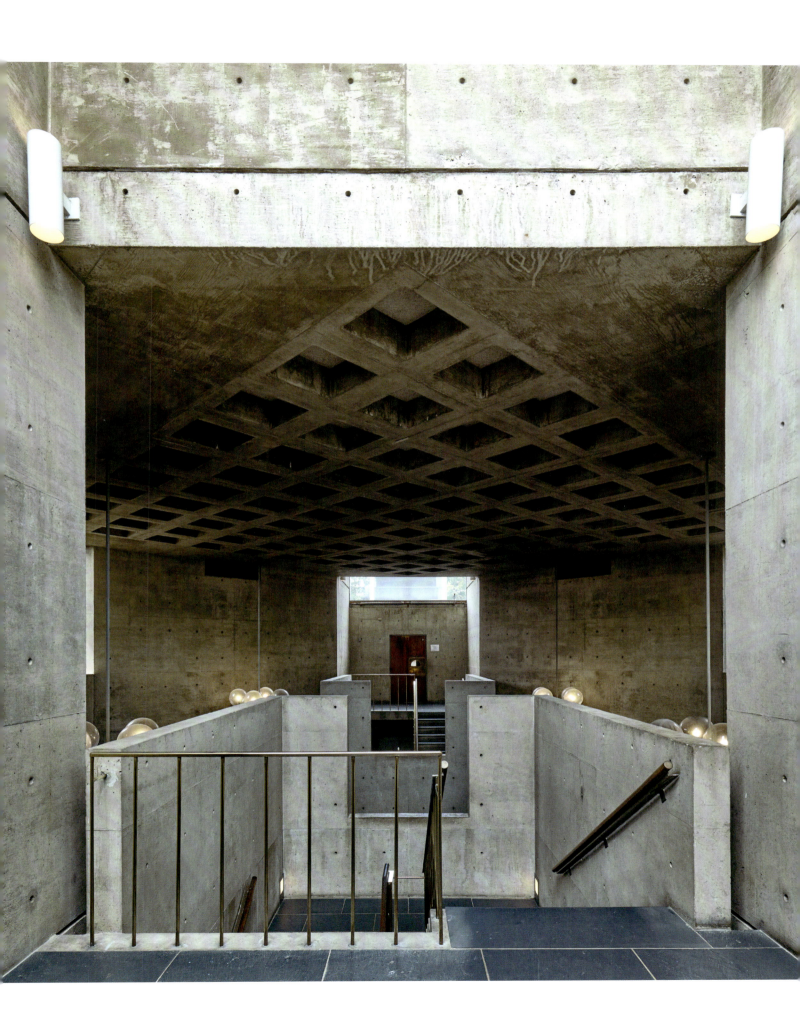

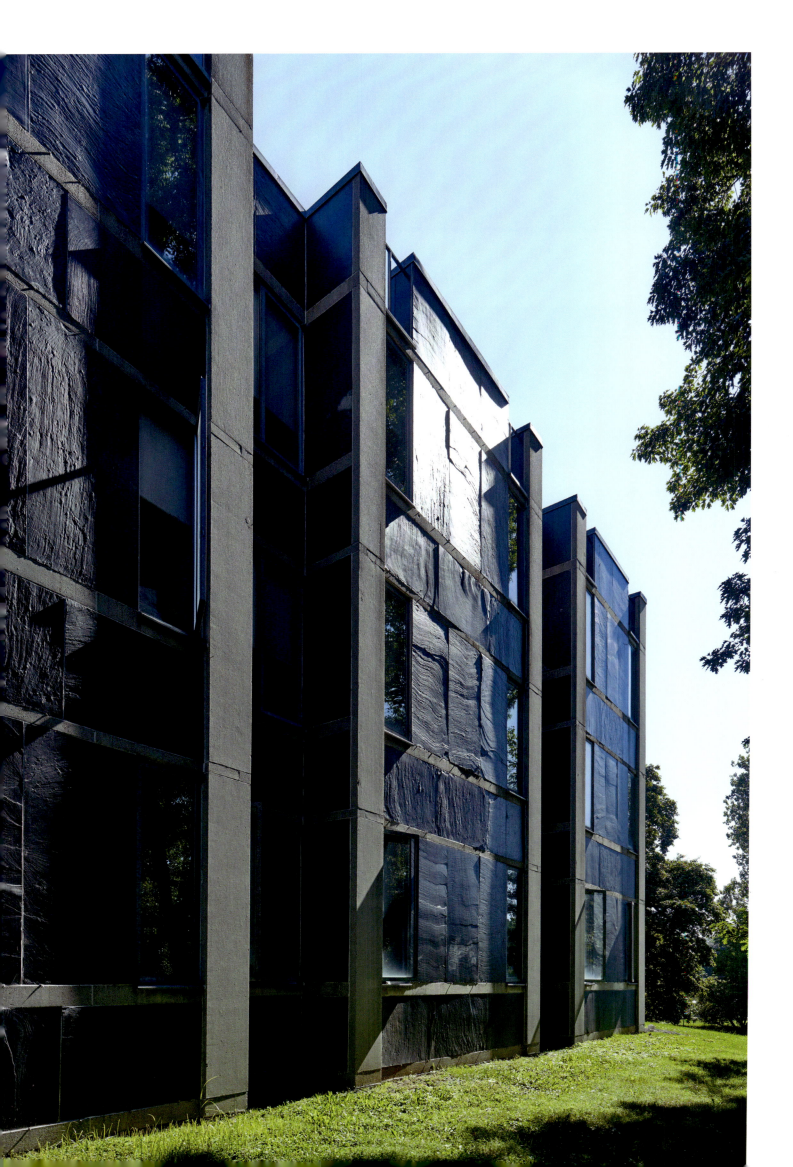

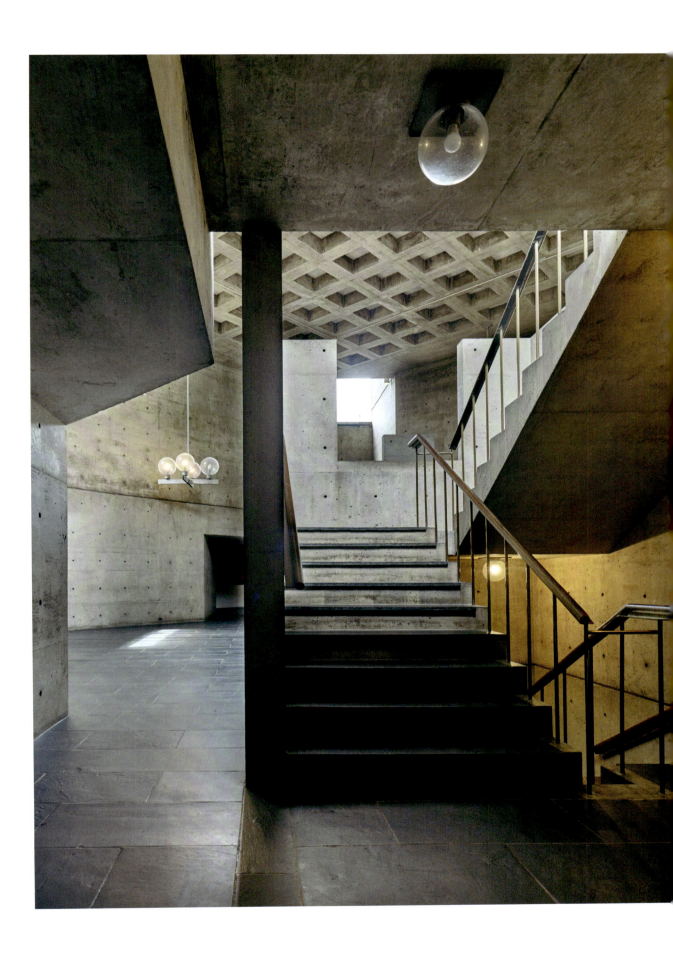

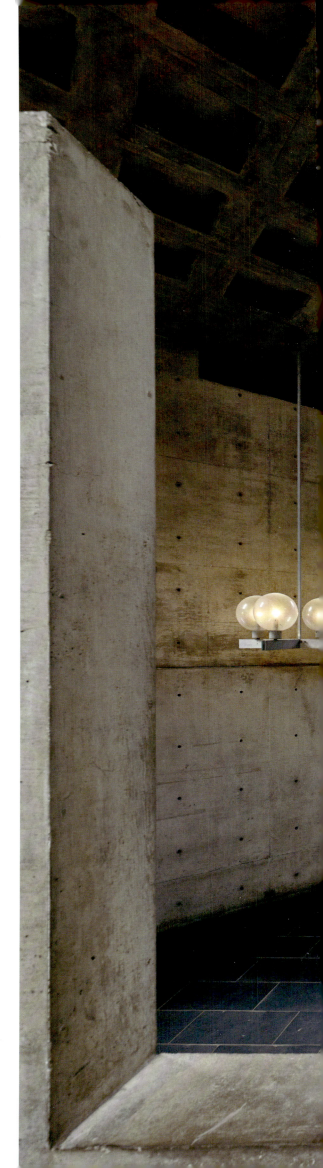

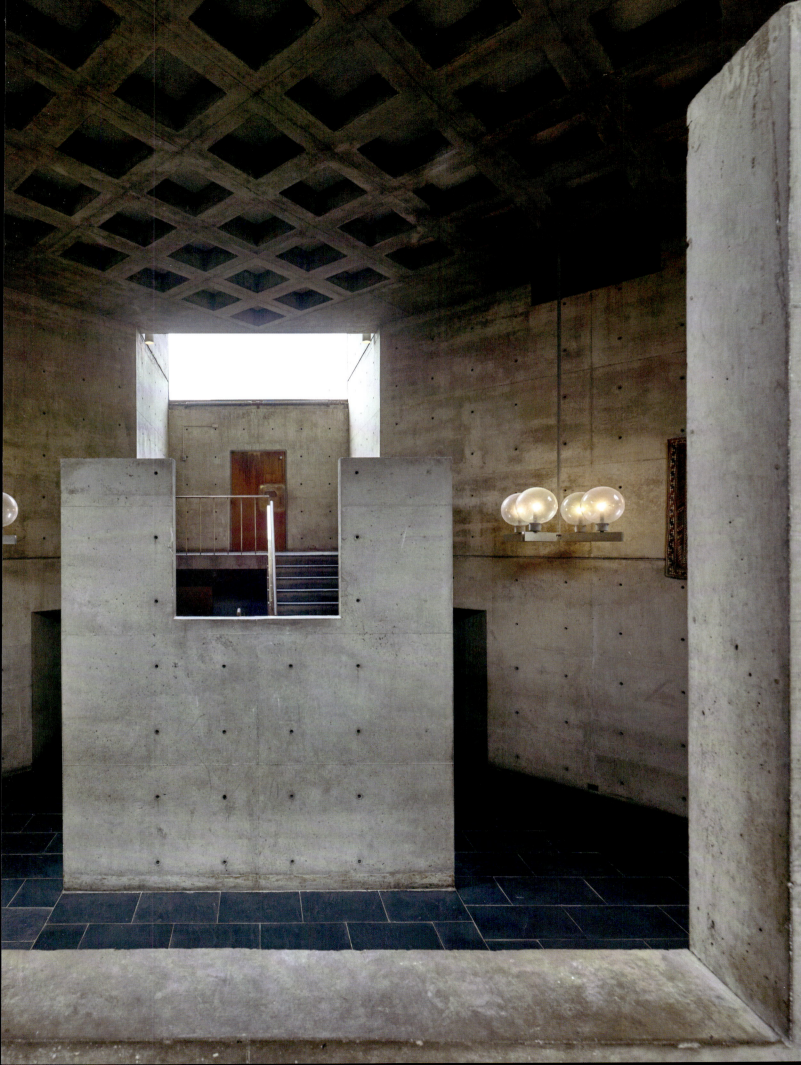

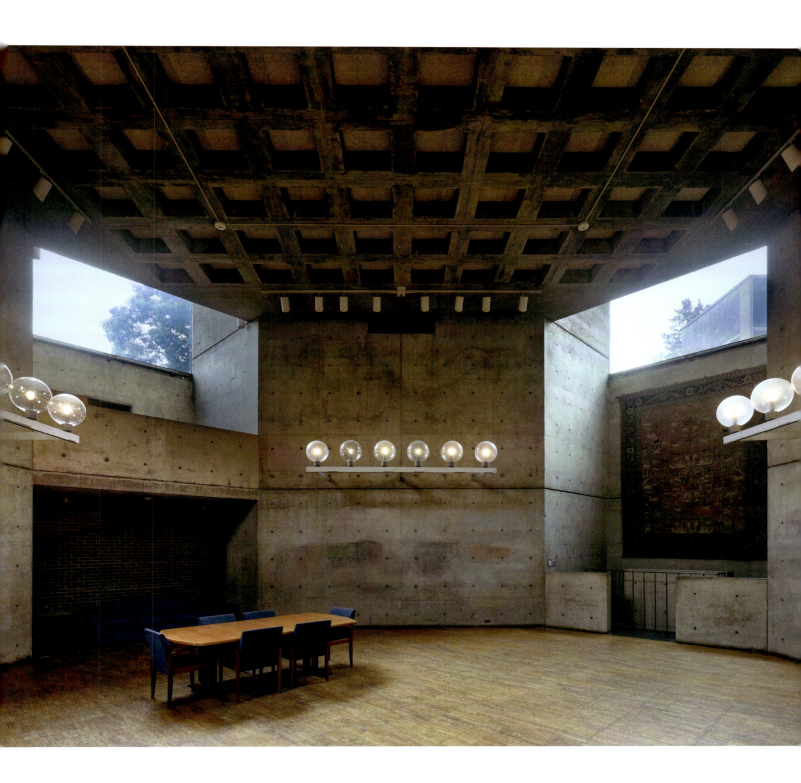

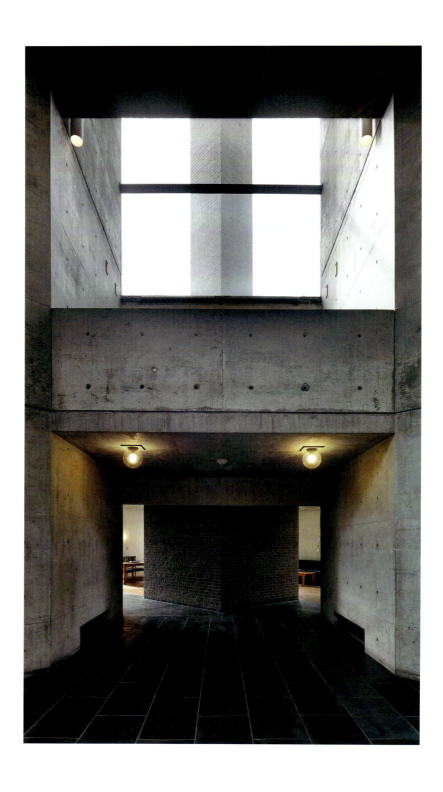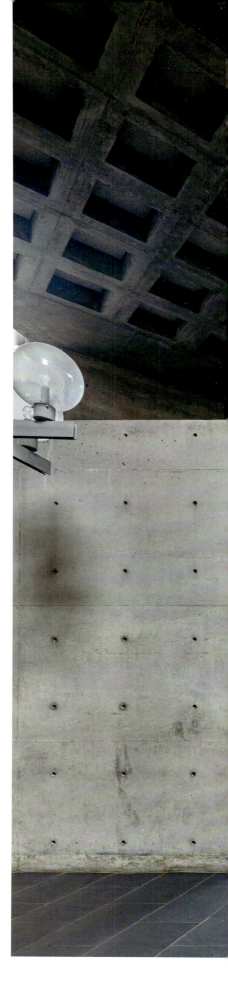

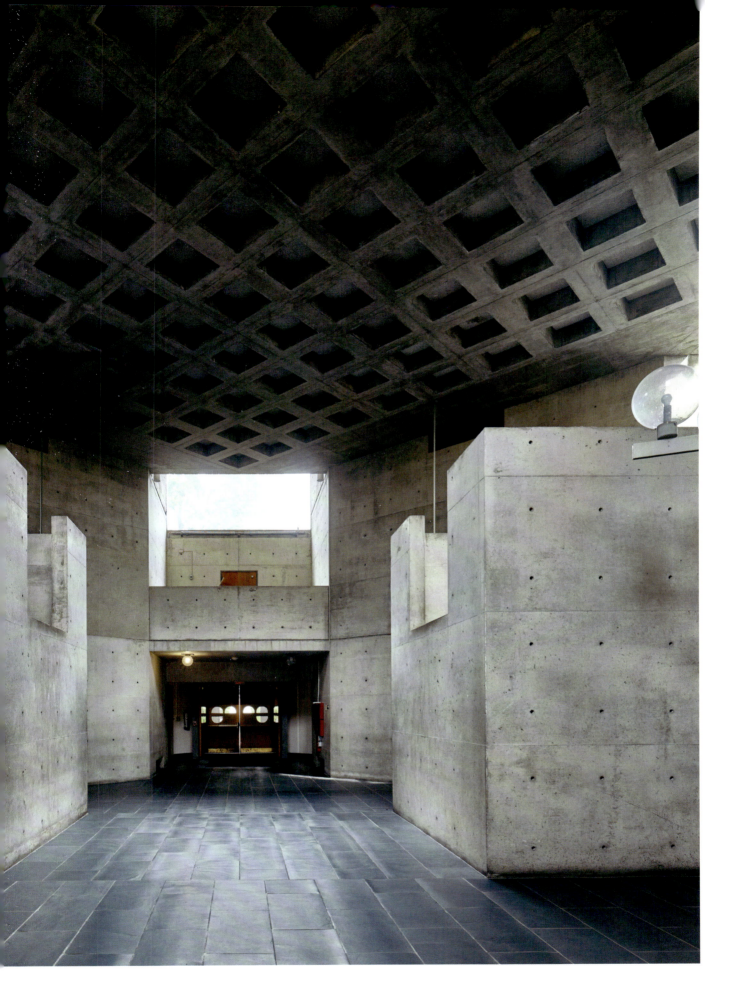

ELEANOR DONNELLEY ERDMAN HALL

I think every building must have a sacred place. I found what I think is a sacred place in a theater which I am designing for Fort Wayne, Indiana. I went through a great deal with that; I didn't know much about theaters. I knew dressing rooms had to be, but as long as I had to know all about dressing rooms, I knew I would never have been able to do the problem, because, you see, I didn't know the spirit ... The sacred place here is the place of the actor, the dressing rooms, the rehearsal room. The dressing room has its balcony overlooking the stage. There is a relationship between this and the stage, you see. As soon as I bunched everything together, it became a sacred space, and it wasn't just left-over space.

Louis Kahn, 'Talks with Students', 1964[1]

Fort Wayne, Indiana
1961–73

PERFORMING ARTS THEATER, UNITED ARTS CENTER

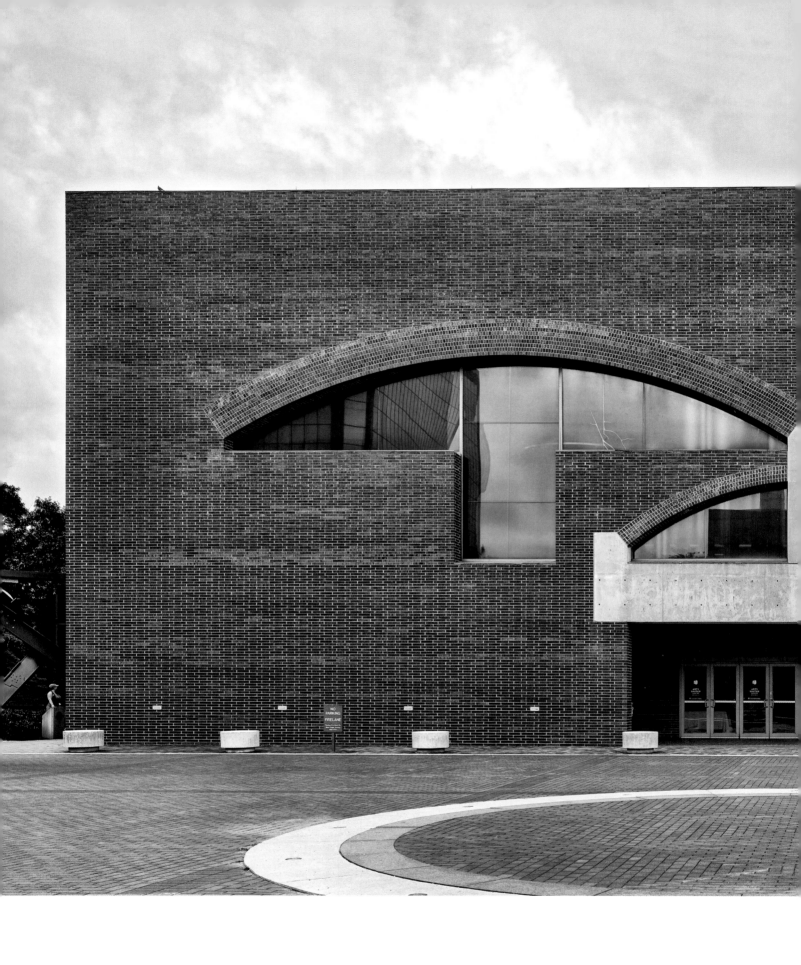

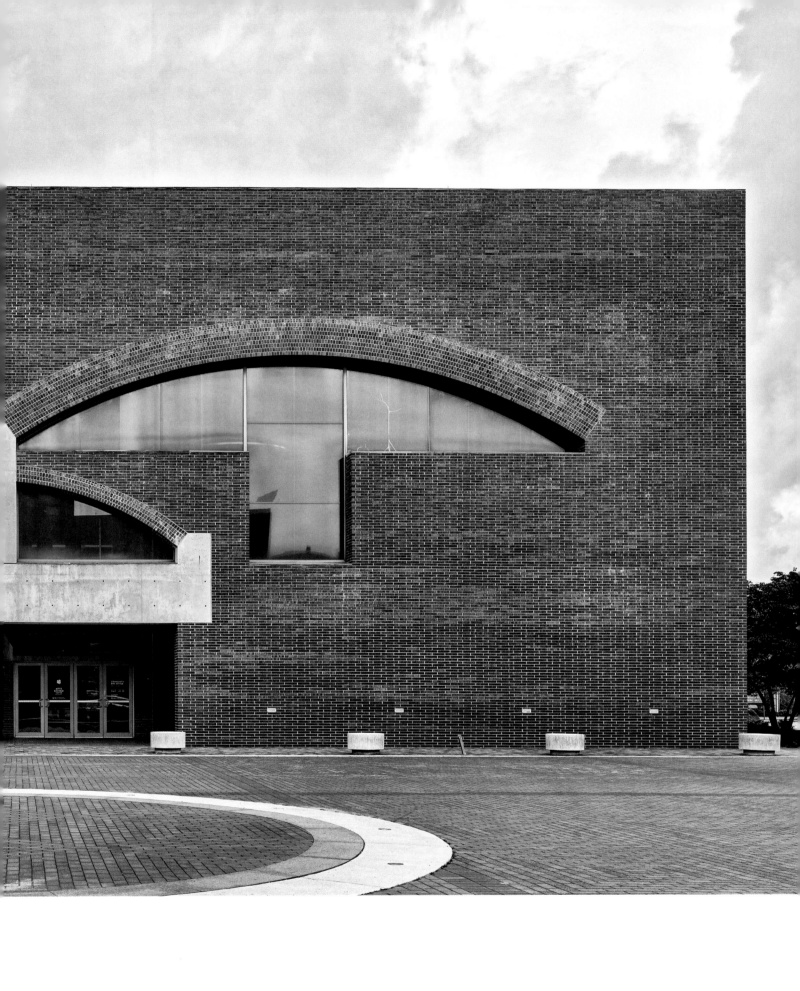

PERFORMING ARTS THEATER

The theatre at the United Arts Center in Fort Wayne, Indiana, was to be part of an ambitious programme for the city's Fine Arts Foundation that would include a philharmonic hall, museum, school of fine arts, dormitories and a parking garage, to be located together as a group. The first scheme Kahn designed contained all these elements, but unfortunately, as he was refining the site plan in the autumn of 1963, the patrons in Fort Wayne determined that they could not afford to build the complex all at once. As David Brownlee and David De Long have explained: 'At Fort Wayne, as at Dacca, Kahn argued passionately for the entirety of the complex, believing that wholeness was essential to its meaning. Yet as proposed the center was vastly more expensive than its backers had expected; confidence in Kahn's ideas and in the ability to raise the needed funds waned, and elements began to drop away.'[2] By 1970, Kahn and his team had completed drawings for the theatre and the school of fine arts, but only the theatre was ultimately built. It was inaugurated in 1973.

1 Louis I. Kahn, 'Talks with Students', Rice University, Houston, Texas, 1964, in *Louis I. Kahn: Writings, Lectures, Interviews,* ed. Alessandra Latour (New York: Rizzoli, 1991), pp. 186–87.

2 David B. Brownlee and David G. De Long, *Louis I. Kahn: In the Realm of Architecture* (New York: Rizzoli, 1991), p. 179.

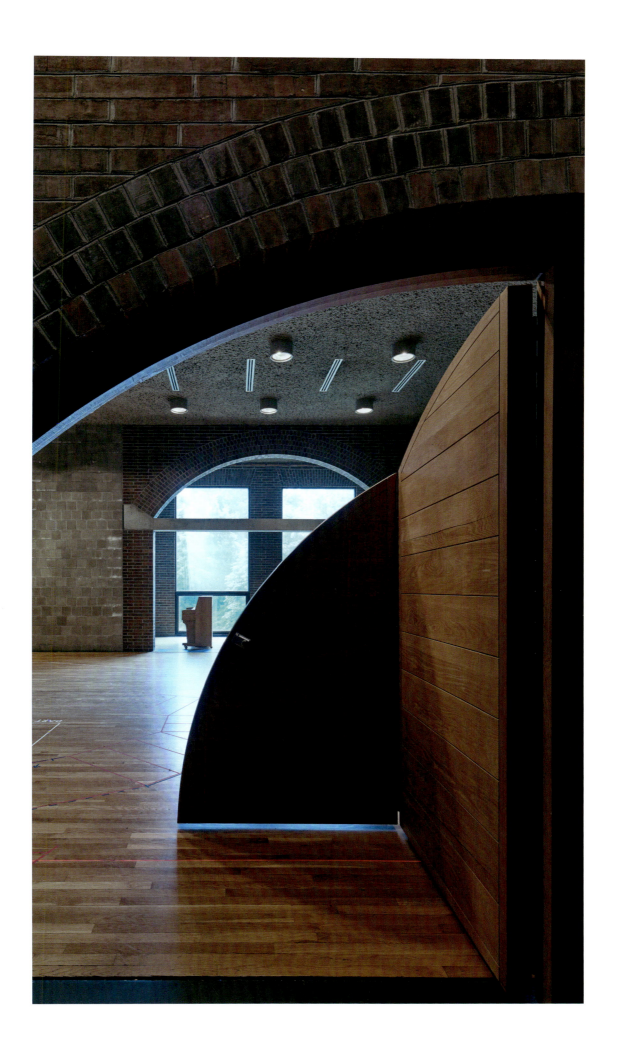

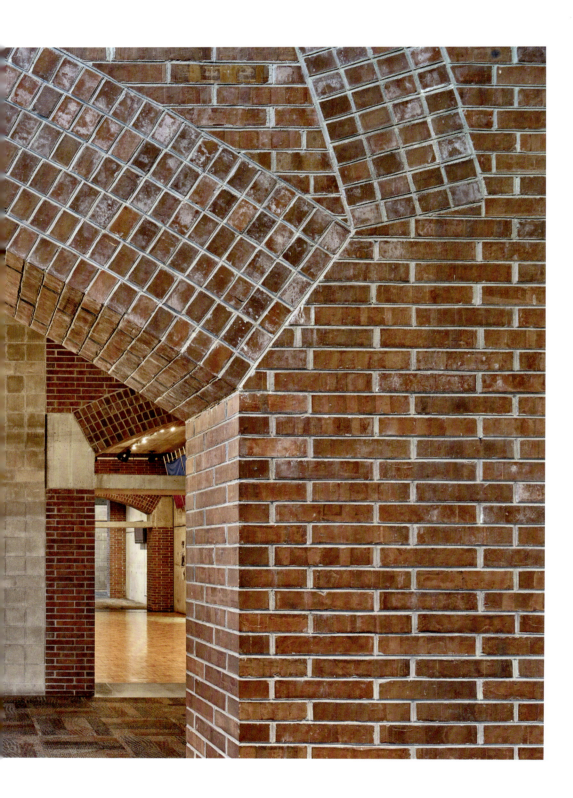

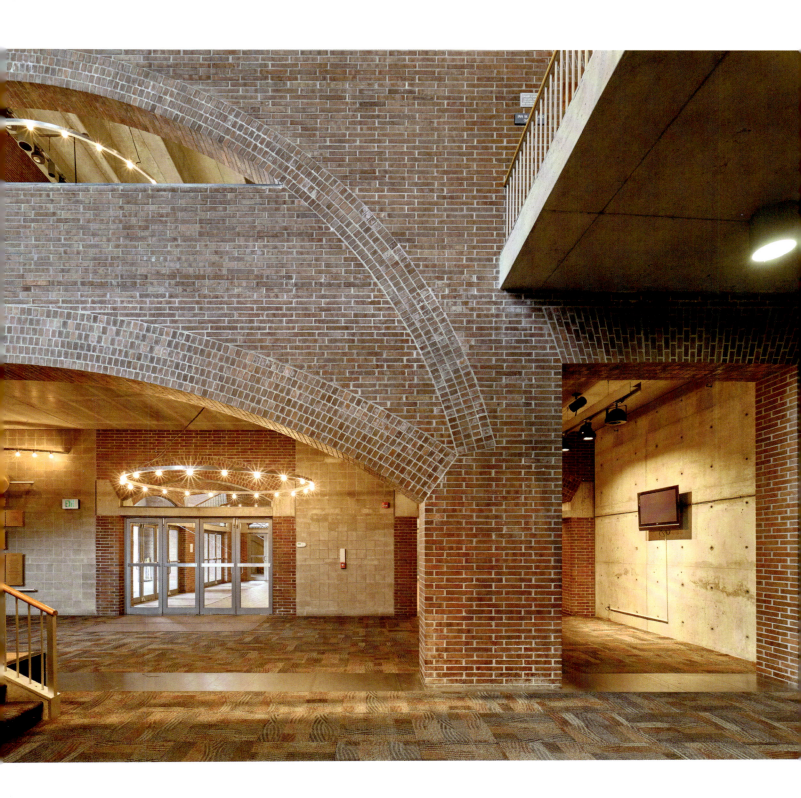

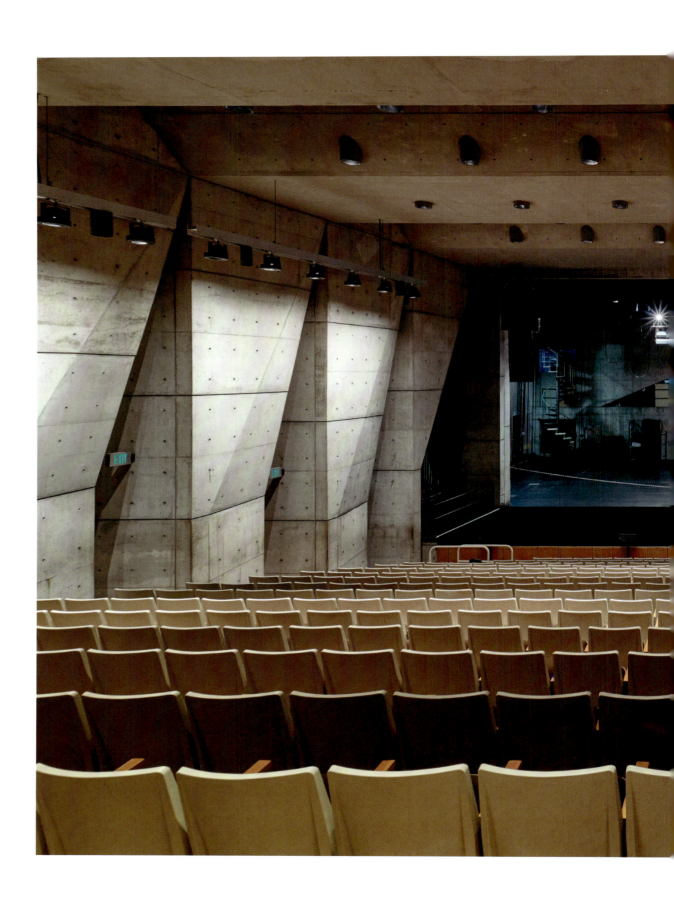

PERFORMING ARTS THEATER 135

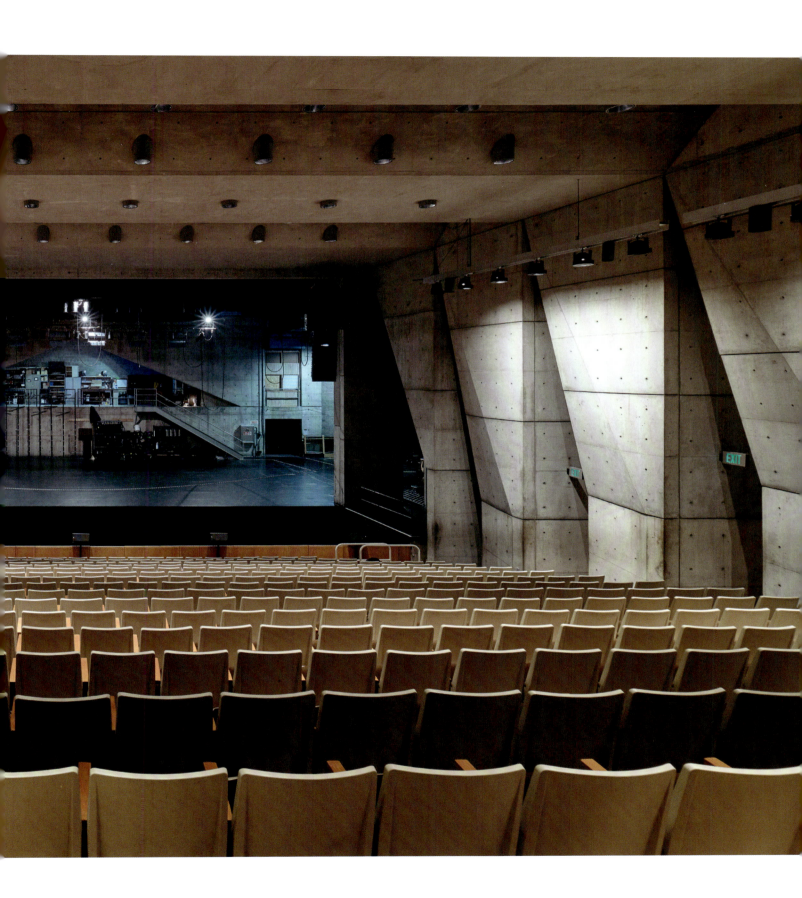

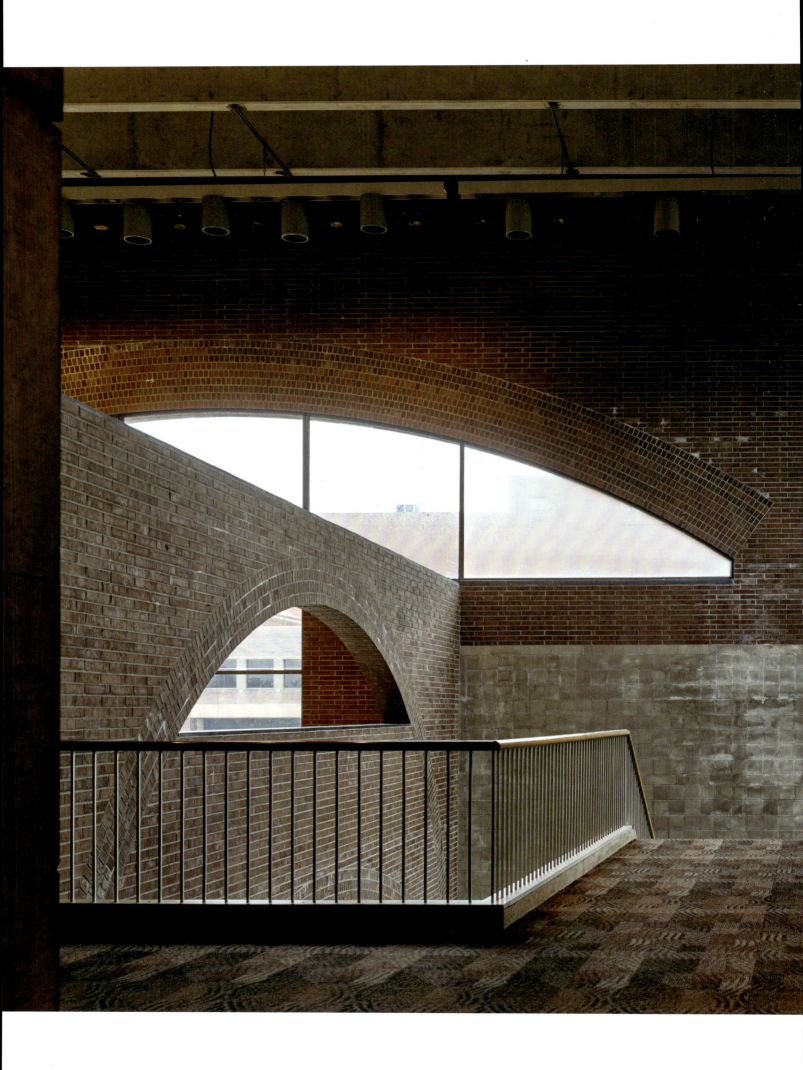

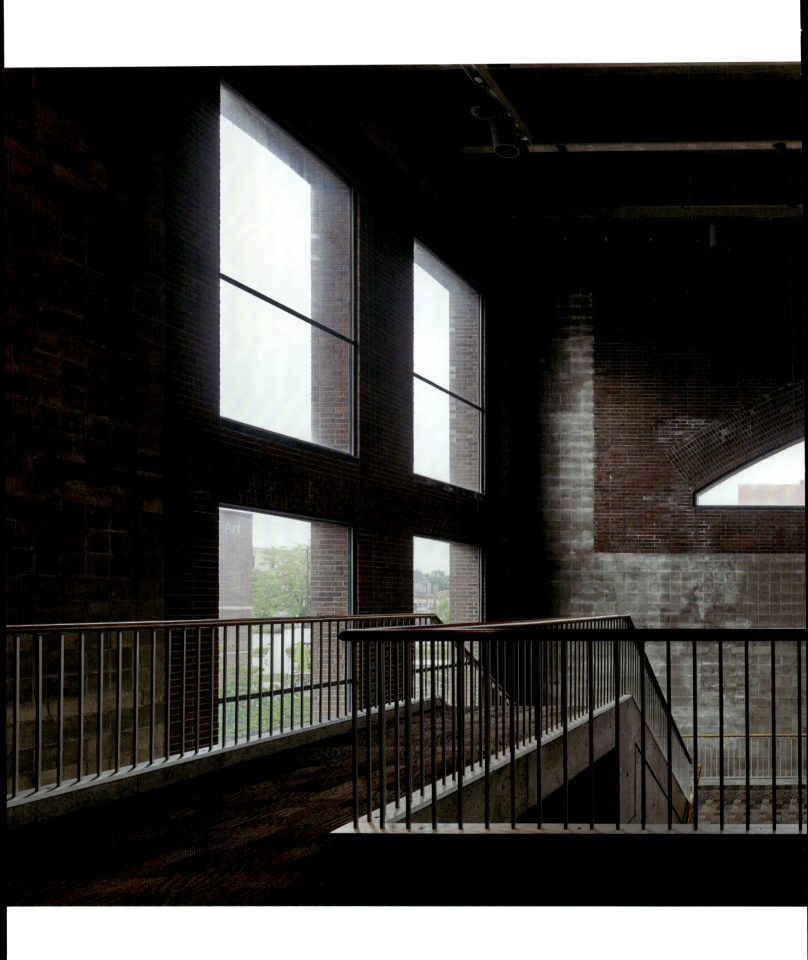

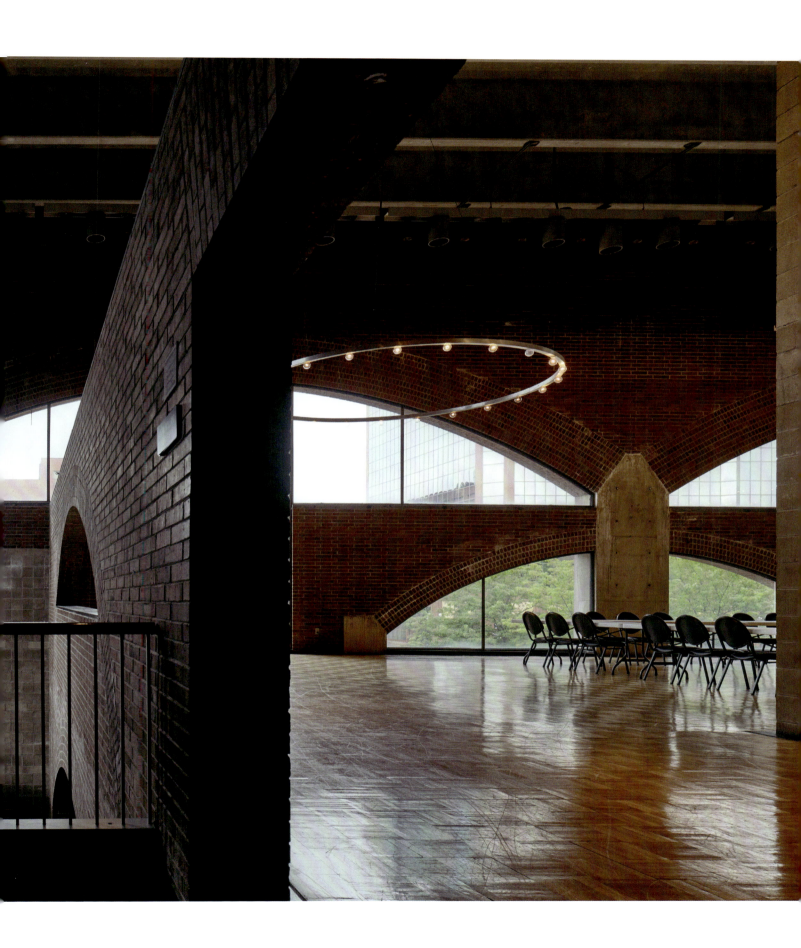

The corridors, by the provision of greater width and alcoves overlooking gardens, would be transformed into classrooms for the exclusive use of the students. These would become the places where boy meets girl, where student discusses the work of the professor with fellow student. If classroom time were allotted to these spaces instead of only the passage of time from class to class, they would become not merely corridors but meeting places — places offering possibilities in self learning. In this sense they would become classrooms belonging to the students.

Louis Kahn, radio lecture, 1960[1]

Ahmedabad, India
1962–74

INDIAN INSTITUTE OF MANAGEMENT

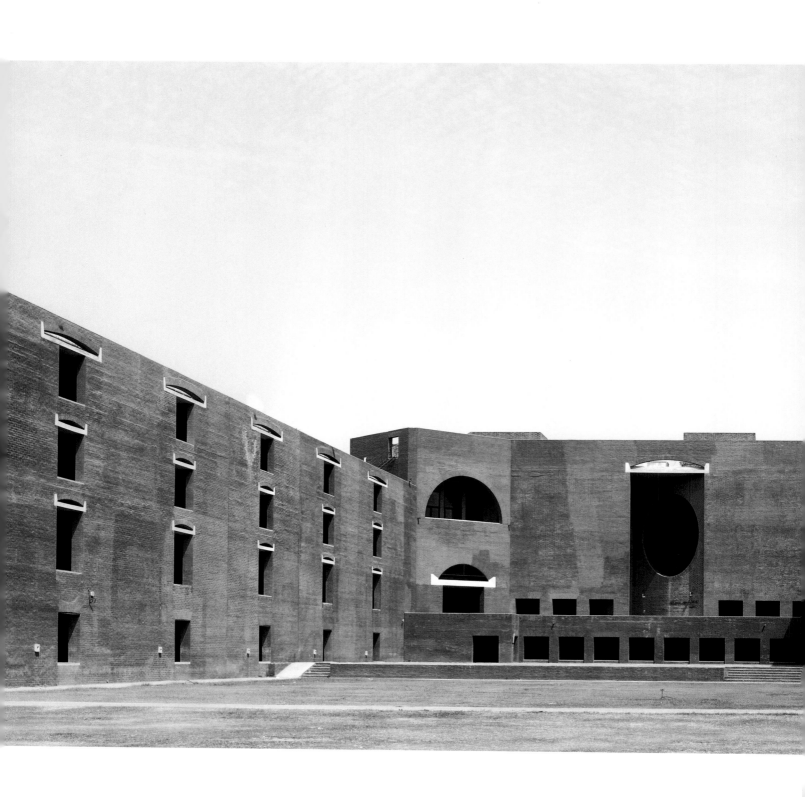

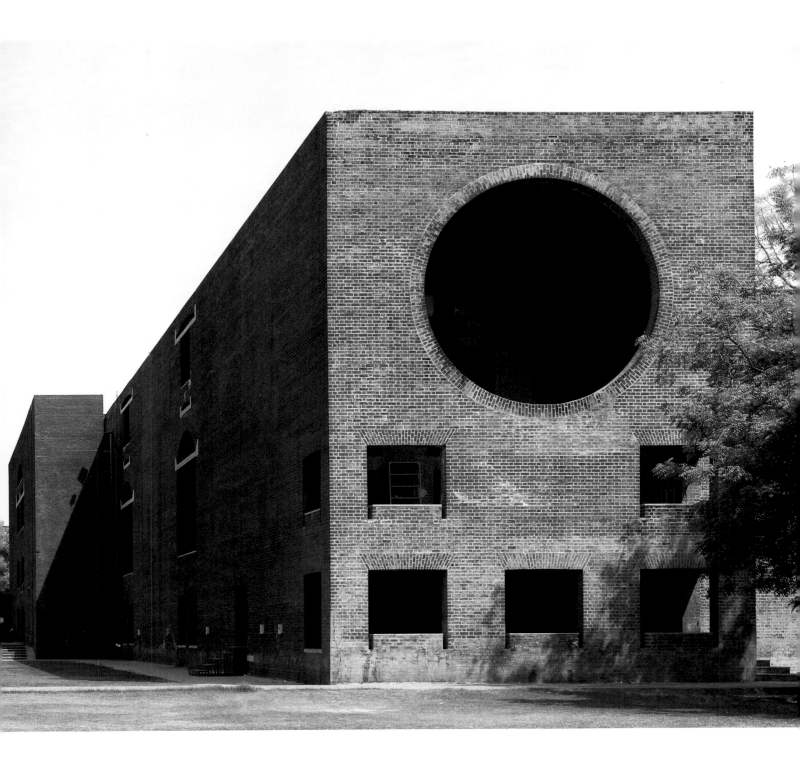

Just as for the residences built around the National Assembly in Dhaka, Kahn mainly used brick for the construction of the Indian Institute of Management in Ahmedabad, Gujarat. Kahn had used brick cladding in some of his earlier work, but here brick became a structural element. Local production of this material and the lower cost of labour made this choice preferable to concrete, which was more expensive. Kahn had already demonstrated how much he appreciated this simple and robust material, which was a real source of inspiration for him. Indeed, in a lecture in 1973 he even imagined a dialogue between an architect and a brick:

If you talk to a brick and ask it what it likes, it'll say it likes an arch. And you say to it, look arches are expensive and you can always use a concrete lintel to take the place of an arch. And the brick says, I know it's expensive and I'm afraid it probably cannot be built these days, but if you ask me what I like it's still an arch.[2]

On the facades, shapes appear as decorative relief work. The pilasters and brick vaults and the lintels with their concrete reinforcements are structural elements that also contribute to the ornamentation of the building. Again working with what had become an established principle for him, Kahn set the workplaces (libraries, administrative offices and classrooms) at the heart of the building, surrounding them with ever finer rings containing the student accommodation and, on the periphery, housing for the professors.

At regular 6-metre intervals, six cubic volumes measuring 14.63 metres on each side, and connected by the same horizontal base, make up the wing of educational buildings. Grouped around a central courtyard, each cube contains a classroom in the form of an amphitheatre, which can be accessed via the courtyard.

1 Louis I. Kahn, Voice of America Forum Lecture, recorded 19 November 1960, broadcast 21 November 1960. Published as Louis I. Kahn, *Structure and Form*, Forum Architecture Series no. 6 (Washington, DC: Voice of America, [1961]), p. 3.

2 Louis I. Kahn in Beverly Russell, 'An Architect Speaks His Mind' (interview with Louis Kahn), *House and Garden*, 142:4 (October 1972), p. 124, reprinted in *Louis I. Kahn: Writings, Lectures, Interviews*, ed. Alessandra Latour (New York: Rizzoli, 1991), p. 296.

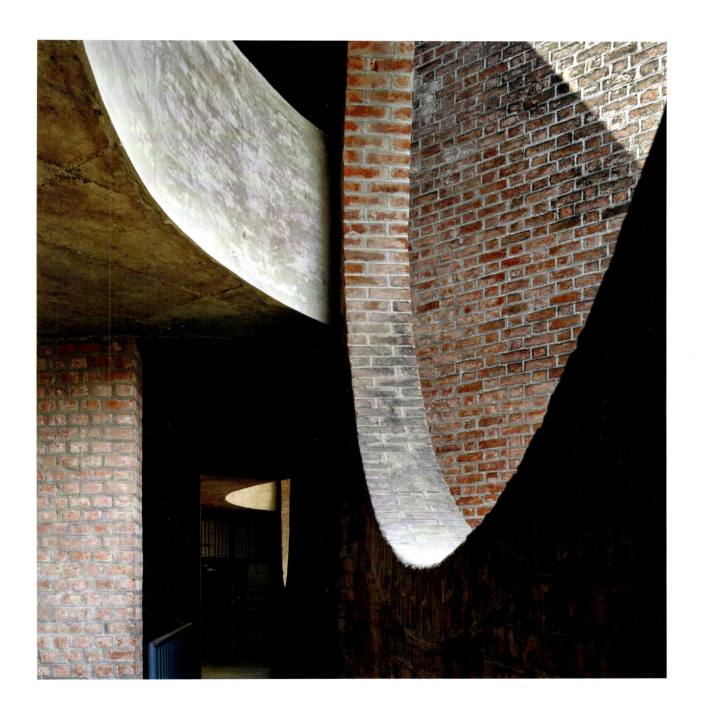

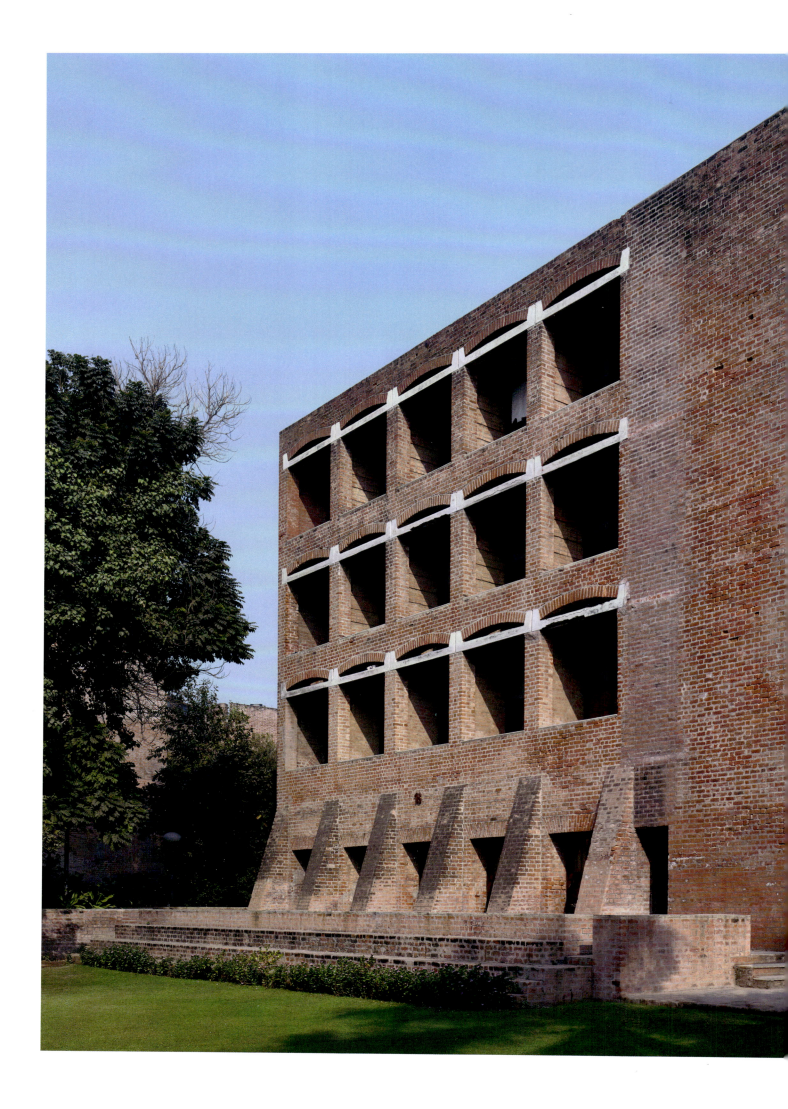

INDIAN INSTITUTE OF MANAGEMENT 147

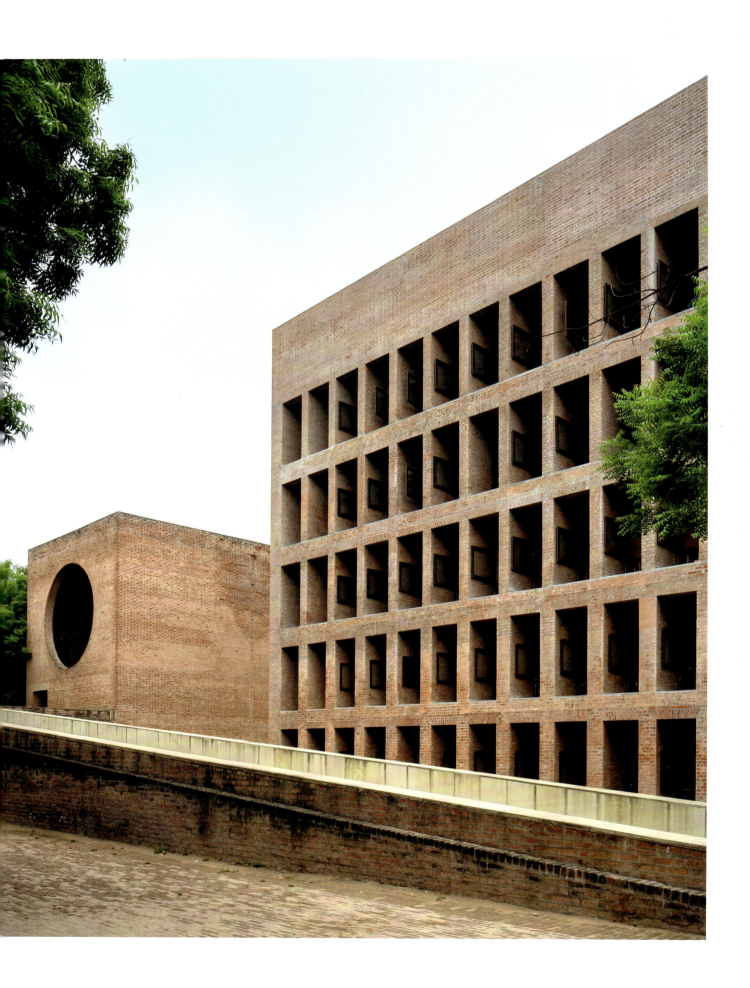

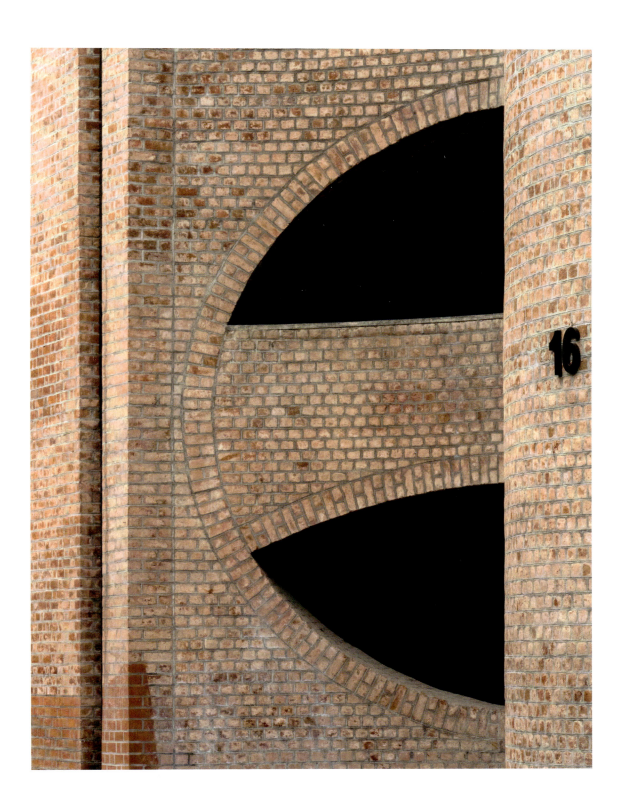

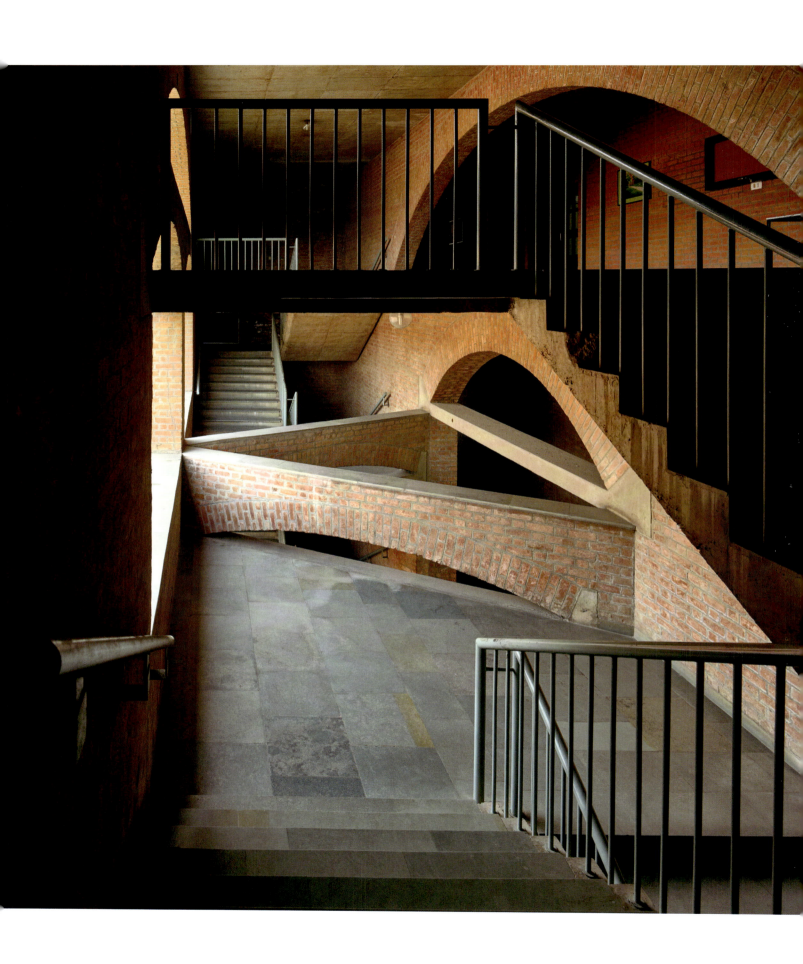

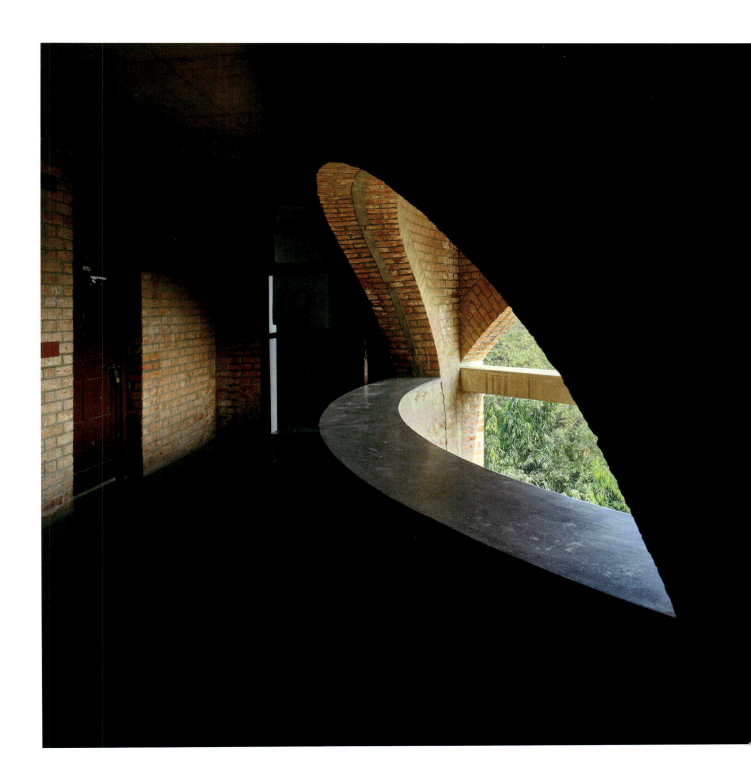

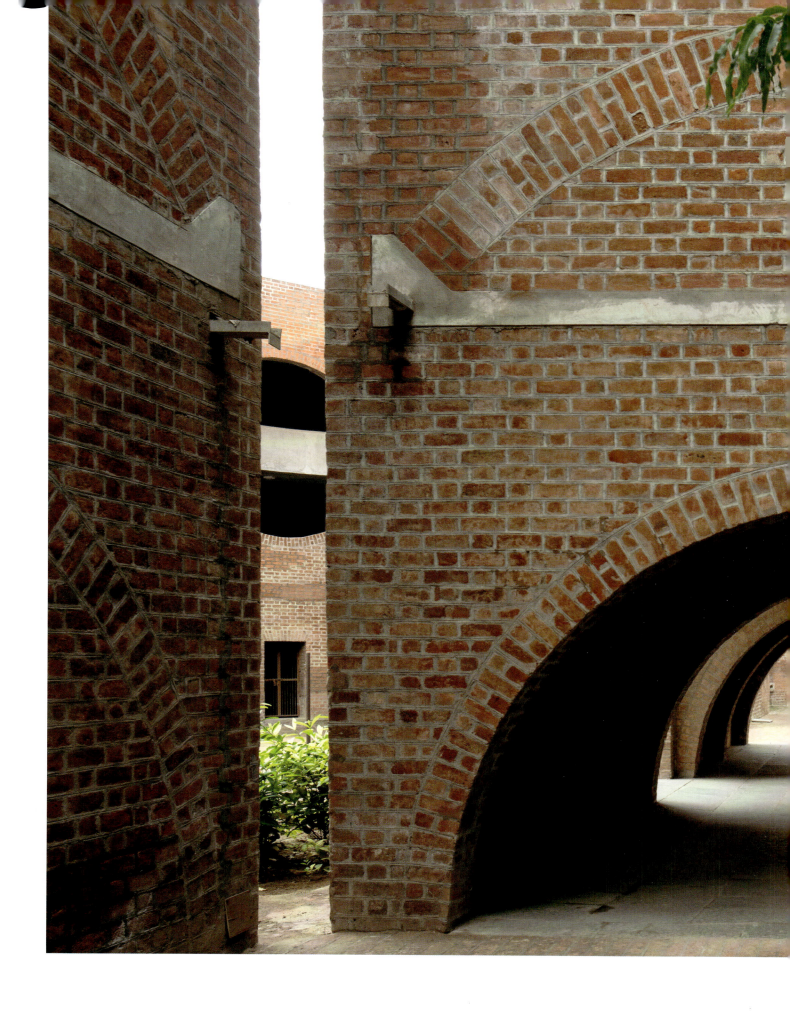

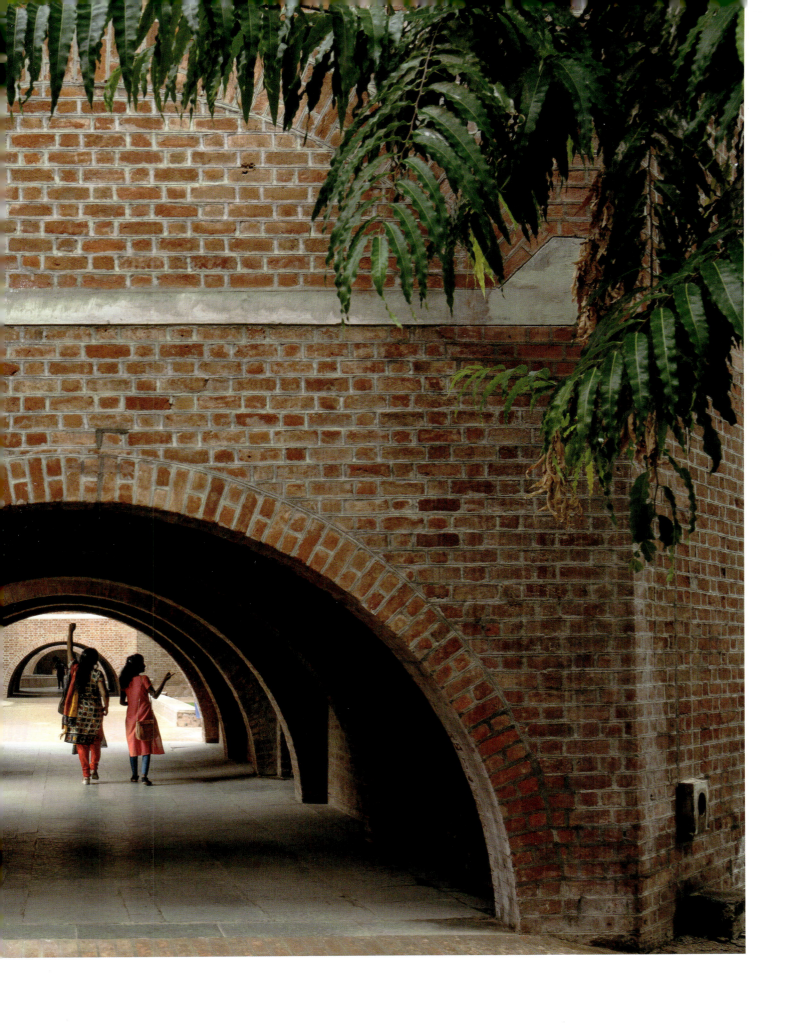

INDIAN INSTITUTE OF MANAGEMENT

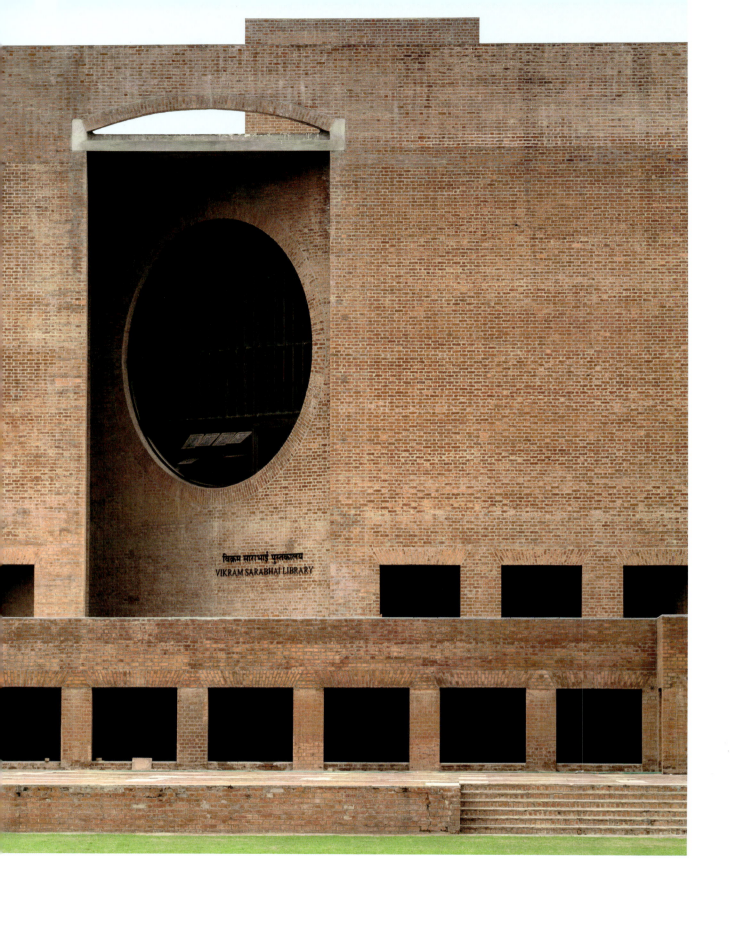

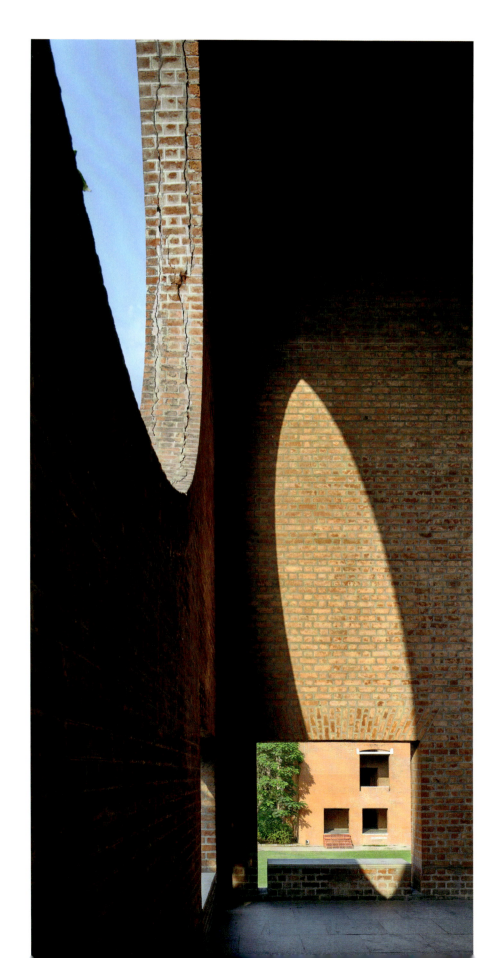

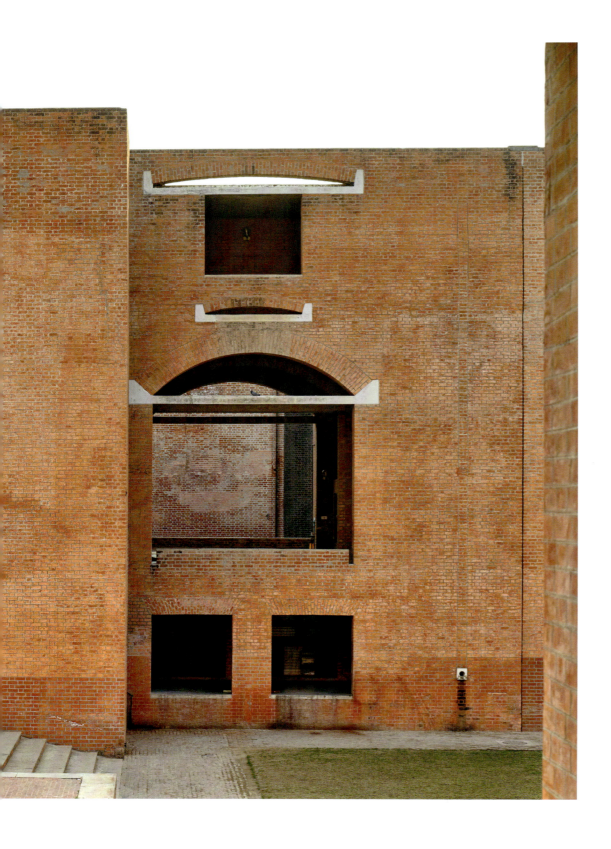

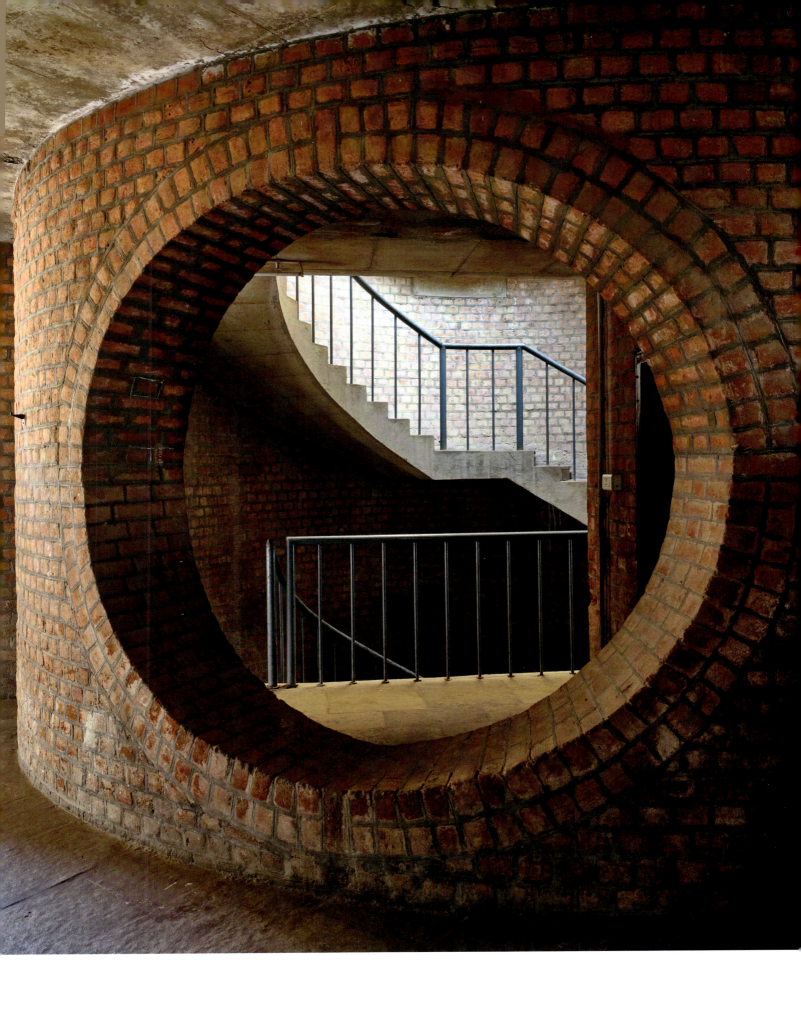

INDIAN INSTITUTE OF MANAGEMENT

Monumentality in architecture may be defined as a quality, a spiritual quality inherent in a structure which conveys the feeling of its eternity, that it cannot be added to or changed. We feel that quality in the Parthenon, the recognized architectural symbol of Greek civilization.

Louis Kahn, 'Monumentality', 1944[1]

Dhaka, Bangladesh
1962–83

SHER-E-BANGLA NAGAR

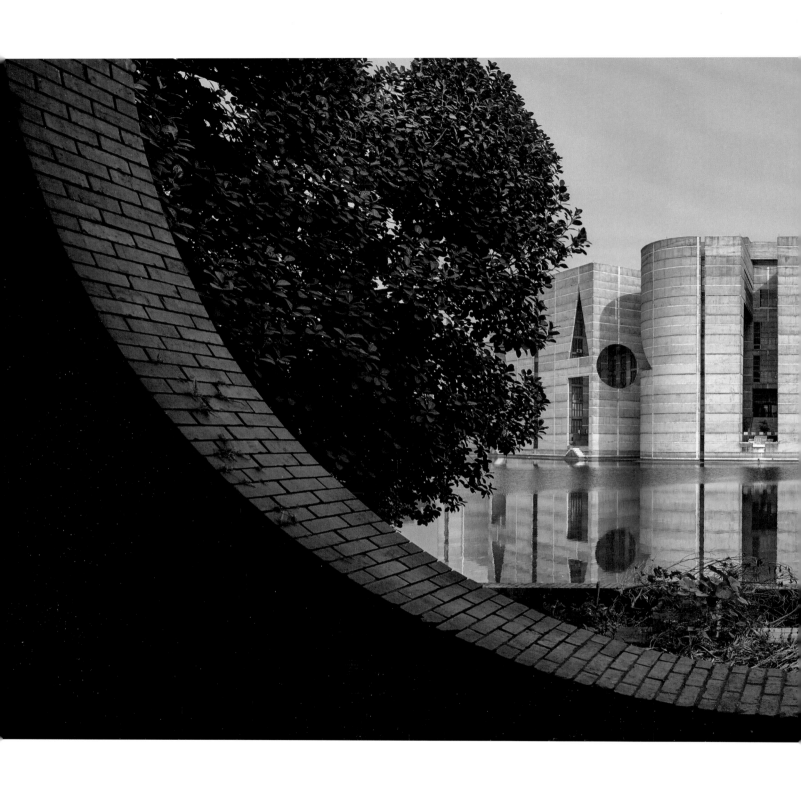

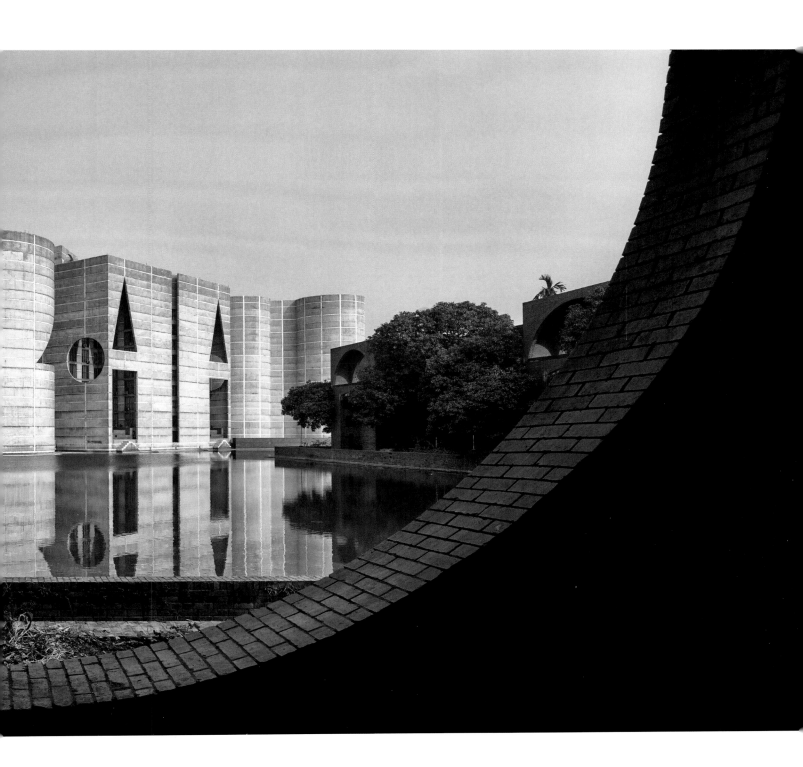

In 1962, the government of Pakistan contacted Kahn to ask him to design a government headquarters in Dhaka, with the National Assembly as its focal point. At the time, the state was divided into two territories, West Pakistan and East Pakistan. In 1971, as a result of conflicts with India, the eastern province finally became a separate state: Bangladesh. Originally designed to strengthen the unity of a two-headed nation, the construction of the capitol in Dhaka resumed after the Bangladesh Liberation War of 1971, this time celebrating the establishing of independence. As the political capital of Bangladesh, the complex consists of the National Assembly (a vast building incorporating a hemicycle, or semicircular debating chamber, a mosque, meeting rooms for ministers, offices and other areas), and two residential wings intended as accommodation for ministers and parliamentarians. This administrative district, named Sher-e-Bangla Nagar (Bengal Tiger City), is one of Kahn's most flamboyant achievements. Incomplete when he died in 1974, the project was finished in 1983 by fellow associates of the architect. The National Assembly is today intimately associated with the nation, its image represented on bank notes, stamps and even ballot papers. This group of buildings, resembling a citadel, is surrounded by an artificial lake, its waters reflecting the concrete walls, whose joints are inlaid with white marble. The use of brick was reserved for the residential parts of the complex. The lake is also occasionally used as a storm water retention pond during the monsoon season and thus combines an aesthetic role with a climatic function.

The National Assembly building is arranged in the form of an octagon, with eight adjacent buildings encircling the central debating chamber. One of Kahn's main concerns was to be able to regulate the light by means of the building's structure.

As with the First Unitarian Church of Rochester, here Kahn surrounded the parliamentary chamber with a rampart of smaller, separate buildings placed side by side, each with its own specific geometric shape. Inside, an interior 'street' is created between the chamber in the centre and the offices located on the periphery. Perhaps because of its similarity to the cloisters of a monastery, Kahn referred to this continuous circular space as an 'ambulatory'.

1 Louis I. Kahn, 'Monumentality' [1944], in *New Architecture and City Planning: A Symposium*, ed. Paul Zucker (New York: New York Philosophical Library, 1944), p. 77.

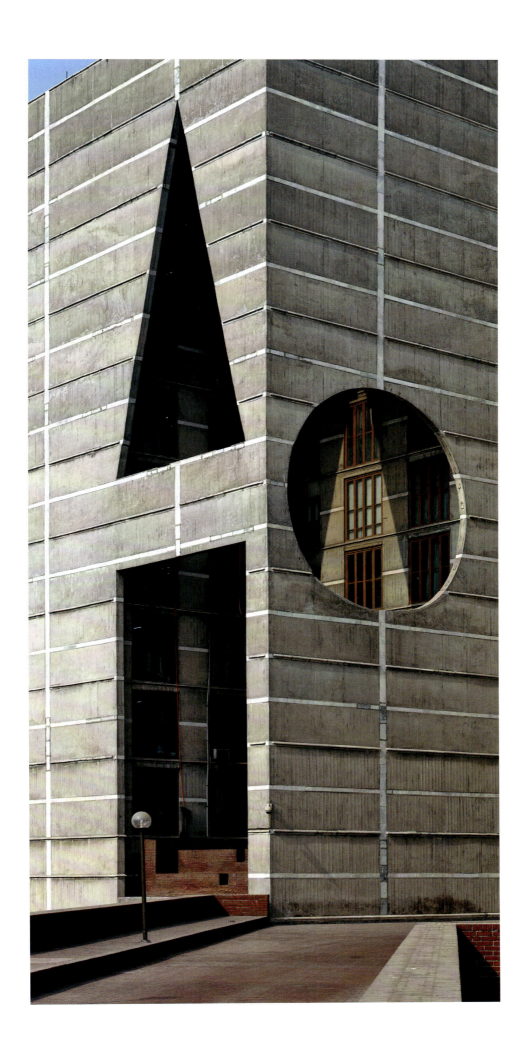

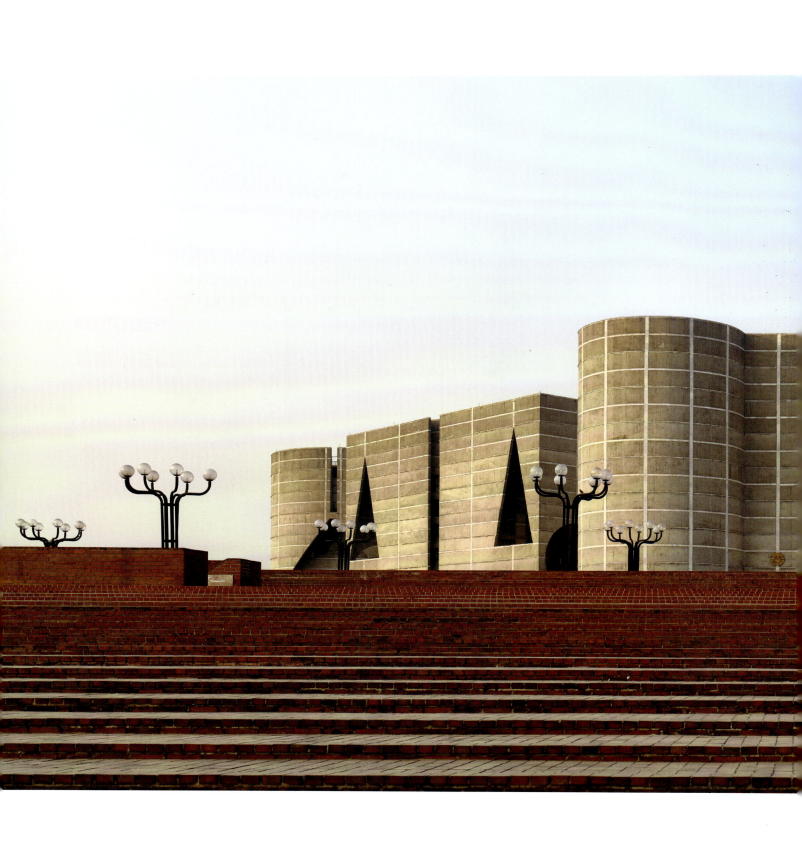

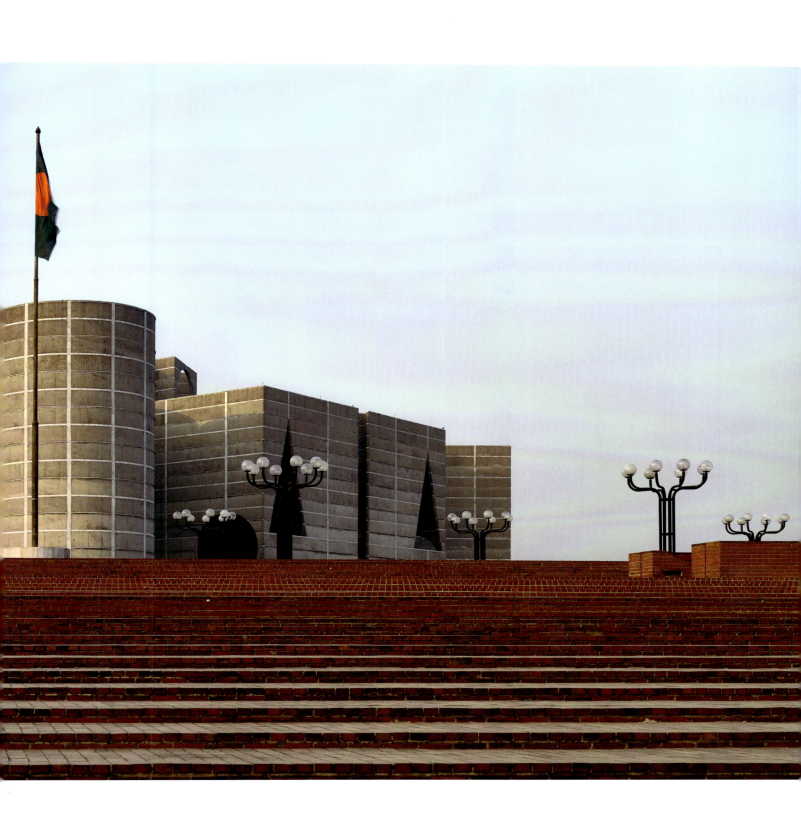

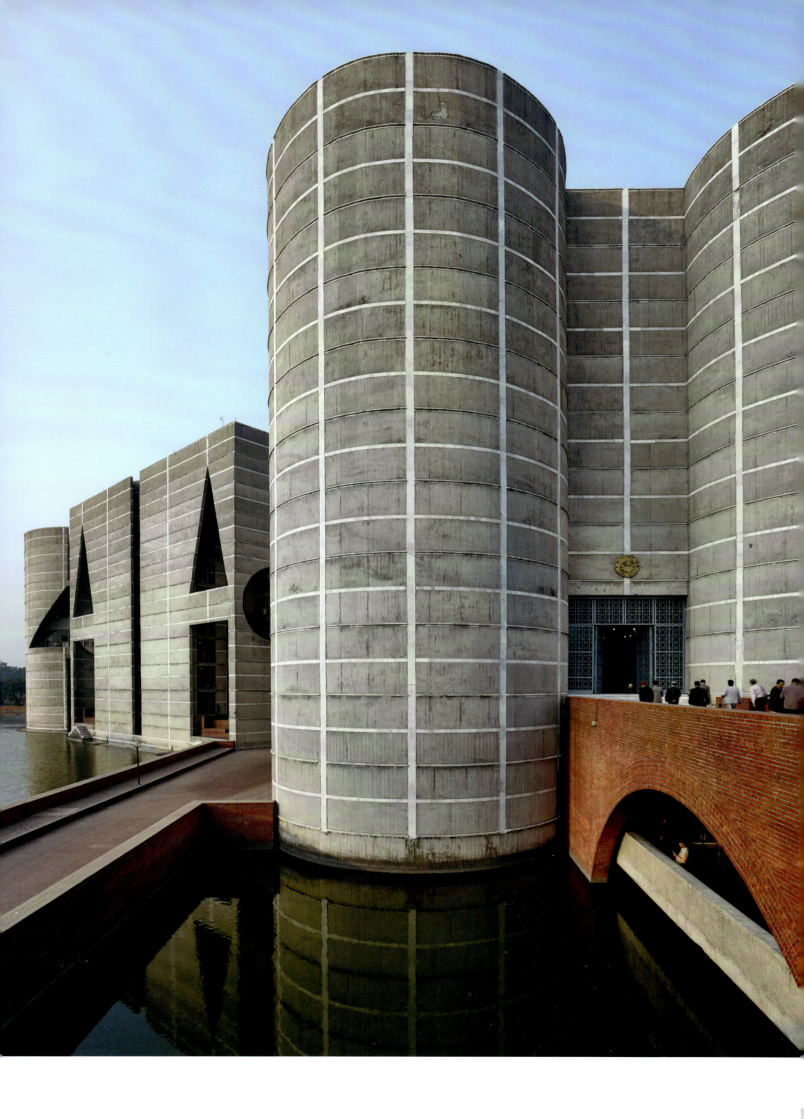

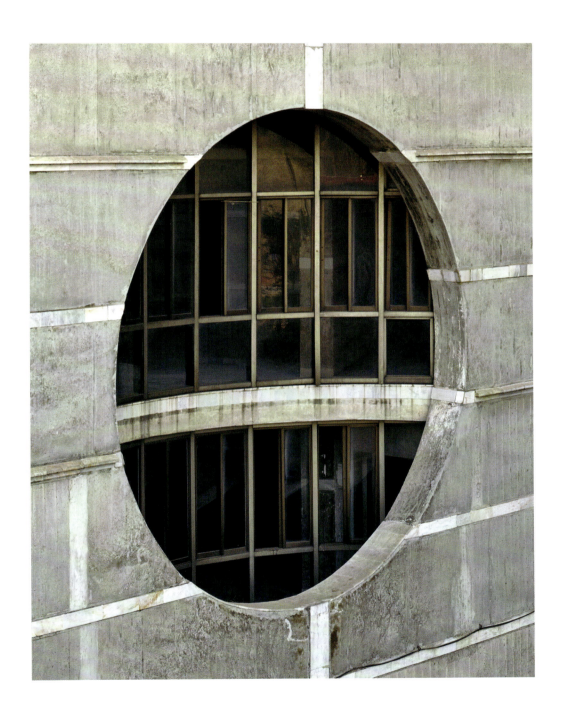

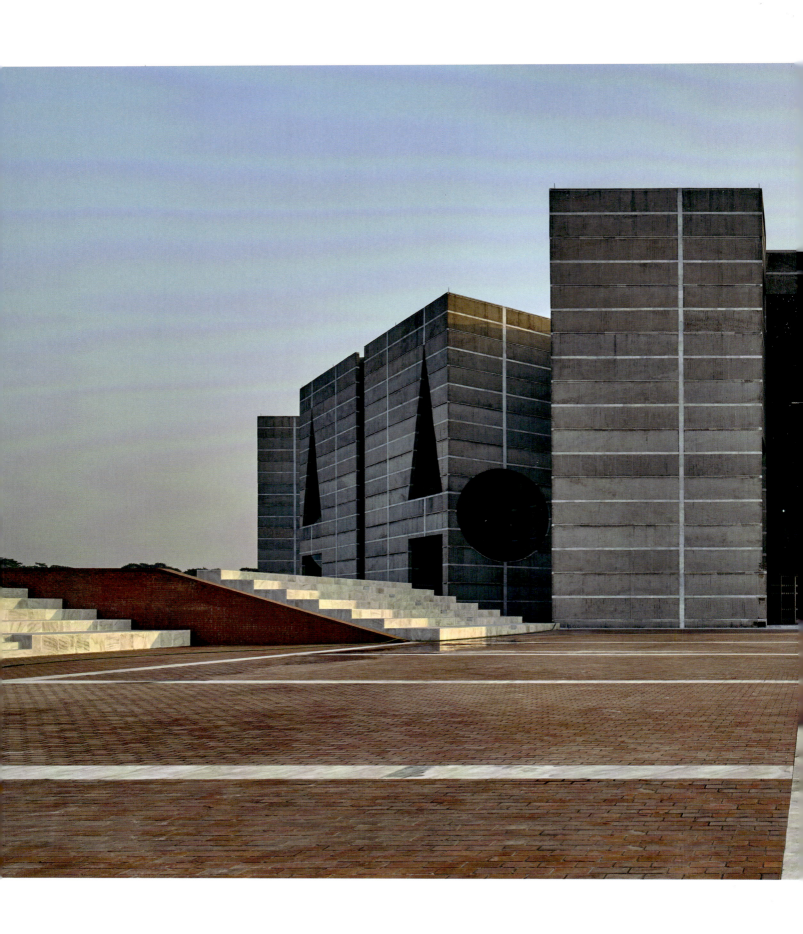

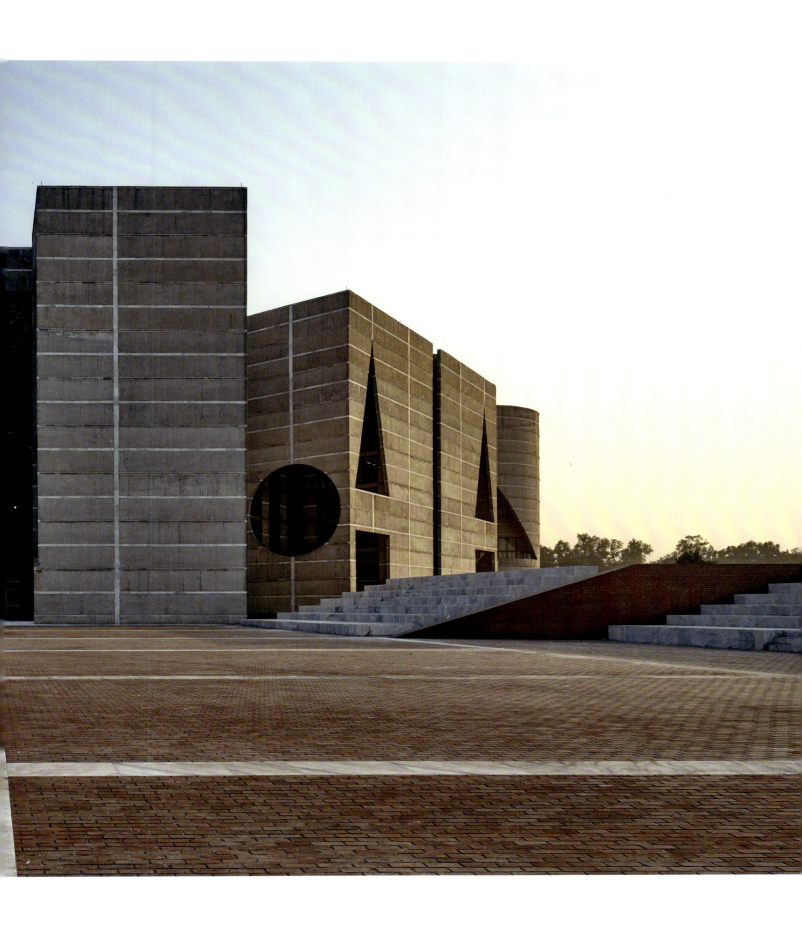

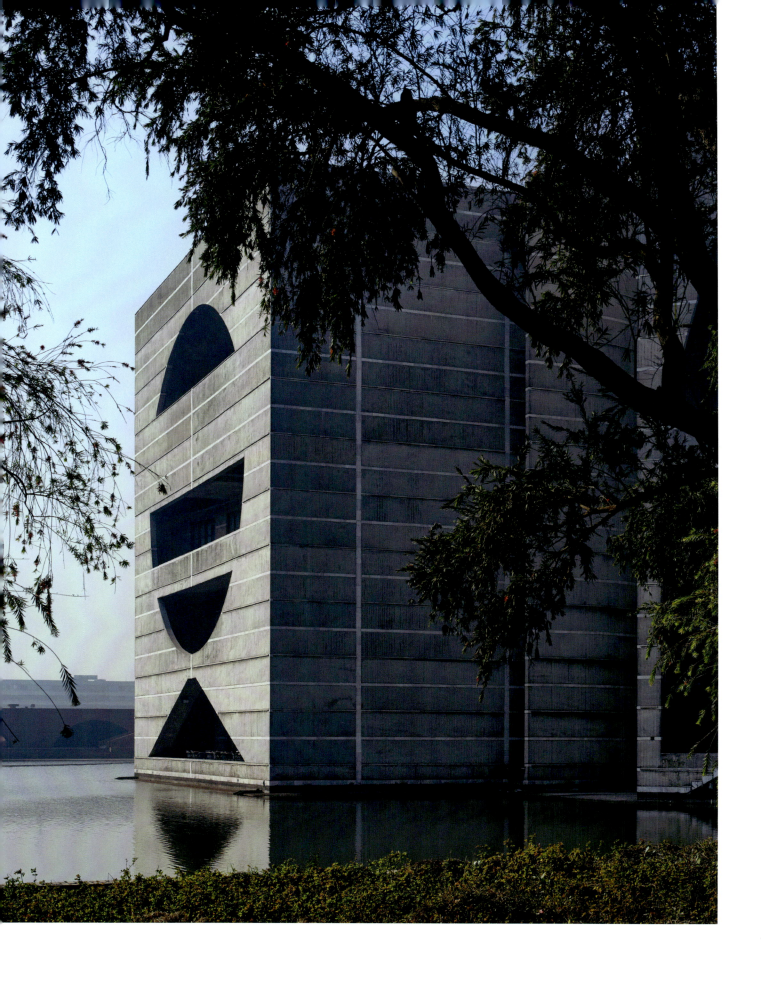

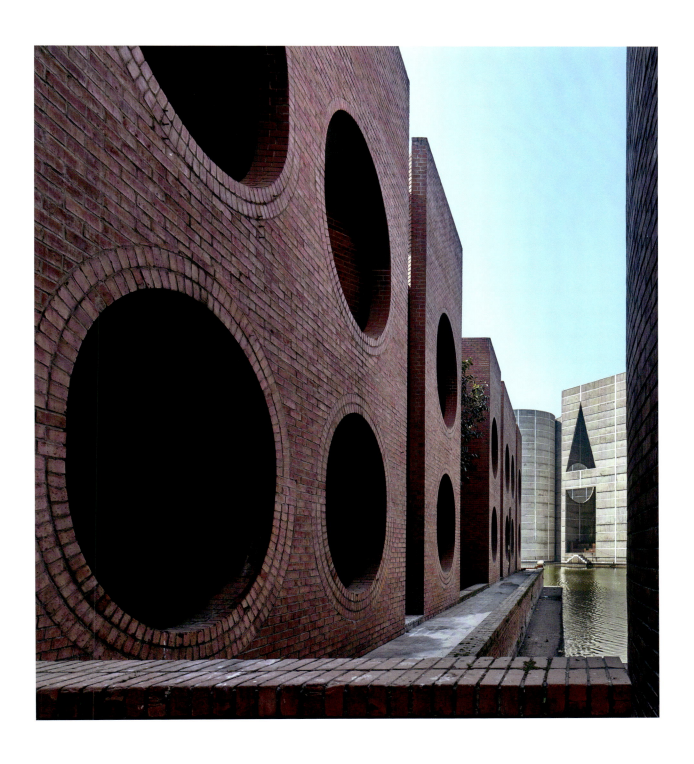

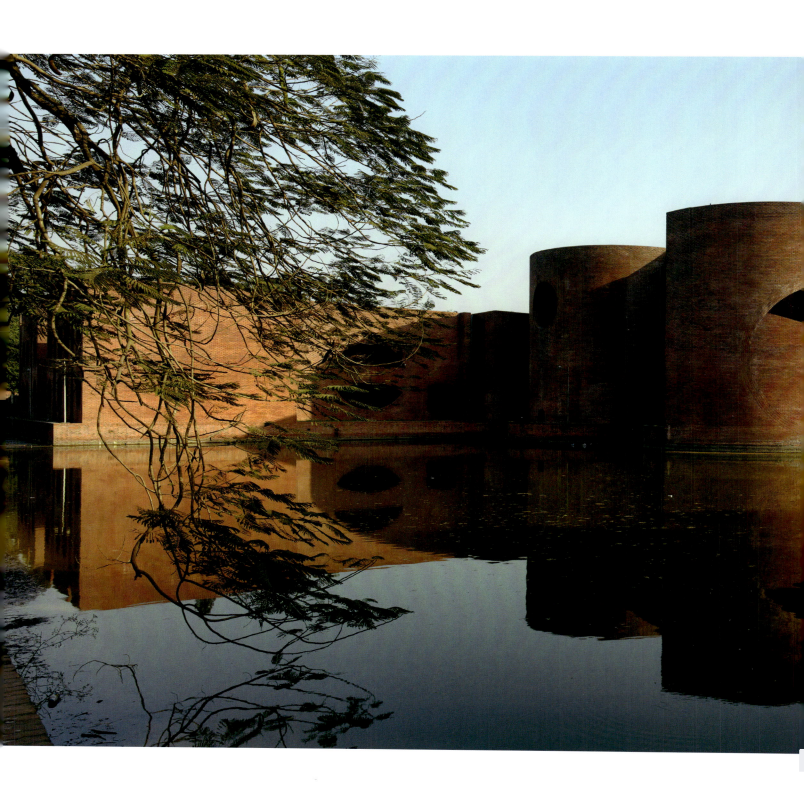

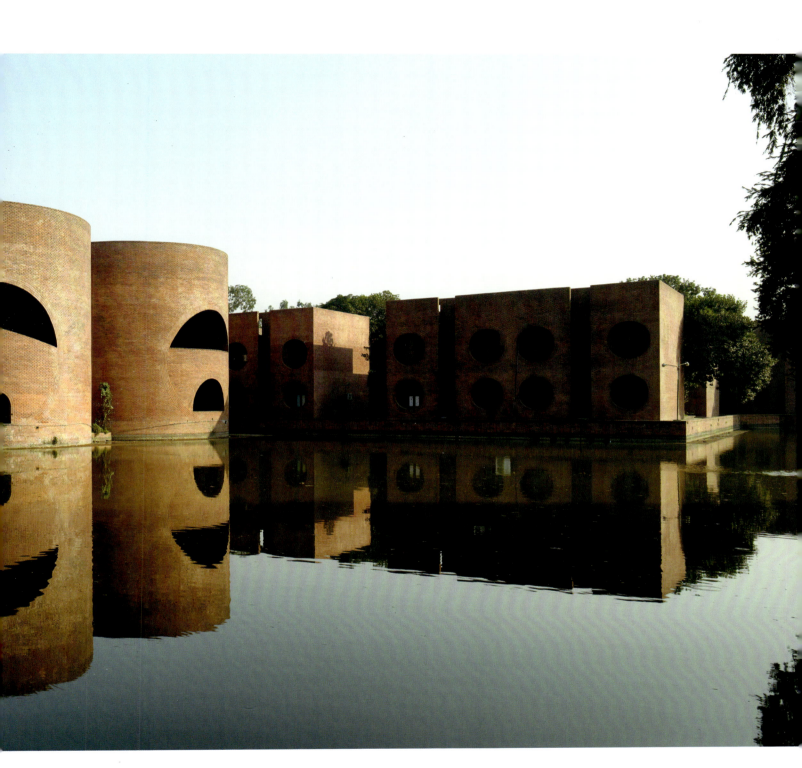

*When a building is completed, it stands as the record of everyone's participation in its making. The architect is expected to have done his best work. The Pakistan Government has concerned itself with excellence of design and the making of exemplary buildings for future work.
I believe that our joint efforts should be bent toward the accomplishment of buildings of architectural importance which would satisfy those who see them and use them.
To accomplish this requires the use of appropriate and lasting materials in the making of the spaces, their construction, quality of their light and the grace of their shapes.*

Louis Kahn, c. 1972–73[1]

Dhaka, Bangladesh
1963–74

AYUB CENTRAL
HOSPITAL

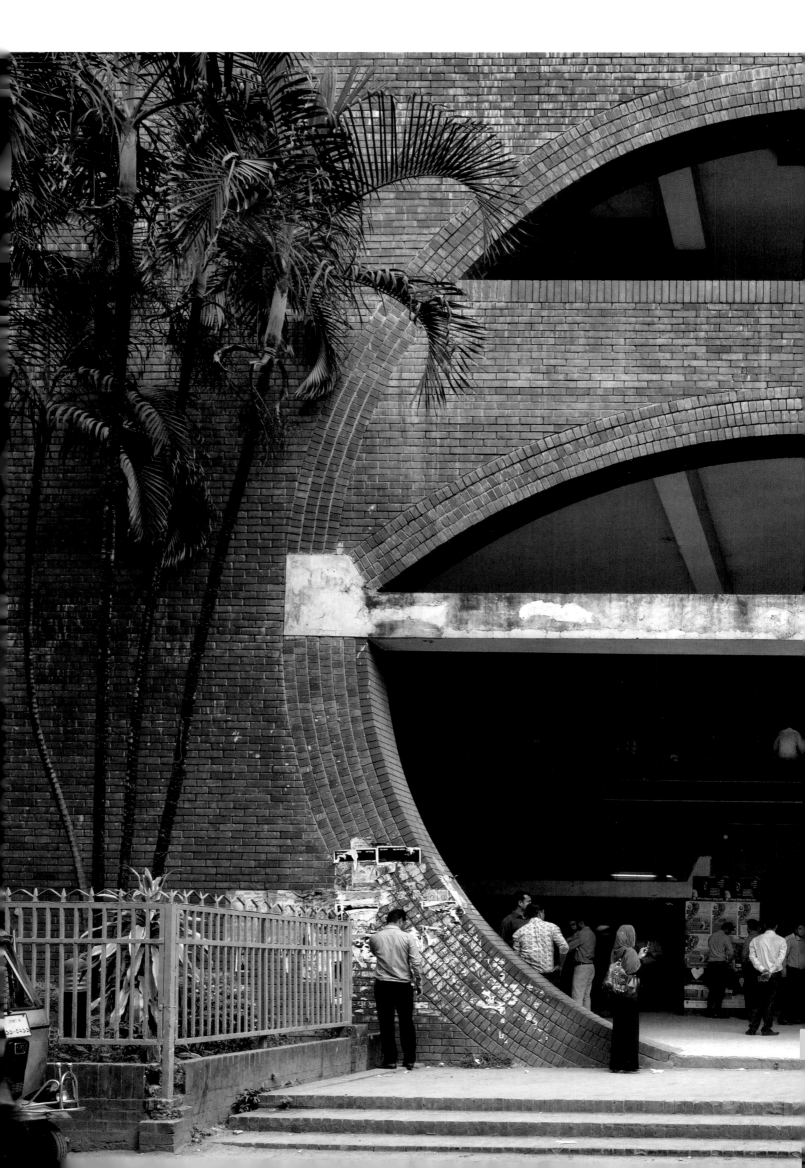

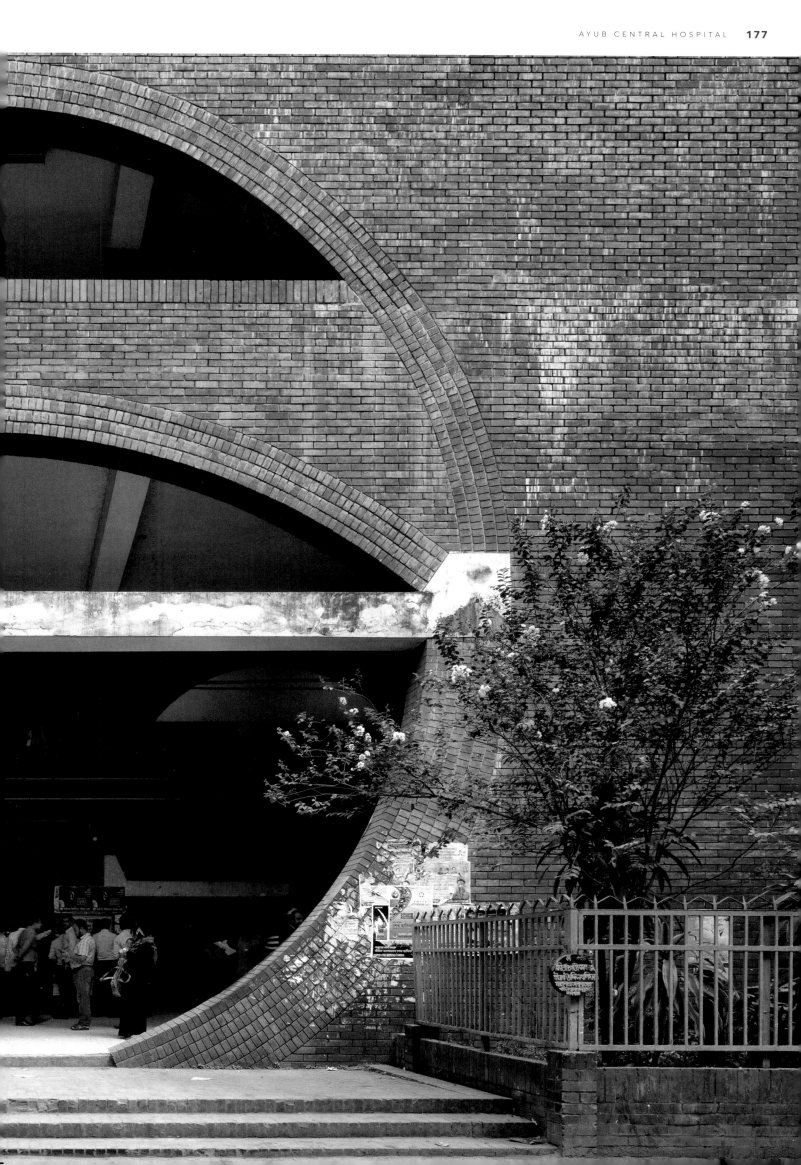

Designed as part of the Sher-e-Bangla Nagar complex in Dhaka, Ayub Central Hospital (now Shaheed Suhrawardy Hospital) is sited to the northwest of Kahn's National Assembly building. Built in brick, the plan comprises a large general hospital connected on the west side to an outpatient clinic. Only this western wing was built during Kahn's lifetime. The plan is organised around a central top-lit hall, with the services arranged on the north and south edges. Extending across the face of the building, a deep arcade punctuated with circular openings ensures the interior areas are not exposed to the heat and glare of the sun. Arches connect this to the main body of the building, creating, as Alexandra Tyng describes it, 'an arcade that catches the sunlight and shelters a second inner hallway from glare ... the hospital is essentially a building for living, surrounded by a building for the sun.'[2]

1 Louis I. Kahn quoted in Kazi Khaleed Ashraf and Saif Ul Haque, *Sherebanglanagar: Louis I. Kahn and the Making of a Capital Complex* (Dhaka: Loka, 2002), p. 145.

2 Alexandra Tyng, *Beginnings. Louis I. Kahn's Philosophy of Architecture* (New York: John Wiley & Sons, 1984), p. 48.

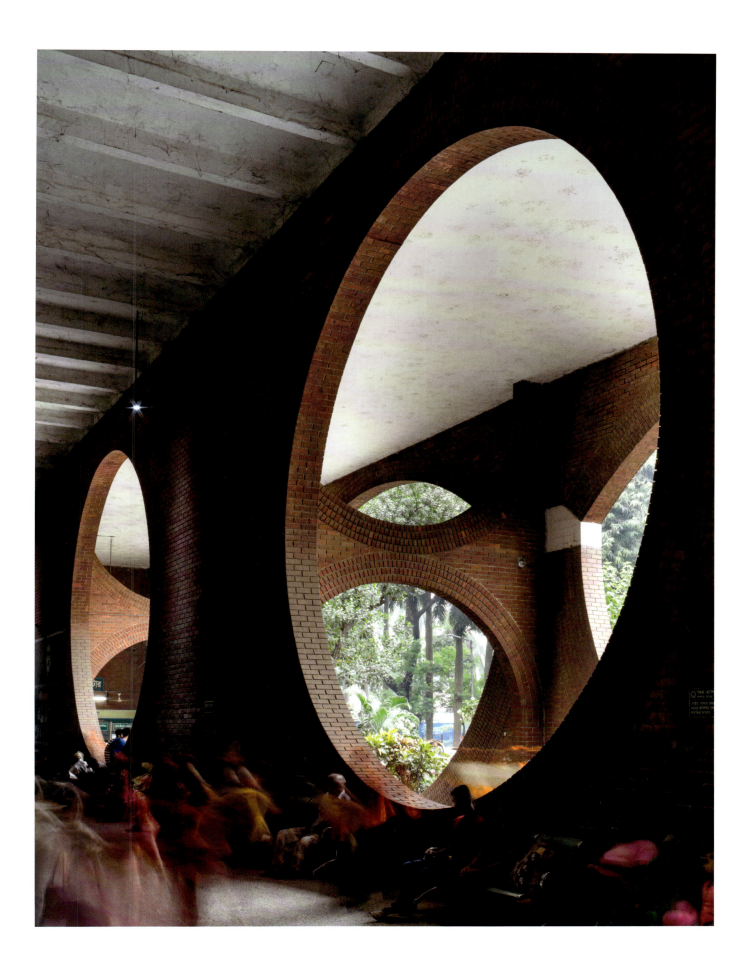

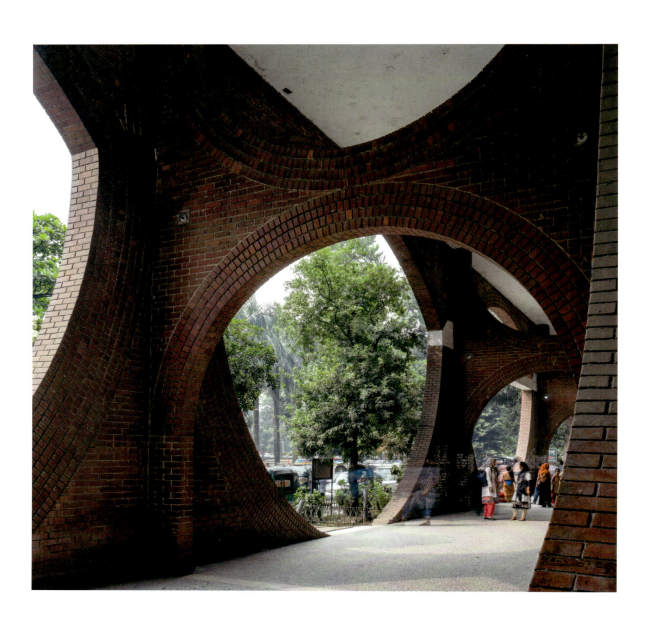

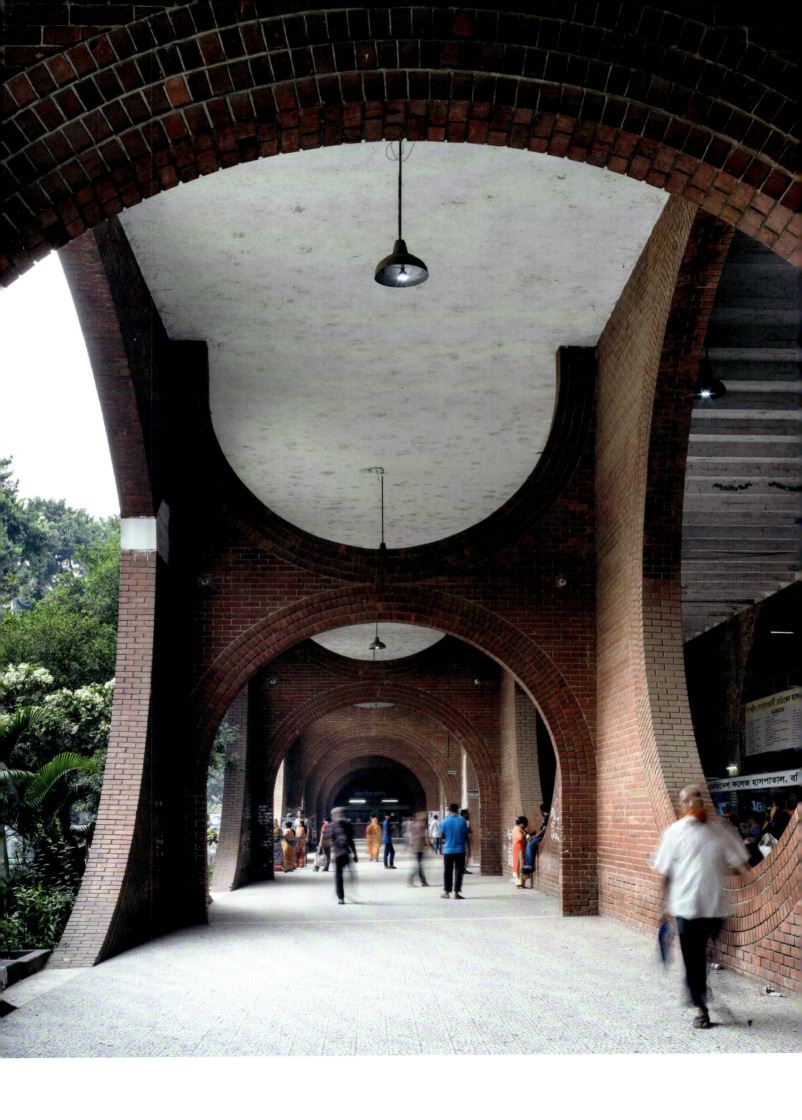

AYUB CENTRAL HOSPITAL

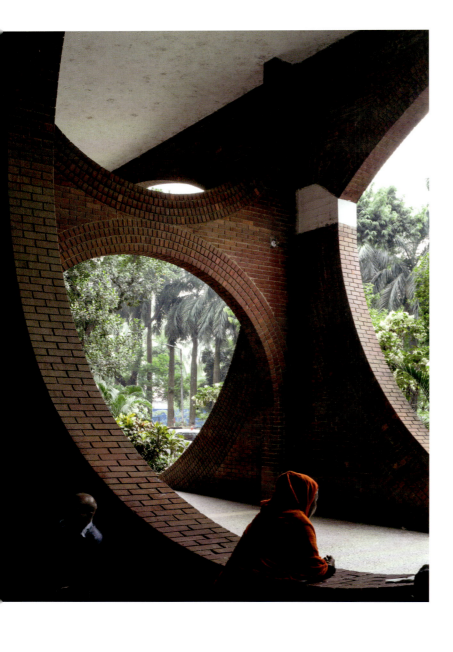
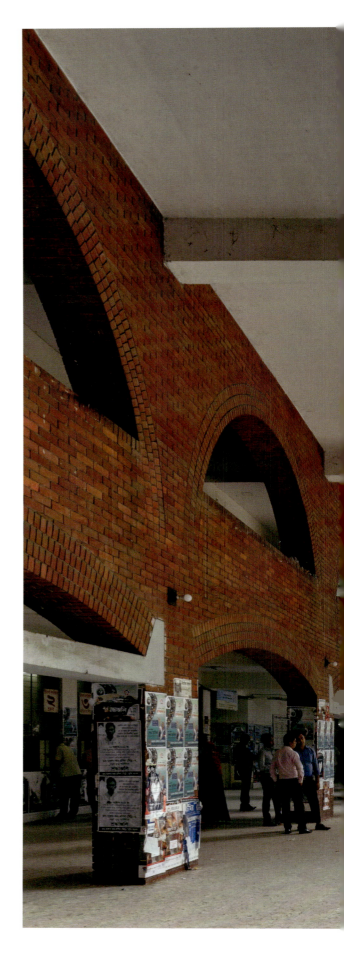

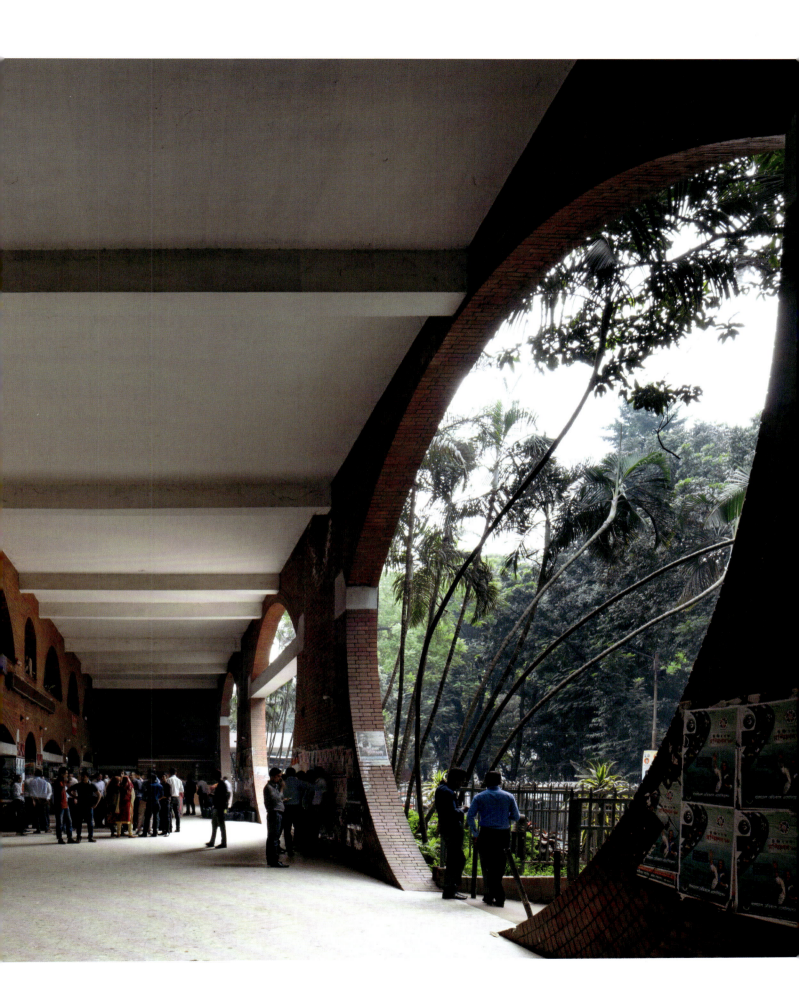

There was a brickyard in the area which had been making bricks since colonial days. It supplied much of the red brick that was used at Harvard. It had to go out of business. In the course of my design I decided I wanted to use brick, and they called my attention to this brick place. I deliberated because I had never used bricks that were quite so irregular. But then I thought the bricks were marvelous, and it was brick which had been used on the campus. So Exeter bought two million bricks; they bought them out.

Louis Kahn, 'Comments on the Library, Phillips Exeter Academy, Exeter, New Hampshire', 1972[1]

Exeter, New Hampshire
1965–72

PHILLIPS EXETER ACADEMY LIBRARY

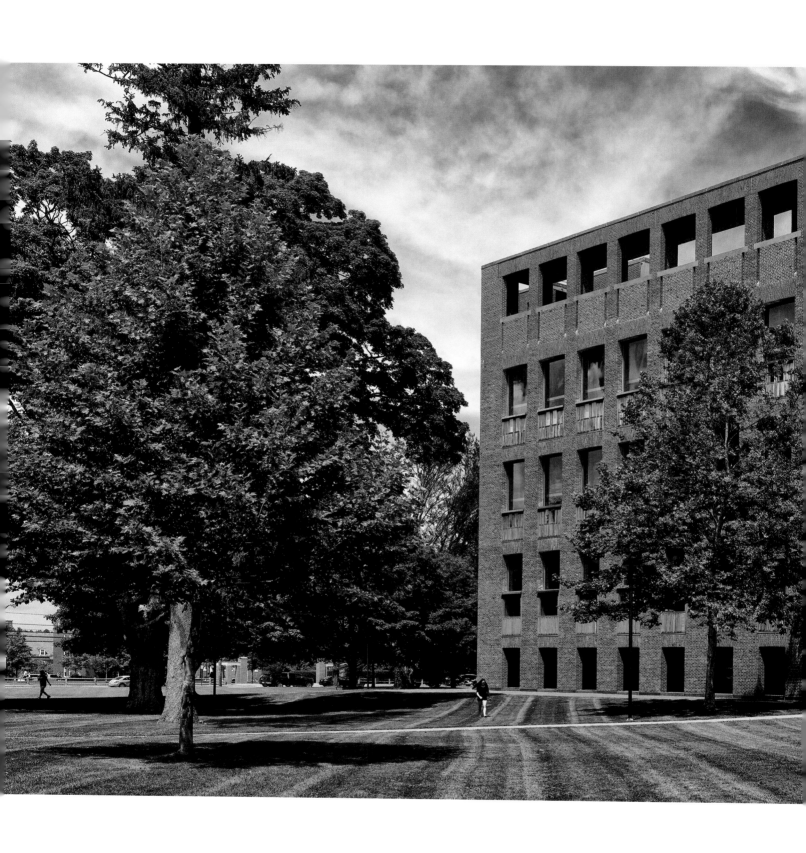

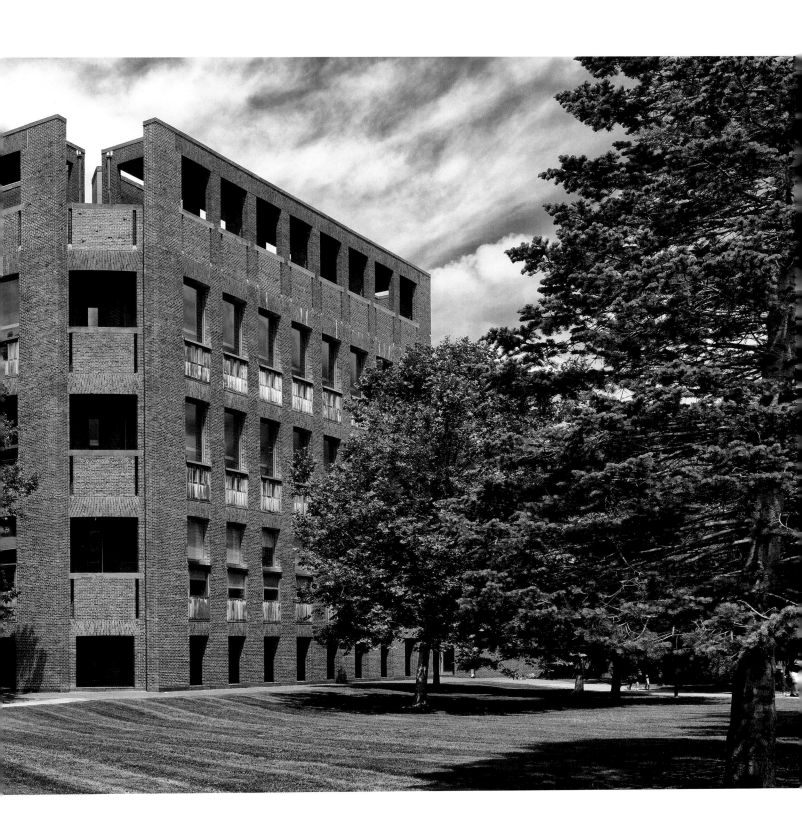

The library at Phillips Exeter Academy in New Hampshire is set on a large lawn within the wider school campus, where brick buildings in a neo-Georgian style predominate. Kahn also designed a low-rise dining hall building, which was built at the same time and is located just behind the library.

The library has four almost identical facades, with regular, repeated openings. The approach used in the building's construction is straightforward but also reveals some interesting subtleties. On each facade, the width of the vertical brick piers decreases the higher up they are. On the top floor, rectangular apertures open up the double wall, and one can contemplate the surrounding landscape from the ambulatory area of the roof terrace. At the four corners of the cube, the brick walls end before they intersect, thus revealing the thickness between the two layers of brick. These cut-off sections, which also accentuate the diagonals, were Kahn's answer to the question of how to link together the walls of the cube. He explained: 'It is always difficult to know how to deal with the corner. Should you introduce abruptly some oblique elements or create some kind of exceptional rectangle here. So I said to myself, why not sidestep this difficulty?'[2]

The large plate-glass windows installed between the brick piers are supported by wooden structures that are continued inside to create double reading desks or study carrels. Each desk has a small window that the reader can close off using wooden shutters, thus contributing to variations in the appearance of the facades when viewed from outside.

Following the logic of a concentric design, rather than a plan with one axis, Kahn did not create a principal facade that would have immediately indicated the building's entrance; rather, one can gain access from any of the four sides. On the ground floor, a covered walkway following the entire perimeter of the building acts as an element of transition between outside and inside. It is only once one is beneath these arcades that the entrance to the building then becomes apparent. Inside the entrance, a horseshoe-shaped travertine staircase leads to the central hall. Kahn argued for the absence of any kind of monumental entry: 'From all sides there is an entrance. If you are scurrying in the rain to get to a building, you can come in at any point and find your entrance. It's a continuous campus-type entrance.'[3]

The specifications prepared by the library officials were extremely precise. Rather than the vast reading room of the Bibliothèque Nationale in Paris, for example, built in 1862–68 by Henri Labrouste, their preference was for small, individual reading spaces. At Exeter, the library user is welcomed into a huge square space, bathed in light thanks to the clerestory windows. The large circles hollowed out in the concrete interior facades and the diagonal beams all contribute to give the space a sense of drama. Here, Kahn's approach was once again to favour the presence of light.

Like Russian dolls nesting inside one another, the library's construction is based on a 'room within a room' concept, with the plan organised around three concentric spaces. At the periphery of the building, paired reading desks are bathed in natural light. These function both as furniture and as a partition, establishing quiet areas for reading: 'I made the carrel associated with the light. It has its own little window so that you can regulate privacy and the amount of light you want. If you like the sun, you have it; if you don't like the sun, you don't have it.'[4] Set further in, a series of bookshelves provide a kind of acoustic and visual screen from the central space. The final space is the central atrium, lit by clerestory windows. Specific materials accentuate and differentiate the spaces: a concrete 'canopy' at the top of the atrium, dramatically emphasised by beams forming a cross; a concrete structure containing the bookshelves, which creates the middle part of the building; and two parallel brick walls demarcating the reading area and making up the outer envelope of the building.

As in his other projects, Kahn, with a keen sense of detail, used different raw materials (brick, prestressed concrete, oak, travertine) to introduce different textures, with varying degrees of roughness, shine or irregularities that catch the light. The geometric shapes used in the library are part of a rigorous logic relating to the structure of the building, but they also embody the motif of a circle drawn within a square, as opposed to the square in a circle advocated by Vitruvius as a model of natural order.

1 Louis I. Kahn, 'Comments on the Library, Phillips Exeter Academy, Exeter, New Hampshire, 1972', in *What Will Be Has Always Been: The Words of Louis I. Kahn*, ed. Richard Saul Wurman (New York: Access Press/Rizzoli, 1986), p. 179.

2 Kahn quoted in William Jordy, 'The Span of Kahn (Criticism: Kimbell Art Museum, Fort Worth, Texas; Library, Phillips Exeter Academy, New Hampshire)', *Architectural Review*, 155 (June 1974), p. 334.

3 Kahn quoted in Wurman, ed., *What Will Be Has Always Been*, p. 178.

4 Ibid., p. 179.

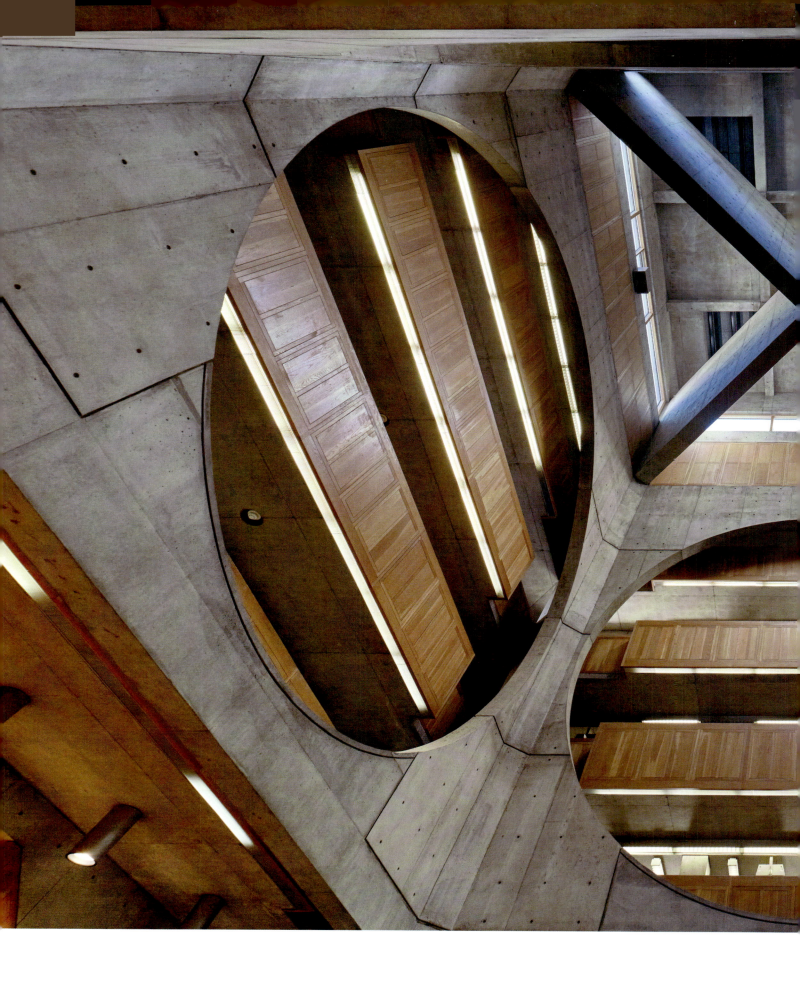

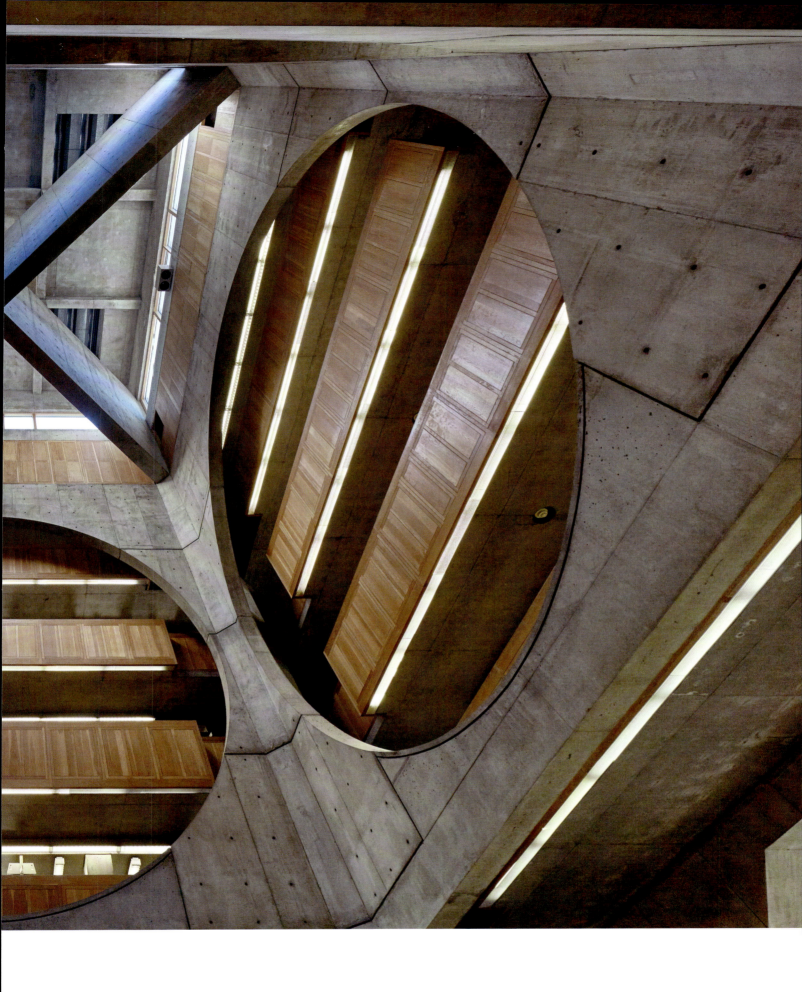

PHILLIPS EXETER ACADEMY LIBRARY

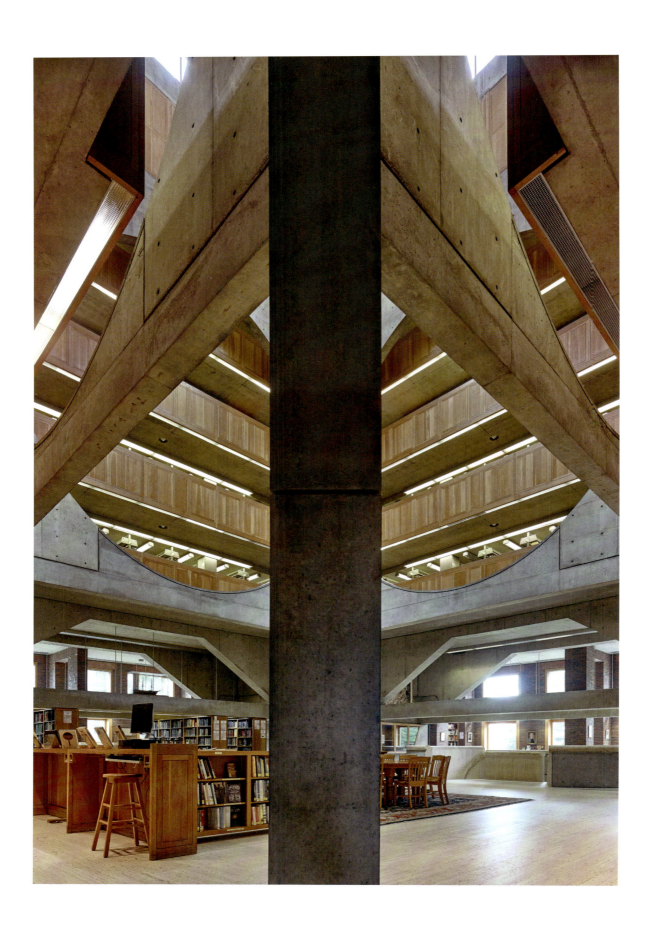

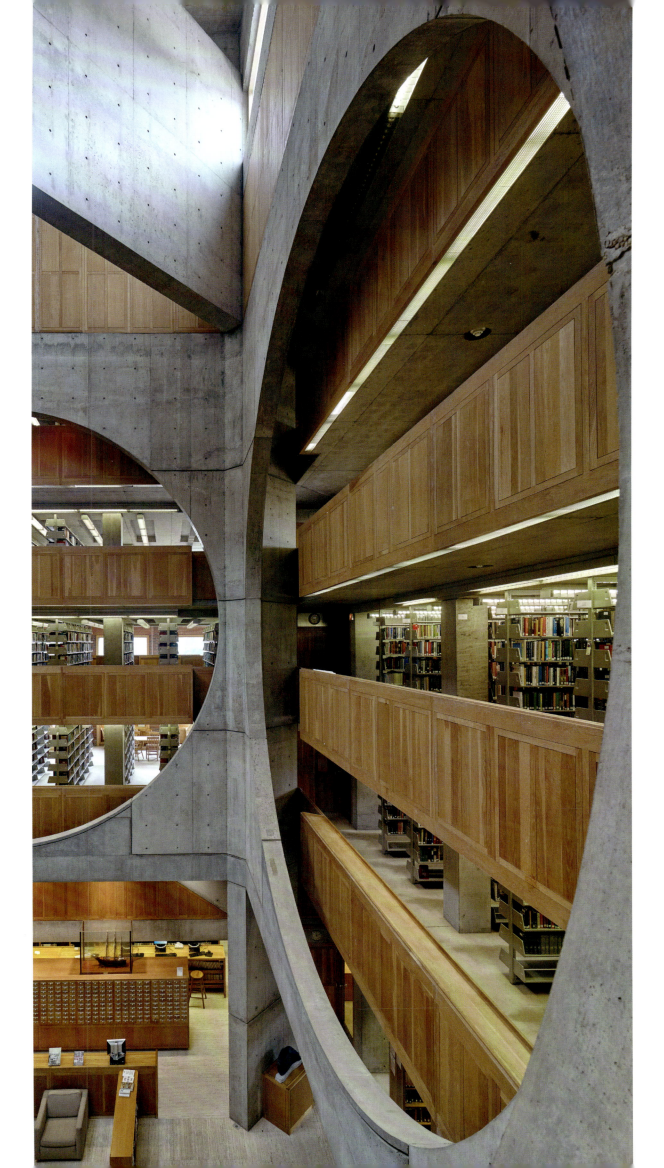

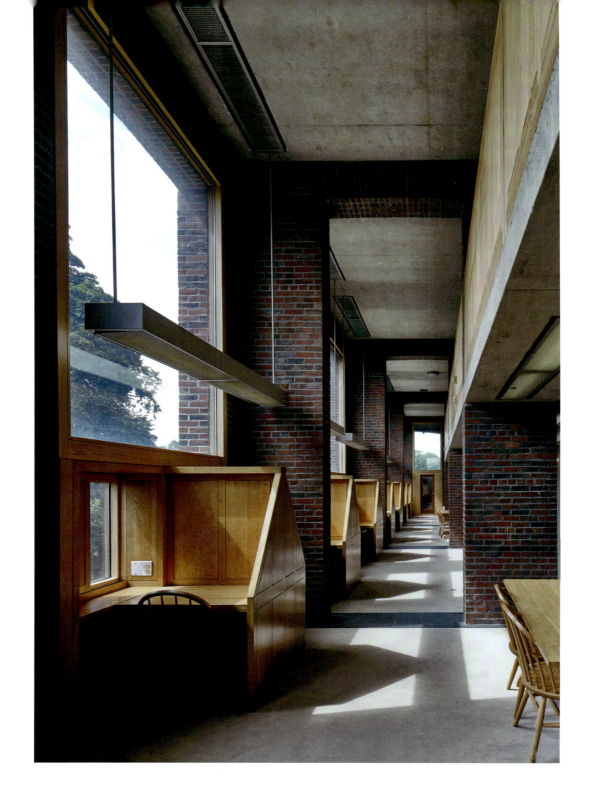

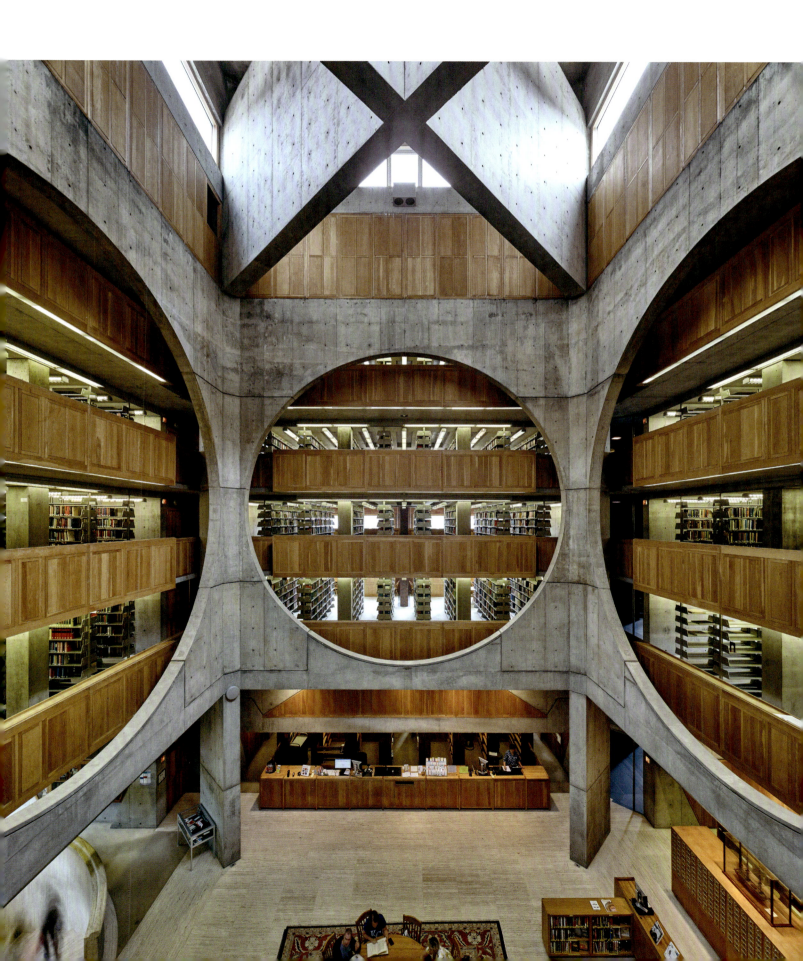

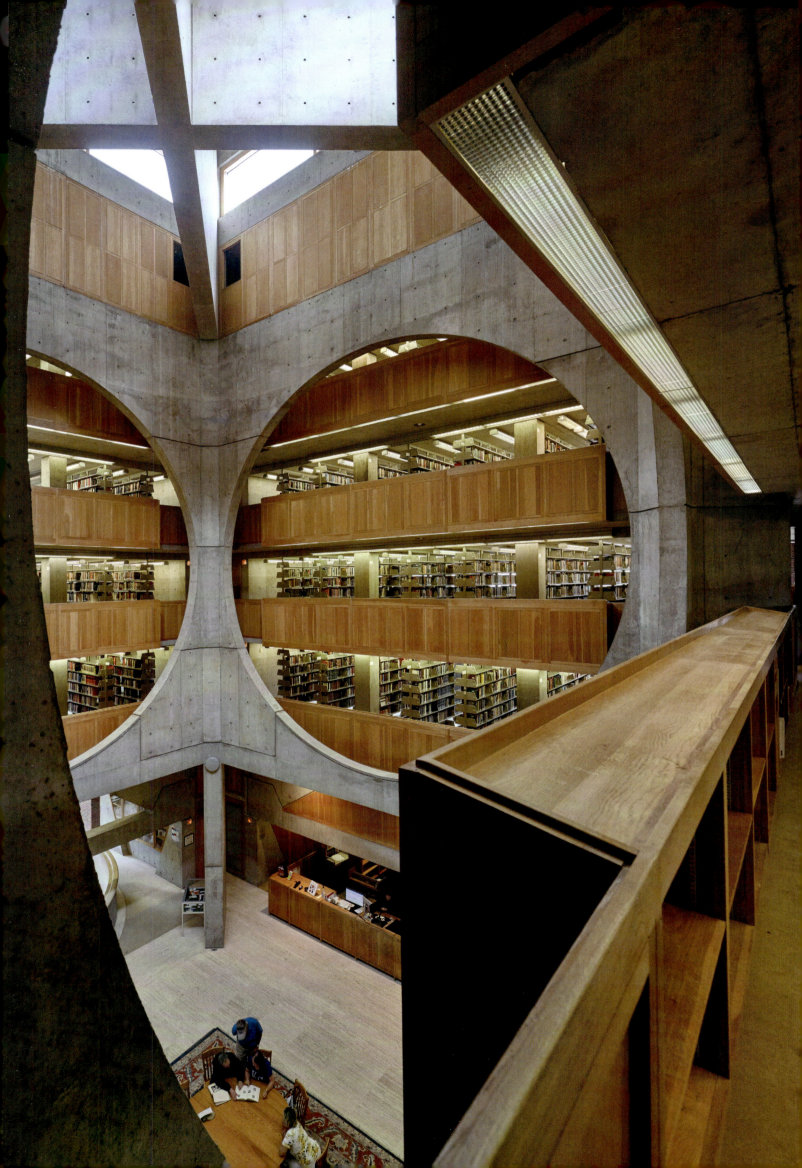

If you are dealing with concrete, you must know the order of concrete. You must know its nature, what concrete strives to be. Concrete wants to be granite, but can't quite make it. The reinforcing rods in it are a play of secret workers that make this so-called molten stone appear marvelously capable.

Louis Kahn, 'I Love Beginnings', 1972[1]

Fort Worth, Texas
1966–72

KIMBELL
ART MUSEUM

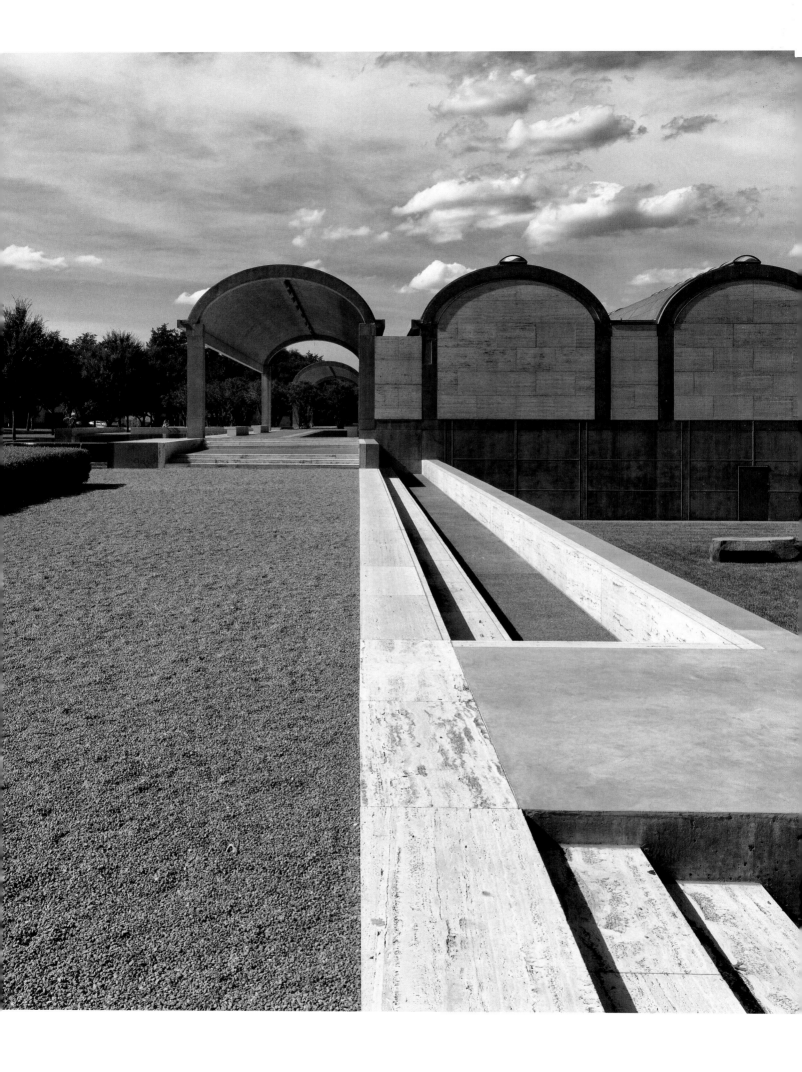

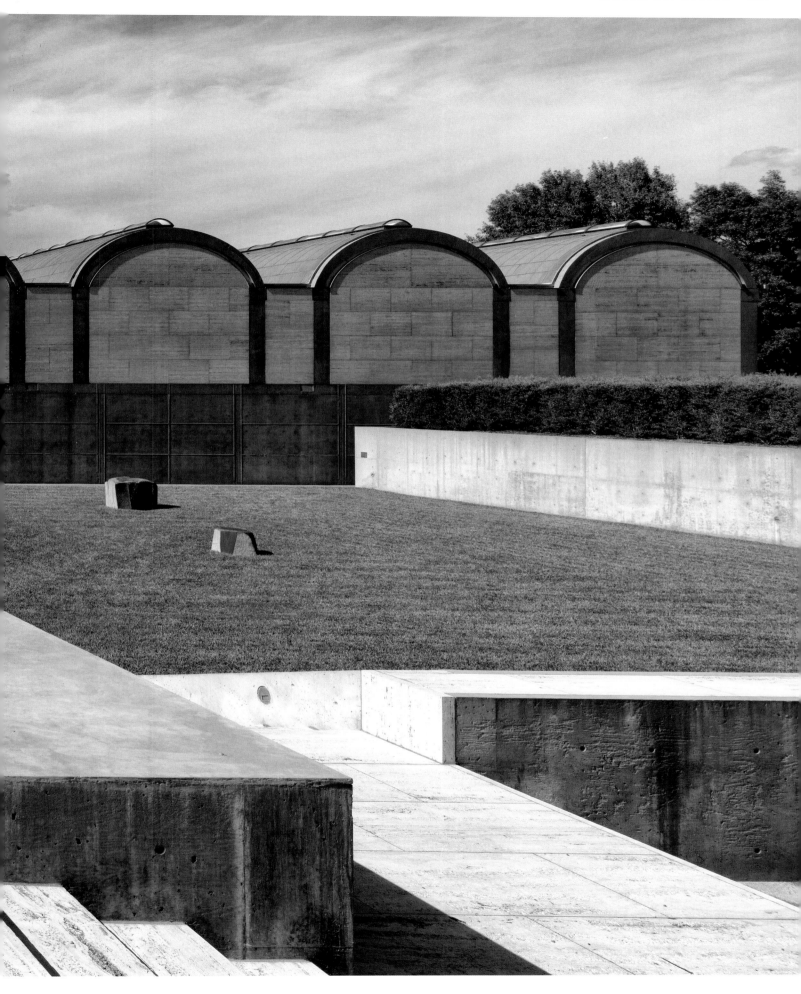

The Kimbell Art Museum, like Kahn's earlier Yale University Art Gallery, is a work of stark materiality, seen in the texture of the materials and the opaque nature of the construction. In this building, no glazed openings are visible from the outside. The museum is composed of a series of vaults set side by side on a concrete base – a construction that is both masterly and uncompromising and that would be just as well suited to a temple or a warehouse. Only one indication is given of the entrance to the building: a single empty vaulted structure that forms a kind of portico.

The portico reveals the framework of the building: a long, cycloidal vault that is self-supporting and which rests on four pillars. Travertine walls are inserted between the end pillars of the successive modules; however, gaps at the base of each wall indicate that they do not have a load-bearing function, while glazing between the tops of the walls and the roof of each vault similarly emphasises the relative independence of these two elements and further testifies to the way in which the building was constructed. This straightforward approach to the building's structure is not always clearly apparent, however. Indeed, the vaults of the other five modules, used for the exhibition spaces, are split in the middle along their entire length (though this cannot be seen from outside). They are divided into two parts at the most crucial point, the keystone, creating a natural light feature. Unlike the portico, the roofs of the exhibition spaces consist of a series of juxtaposed concrete shells and beams, each one forming a half-vault.

The Kimbell Art Museum is set in a landscaped park that brings together various cultural institutions in the city of Fort Worth. The outside garden area is made up of two pools with cascades of water, and planted green spaces. In Kahn's opinion, 'a museum needs a garden. You walk in a garden and you can either come in or not. This large garden tells you you may walk in to see the things or you may walk out. Completely free.'[2]

Each of the cycloidal vaults delimits a series of identical galleries, each 30 metres long and with a span of 6 metres. Although, from the outside, the building appears not to have any openings, upon arrival in the central gallery one is immediately surprised by the wealth of natural lighting. The light comes from the full-length glazed end wall and also from the reverberation of the light on the ceilings: indeed, perhaps the most impressive aspect of the interior of the museum is the silvery light diffused by the generous curves of the vaults. Metal reflectors mask the narrow slits between the barrel vaults that compose the ceilings. Here again, a strong relationship between the building's structure and the use of natural light is at work: 'The natural light comes directly through ten-foot slits in the vaults. Below them are what I call natural light fixtures which send light on the vaults, and from the vaults you get the light in the room.'[3]

The variations generated by the roof lighting alter one's perception of the space, an effect already seen in the Unitarian Church in Rochester and, to a lesser extent, in the student accommodation at Bryn Mawr or in the ambulatory at the National Assembly in Dhaka.

The galleries are separated from each other by intermediary spaces that are large enough to accommodate the technical elements of the building, such as the conduits for ventilation, air conditioning and heating. In these same intermediary spaces, at ground level, two flights of stairs allow access to the lower level of the museum, where the administrative offices, storage and technical facilities are found. From the entrance, one can see a small glazed atrium to the north, ornamented by a fountain and a sculpture by Aristide Maillol. Three further courtyards lie between the vaulted modules, introducing subtle, coloured variations in the light. Two of the courtyards allow natural light to filter into the room used for the restoration of paintings and also into the administrative areas situated under the galleries. Kahn named the three courtyards Green Court, Yellow Court and Blue Court based on the colour of light he expected would be produced by their different proportions and positions in relation to the sky.

1 Louis I. Kahn, 'I Love Beginnings', lecture at International Design Conference, Aspen, Colorado, 19 June 1972, in *Louis I. Kahn: Writings, Lectures, Interviews*, ed. Alessandra Latour (New York: Rizzoli, 1991), p. 288.
2 Kouis Kahn quoted in *What Will Be Has Always Been: The Words of Louis I. Kahn*, ed. Richard Saul Wurman (New York: Access Press/Rizzoli, 1986), p. 159.
3 Ibid., p. 238.

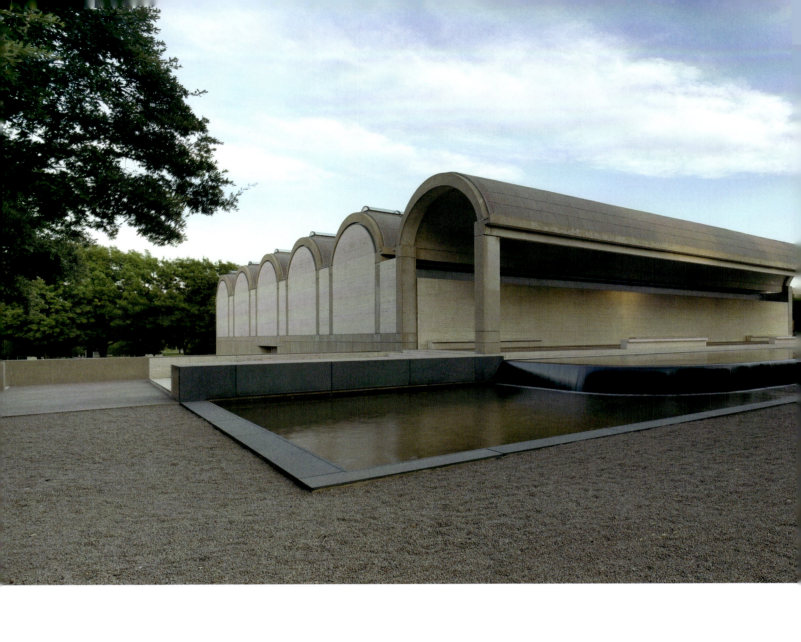

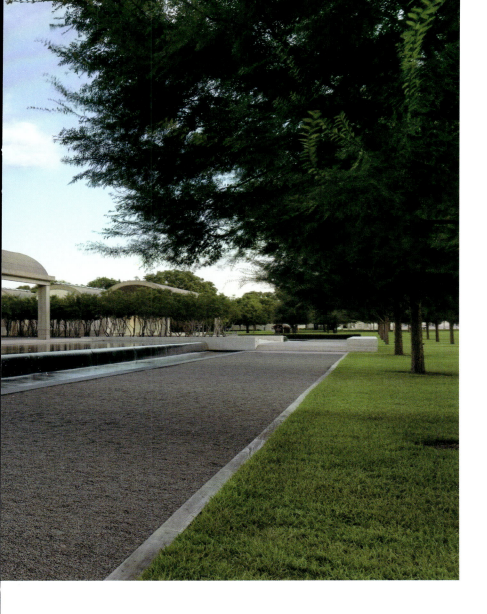
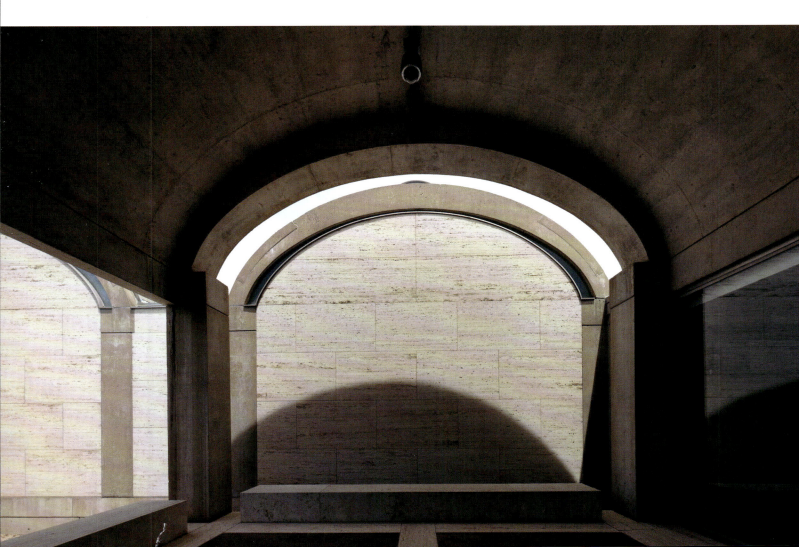

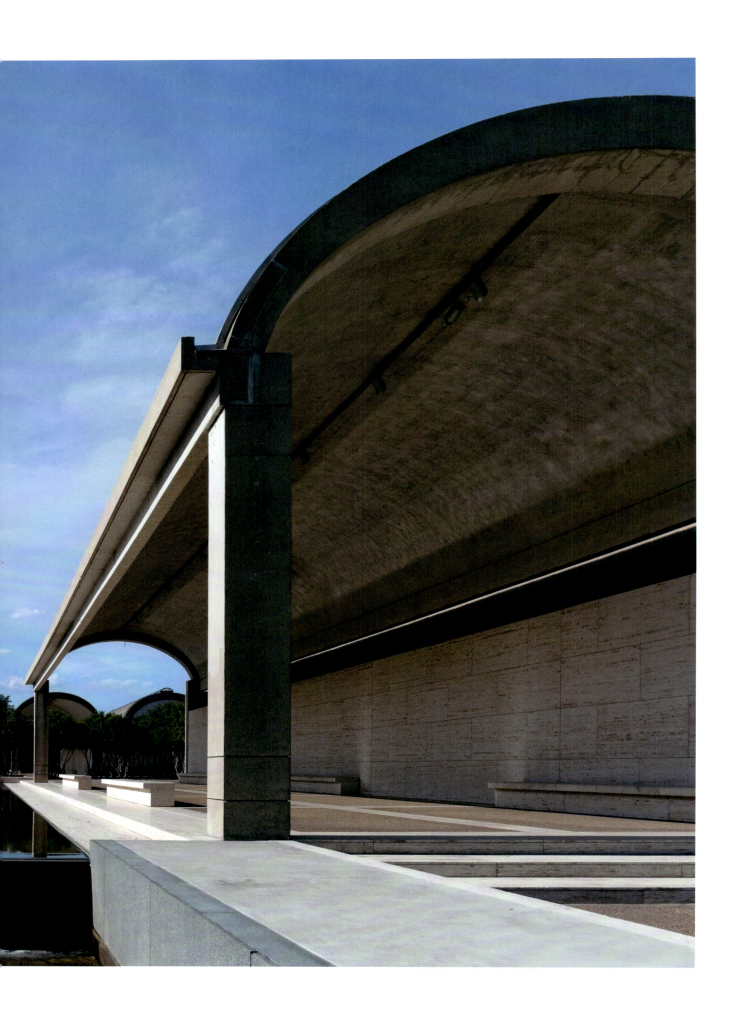

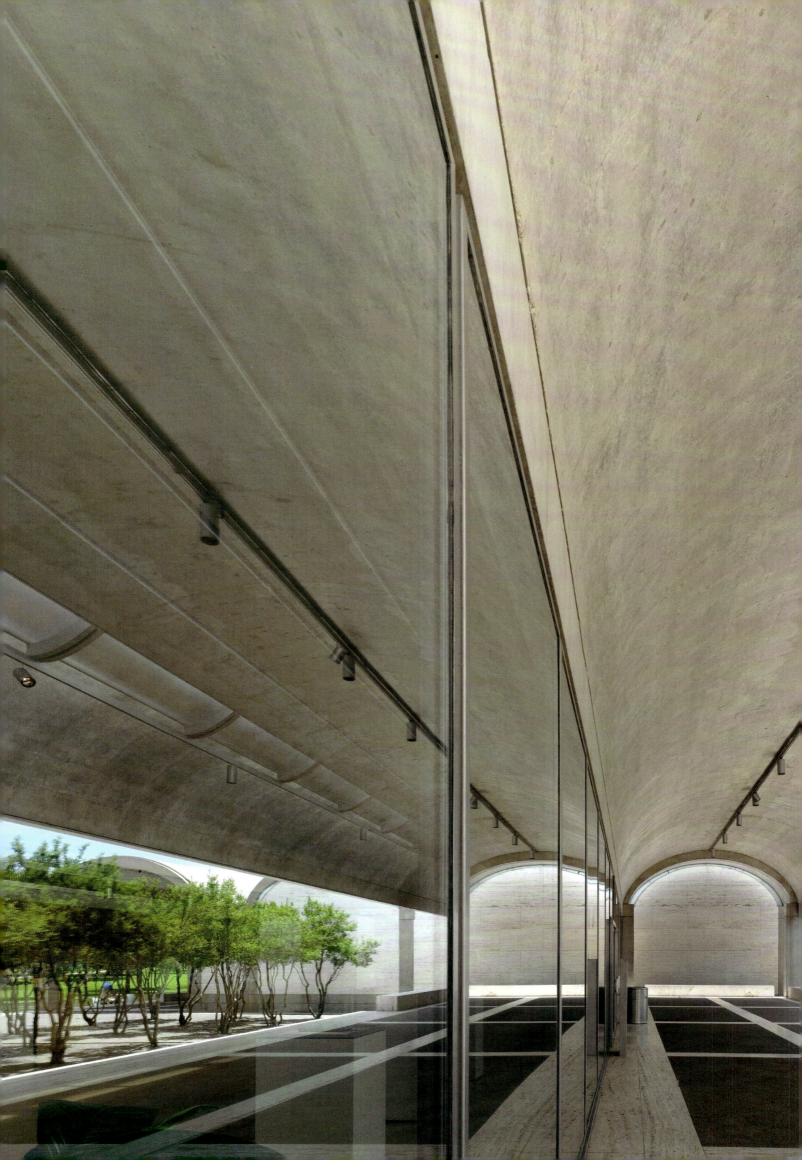

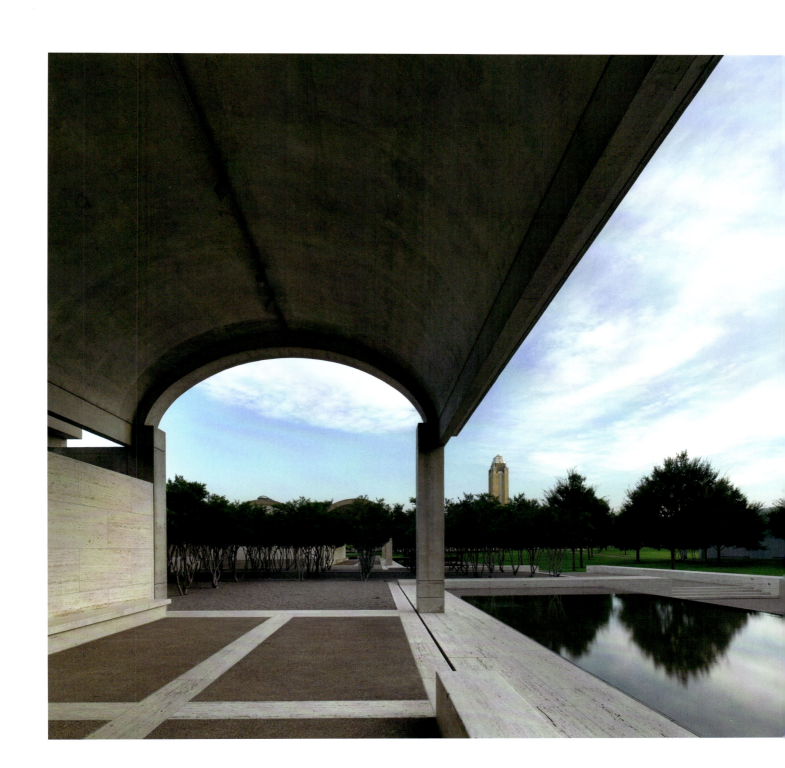

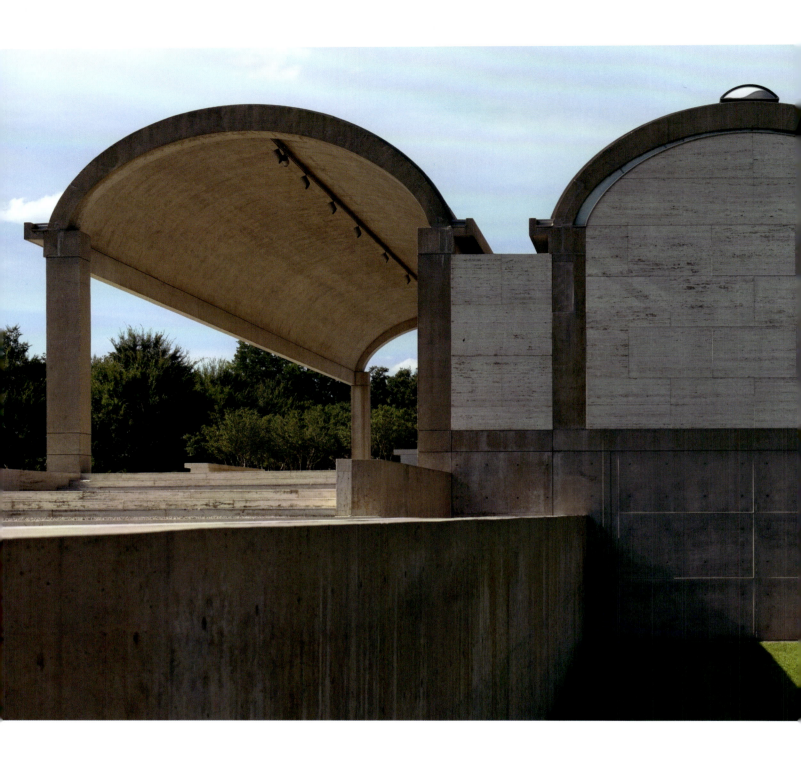

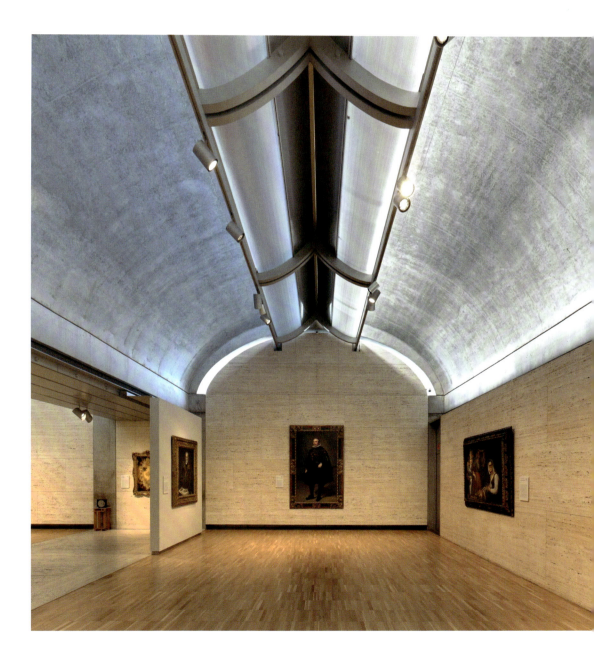

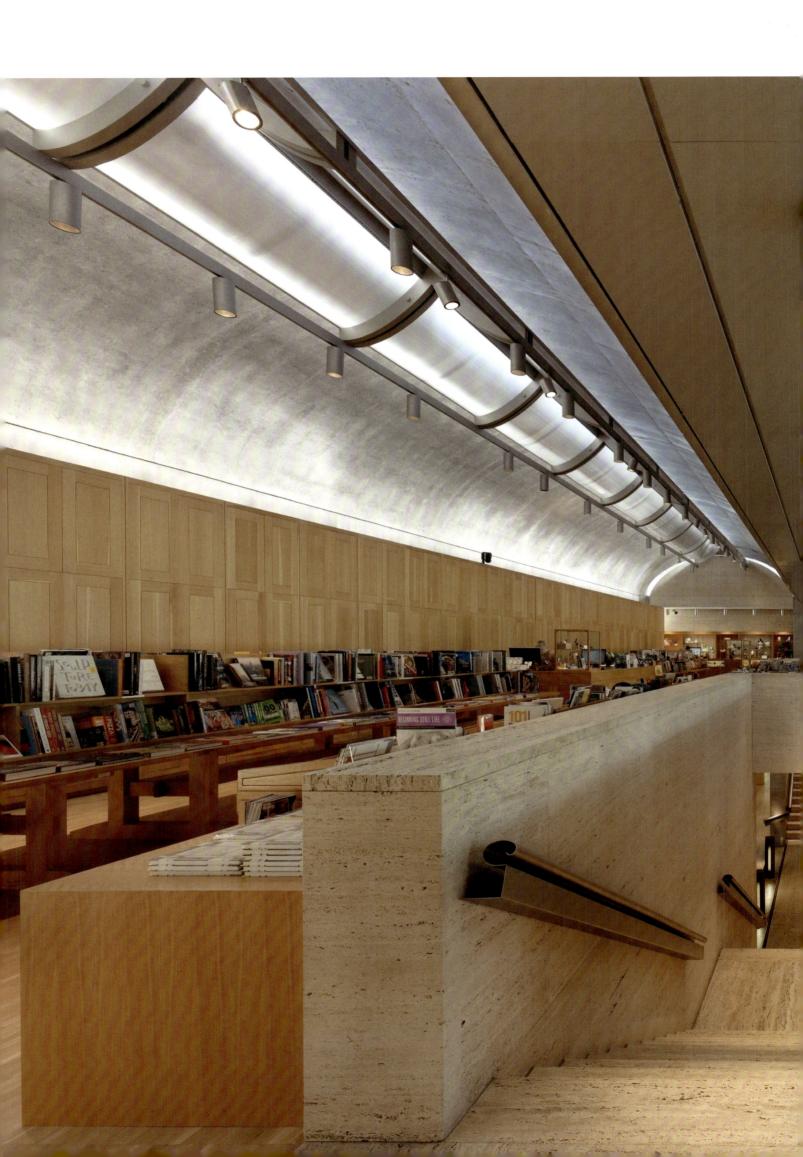

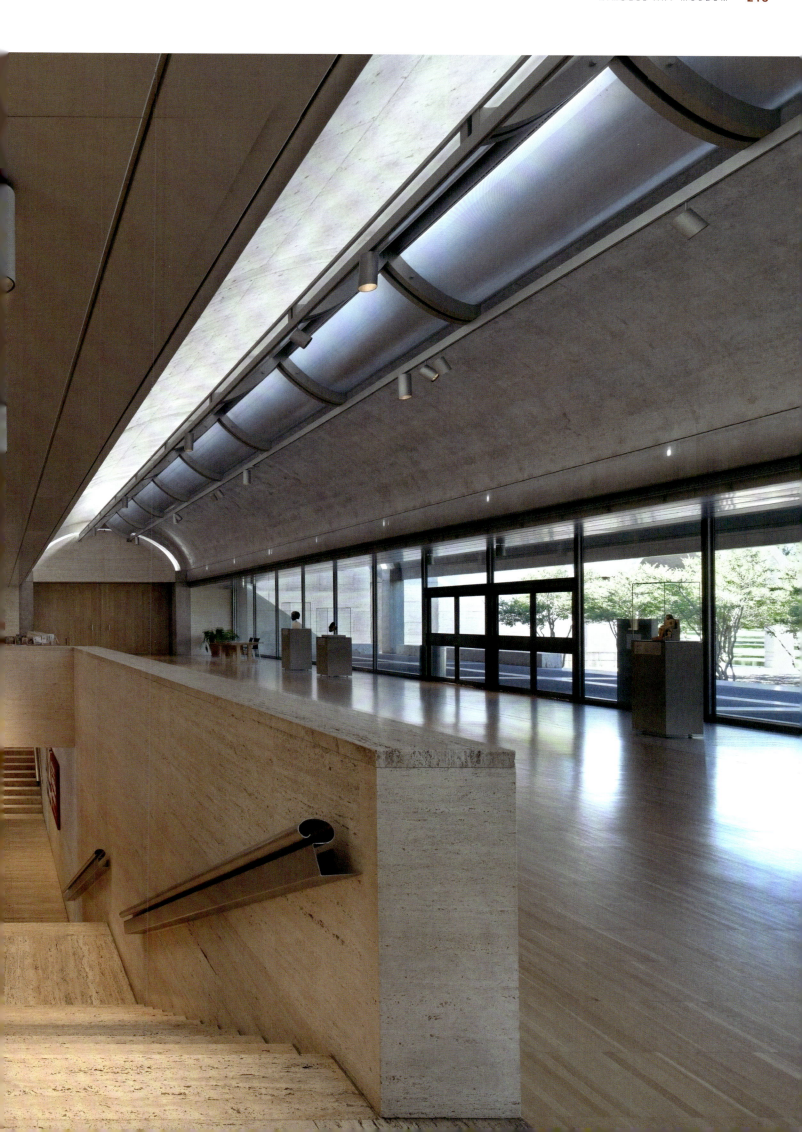

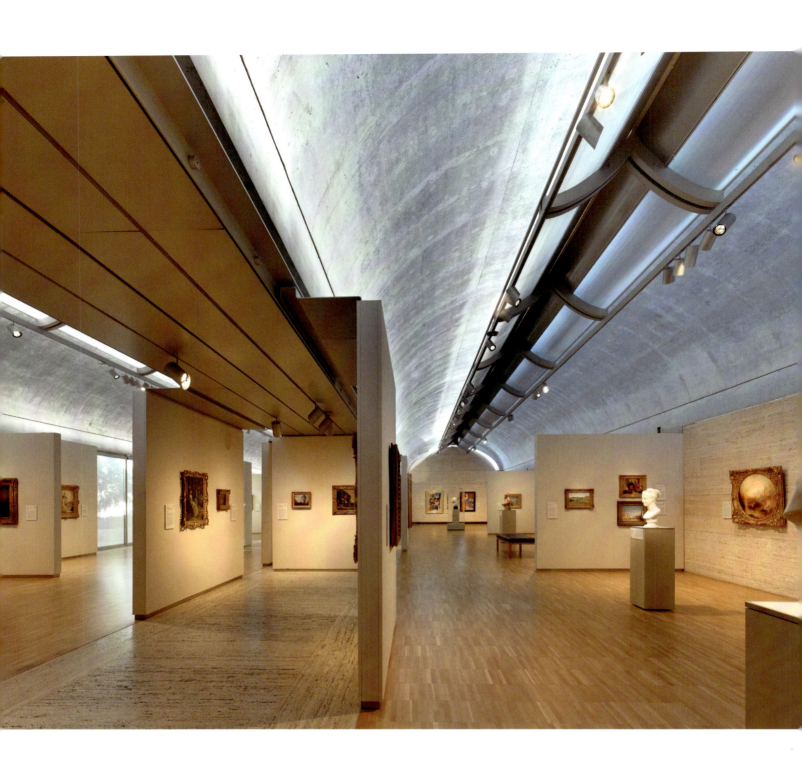

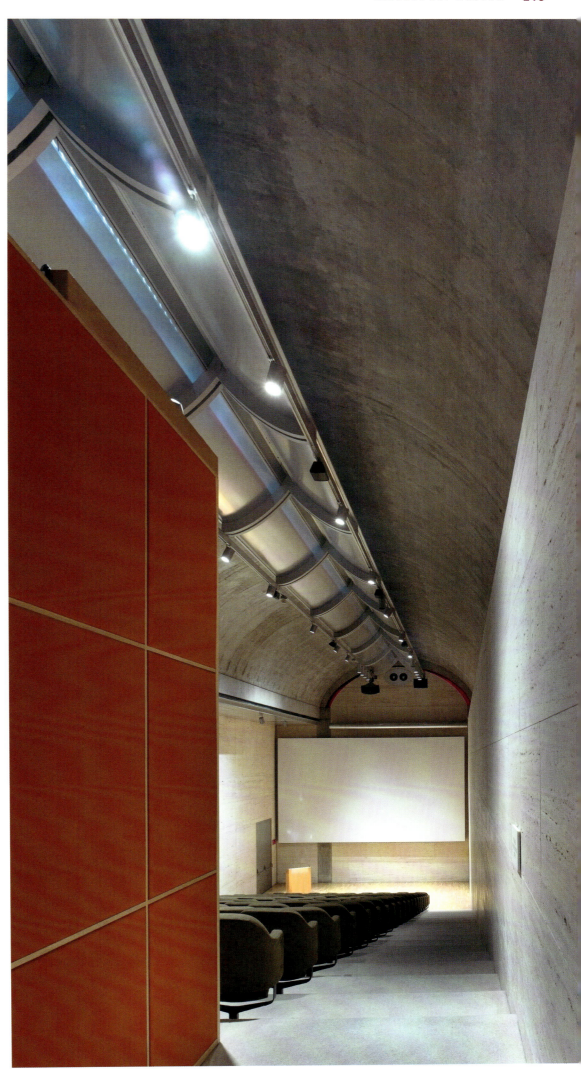

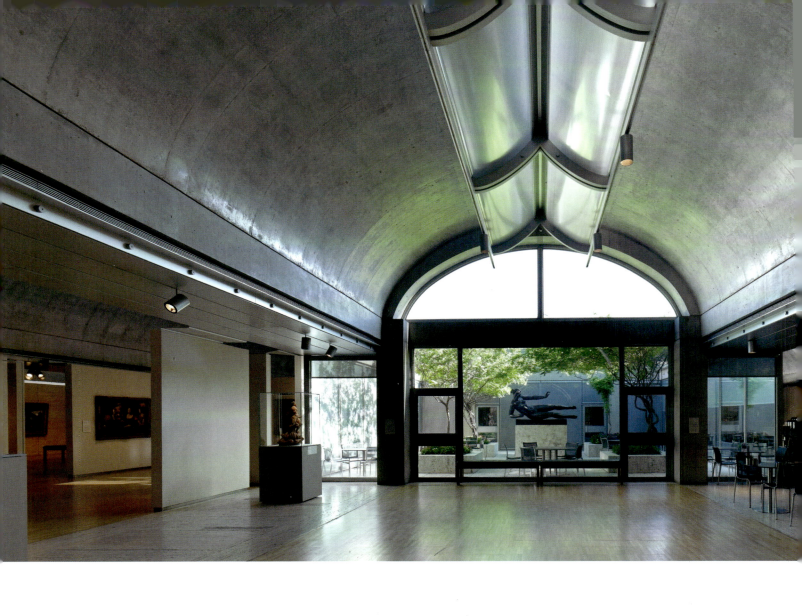

216 THE ESSENTIAL LOUIS KAHN

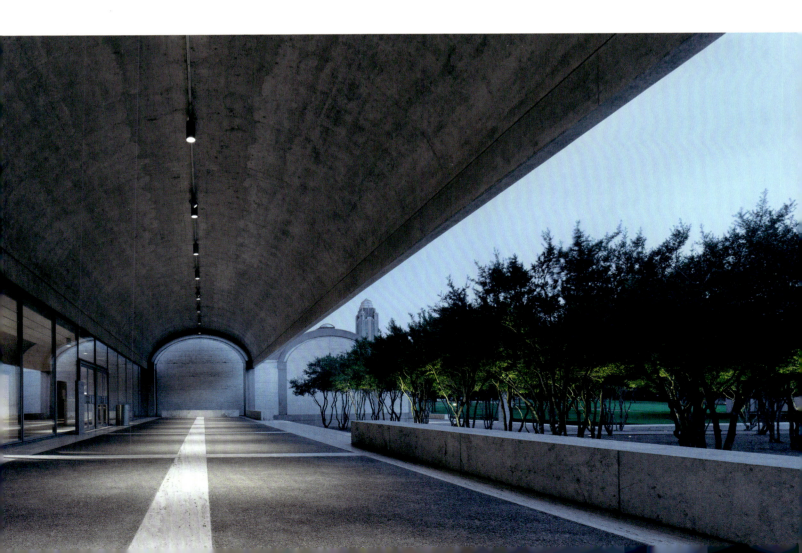

The architect should give spaces to an institution which evoke new meaning for it. Our institutions need spaces which will evoke a greater sense of dignity, a greater sense of loyalty to the institutions and its relationships.

Louis Kahn, 'The Nature of Nature', 1961[1]

Chappaqua, New York
1966–72

TEMPLE BETH-EL

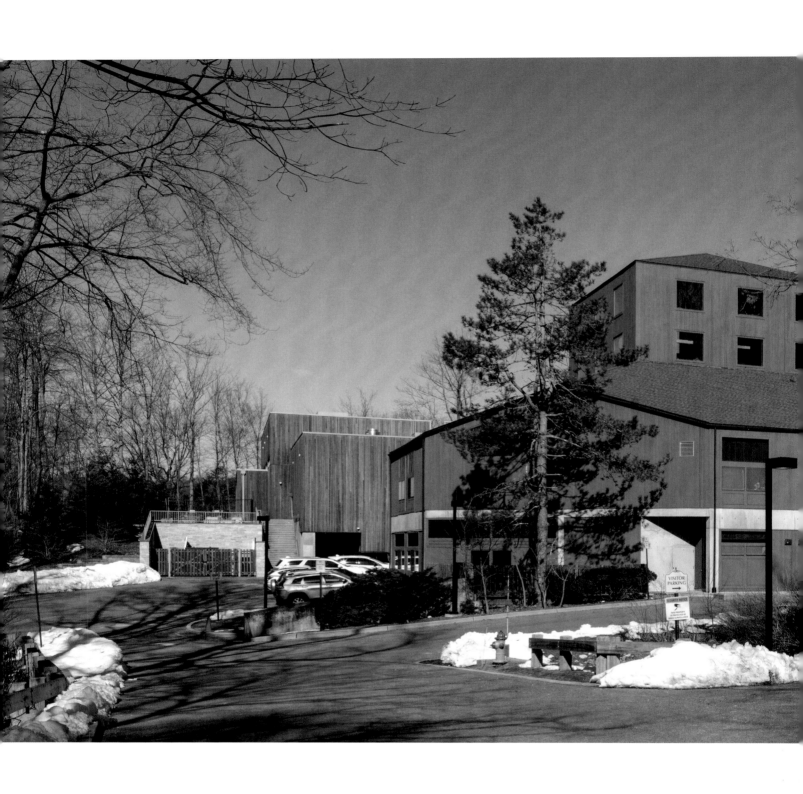

As the architectural historian Susan G. Solomon has remarked: 'Louis I. Kahn's personal view of religion was never mystical or other-worldly. It was non-denominational, secular, reverential of nature, and often pragmatic. He strove to create buildings that looked timeless, felt eternal, and which would enrich human experience and promote interaction among worshipers.'[2] Kahn designed several synagogues during his career, of which two were built: one was his first independent commission, Ahavath Israel synagogue (1935–38) in Philadelphia. The other, Temple Beth-El, was completed in Chappaqua, New York, in 1972.

1 Louis I. Kahn, 'The Nature of Nature', seminar discussion at Cranbrook Academy of Art, 1961, in *Louis I. Kahn: Writings, Lectures, Interviews*, ed. Alessandra Latour (New York: Rizzoli, 1991), p. 142.

2 Susan G. Solomon, 'Louis Kahn's Buildings for Three Faiths: "Religion … Not a Religion"', in *Louis Kahn: The Power of Architecture*, ed. Mateo Kries, Jochen Eisenbrand and Stanislaus von Moos (Weil am Rhein: Vitra Design Museum, 2012), p. 149.

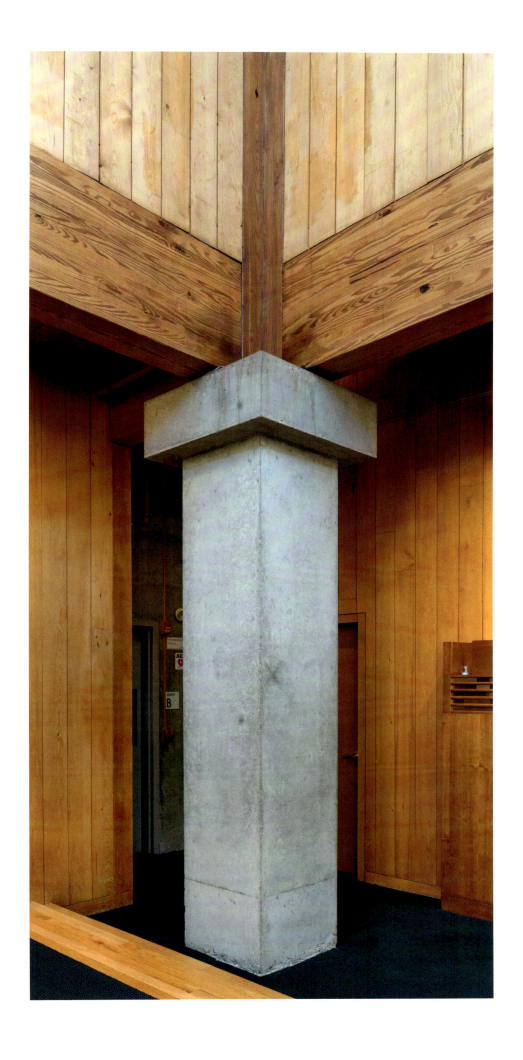

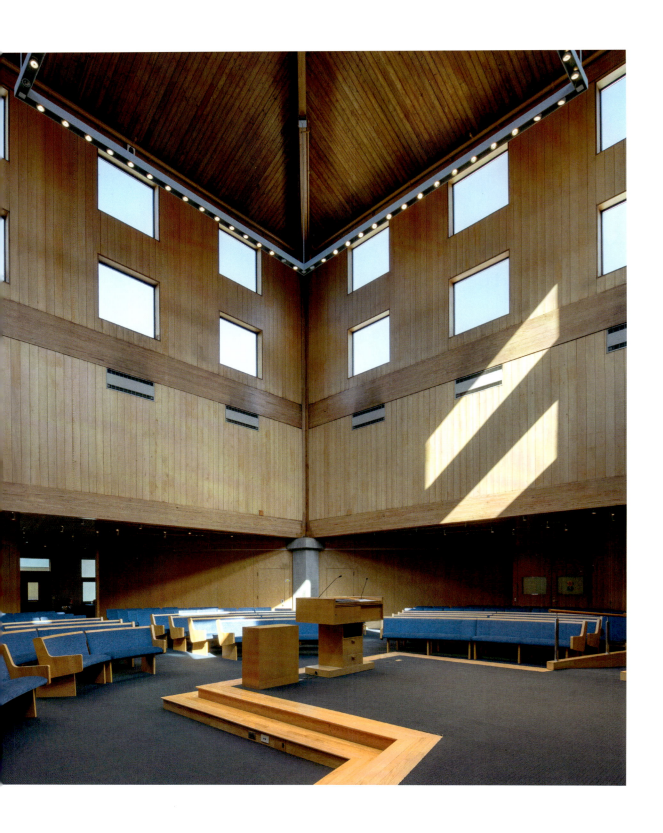

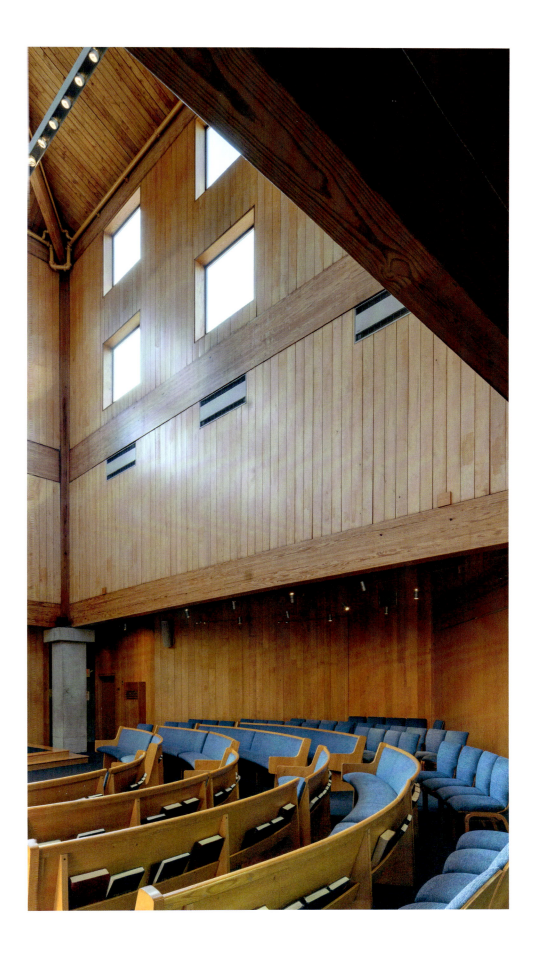

Steel, the lighter metals, concrete, glass, laminated woods, asbestos, rubber, and plastics, are emerging as the prime building materials of today. Riveting is being replaced by welding, reinforced concrete is emerging from infancy with prestressed reinforced concrete, vibration and controlled mixing, promising to aid in its ultimate refinement.

Louis Kahn, 'Monumentality', 1944[1]

New Haven, Connecticut
1969–77

YALE CENTER FOR BRITISH ART

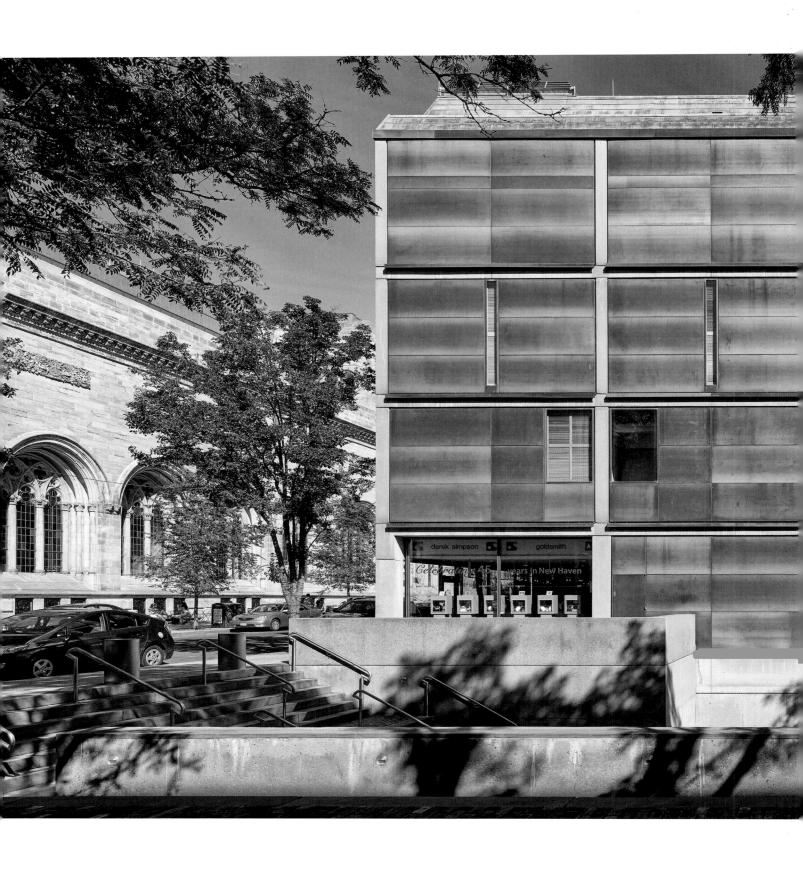

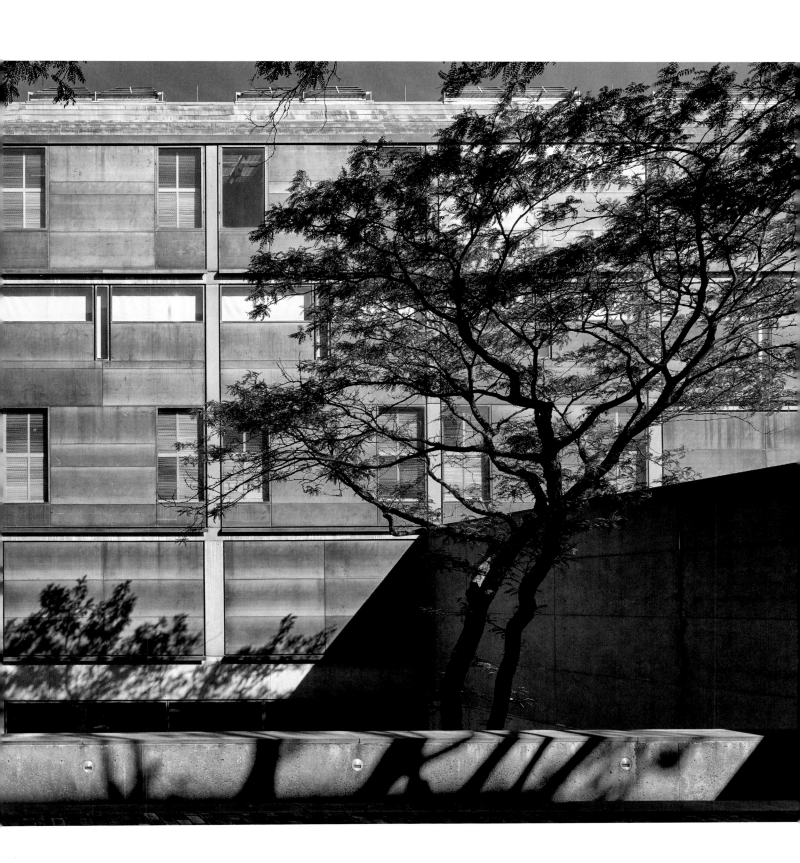

The first sketches for the Yale Center for British Art date back to 1969, but the building was fully completed and inaugurated in 1977, after Kahn's death. In addition to a museum devoted to Paul Mellon's collection of English paintings, the project was to include galleries, three small libraries, an auditorium, rooms for conservation work, and other rooms specifically devoted to the study of drawings and prints. Indeed, the museum had a specific educational purpose, being designed specially for the teaching of history of art.

The municipality of New Haven wanted to maintain the commercial activity of the street that runs along the north facade of the museum, and shops therefore occupy the ground floor. The inclusion of both commercial and cultural activities in one building is one of the accomplishments of this development. The idea is reminiscent of the Italian palazzi built by influential families during the Renaissance, which were organised around an atrium, with the ground floor at street level often reserved for market stalls and shops. Just as for the earlier Yale University Art Gallery, located opposite, Kahn designed a simple volume, clearly defined by the outer walls and well integrated into the urban environment. The volume is easy to apprehend thanks to the simplicity of the supporting structures. The facades are clad with stainless steel panels with a pattina resembling pewter, while tinted glass windows, arranged asymmetrically along the four facades, reflect the image of the surrounding buildings. The structure is built around two large covered courtyards: one acts as an extension to the entrance porch, the other leads to the libraries.

1 Louis I. Kahn, 'Monumentality' [1944], in *New Architecture and City Planning: A Symposium*, ed. Paul Zucker (New York: New York Philosophical Library, 1944), p. 87.

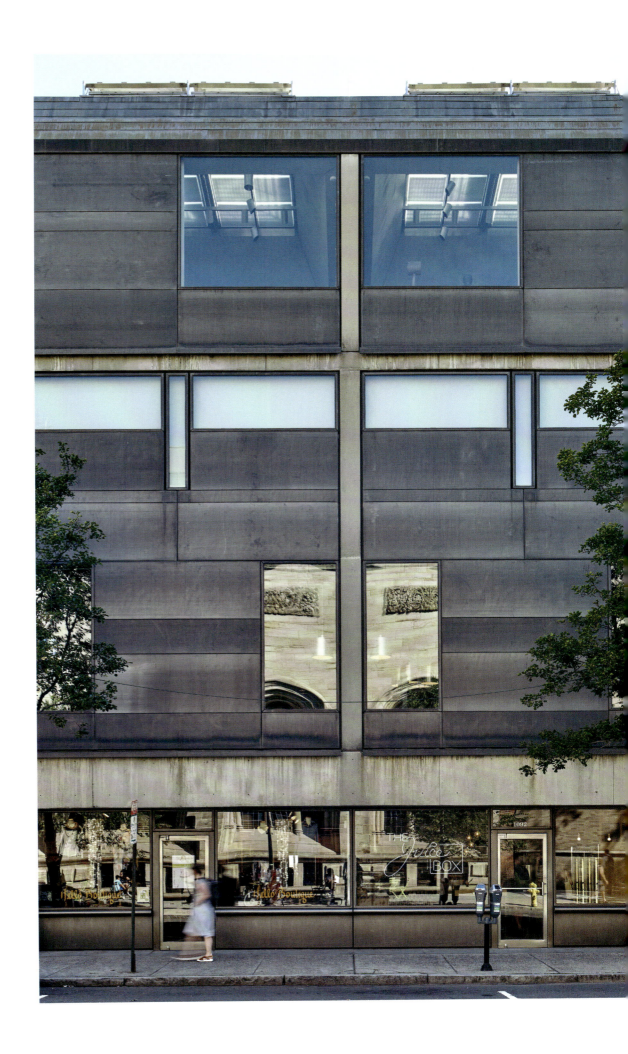

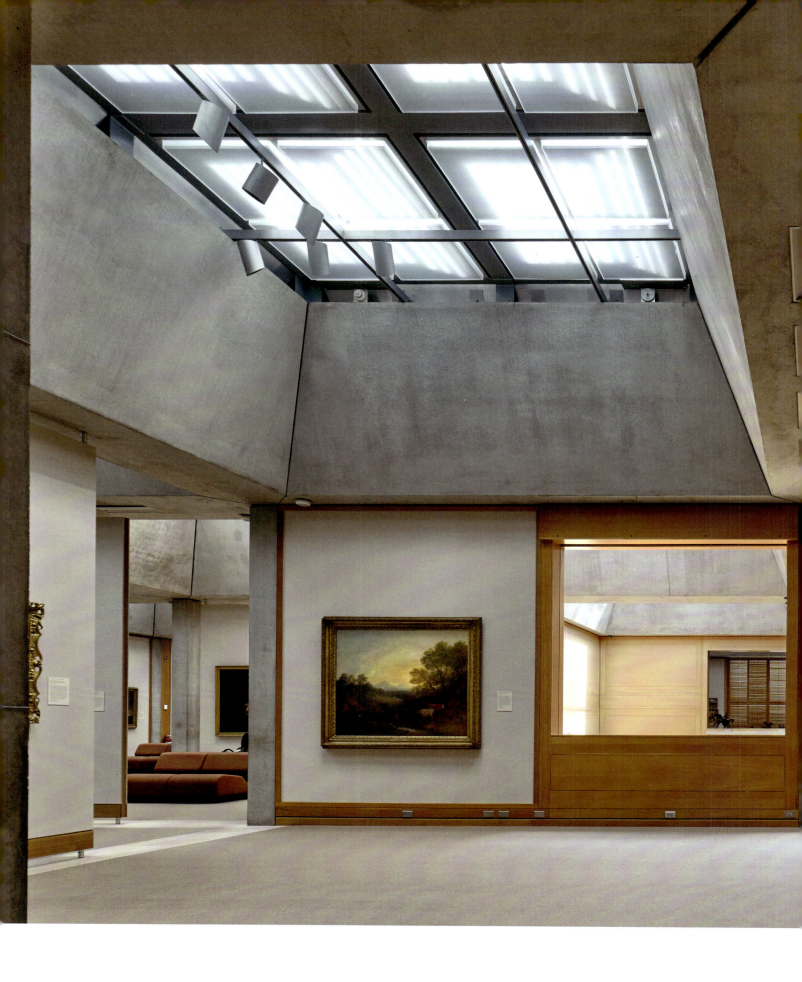

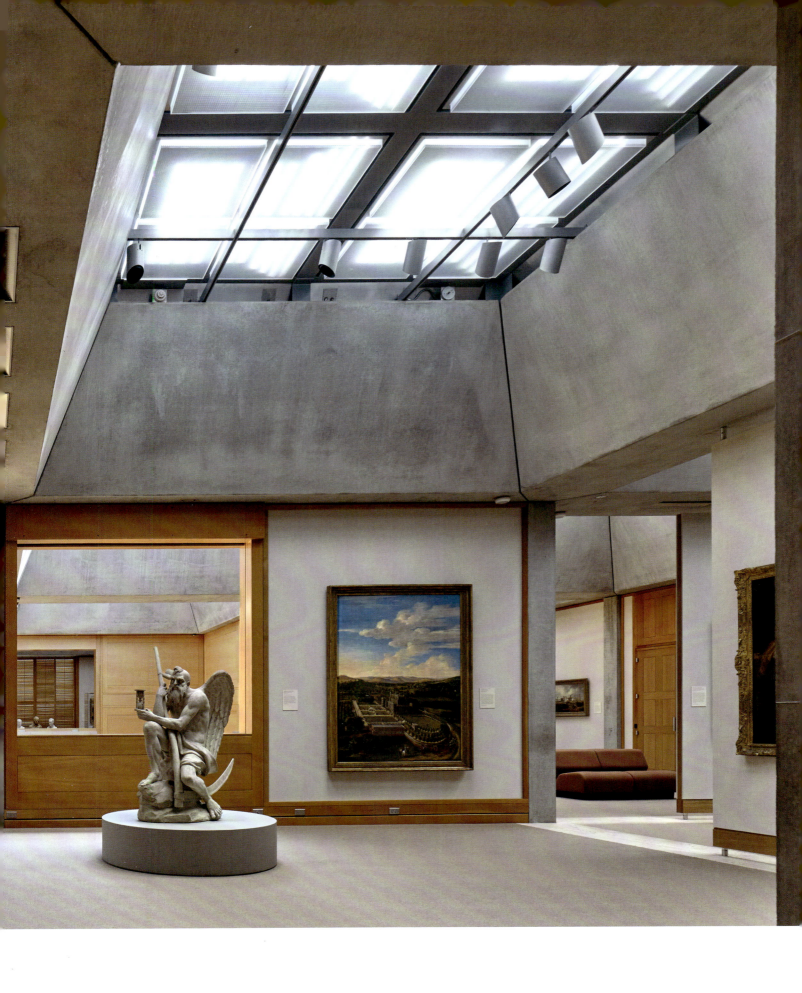

YALE CENTER FOR BRITISH ART

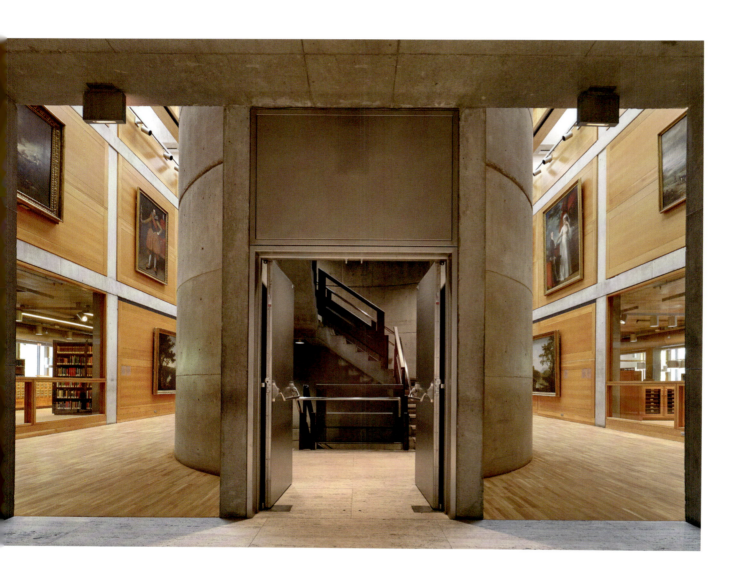

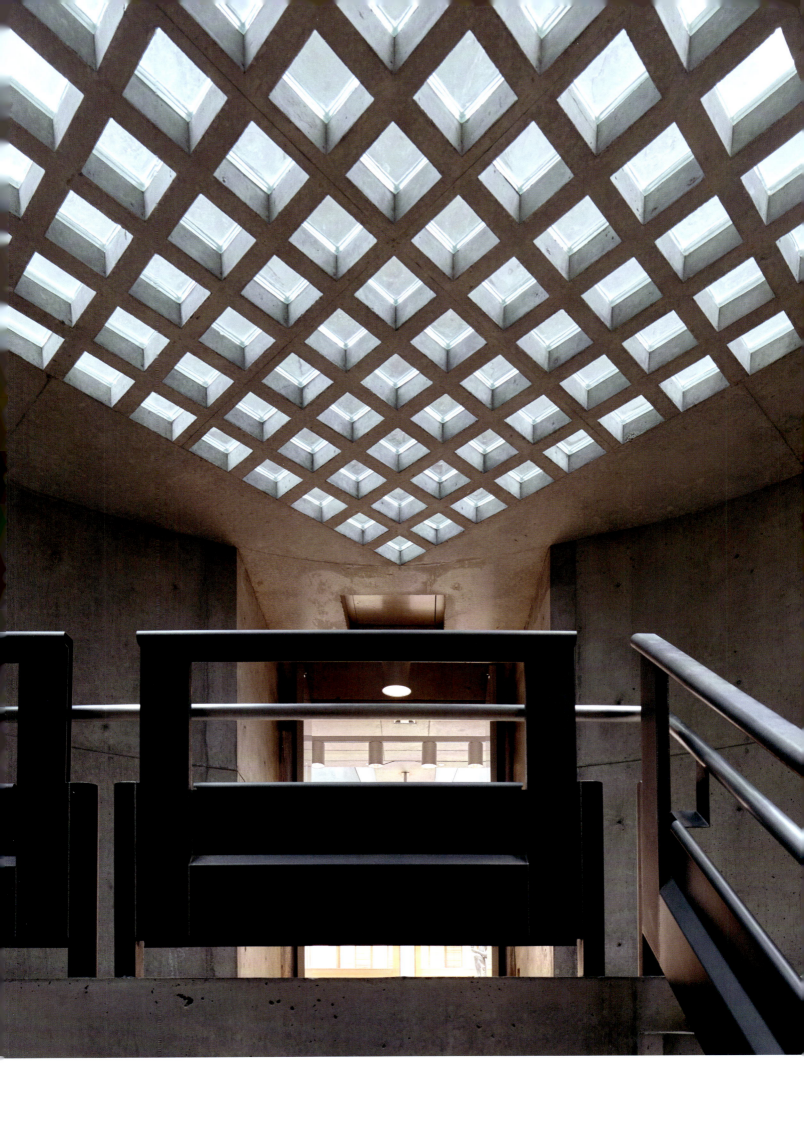

YALE CENTER FOR BRITISH ART

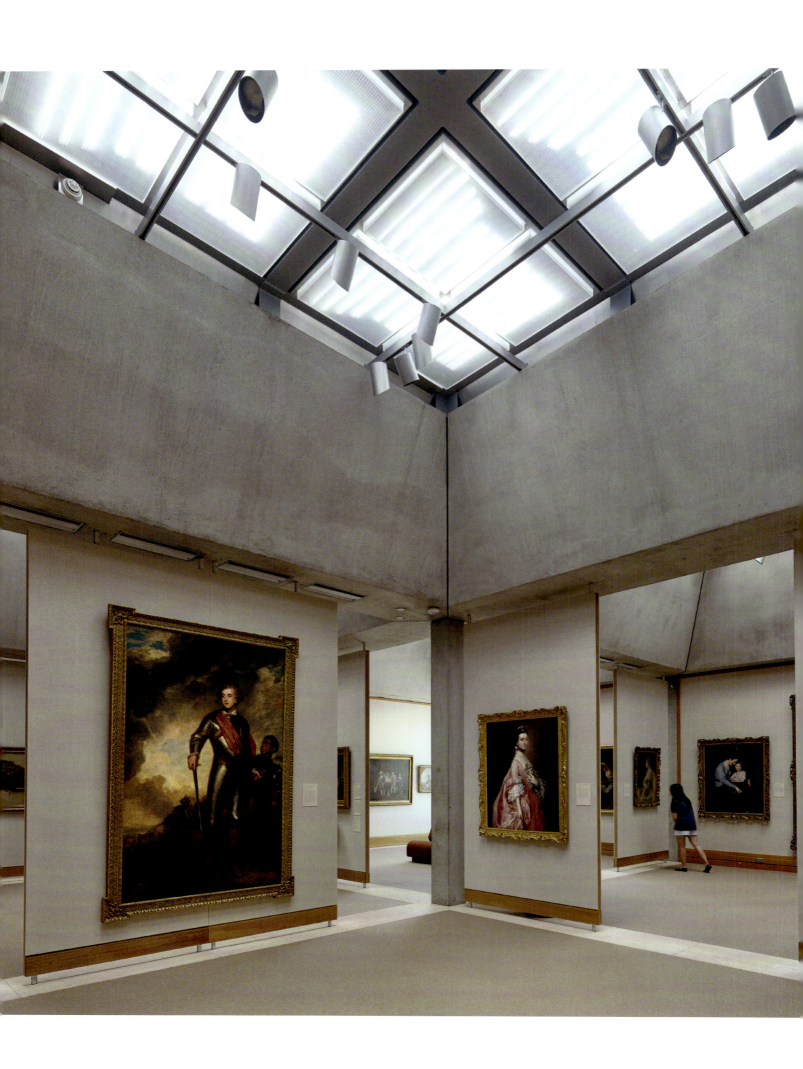

236 THE ESSENTIAL LOUIS KAHN

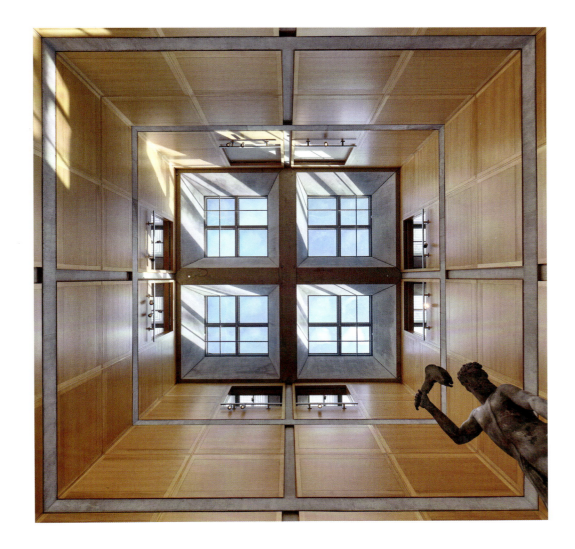

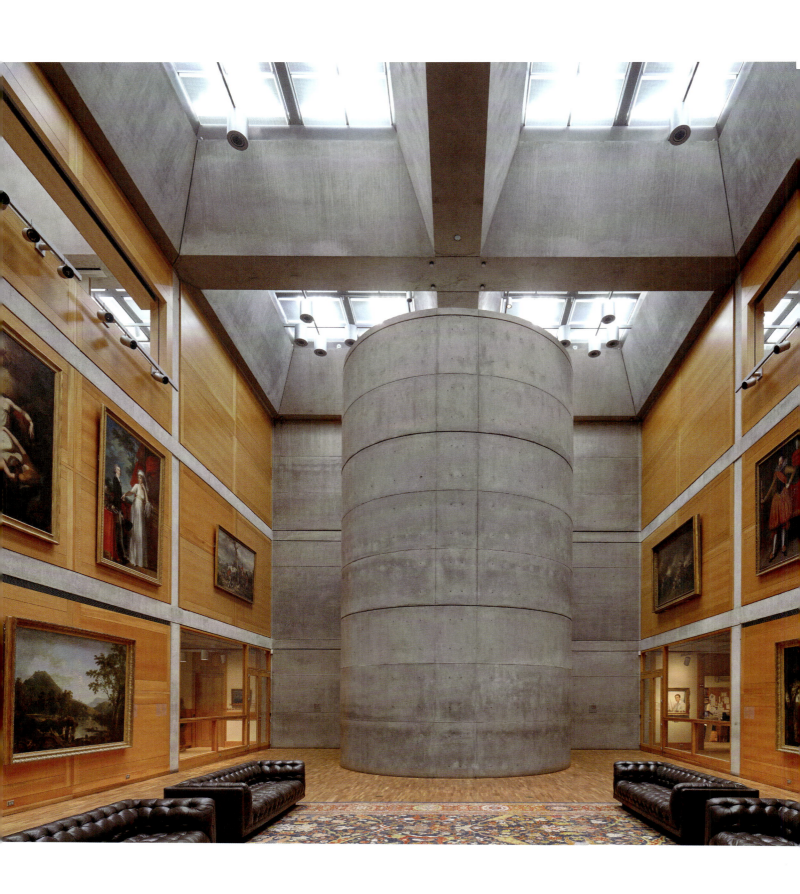

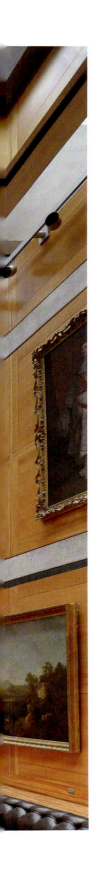
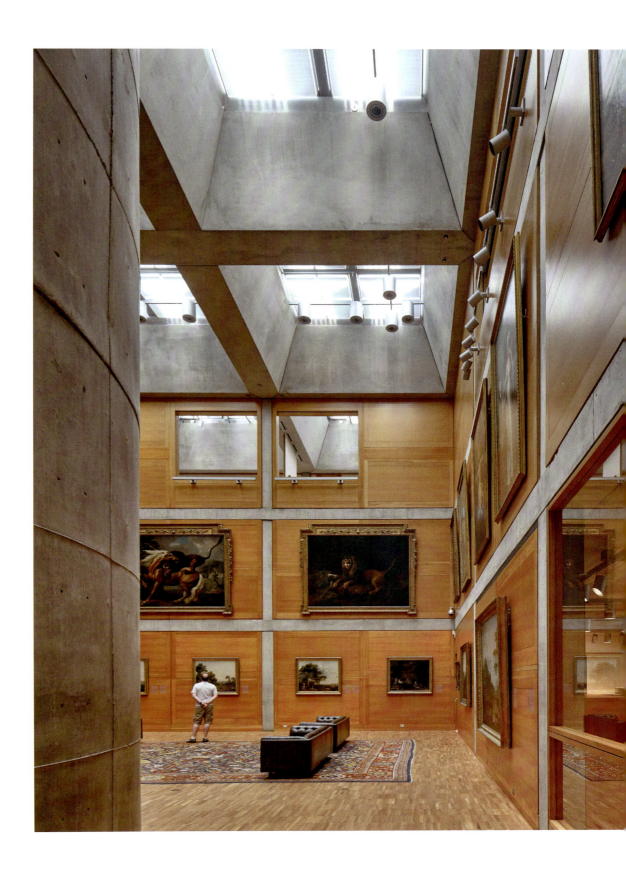

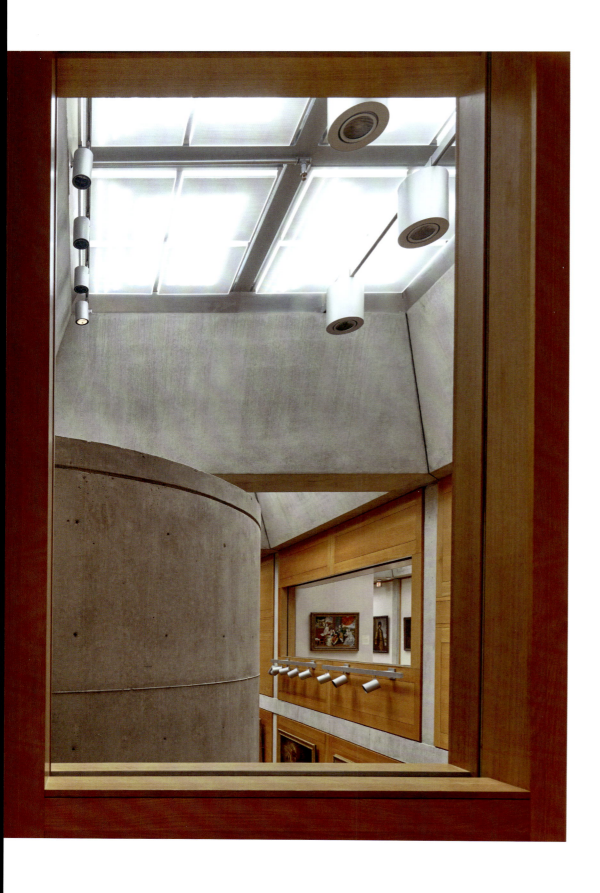

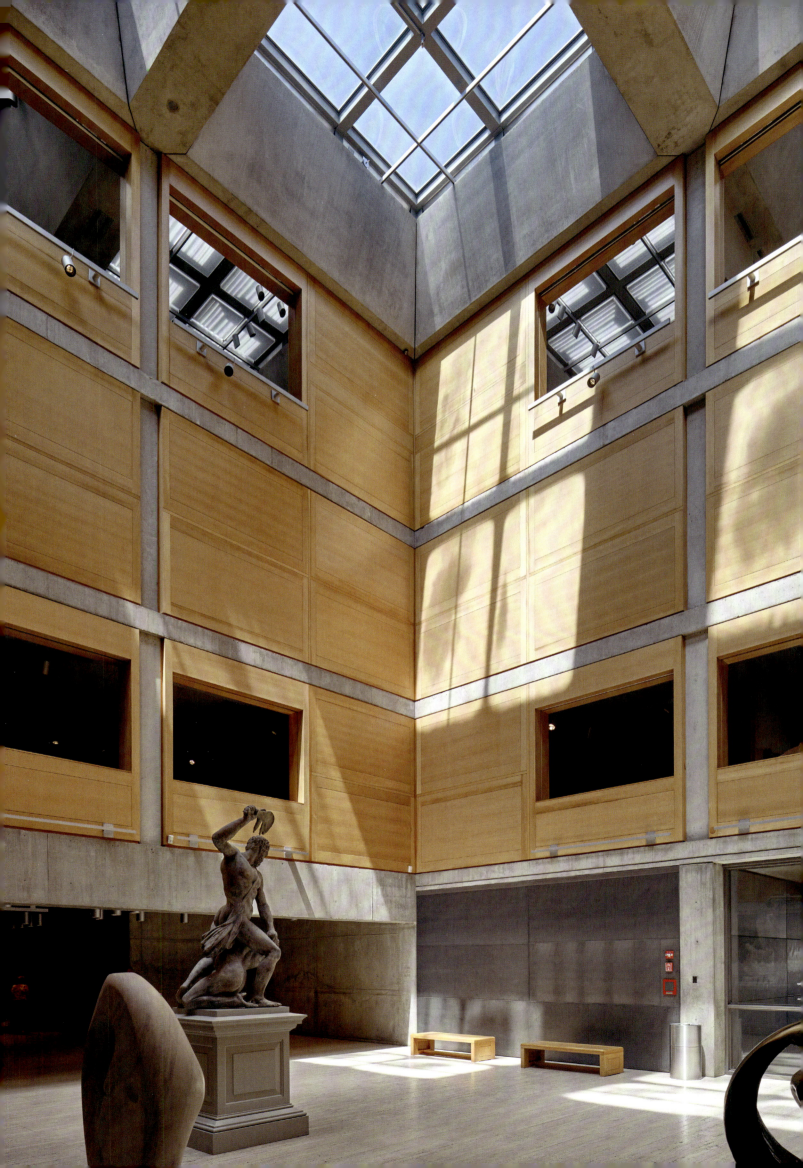

I make a space as an offering, and do not designate what it is to be used for. The use should be inspired, that is to say, I would like to make a house in which the living room is discovered as the living room. I will not say that it is a living room and you must use it as such.

Louis Kahn, interview with John W. Cook and Heinrich Klotz, 1973[1]

Fort Washington, Pennsylvania
1971–73

STEVEN AND TOBY KORMAN HOUSE

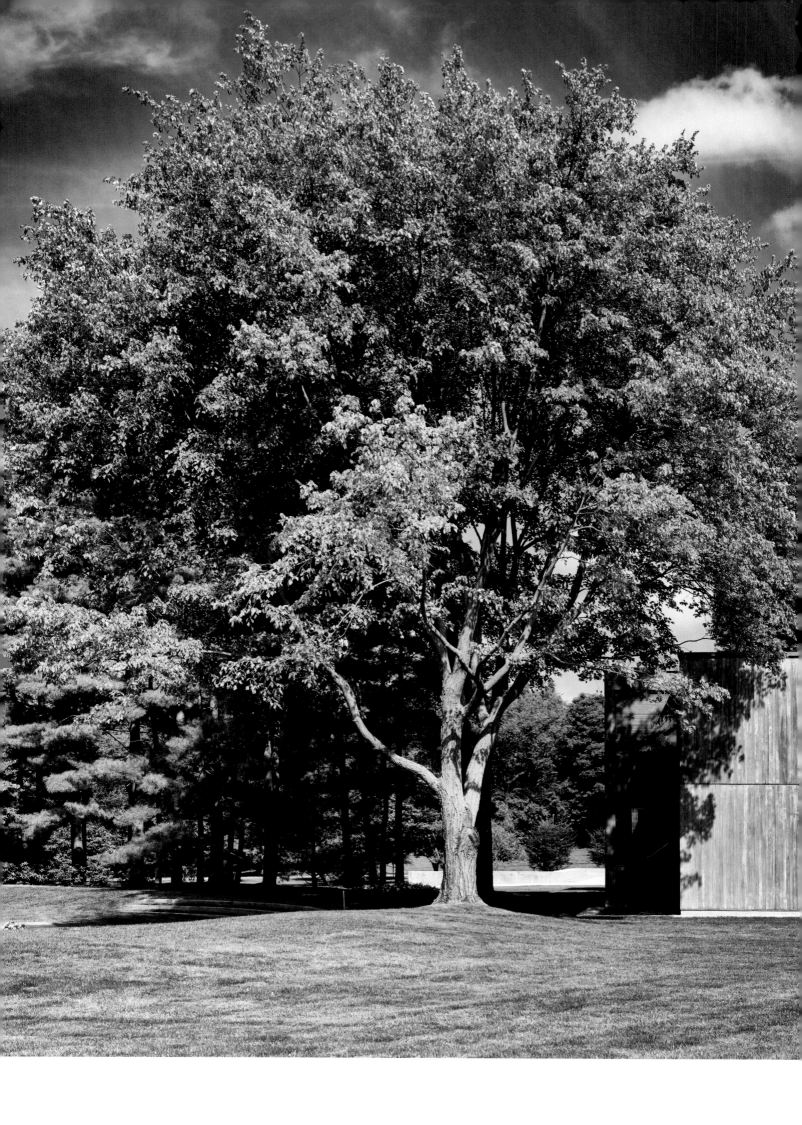

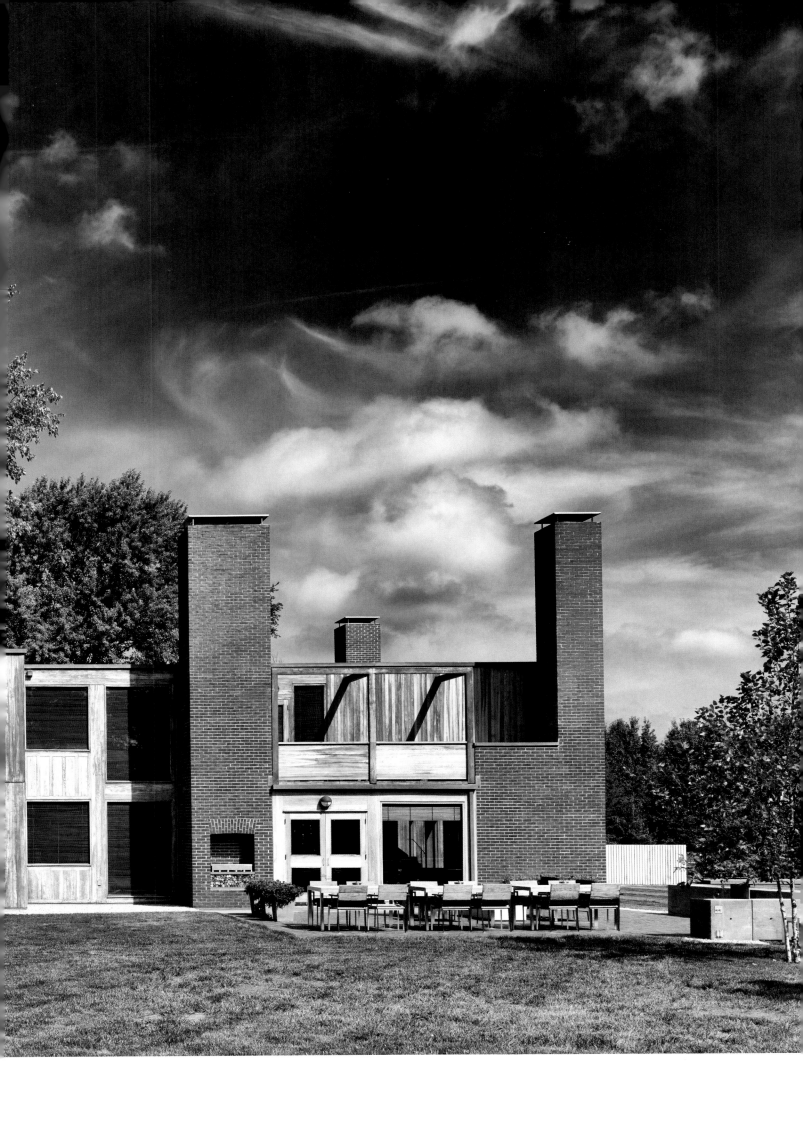

STEVEN AND TOBY KORMAN HOUSE

For this residence built in 1973, located not far from Philadelphia, Kahn designed a wooden-framed house made up of a series of adjoining double rooms leading into one another: living room and dining room, kitchen and breakfast area, bedrooms and hallway. Unlike the buildings he designed in the 1950s and 1960s, this house does not consist of cubic pavilions fitting into a simple geometric envelope. Here, each group of rooms forms a different ensemble and has its own particular layout, giving each member of the family a certain independence. The side facade, corresponding to the double-height day area (living room and dining room), is flanked by brick chimneys that stand out against the sky. Located on the outer edges of the building, these create useful alcove spaces inside: a bench and shelves are built into the inglenook in the living room, while part of the kitchen is set into a third chimney, on the west side. These chimneys have a role similar to that of a corner stone, protecting and marking the boundaries of the house. The rough texture and opacity of the brick contrasts with the smooth transparency of the large windows.

1 John W. Cook and Heinrich Klotz, 'Louis Kahn', in *Conversations with Architects* (New York: Praeger, 1973), p. 204.

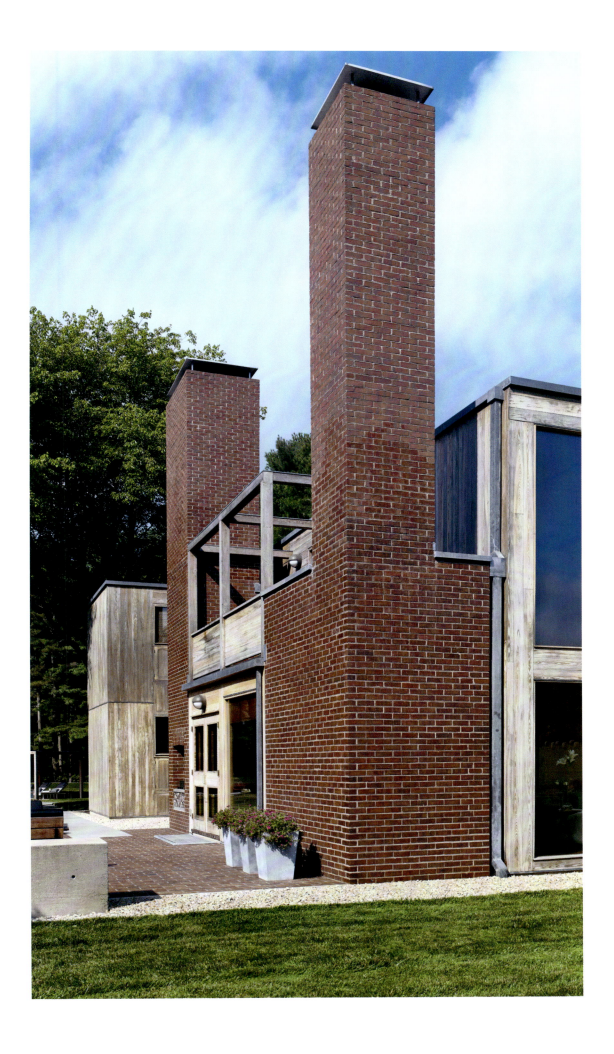

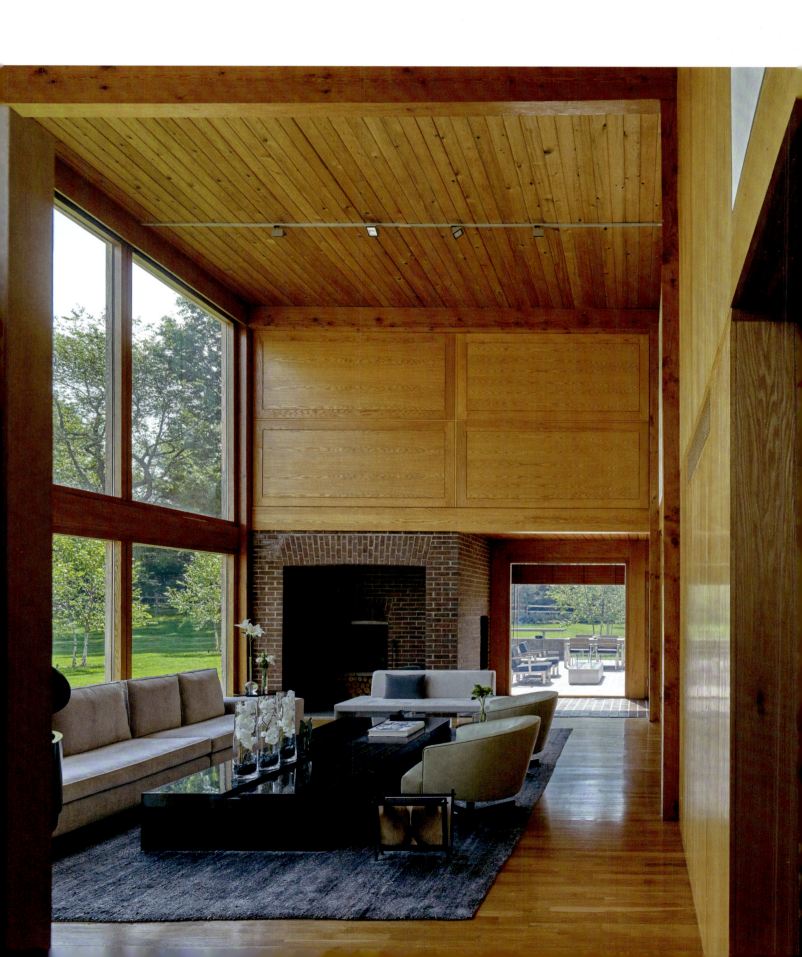

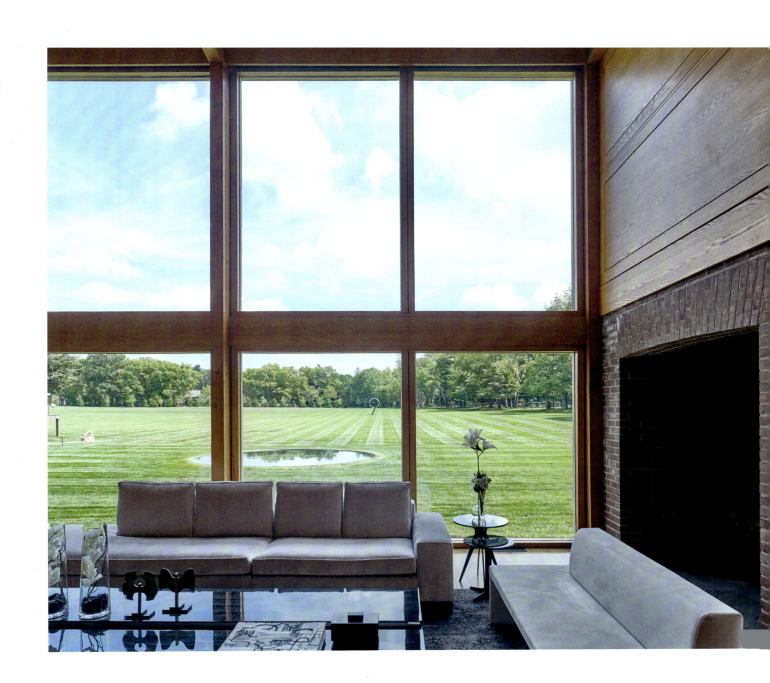

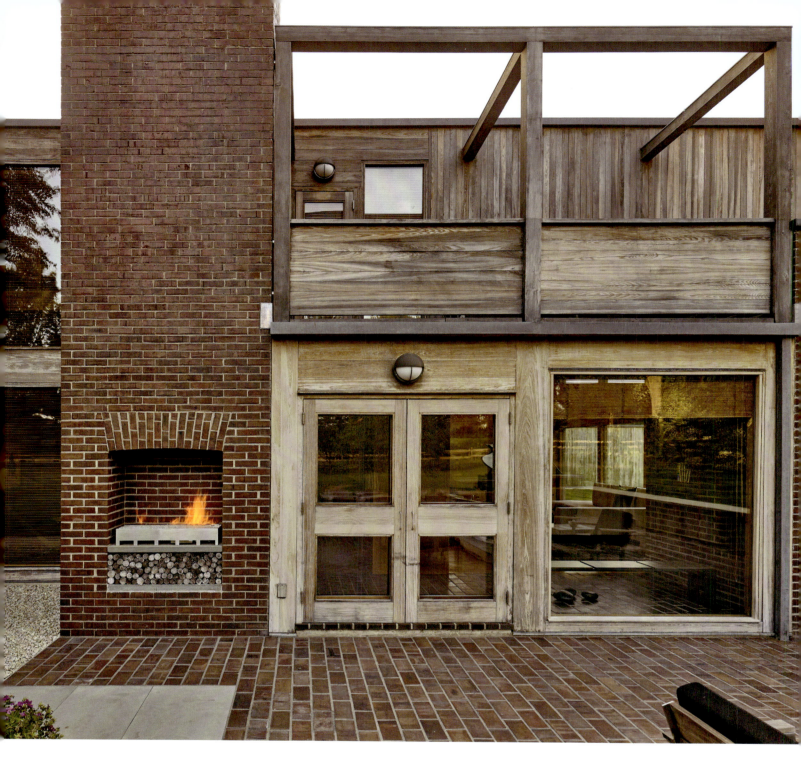

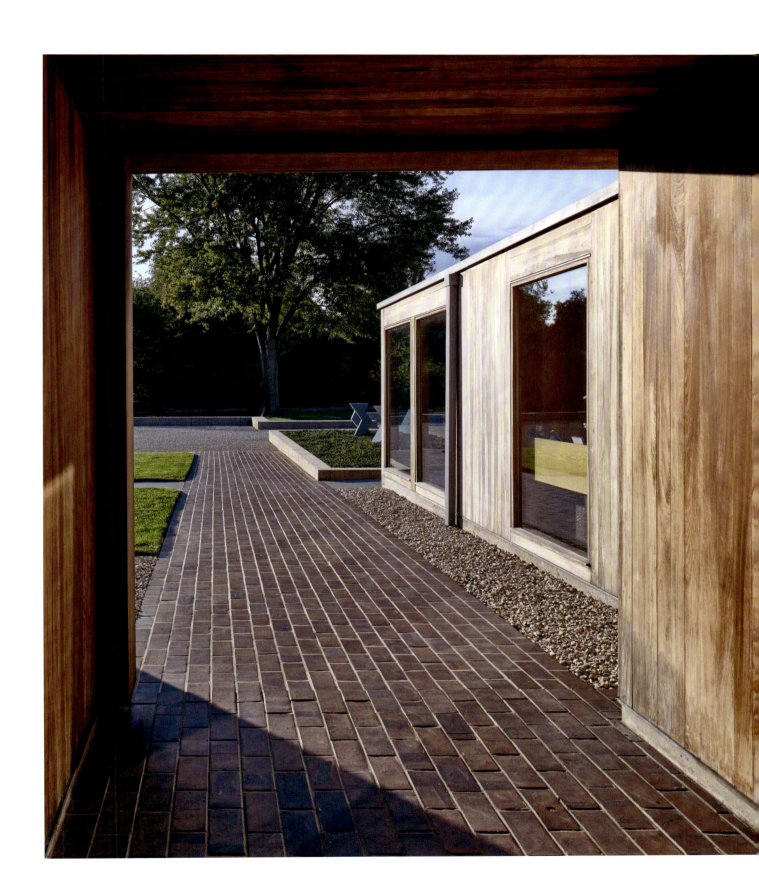

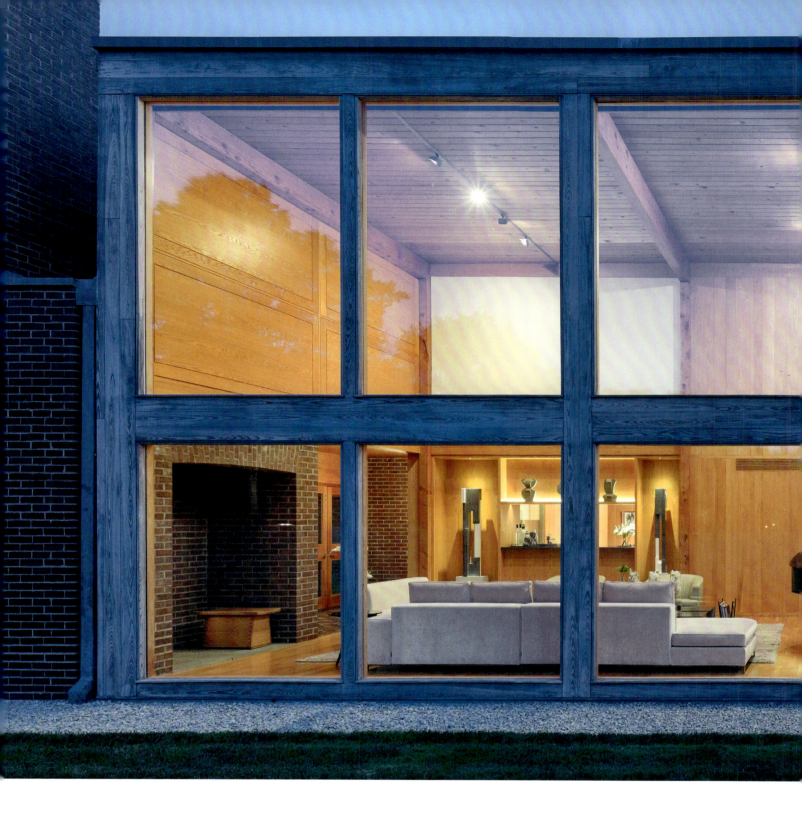

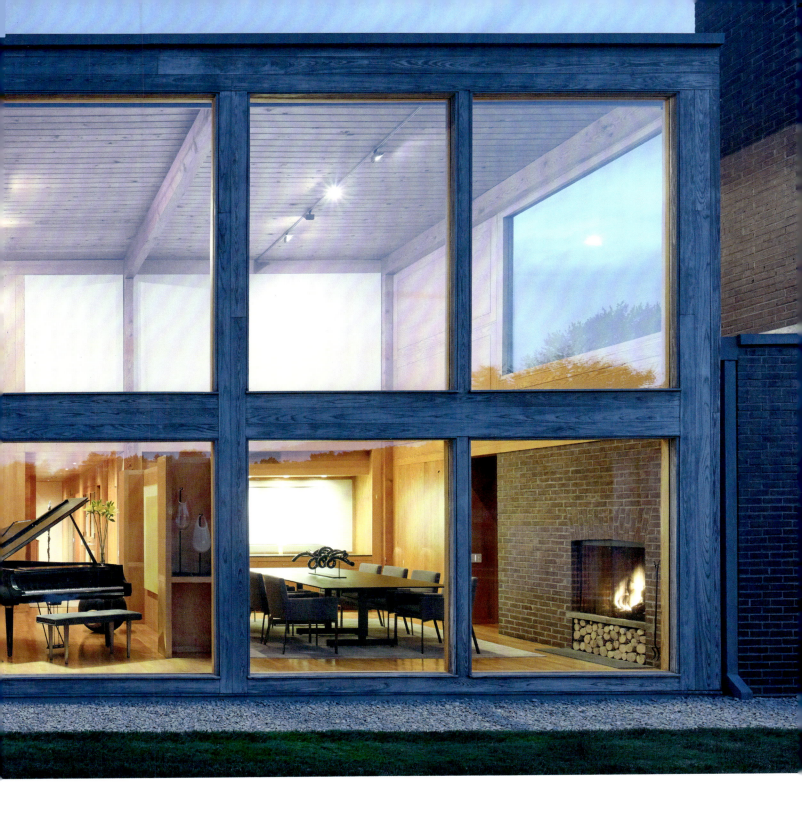

STEVEN AND TOBY KORMAN HOUSE

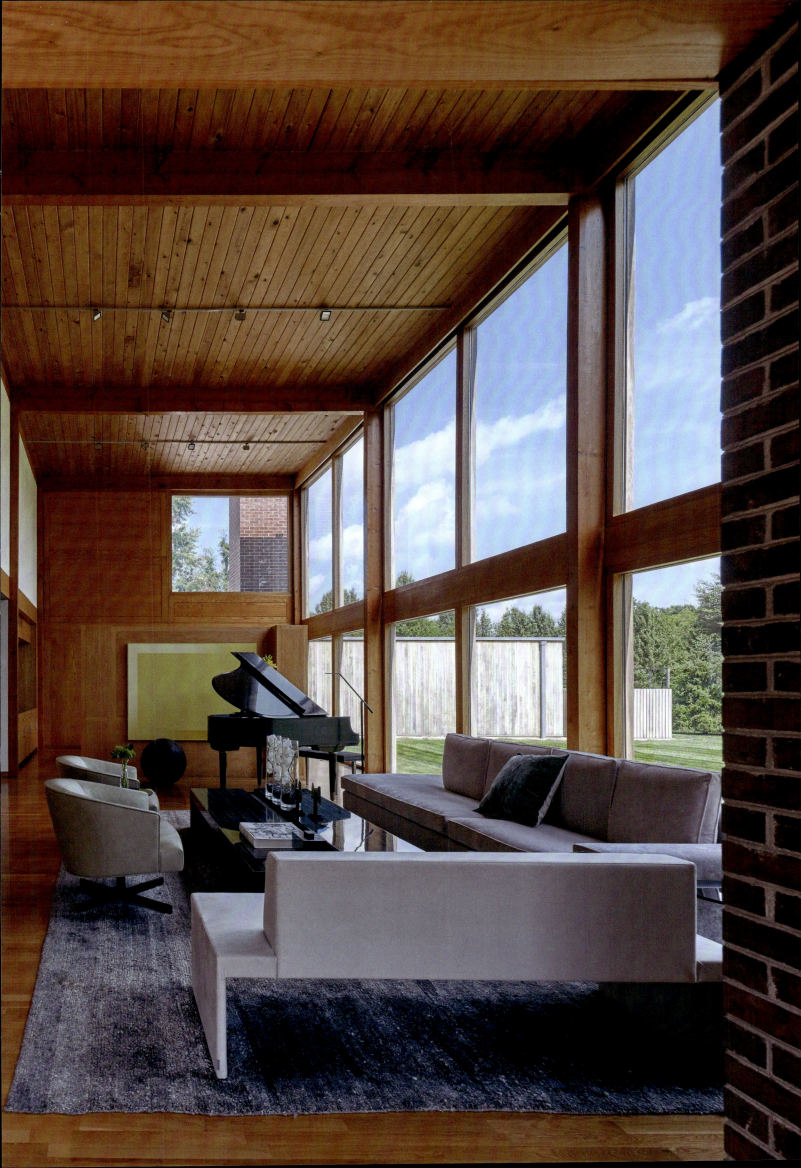

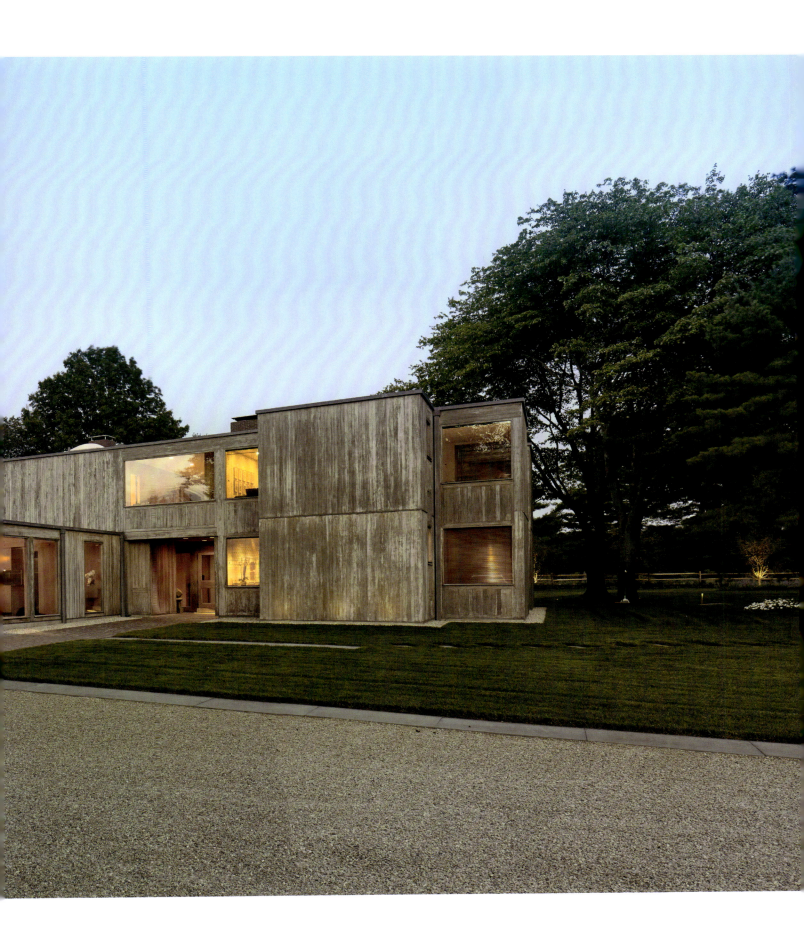

I had this thought: that a memorial should be a room and a garden. That's all I had. Why did I want a room and a garden? I just chose it to be the point of departure. The garden is somehow a personal nature, a personal kind of control of nature, a gathering of nature. And the room was the beginning of architecture. I had this sense, you see, that the room wasn't just architecture, but was an extension of self … I think it has qualities that don't belong to me at all. It has qualities which bring architecture to you. It has nothing to do with the practice of architecture, which is a different thing entirely. Architecture really has nothing to do with practice. That's the operational aspect of it. But there is something about the emergence of architecture as an expression of man which is tremendously important because we actually live to express. It is the reason for living.

Louis Kahn, lecture at Pratt Institute, 1973[1]

Roosevelt Island,
New York City,
New York
1973–2012

FRANKLIN D. ROOSEVELT FOUR FREEDOMS PARK

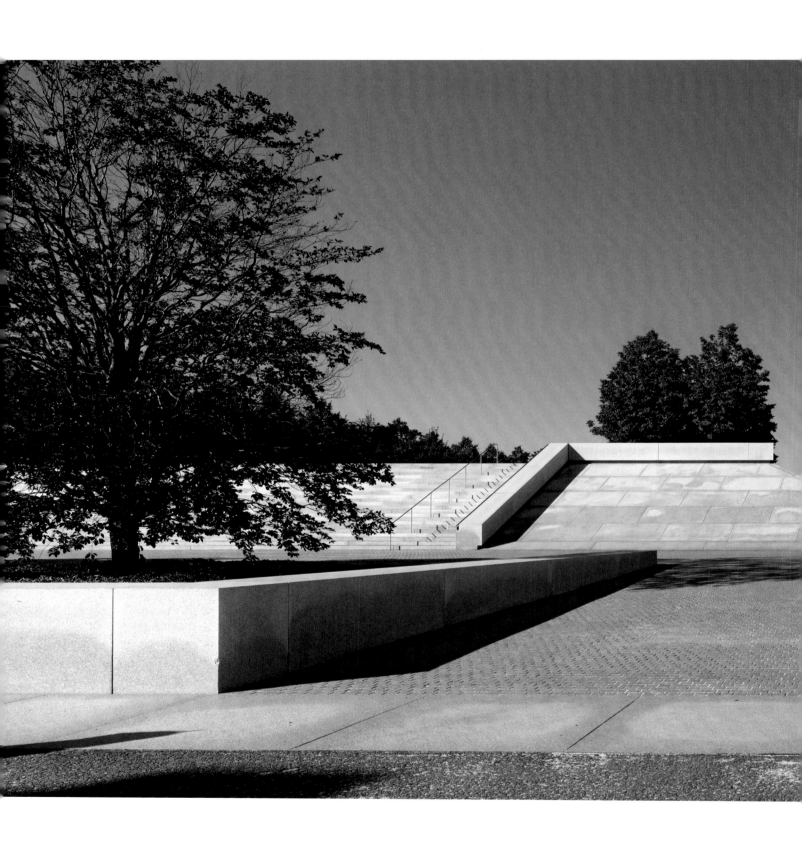

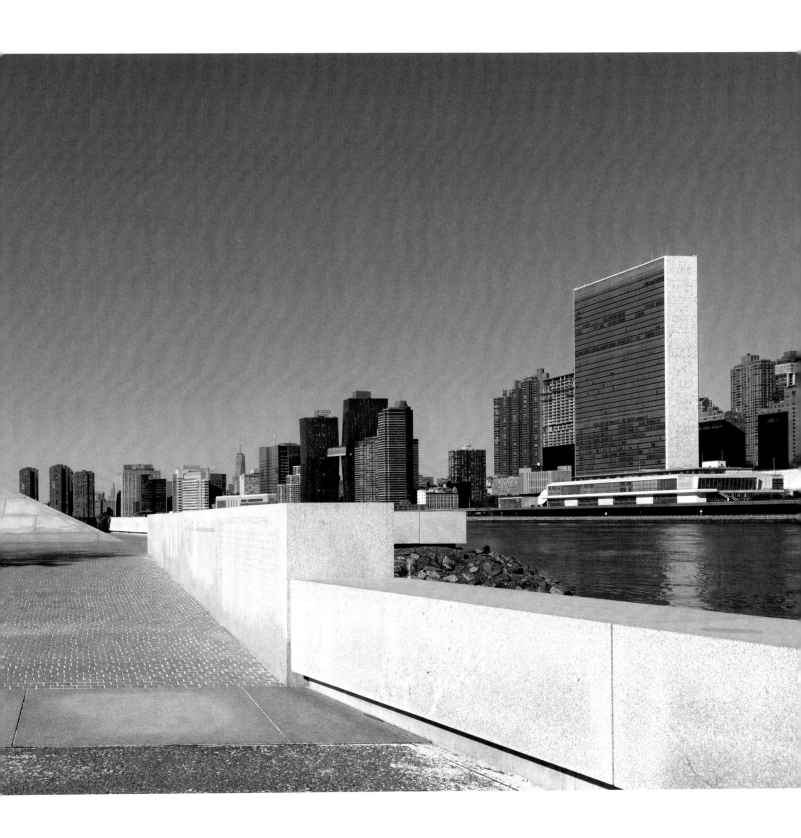

Louis Kahn was asked to design a monument to Franklin D. Roosevelt in 1972, to commemorate the former president's 1941 'Four Freedoms' speech to the United States Congress. Following Kahn's death in 1974 and the fiscal crisis in New York, the project for the park was halted. It was continued four decades later by David Wisdom & Associates in association with Mitchell/Giurgola Architects and was finally completed in 2012.

Situated at the southern point of Roosevelt Island, in the middle of the East River in New York City, the 4-acre park opens to the sky and faces Lower Manhattan. To the west – across the river – is the United Nations complex. Kahn explained that he envisaged the project as not in itself architectural but rather as intended to have an architectural effect – one that also resounds on a very human, intimate level as 'an extension of self.'[2] The visitor approaches the park from the north, climbing an imposing set of steps. At the top, a spectacular view presents itself: a sharply tapering open lawn that slopes downwards and is framed on either side by a double row of trees. The dramatic perspective of this inclined wedge is heightened by dazzling trompe-l'oeil effects and focuses attention to the end point, where a bust of Roosevelt is framed by a block of white granite. Inscribed on the reverse are extracts from Roosevelt's famous speech, in which he set out the four freedoms which everyone in the world should enjoy: freedom of speech, freedom of worship, freedom from want and freedom from fear.

The monument is a powerful statement of Kahn's belief in the emotional power of abstraction. Passing beyond the portrait bust, the visitor enters a roofless space framed by mammoth blocks of white North Carolina granite. The 28 individual stones that make up the walls are separated by a slight but exact 1-inch gap, and each stands at more than 3.5 metres high and weighs 36 tons. This open 'room' is a place of stillness and contemplation, evoking a sense of antique monumentality and spiritual awe.[3]

1 Louis I. Kahn, '1973: Brooklyn, New York', lecture at Pratt Institute, New York, 1973, in *Louis I. Kahn: Writings, Lectures, Interviews*, ed. Alessandra Latour (New York: Rizzoli, 1991), p. 321.
2 Ibid.
3 For more information see Belmont Freeman, 'Past Perfect: Four Freedoms Park', *Places Journal*, www.placesjournal.org, November 2012.

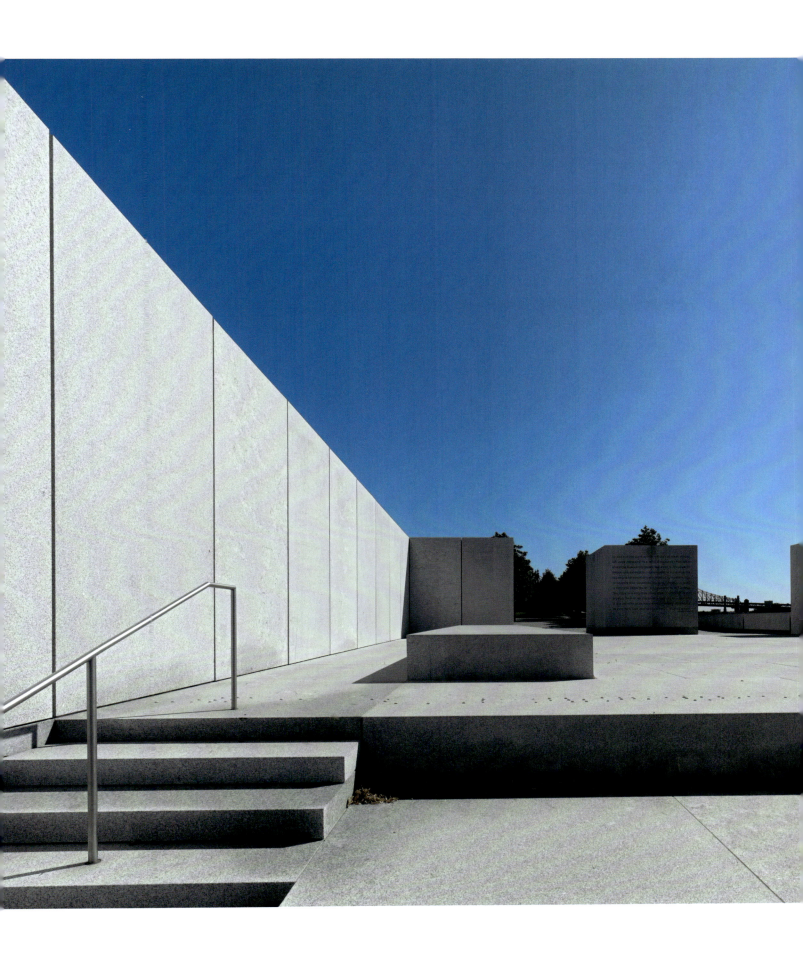

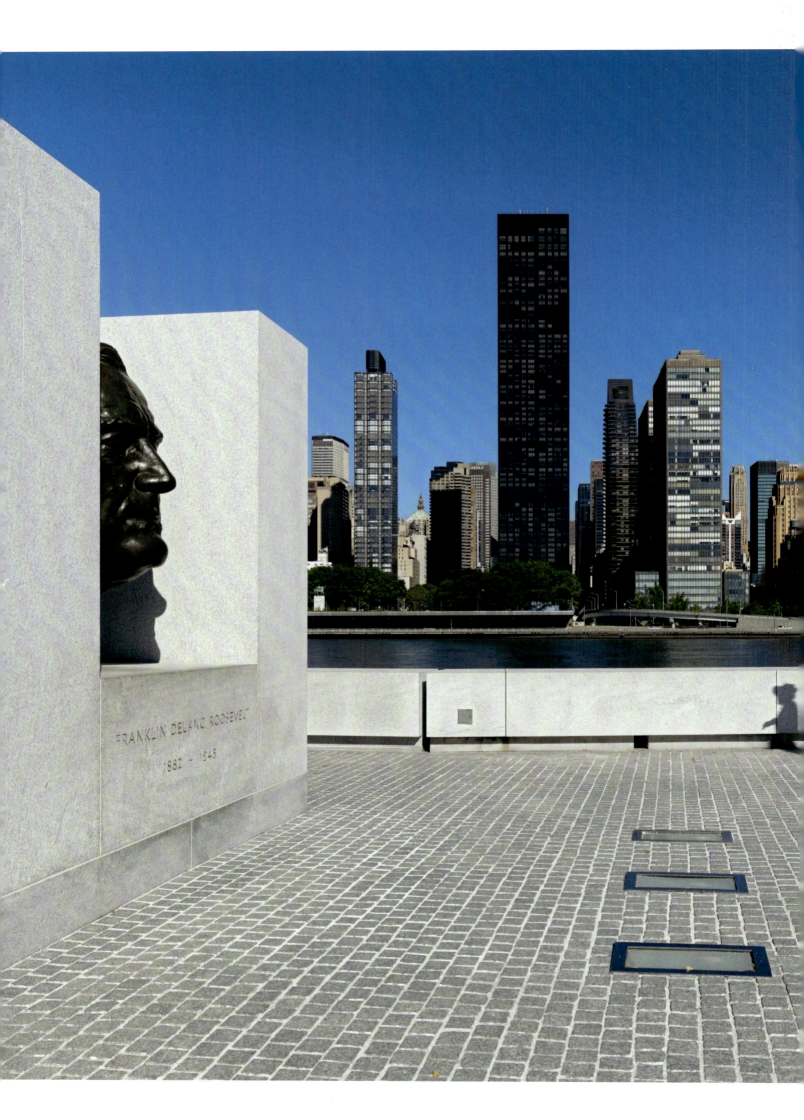

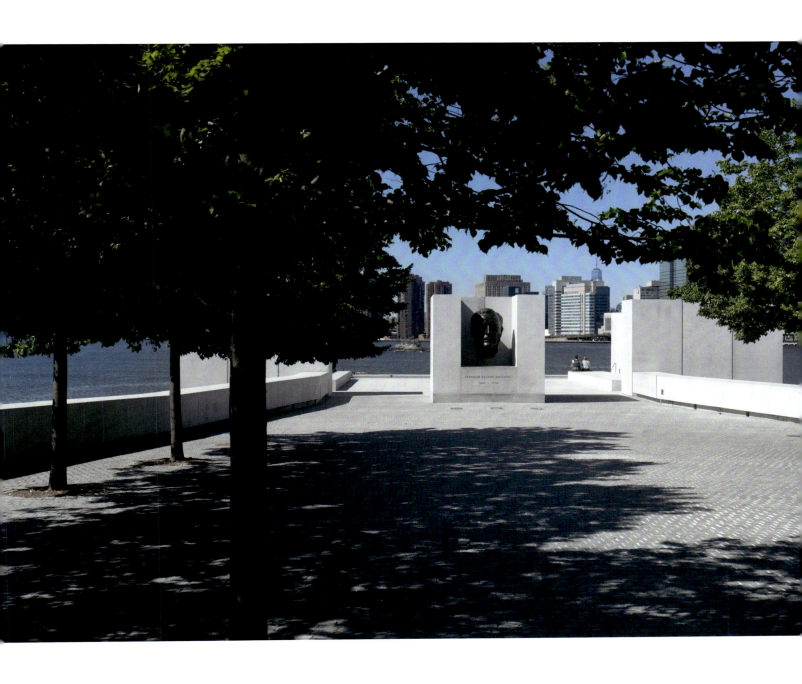

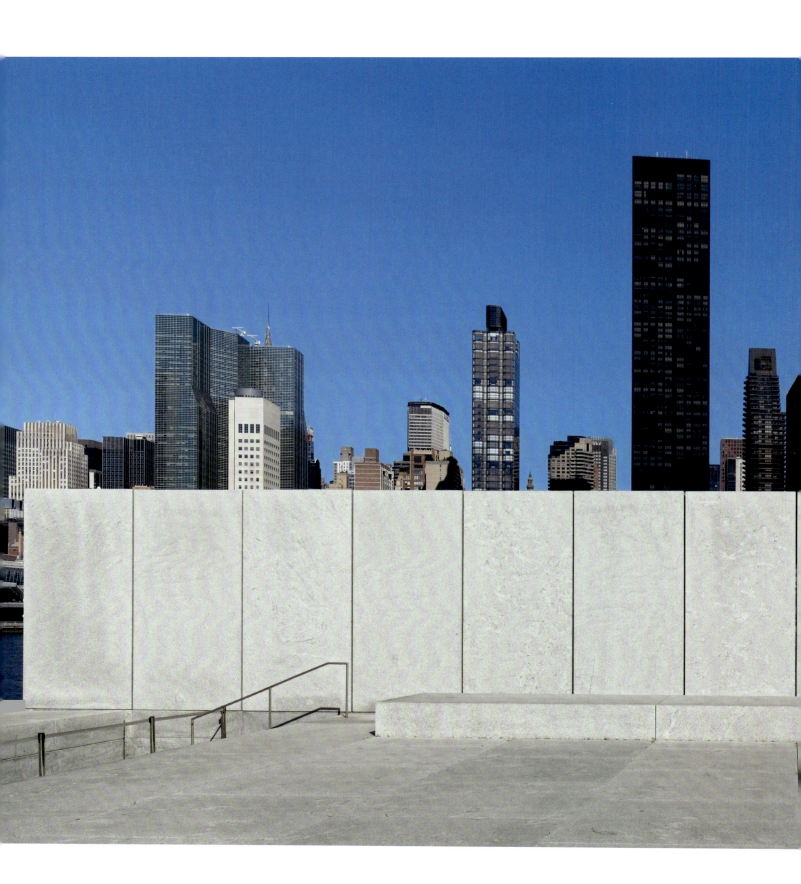

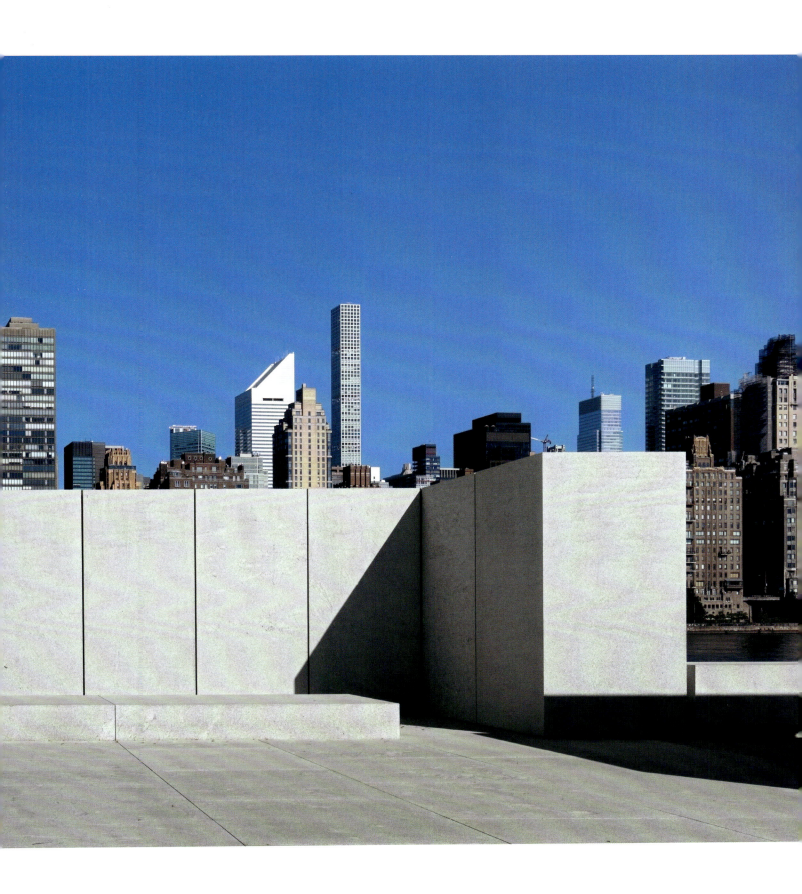

Reflect then on what characterizes abstractly House, a house, home. House is the abstract characteristic of spaces good to live in. House is the form, in the mind of wonder it should be there without shape or dimension. A house is a conditional interpretation of these spaces. This is design. In my opinion the greatness of the architect depends on his powers of realization of that which is House, rather than is design of a house which is a circumstantial act. Home is the house and the occupants. Home becomes different with each occupant.

Louis Kahn, 'Form and Design', 1961[1]

RESIDENTIAL PROJECTS

From 1942 to 1973 Louis Kahn designed some thirty houses, all located in the northeastern United States and in particular around Philadelphia. Of these residential projects, barely half were actually constructed. An analysis of the corpus will allow us to define his strategies of implantation in the site and his conception of the appropriate space in which to unite a very small community, the family. The individual houses also bring Kahn's basic architectural principles to light. Whether in public buildings or private residences, the architect isolated concepts which he then adapted for use at all scales, from the domestic to the monumental.

After building public housing projects in his first twenty years of practice – 'binuclear' type residences, composed of two wings linked by an entrance hall (a characteristic of American architecture in the early 1940s, particularly in the work of Marcel Breuer) – Kahn set out in a new direction in the early 1950s. His search did not originate in abstraction or geometric eloquence but rather evolved from a metaphor of growth. For Kahn, suspicious of the subjective nature of composition, the idea of growth offered the benefits of a dynamic process, a condition of 'emergence' coupled with an internal generation of forms. Through internally generated form, he hoped to escape the ephemerality of personal expression in favour of a timeless, universal architecture. Kahn's architecture was not conceived from this metaphor alone, however. He rediscovered the room as the fundamental unit of architecture. Combined with his notion of growth, this apparently benign finding held a radical implication. Intrigued by the coincidence of space and structure, he experimented with the notion of a repeatable 'unit' as the fundamental component of architecture, the 'cell' of his biological growth metaphor, taking the square as datum. These square units are organised according to a functional hierarchy, distinguishing the principal (served) areas from the secondary (servant) ones.

The houses were the proving grounds for this new formal and structural expressivity. Here Kahn searched for the generative core of his entire architecture. Indeed, he developed his reflection on the repetition of the square unit while designing the Fruchter, Adler and DeVore houses (1951–54, 1954–55 and c. 1954–55, respectively, unbuilt). At first he juxtaposed square modules;[2] then he adopted a centralised organisation, with a square perimeter surrounded by smaller squares. The Trenton Bath House, the Clever house (1957–62) and the Goldenberg house (1959, unbuilt) adopt this principle of spatial organisation around a patio, exemplifying the notion of cluster.

The choice of material shares in this quest for monumentality. Mass confers sculptural force and memorability. Because they lend a certain thickness and an impression of stability, raw, roughly hewn stones are impressive to the eye, whether they are used for walls or for the base of a fireplace and chimney (as in the Weiss[3] and Fisher houses). Kahn always insisted on immediately revealing how a building has been constructed. The readability of the framework should allow one to distinguish the weight-bearing elements and the fill-in panels. This same logic of constructive honesty led him to leave his materials in their raw state, their textures and optical qualities forming the sole ornaments of the outer wall. Brick, stone and wood enter into a harmony, offering a peculiar type of skin that captures the light more intensely than a treated surface whose natural roughness has been smoothed out.

For each of these houses, Kahn installed two different systems for opening and closing the windows, depending on whether the window is at the back of the house or in front along the street. He attempted to respond to his clients' preoccupations with independence and privacy. He imagined a system of openings that would allow the inhabitant to 'check' the visitor – seen for example in the T-shaped window of the Esherick House. As with his public buildings, Kahn assigned his houses a role as a kind of sundial, whereby they reveal the transformation of the light at each hour of the day and through each season of the year.

Kahn's houses were not merely a prelude to his major public works; he conceived them in parallel to those projects. The two influenced each other reciprocally and were treated by the architect with the same care, the same slowness and the same hesitation. One senses the intense progression of his thought from project to project, always culminating in a new work.[4]

1 Louis I. Kahn, 'Form and Design' [1961], quoted in Caroline Maniaque, 'Essays on Residential Masterpieces: Louis I. Kahn', *GA Houses*, 44 (1994), p. 12.

2 In the DeVore house plan of 1954–55 (unbuilt), six squares are organised about a linear wall. Each square is defined by six columns, three to a 'side', with the 'back' and 'front' faces column-free. The resulting pavilions are joined in a variety of ways: side to side, front to front, column to column. For the sake of articulation, the structure is duplicated, resulting in either a thickened wall (as between the centre pavilion and its two flanking pavilions) or an interstitial space (occupied by a fireplace). Kahn takes advantage of the spaces between columns to slip in functional bands that hold the servant spaces – stairwells, bathrooms, kitchens, closets – thus freeing the rest of the space. The effort to rationalise the space crystallises in the geometrical forms and in the distinction between served and servant spaces.

3 Morton and Lenore Weiss House, 1947–50, East Norriton, Pennsylvania. Kahn worked on the project with Anne Tyng.

4 See Maniaque, 'Essays on Residential Masterpieces', pp. 10–33.

Elkins Park, Pennsylvania
1940–42

JESSE AND RUTH OSER HOUSE

Wynnewood, Pennsylvania
1948–51

SAMUEL AND RUTH GENEL HOUSE

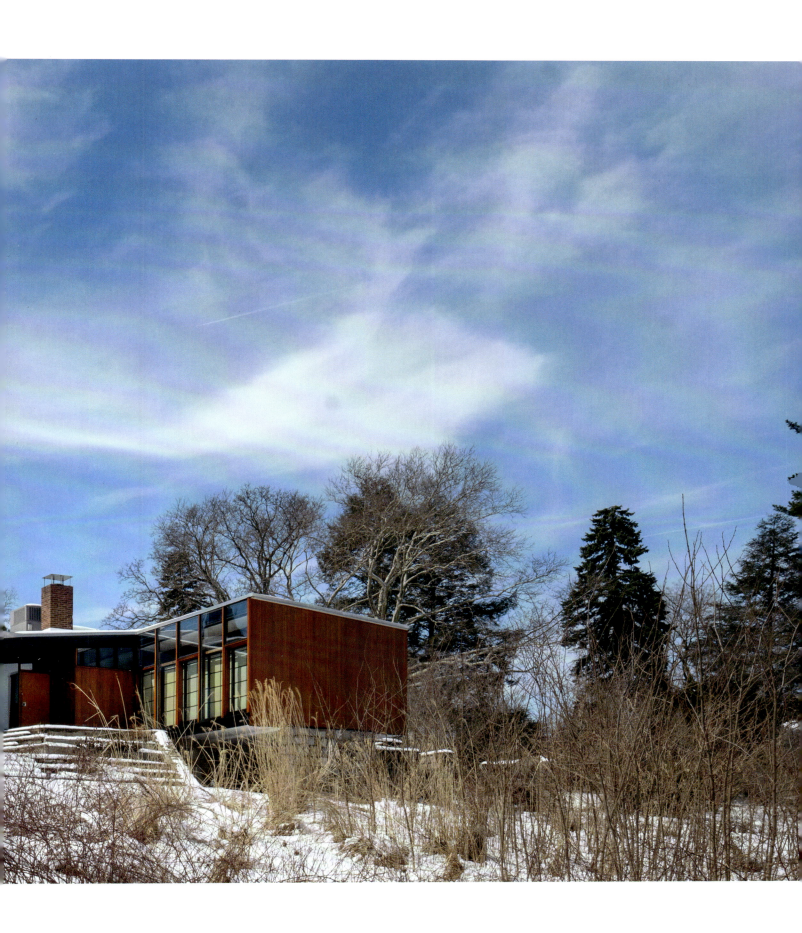

Narberth, Pennsylvania
1956–62
(Addition by Kahn and
Anne Tyng, associate architect,
1972–75)

BERNARD AND NORMA SHAPIRO HOUSE

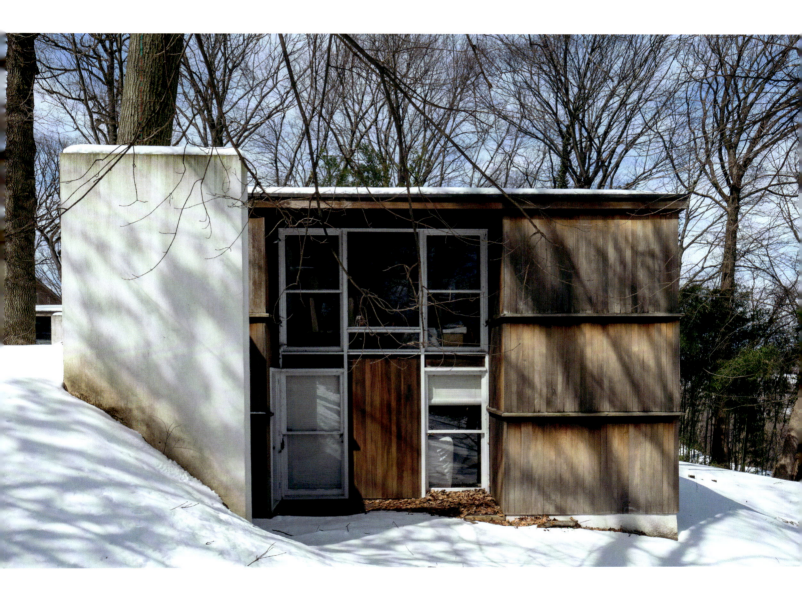

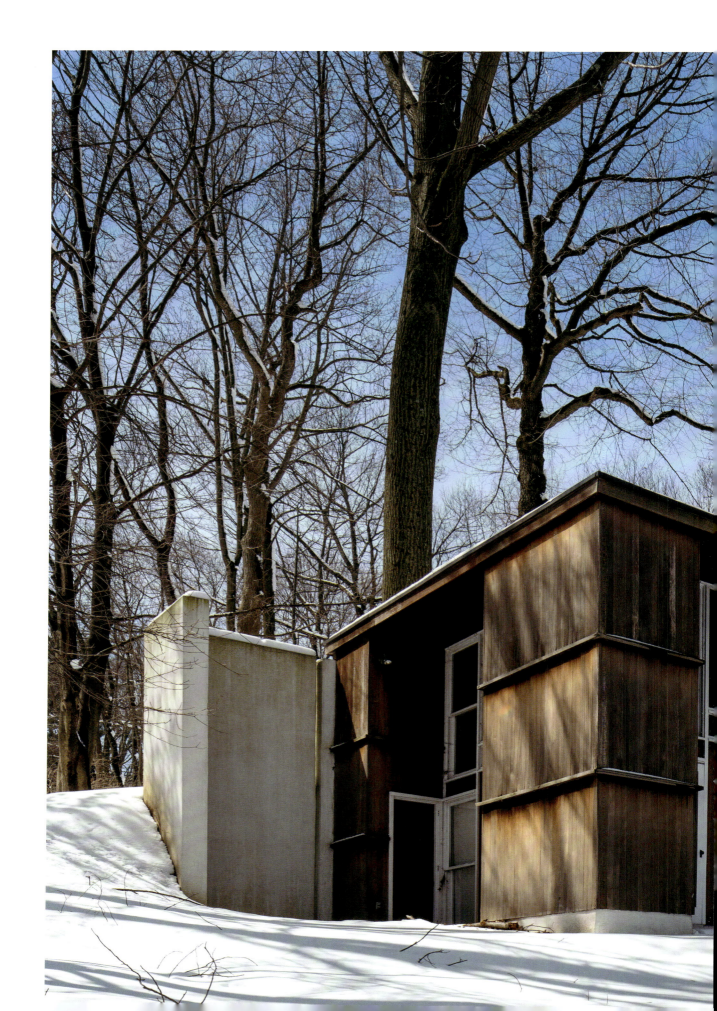

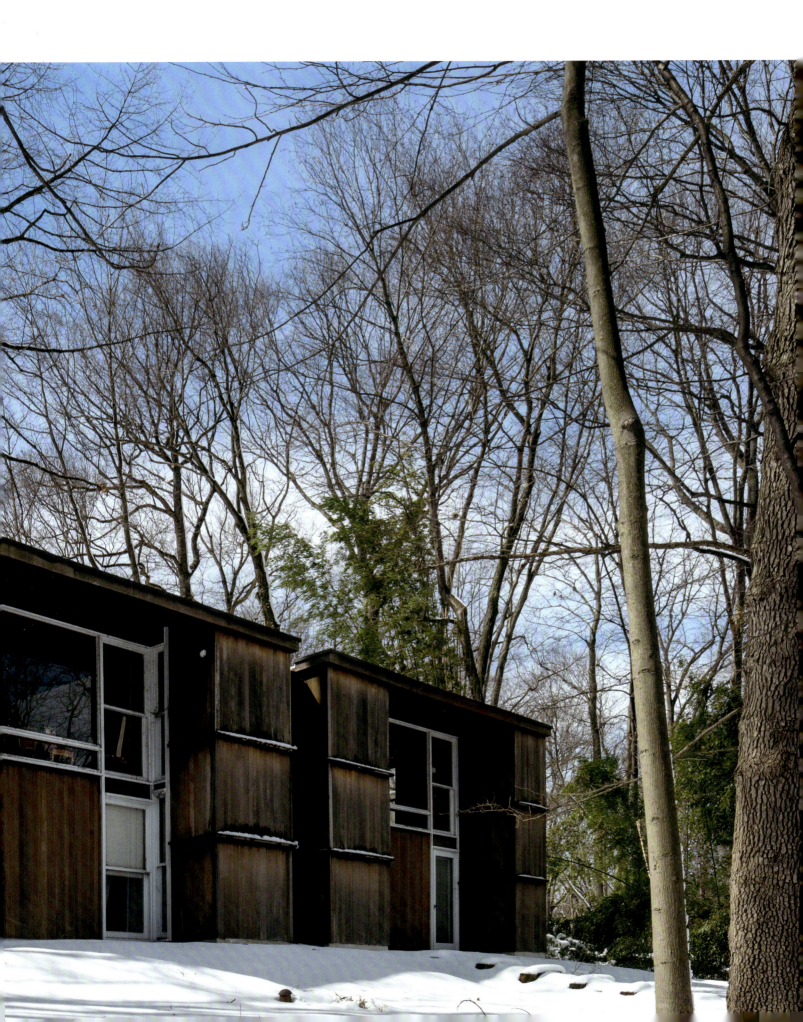

Cherry Hill, New Jersey
1957–62

FRED E. AND ELAINE COX CLEVER HOUSE

Hatboro, Pennsylvania
1960–67

NORMAN AND DORIS FISHER HOUSE

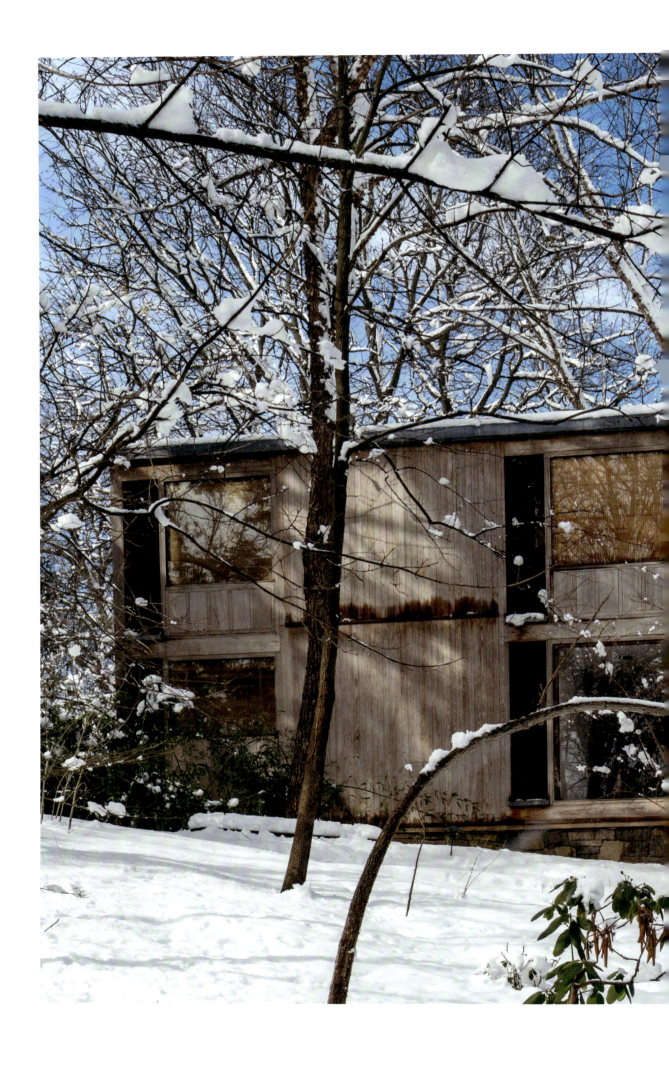

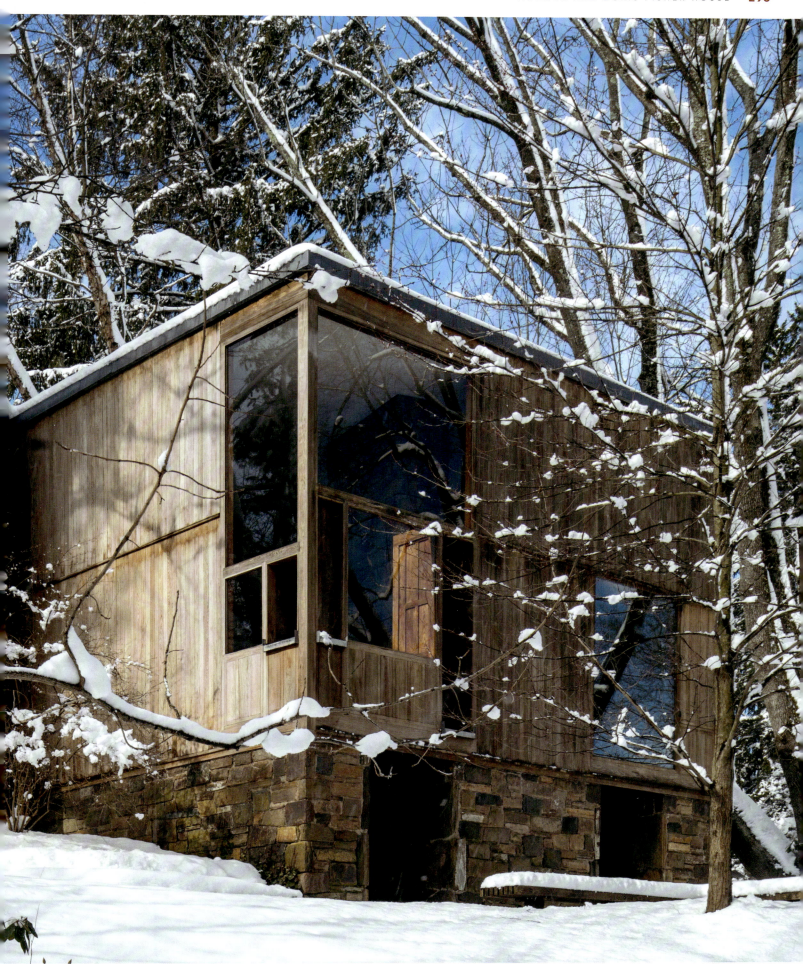

Ayşe Zekiye Abalı

THE TIMES AND WORKS OF LOUIS KAHN

Louis Isadore Kahn was born Leiser-itze Schmulowsky in 1901 in Pärnu, Estonia (at the time, part of the Russian Empire). His family emigrated to the USA in 1906 and settled in Philadelphia, Pennsylvania, where Kahn would live until he passed away in 1974. A seminal figure in mid-century American modernism, he is known for developing a massive, monumental and geometric architecture in a style all his own. He utilised novel concrete technologies in diverse ways as well as traditional materials such as stone, brick and timber. He was also an inspiring design critic and architecture professor who taught at Yale School of Architecture and the University of Pennsylvania, among other institutions. In 1966, the University of Pennsylvania appointed him Paul Philippe Cret Professor of Architecture, after the teacher who had once taught him at the same university. Among the awards he received during his lifetime were the AIA Gold Medal in 1971 and a Royal Gold Medal from the Royal Institute of British Architects in 1977.

Kahn's formative years coincided with periods of great transition and upheaval both in the United States and across the world. He started life as a talented yet disadvantaged immigrant in an economically and politically turbulent world. Philadelphia, at the time of Kahn's arrival, was home to a mixture of both the most elite and the most disadvantaged populations. His family lived in Northern Liberties, a slum neighbourhood filled with European immigrant families, and in the following years they moved frequently. Kahn's devotion to the improvement of housing conditions in his later years may be rooted in this aspect of his early life. During the years preceding and following the Second World War, sufficient housing was a critical issue, and social policies across the major cities of Europe allowed architects to work on experimental mass housing projects. In the US, during the New Deal period inaugurated by Franklin D. Roosevelt in 1933, efforts were made in the same direction through institutions such as the United States Housing Authority (USHA). In the later 1930s, Kahn would work as a technical adviser to the USHA as well as for the Philadelphia Housing Authority. A fine artist, he also illustrated booklets for the USHA, and prepared two primers on the topic of post-war planning, of which more than 100,000 copies were distributed. He also engaged in activism: in 1940, with Edmund Bacon, later executive director of the Philadelphia City Planning Commission, Kahn organised a public protest for the improvement of housing conditions in Philadelphia.

Between 1933 and 1945, Kahn, either as an employee or as team leader of the Architectural Research Group, developed 27 mass housing projects to be submitted to housing authorities or sponsored competitions. Very few of these schemes were realised, but some were exhibited or published, and one in particular, the Jersey Homesteads project for a

cooperative development of low-cost housing for Jewish garment workers, along with a factory, school and shops – which Kahn took part in as a co-designer with Alfred Kastner for the Resettlement Administration – was highly praised and included in an exhibition at the Museum of Modern Art, New York, in 1937.

In the late 1930s and 1940s, in addition to his work with the Architectural Research Group, Kahn partnered with the modernist architects George Howe and Oscar Stonorov (from 1941 to 1947, solely with Stonorov). They worked hard but had little success in realising their projects during these difficult years; as an example, in 1945 – a busy year for them – Kahn and Stonorov worked on seventeen projects. Of these, only four were built to their design; three others were alterations and/or additions to existing buildings, and one was an unrealised competition project. The war years were surely hard for everybody, but details such as these reveal an architect devoted to his work, without discriminating against minor jobs, and for whom material gain or fame were not important.

Kahn also designed numerous private houses throughout his life, the first known example being the Jesse and Ruth Oser House in Elkins Park, Philadelphia, built in 1940–42. This was a modest residence compared to those he would undertake from the 1950s onwards, such as the Margaret Esherick House of 1959–61. Again, the number of unbuilt houses exceeds the number of built ones, and Kahn might spend a year or two working on a single project that then did not reach construction.

At a young age, and at a time when long-distance flights were not easily afforded or accessed, Kahn travelled overseas. Such trips were an enormous source of inspiration and learning for him. Kahn's first tour of Europe took place in 1928, just prior to the Depression, and he visited more than twenty cities. That a young graduate from a poor family successfully embarked on a trip like this seems incredible, and most likely he achieved it by taking jobs that might have been considered menial by others. We know that he did not mind taking illustration jobs or playing piano for entertainment. With knowledge of his European roots coming only from family stories, Kahn was determined to study European civilisation through his own artist's and architect's point of view. He produced numerous drawings on this trip, and his later travels in North America were also inspirational occasions for drawing and painting. He also paid a short visit to Palestine in 1949 to advise on emergency housing. His second stay in Europe, in 1950, was for academic purposes – as a resident architect at the American Academy in Rome – but he and his peers journeyed to Egypt and Greece, trips that surely introduced him to the landscape, colour and light qualities of the Mediterranean, along with the monuments of antiquity.

Kahn's achievements as an architect are equalled only by his success as a studio master. Starting in 1947, Kahn undertook part-time teaching work at Princeton and Yale. In 1955, a one-year master's programme was established solely for Kahn at the University of Pennsylvania's School of Fine Arts. His charismatic personality, together with his teaching style, attracted many students. His approach was not merely to teach; assuming the presence of a 'soul' in materials, loads, structures and light and shade, his mode of perception opened the eyes of his students to new ways of looking at their environment.

Much has been written of Kahn's major architectural works after 1951, when he achieved fame with the Yale University Art Gallery project. However, his own, very particular architectural approach was realised in the Trenton Bath House for the Jewish Community Center in Ewing Township, New Jersey, built in 1954–59. During this latter phase of his career, we see Kahn taking fewer contracts but from more powerful clients, allowing him to build with finer materials and detailing. Yet there were nevertheless some important projects that went unrealised. Among them, the City Tower Project and Market Street East Studies (1960–63), the International Bicentennial Exposition Master Plan (1976) and the related Independence Mall Area Redevelopment (1972–74) were all intended as contributions to his home city of Philadelphia, where his practice was rooted.

When Kahn was found dead of a heart attack in Penn Station, New York, on 17 March 1974, he was carrying in his briefcase drawings for a contract he had received a year earlier: the Franklin D. Roosevelt Four Freedoms Park. Having lived through the Great Depression and the war years, and having worked on so many New Deal housing projects, Roosevelt was an important figure for Kahn, who had in fact been working on an idea for such a monument since 1960. Devoted to this project because of the social ideas for which it stood, Kahn unveiled his design at a grand gala in New York in 1973; and it was finally completed in 2012 by David Wisdom & Associates and Mitchell/Guirgola. I hope the following chronology may inspire the reader to identify new connections and finer details in the times and works of this hard-working, self-made architect, artist, thinker, musician and studio maestro.

A Note to the Reader on the Chronology

The website of the Philadelphia Architects and Buildings project (PAB) provides access to a database that includes some 222 projects listed under 'Louis Isadore Kahn'. This number alone suggests the breadth and intensive nature of the architect's career, to say nothing of the paintings he produced, the many journal articles and pamphlets he published, his participation in conferences and his teaching activity. In creating this list, our main criterion was to identify not only the buildings Kahn designed and realised, but also the sometimes lesser-known buildings with which he was involved as designer or consultant architect. Even if they were later demolished or altered, every built work was to be included. However, the many additions, extensions, remodelling schemes and even refurbishing projects on which Kahn worked have been excluded, except one: the Samuel Radbill extension to the Philadelphia Psychiatric Hospital, for it can be considered a building of its own. We cross-checked this list against similar chronologies in other sources; and on occasion combined projects under a single entry, as in the case of the two barge projects, *Point Counterpoint* and *Point Counterpoint II*. Certain of Kahn's commissions were developed by other architects after his death in 1974, based on his original sketches. If built, even if many years later – such as the Franklin D. Roosevelt Four Freedoms Park – they are included here.

Though we intended to include an image for each entry, it has not always been possible. Certain of Kahn's works from the Depression and Second World War years were not well documented, and where images exist they are often in poor condition. Other entries lack photographs because they were redevelopment projects for larger sections of Philadelphia, and they cannot be represented in a single image; where possible, we have included drawings by Kahn that represent the initial concept for a project rather than the end result.

Chronology

Sesquicentennial International Exposition
1925–26
Philadelphia, Pennsylvania (demolished)

John Molitor, city architect of Philadelphia, supervised the design of all the buildings for this world's fair, which opened in 1926 in League Island Park (now Franklin Delano Roosevelt Park). Kahn was employed as chief draftsman on the project. Kahn also designed, in association with Herman Polls, the Textile Industries Exhibit in the exposition's Palace of Fashion.

Jersey Homesteads
1935–37
Hightstown, New Jersey

Kahn was recruited by Alfred Kastner as assistant architect for this programme to rehouse Jewish garment workers from New York and Philadelphia. The project was sponsored by the Resettlement Administration, one of the New Deal agencies created by Franklin D. Roosevelt during the Depression years The architects built 200 low-cost homes using lightweight prefabricated elements; and the radical

development was cooperative, with a factory, farm, stores, school, pumping station and sewage plant also on site. Throughout his career Kahn worked on numerous housing and slum clearance projects for the Philadelphia Housing Authority as well as serving as a technical adviser to the United States Housing Authority (USHA) in the 1930s. Lewis Mumford singled out the Jersey Homesteads project as 'If not the best, surely the most adventurous, the most stimulating'[1] when it was included in the *Architecture in Government Housing* exhibition at the Museum of Modern Art, New York, in 1937.

Ahavath Israel Synagogue
1935–38
Philadelphia, Pennsylvania

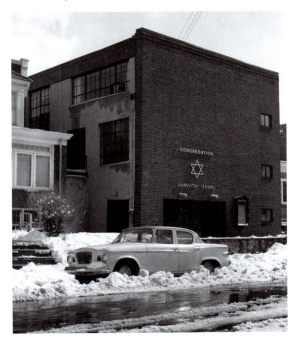

Kahn's first contract after passing his architectural registration examination in 1935 was this synagogue for Congregation Ahavath Israel in the Oak Lane area of Philadelphia. The modest neighbourhood synagogue is now the Grace Temple Church, its facade changed beyond recognition.

Jesse and Ruth Oser House
1940–42
Elkins Park, Pennsylvania

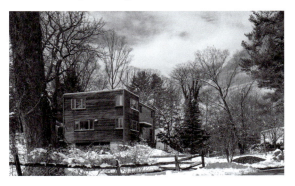

The first known private house Kahn designed was for his friends Jesse and Ruth Oser. Kahn made use of the north-facing slope of the site to create a two-car garage beneath the house, which is a two-storey cubic mass that opens out to the south and is clad in local stone and wood. The ground floor is open plan and accommodates the living, dining and kitchen areas, while the upper level houses the bedrooms. Owing to the limited financial resources of Kahn's clients the outcome was a relatively modest house, but when it was finished the *Philadelphia Inquirer* described it as 'a marvel of compactness'.[2]

Pine Ford Acres
1941–43
Middletown, Pennsylvania (demolished)

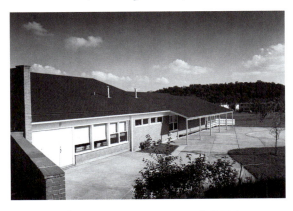

Pine Ford Acres was a group of 450 low-cost units designed by Kahn in partnership with the prominent modernist architect George Howe. Commissioned by the Defense Housing Division of the Federal Works Agency (FWA), the development also included community and maintenance facilities.

Pennypack Woods
1941–43
Philadelphia, Pennsylvania

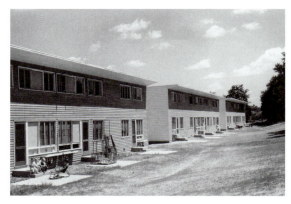

In 1941, Kahn and Howe partnered with the German-born modernist Oscar Stonorov, and together they undertook the design of government housing projects for low-income workers, although not all were realised. One completed scheme was Pennypack Woods, created for the USHA. As well as housing, the development included a community centre and shops. In 1942 the USHA was redesignated as the Federal Public Housing Authority (FPHA) and along with the FWA was consolidated under the new National Housing Agency (NHA).

Carver Court
1941–43
Coatesville, Pennsylvania

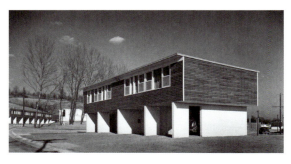

This wartime scheme of wood-panelled apartments and duplexes was designed to house 100 African American steelworkers and their families. The two-storey buildings incorporated services and carports on the ground floor. The rural development included community and administrative buildings and shared public spaces and was again designed by Kahn in association with Howe and Stonorov for the FWA's Defense Housing Division.

Lily Ponds Housing
1942–43
Washington, DC

This large development of 475 homes was designed by Kahn, Howe and Stonorov for the Alley Dwelling Authority, a government-funded programme that renovated and redeveloped the alleys of Washington, DC, where many residents were African American and where living conditions were poor.

Lincoln Highway Defense Housing
1942–44
Coatesville, Pennsylvania

This community of 44 dwellings as well as a community administration building was designed for the FPHA by Kahn, Howe and Stonorov. It is still extant today.

Health Center, International Ladies' Garment Workers' Union
1943–45
Philadelphia, Pennsylvania

By the 1920s, the International Ladies' Garment Workers' Union was one of the largest labour unions in the USA. Its health centres in large cities across the country provided free health care for its members, and Kahn and Stonorov were awarded the contract to build the Philadelphia branch. The building was later altered and is now used as law offices.

Prefabricated Houses, William H. Harman Corporation
1945–47
West Chester, Pennsylvania (demolished)

In response to the significant demand for low-cost housing in the post-war period, the private firm of William H. Harman invested in the development of novel prefabrication methods. Kahn worked in association with Stonorov on a scheme of prefab homes in West Chester, Pennsylvania, several of which were built.

Dormitories, Camp Hofnung
1945–47
Pipersville, Pennsylvania (demolished)

Camp Hofnung was a Jewish union-sponsored children's camp established in 1927. In 1946, Kahn joined the National Jewish Welfare Board's building bureau, which oversaw the architectural aspects of the organisation's community and social activities. Kahn, still in his partnership with Stonorov, built two modest timber-frame buildings at Camp Hofnung in response to a commission for two dormitories.

Philadelphia Building, Unity House
1945–47
Bushkill Township, Pennsylvania

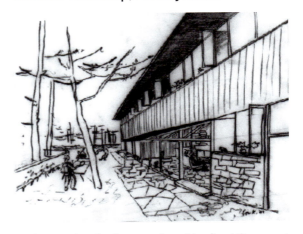

In the 1920s, the International Ladies' Garment Workers' Union bought and renovated a former resort hotel in Bushkill Falls, Pennsylvania, turning it into Unity House, an educational, leisure and cultural retreat for its members and those of other labour unions. Workers could take classes in English, literature and economics, hear speeches on the role of women in the trade union movement, and enjoy sports and concerts. In 1945, Kahn and Stonorov were

commissioned to add a country-style recreation centre and, later, a dormitory building. The resort closed in 1990.

Philip Q. and Jocelyn Roche House
1945–49

Whitemarsh Township, Pennsylvania

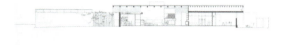

Located on a large plot just beyond the northwest boundary of Philadelphia, the Roche House is a single-storey rectangular building with a simple layout: bedrooms on one side and the living area on the other. The two zones are expressed through varying degrees of openness and demarcated by a brick fireplace that protrudes at an oblique angle from the exterior wall while creating a cosy alcove inside. Kahn worked with Stonorov on this early residential project.

Memorial Playground, Western Home for Children
1946–47

Philadelphia, Pennsylvania (demolished)

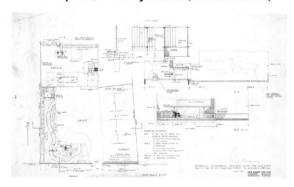

In 1946, Kahn and Stonorov designed a playground for the Western Home for Children. The urban site in the historic centre of Philadelphia incorporated sculptural forms and multilevel areas as well as play facilities.

Greenbelt Co-op Shopping Center
1946–48

Greenbelt, Maryland

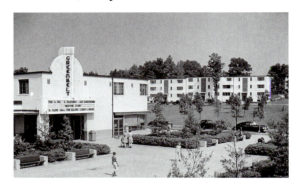

The federally planned community of Greenbelt, Maryland, was established in 1935 under the New Deal programme. The resident-operated Greenbelt Consumer Services ran its numerous cooperative businesses, beginning with a grocery store. This was later developed into a large shopping centre. Kahn worked on the project as design consultant to the architects Ross & Walton.

Coward Shoes
1947–49

Philadelphia, Pennsylvania (demolished)

In 1949 Kahn and Stonorov (as lead architect) completed construction of a glass-fronted, modernist shoe shop at 1118–1120 Chestnut Street, Philadelphia. The building was demolished in 2015.

Morton and Lenore Weiss House
1947–50

East Norriton Township, Pennsylvania

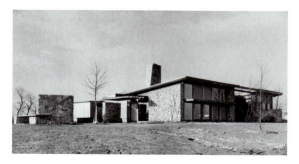

At the Weiss House, located on a hilltop with scenic views in all directions, Kahn used rough stone masonry and timber to express his

intention for 'a house that is contemporary but does not break with tradition'.³ He again utilised a rectangular scheme, with the circulation and service areas forming a longitudinal backbone between the living and dining areas in the west and the sleeping areas in the east. At the centre of the living zone, a fireplace and inglenook divides the dining and living areas. Kahn also created an innovative glass and panel window system that allowed the light to be altered, and along with Anne Tyng created a mural for the wall next to the chimney. In 1951 the Philadelphia Chapter of the American Institute of Architects (AIA) awarded the Weiss House a gold medal in its annual exhibition.

Samuel and Ruth Genel House
1948–51
Wynnewood, Pennsylvania

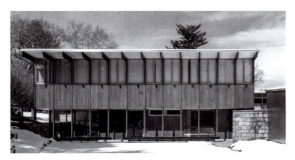

At the Genel House – another private residence in suburban Philadelphia – Kahn carried forward many aspects from the Weiss House. The exterior is defined by the contrast between the rough stone of the walls and the carefully modulated California redwood sidings and posts. The H-shaped plan comprises two rectangular volumes connected by a space for the entrance, circulation and staircase. The single-storey block to the north accommodates the living, dining, kitchen and maid's quarters, while the other wing has a playroom and garage in the lower level and sleeping quarters above. The fireplace, which juts into the hallway, is a large, free-standing mass of Carrara marble and black slate, directing the path of circulation around its triangular form.

Bernard S. Pincus Occupational Therapy Building, Philadelphia Psychiatric Hospital
1948–51
Philadelphia, Pennsylvania

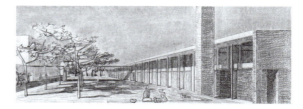

In 1948–51 Kahn built this single-storey auditorium and occupational therapy building for the Philadelphia Psychiatric Hospital, working with hospital consultant Isadore Rosenfeld. He employed a double-height, movable panel window system similar to the one he had used at the Weiss House, while the structure was a light steel open-work frame – the last time Kahn built in metal.

Samuel Radbill Building, Philadelphia Psychiatric Hospital
1948–54
Philadelphia, Pennsylvania

In 1948–54 Kahn also designed a three-storey extension to the existing Philadelphia Psychiatric Hospital. The concrete block features horizontal tile sun-shades and a triangular entrance canopy. Kahn again worked on the project with Rosenfeld.

Jewish Community Center
1948–54
New Haven, Connecticut

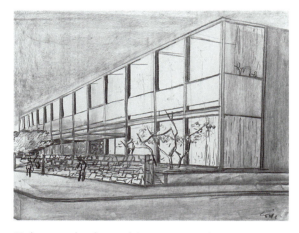

Kahn worked on this community centre on Chapel Street, New Haven, as consultant to the architects Jacob Weinstein and Charles Abramowitz. After undergoing adaptive reuse works in the late 1990s, the long derelict building reopened as the Holcombe T. Green Jr Hall, home to the Yale School of Art.

Southwest Temple and East Poplar Redevelopment
1950–52
Philadelphia, Pennsylvania

In the post-war years, Philadelphia city centre was in urgent need of renewal due to rapid mass suburbanisation. With Kenneth Day, Louis McAllister, Douglas Braik and Anne Tyng, Kahn formed Architects Associated, and together the team developed several urban renewal projects for the Philadelphia City Planning Commission. Two schemes were implemented: Southwest Temple and East Poplar.

University Redevelopment Area
1951
Philadelphia, Pennsylvania

In the early 1950s Kahn worked as part of Architects Associated (with Day, McAllister, Braik and Tyng) on a plan for the University of Pennsylvania, to expand and redevelop its campus in west Philadelphia. It was part of a post-war project for urban renewal in the vicinity run by the Philadelphia City Planning Commission. The plan was partially implemented.

Manufacturing Building, Container Corporation of America
1951–52
Upper Pottsgrove Township, Pennsylvania

In 1951–52 Kahn designed and built a factory for the Container Corporation of America, working with local architect Howard Carter Hill and Associated Architects. No imagery remains.

Yale University Art Gallery
1951–53
New Haven, Connecticut

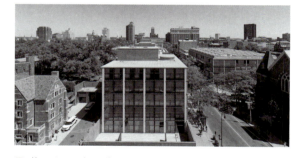

Following the donation of a collection of contemporary artworks to Yale University, a new building was planned to accommodate it; the university allocated a site next to the existing museum building and wanted the two to be connected. Kahn, who had taught in Yale's architecture department since 1947, received the commission with excitement: it was to be the first modern building on the campus, as well as his first major public work. He proposed a simple open-plan concept with a central band containing the stairs, elevators, bathrooms and

other 'servant' functions. The challenge lay in spanning the wide space, as steel was rationed in the USA as a result of the Korean War. Kahn devised a highly innovative ceiling: a poured concrete slab formed in a tetrahedral pattern. The new Yale University Art Gallery and Design Center, as it was originally called, also housed architecture studios on the fourth floor. With its use of exposed concrete and simple glass and steel facade, the building is an excellent example of the American modern movement, and in 1979 it was recognised by the AIA for the 'enduring significance' of its design. Kahn worked on the project in association with Douglas Orr.

Mill Creek Housing
1951–56
Philadelphia, Pennsylvania (demolished)

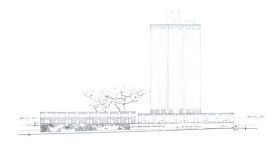

Kahn was hired to design an urban renewal plan and community housing for the Mill Creek area of Philadelphia, a predominantly African American neighbourhood. The first phase of the project, comprising three seventeen-storey buildings and additional low-rise homes, was built in 1951–56. Not all aspects of this controversial redevelopment plan were carried out, however, and the design was revised in the process. Kahn worked in association with Day, McAllister and Braik.

Greenbelt Knoll
1952–57
Philadelphia, Pennsylvania

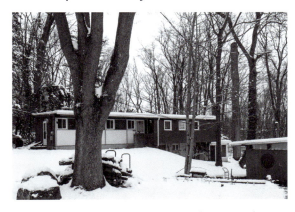

Kahn was involved as consulting architect to the firm of Montgomery & Bishop for this significant project in Philadelphia. The client, Morris Milgram, was a private developer and the project was to be the first racially integrated planned development in the city, with the planning documents specifying that 55 per cent of buyers should be white and 45 per cent non-white. The resulting houses were one-storey wood-frame family homes in a modernist style, with flat roofs and wood cladding. The design won numerous awards and is today listed in the US government's National Register of Historic Places.

Wheaton Co-op Shopping Center
1953–54
Wheaton, Maryland

Kahn worked as consulting architect to John Hans Graham, with Sweet & Swartz as associated architects, on this modernist shopping centre in Wheaton, Maryland.

American Federation of Labor Medical Services Building
1954–57
Philadelphia, Pennsylvania (demolished)

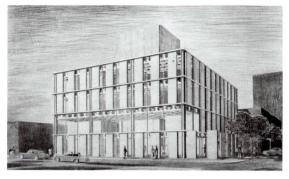

This health centre offered free health care to labour union members. It was an early example of Kahn's use of exposed V-shaped trusses.

Trenton Bath House and Day Camp, Jewish Community Center
1954–59
Ewing Township, New Jersey

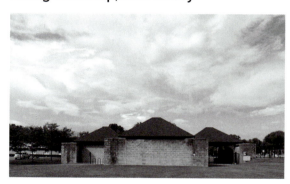

The Trenton Jewish Community Center commissioned Kahn in 1954 to build a complex on a new site in Ewing Township. Although Kahn worked out four schemes for the planned main building, this part of the project was later abandoned and only the so-called Bath House (which houses the lockers, showers and dressing rooms for the swimming pool) and pavilions for the centre's day camp were realised. Despite this displeasing result, the project was Kahn's first major architectural statement. For the Bath House, Kahn devised what he called 'hollow columns' – elements that are both structurally load-bearing and functional. The plan consists of four large square volumes forming a cross around an inner court. Each pavilion is topped with a truncated wooden pyramid roof, while square 'hollow columns' at each corner provide entranceways, storage areas and access to a basement vault. Anne Tyng collaborated with Kahn on the project, while Louis Kaplan was named as associated architect.

Mill Creek Housing
1956–63
Philadelphia, Pennsylvania (demolished)

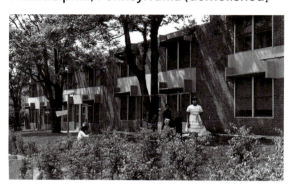

The second phase of Kahn's Mill Creek community housing project (with Day, McAllister and Braik) was completed in 1963 and was a scheme of two- and three-storey houses with a community centre. They were demolished in 2003.

Bernard and Norma Shapiro House
1956–62, 1972–75
Narberth, Pennsylvania

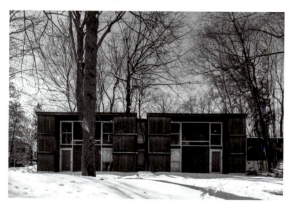

The front facade of the Shapiro House, located on a slope overlooking a valley, is almost blind, with only two doorways in the otherwise blank stucco walls, in accordance with the clients' wishes. Although the house has two levels, it appears to be single-storey from the

entrance approach; the rear split-level facade, which overlooks the scenery below, consists of large areas of glazing modulated by mahogany panels. The overall plan consists of two square units with a narrow central space incorporating the staircase and service areas. The two volumes have shallow pyramidal roofs and 'hollow columns' at the corners, similar to those at the Trenton Bath House. Kahn designed the house in association with Anne Tyng, and together they also carried out an addition and alterations in 1972–75.

Alfred Newton Richards Medical Research Laboratories and Biology Building, University of Pennsylvania
1957–60, 1957–65
Philadelphia, Pennsylvania

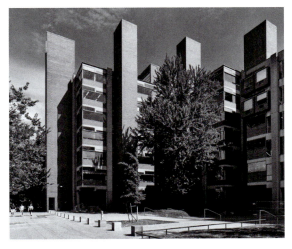

The Richards Medical Research Laboratories for the University of Pennsylvania were another technologically challenging building for Kahn, who approached the problem by further developing concepts he had utilised in the Yale art gallery project. The aim was to balance maximum flexibility in the laboratory spaces with the requirement for piping and ducting to supply them. Kahn conceived a scheme of three square towers, internally free of columns, placed around a central service block. The verticality of the eight-storey building was further emphasised by eight shafts, housing fire escapes and exhaust ducts, placed around the exteriors of the towers and well exceeding them in height. The prestressed concrete slabs, columns and trusses were developed with August Komendant, an engineer who worked with Kahn in subsequent projects. The second phase of the project, the Biology Building (now the David Goddard Laboratories), follows a similar structure of two towers and a service tower and is connected to the west end of the Richards building. The building marked a turning point for Kahn – who was by now almost sixty – and led to him receiving the Salk Institute contract.

Fred E. and Elaine Cox Clever House
1957–62
Cherry Hill, New Jersey

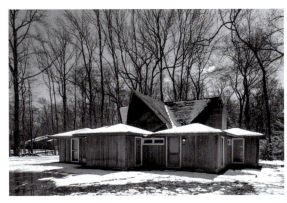

Situated on a flat, wooded site in the Cherry Hill suburb of Philadelphia, the Clever House was built at a time when Kahn had recently finished the important Trenton Bath House project and was beginning work on the Richards Medical Research Laboratories. His collaborator Anne Tyng thus had a large hand in the project, seen in particular in the unusual roof based on triangular geometries. Kahn and Tyng established a plan of a cruciform central area surrounded by six square units; each has an independent, gently sloped roof, while the high, steeply angled roof forms the ceiling of the central living area. This spatial contrast becomes particularly dominant from the exterior. Inside, clerestory windows provide plenty of natural light to the living space and add to the spacious effect.

Tribune Review Publishing Company Building
1958–62
Greensburg, Pennsylvania

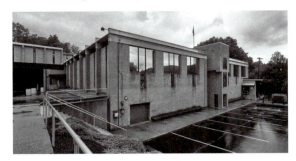

For the *Tribune-Review* newspaper headquarters, Kahn again used a concrete structure to leave the internal spaces free of support columns. The rectangular building was divided by a central 6-metre-wide service zone, creating two equal sections, one housing the offices and the other the printworks. The service area also provided a barrier from the noise created by the machinery. Kahn again worked with Komendant, who applied prestressed concrete beams to span each 15-metre-wide space, supported by piers along the sides. Ample natural light is provided by narrow vertical slit windows together with 'keyhole' windows, larger at the top, to give light mainly from above.

Margaret Esherick House
1959–61
Philadelphia, Pennsylvania

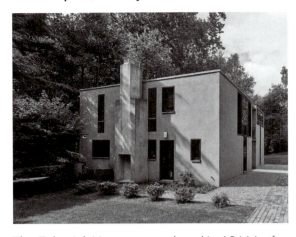

The Esherick House, completed in 1961 in the Chestnut Hill area of Philadelphia, crystallises the architectural principles Kahn had developed in the preceding years. The house is a rectangular concrete block with a flat roof and white stucco facades. However, the simple mass exhibits a complex play of natural light throughout the day, both on the exterior and inside. The deep inset windows – varying in size and shape according to the orientation and requirement for light – create a geometric order when seen from outside, while a full-height window and shutter system at the rear allows for variations in openness and ventilation. Doors inset within alcoves, with loggia-type balconies above, also contribute to the play of light. The plan clearly incorporates Kahn's method of served and servant spaces, with the double-height living area separated from the dining room with a single-flight staircase. The upper level accommodates the bedrooms. As in most of Kahn's private houses, the fireplace chimneys are visible from outside, on each end of the rectangular block.

First Unitarian Church of Rochester
1959–62, 1965–69
Rochester, New York

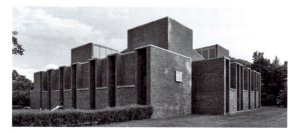

The First Unitarian Church originally occupied a nineteenth-century building in downtown Rochester, but when development forced the congregation to move, a new site was selected at the borders of the city. After the church committee consulted with other notable architects, Kahn won the contract. He designed a scheme incorporating a centrally located sanctuary surrounded by corridors on all sides. The main entrance is on the central axis of the brick building, but there are also side entrances. Classrooms for the church school, an ambulatory and service spaces are located around the perimeter corridor. The spatial quality of the sanctuary is created by the natural light that filters in from all four corners via huge light towers, visible from outside as four partially screened blocks. The only decoration in the cross-shaped space is a set of wall hangings, also designed by Kahn, representing the colours of the light spectrum.

Salk Institute for Biological Studies
1959–65
La Jolla, San Diego, California

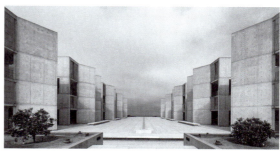

Epidemiologist Jonas Salk's work had resulted in 1954 in his development of the first polio vaccine, opening the way for him to establish a non-profit research institute. In 1960 the city of San Diego granted a site on a coastal cliff in La Jolla, and together Salk and Kahn, with Jack MacAllister from Kahn's firm, decided on a complex of three main sections: a research centre with laboratories and study rooms, a meeting centre and residences. Kahn's solution for the laboratory spaces was to use Vierendeel trusses with supports at the edges, creating not only wall- and column-free areas for working in but also interstitial service floors for all the required piping and ducting. The two monumental laboratory blocks face each other, creating an open courtyard between, oriented towards the setting sun over the ocean. The area was conceived in Kahn's early sketches as a planted garden, but after he invited Luis Barragán to visit the site, Kahn took up his remark that it should remain a paved plaza. Unfortunately, work on the project was terminated in 1965 and the meeting house and residences were never built.

Eleanor Donnelley Erdman Hall, Bryn Mawr College
1960–65
Bryn Mawr, Pennsylvania

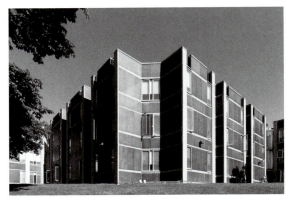

When Bryn Mawr College needed to expand its student housing, Kahn was commissioned to design a dormitory for 130 students. The requirements also specified a dining hall and one large and several smaller reception rooms. After several proposals, the result was three square towers oriented as diamonds and attached at the corners. At the centre of the buildings are communal spaces including the dining hall, meeting areas and living room, with the bedrooms in varying sizes and shapes encircling them on the periphery. The central spaces are lit by light towers at the corners of each square, providing ample natural light in the core. As in other Kahn buildings, the light towers dominate the three-storey main structure in height. The exterior is clad with a revetment of grey slate.

Norman and Doris Fisher House,
1960–67
Hatboro, Pennsylvania

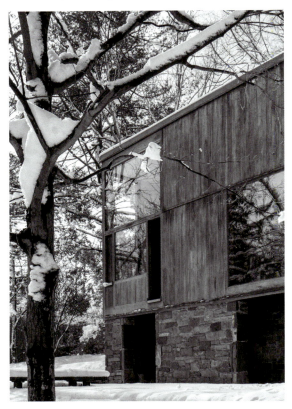

At the Fisher House, two cubes of identical dimensions are set at oblique angles from each other and connected near their corners. This creates a surprising location for the entrance corridor, which runs along the edge of the residential volume, into the heart of that junction. The cube to the north is a double-height living, dining and kitchen space with a diagonally placed free-standing fireplace. The cube to the south has two levels, with bedrooms, bathrooms and staircase. Kahn initially wanted to build part of the house in stone, but to cut down costs, the height of the stone wall was lowered, resulting in what Kahn described as 'a wooden house on a stone plinth'.[4] The blue-brown local stone walls, visible at the terrace on the lower side of the house, combine with the cypress siding above to create a harmonious effect.

Performing Arts Theater, United Arts Center
1961–73
Fort Wayne, Indiana

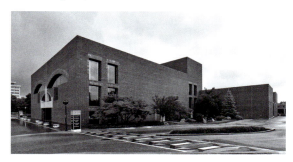

Originally known as the Fine Arts Foundation Civic Center, this project began as an ambitious programme for facilities including a 2,500-seat philharmonic concert hall, civic theatre, art school, gallery and reception centre. In his first studies, Kahn imagined separate buildings grouped around a central reception court. However, severe cutbacks in the budget resulted in the construction of only the Performing Arts Theater, with seating for 1,000 people. Kahn was not happy with this greatly reduced result, complaining that without the other buildings framing the entrance courtyards, the theatre was 'lonely and bare'.[3] The facade with its eye-like arched windows resembles a face or mask, and combined with the recessed entrance emphasises the way the brick exterior wraps around an internal core, a principle Kahn had used in other buildings. The theatre and offices were finalised in 1973 by T. Richard Shoaff, supervising architect.

Indian Institute of Management
1962–74
Ahmedabad, India

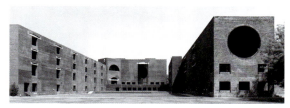

The famed merchant city of Ahmedabad in Gujarat, western India, became known in the twentieth century for its modernist buildings, including several by Le Corbusier and Frank Lloyd Wright. When the city decided to establish a world-grade school of management in 1961, the contract was offered to B. V. Doshi, a pioneer of modernism in India, who turned to Kahn to carry out the campus design; the pair also worked closely with leading architect Anant Raje. The resulting scheme consists of an education building with classrooms, offices, library and hallways around a court, giving a massive, fortress-like appearance with bold brick walls and buttresses, cut with deep openings. The dormitory blocks are distributed across the site with smaller courtyards and massive cylindrical stair towers. As a solution to climatic concerns, layers of shade are created by large circular openings in the walls, braced with concrete beams.

Sher-e-Bangla Nagar
1962–83
Dhaka, Bangladesh

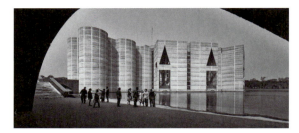

This monumental scheme for the central government of East Pakistan (later to become Bangladesh) was a fascinating opportunity for Kahn to build a 'new capital' for a young nation with a challenging natural environment and rich cultural heritage. He immediately accepted the contract, which as well as a 300-seat National Assembly chamber would include numerous offices, a mosque, a dining hall and accommodation for delegates. Kahn created a bold exposed concrete structure with horizontal strips of white marble, and the entire complex was surrounded by water like the great monuments of Mughal architecture. The assembly chamber forms the building's inner core, with the offices surrounding it. All are wrapped in perforated screen walls, creating a play of light and shade while providing valuable breeze. At the south of the hall is a mosque, set slightly off the central axis in order to face Mecca. Construction of the complex was completed after Kahn's death by David Wisdom & Associates.

Ayub Central Hospital
1963–74
Dhaka, Bangladesh

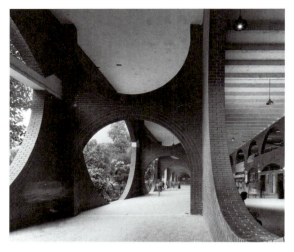

Kahn was contracted to design a national hospital as part of the Sher-e-Bangla Nagar area. At the western edge of a large plot to the northwest of the main complex, a low, wide brick building with shaded colonnade was built to Kahn's design and under his supervision. This outpatient clinic is now part of a larger development, the Shaheed Suhrawardy Medical College and Hospital. We know that Kahn was working on multiple projects for Dhaka at the time of his sudden death in 1974, but his plans for the rest of the hospital plot have not survived, and it is unknown how closely the current buildings relate to his designs.

Point Counterpoint and *Point Counterpoint II*
1964–76
Tidewater, Virginia

The American Wind Symphony Orchestra, founded in 1957, was known for performing on a former coal barge named *Point Counterpoint*, converted by Kahn in 1961. In 1964 Kahn began designing a new vessel for the group that would be easier to navigate as well as providing a floating concert hall. The streamlined,

195-foot-long (60 m) steel vessel was equipped with a 23-metre-wide stage and a hydraulic roof that could be raised for performances, creating an acoustic shell. After Kahn's death in 1974 it was completed to his design by architect George Djurkovic and set sail in 1976 for the American Bicentennial. The boat was retired in 2017 after covering more than 800,000 kilometres of the world's waterways.

Philips Exeter Academy Library and Dining Hall
1965–72
Exeter, New Hampshire

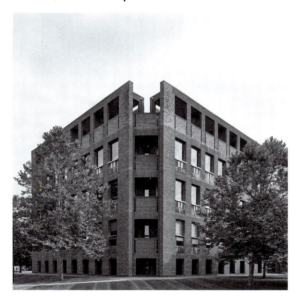

After outgrowing its existing small library, the Phillips Exeter Academy in New Hampshire awarded Kahn the commission to design its new building. The academy then offered an additional contract for a dining hall, which was built at the same time and situated adjacent to the library. The central library hall forms the core of the building, rising eight storeys high and covered with a roof with striking concrete X-brace. In the mezzanine levels overlooking the hall, book stacks are visible, while in the periphery are the study and reading areas. Timber study carrels are set into the structural brick walls and incorporated into the window frames with movable shutters. Above them, larger single windows provide natural light for the open desks set between the carrels and the shelving. A roof garden forms an important element that adds to the building's aesthetic and functional value.

Olivetti-Underwood Factory
1966–70
Harrisburg, Pennsylvania

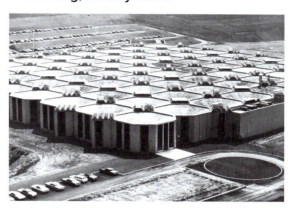

Following its merger with the Underwood Typewriter Company, Olivetti planned a new factory building in Harrisburg, Pennsylvania, for the production of a new line of typewriters and related products. The Italian firm was already known for its pioneering collaborations with architects, such as with Carlo Scarpa for their offices in Venice, and intended the new factory building to be an architectural statement. They offered the commission to Kahn, who in executing the project relied on the expertise of his long-term engineering associate August Komendant. The building has an experimental structural system of 72 prestressed concrete units each carrying an inverted prismatic shell supported by a tall, slender column. The rims of the adjacent shells are tied and the corners cut off, creating space for light to enter from the sky above. During renovation works in 1997, the concrete facade was altered beyond recognition.

Kimbell Art Museum
1966–72
Fort Worth, Texas

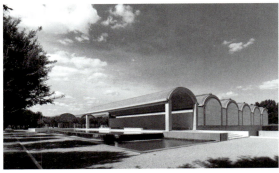

During their lifetimes, Kay Kimbell and his wife Velma Fuller amassed a significant private art collection, including paintings by Old Masters. They left many of these works to the Kimbell Art Foundation, which they had set up in 1935. Following Kimbell's death in 1964, plans were made for a building to house the works, with flexible, open-plan spaces. While Kahn favoured the open-plan idea, he also believed in the emphasis provided by distinct galleries, and so he designed a series of parallel vaults that together form a rectangular plan. The building is surrounded by reflecting pools, porches and arcades, while at the centre, four vaults border the recessed entrance porch and lobby. Six vaults in each of the north and south wings house the main galleries, while 2.5-metre-wide zones running parallel to the vaults house the air ducts and mechanical services. Natural light enters the galleries through slots down the centre of the cycloid shell roofs and are diffused by wing-like reflectors. Kahn said of this system: 'This light will give a touch of silver to the room without touching the objects directly.'[5] Kahn worked here with the local firm of Preston Green as associate architect.

Temple Beth-El
1966–72
**Chappaqua, New York
(partially demolished in 2011)**

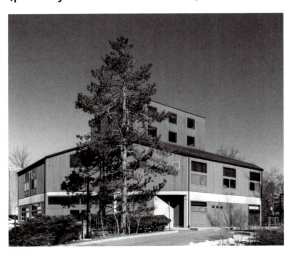

Kahn designed several synagogues during his career, but only two were built, including Temple Beth-El in Chappaqua, New York. Very little was published about the synagogue – which is still in use today – between its completion and its partial demolition and extension in 2011. The outer form is a wood-clad structure with exposed concrete beams set between the floors, while inside, at the centre of the octagonal plan, a square sanctuary for the congregation is defined by four columns, at the top of which sits a cubic cupola rising 15 metres high and with 24 square windows. Although an increase in the size of the congregation and new safety requirements necessitated additions be made to the building – which doubled its size – Kahn's original facade was preserved.

Wolfson Center for Mechanical and Transportation Engineering
1968–77
Tel Aviv, Israel

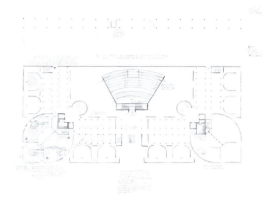

This centre for mechanical engineering was contracted to Kahn by Tel Aviv University, although design and construction were completed posthumously by the firm Mochly Eldar Ltd. From the outside, it is a massive structure with blank concrete walls. However, as in other buildings by Kahn, contrary to its external appearance, plenty of light reaches the interior spaces – but in a controlled and dispersed fashion so as to achieve an introverted effect.

Yale Center for British Art
1969–77
New Haven, Connecticut

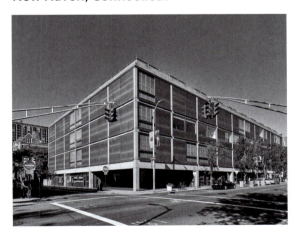

When Paul Mellon donated his collection of British art to Yale University in 1966, along with funds to construct a building to house them, it was Kahn who was contracted to design it, having designed the university's Art Gallery in 1953. The chosen site had important commercial value and the building thus incorporates retail spaces on the ground floor, which Kahn welcomed as a challenge that could enliven the museum, contrary to conventional designs. Access from two directions leads to the covered entrance courtyard, while the museum premises begin on the upper level, around the three-storey Library Court at the centre, where a massive cylindrical staircase dominates. The structure consists of a concrete frame with steel and glass infill panels in the facade, while in the interior, white oak panels are used on the walls. After Kahn died in 1974, construction was completed by Pellecchia & Meyers, and the galleries opened to the public in 1977.

Family Planning and Maternal Health Centre
1970–75
Kathmandu, Nepal

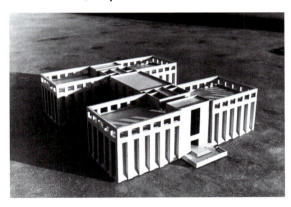

Contracted by His Majesty's Government of Nepal, this family planning centre was partially built to Kahn's design. Initial plans were for a two-part educational and administrative building in concrete, but only the latter was built, in masonry. Construction of the building, with inset windows and niches, was completed after Kahn's death by David Wisdom & Associates.

Steven and Toby Korman House
1971–73
Fort Washington, Pennsylvania

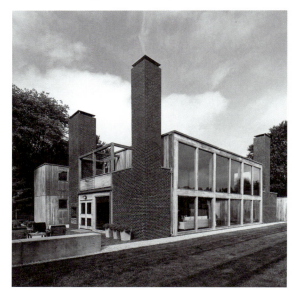

Completed in 1973, the Korman House was the last – and largest – private residence by Kahn. As in most of Kahn's houses, the plan consists of two main zones connected by entrance and circulation areas. The living area is double-height and the bedrooms are arranged over two storeys. Chimneys were a symbol of domestic life for Kahn, who increased their number in the Korman House: the tall, dominating chimneys that flank the living area from outside serve fireplaces in the living and dining areas and a grill in the kitchen, and an additional fireplace in the master bedroom. The longer side of the living area is fully glazed, opening to a northeasterly direction. When the house is viewed from other directions, the warm colour of the cypress siding dominates.

Graduate Theological Union Library
1972–87
Berkeley, California

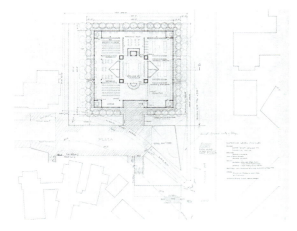

In 1972, Kahn began work on the design of a library and administration building for the Graduate Theological Union in Berkeley, California. Now renamed the Flora Lamson Hewlett Library, the building was completed after Kahn's death, based on his preliminary designs, by the firm Peters, Clayberg & Caulfield in association with Esherick Homsey Dodge & Davis. From outside, the building rises in terraces, while inside is a high central space that culminates in a skylight and has surrounding mezzanine levels that partly open on to it.

Bishop Field Estate
1973–74
Lenox, Massachusetts

This housing estate in Lenox was built after Kahn's death, based on his original designs and site plan.

Franklin D. Roosevelt Four Freedoms Park
1973–2012
Roosevelt Island, New York City, New York

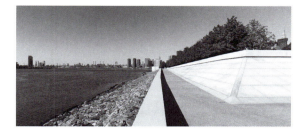

For those who lived through the Great Depression and the Second World War years, Franklin D. Roosevelt was a seminal figure, and in 1960 Kahn submitted an entry to a competition for a memorial to Roosevelt in Washington, DC. Although this project was not realised, Kahn continued to work on the concept of a monument for Roosevelt until he finally received a contract for a memorial park on the tip of an island in New York, to be renamed Roosevelt Island. In 1973 he unveiled his design for the park, which Kahn explained as 'a room and a garden'.[6] After his death, the project was developed to his design by David Wisdom & Associates and Mitchell/Giurgola Associates, with construction finally completed in 2012.

1 Lewis Mumford, 'The Sky Line: Houses and Fairs' [30 June 1936], in *Sidewalk Critic: Lewis Mumford's Writings on New York*, ed. Robert Wojtowicz (New York: Princeton Architectural Press, 1998), p. 159.
2 George H. Marcus and William Whitaker, *The Houses of Louis Kahn* (New Haven, CT, and London: Yale University Press, 2013), p. 99.
3 Louis I. Kahn in Barbara Barnes, 'Architects' Prize-winning Houses Combine Best Features of Old and New', *Evening Bulletin*, 20 May 1950, quoted in David B. Brownlee and David G. De Long, *Louis I. Kahn: In the Realm of Architecture* (New York: Rizzoli, 1991), p. 40.
4 Louis I. Kahn, handwritten note on first-floor plan drawing set, 22 December 1963, quoted in Marcus and Whitaker, *The Houses of Louis Kahn*, p. 69.
5 Louis I. Kahn, 'Space and Inspirations', lecture at New England Conservatory of Music, Boston, 14 November 1969, quoted in Brownlee and De Long, *Louis I. Kahn*, p. 312.
6 Louis I. Kahn, '1973: Brooklyn, New York', lecture at Pratt Institute, New York, 1973, quoted in Brownlee and De Long, *Louis I. Kahn*, p. 139.

SOURCES

Brownlee, David B., and David G. De Long, *Louis I. Kahn: In the Realm of Architecture* (New York: Rizzoli, 1991)

Komendant, August E., *18 Years with Architect Louis I. Kahn* (Englewood, NJ: Aloray, 1975)

Kries, Mateo, Jochen Eisenbrand and Stanislaus von Moss, eds, *Louis Kahn: The Power of Architecture* (Weil am Rhein: Vitra Design Museum, 2013)

Louis Isadore Kahn database, www.philadelphiabuildings.org, accessed July 2020

Marcus, George H., and William Whittaker, *The Houses of Louis Kahn* (New Haven, CT: Yale University Press, 2013)

McCarter, Robert, *Louis I. Kahn* (London: Phaidon, 2005)

Mumford, Lewis, *Sidewalk Critic: Lewis Mumford's Writings on New York*, ed. Robert Wojtowicz (New York: Princeton Architectural Press, 1998)

Thomas, Leslie, *Louis I. Kahn: Building Art, Building Science* (New York: George Braziller, 2005)

Bibliography

Ashraf, Kazi Khaleed, and Saif Ul Haque, *Sherebanglanagar: Louis I. Kahn and the Making of a Capital Complex* (Dhaka: Loka, 2002)

Brownlee, David B., and David G. De Long, *Louis I. Kahn: In the Realm of Architecture* (New York: Rizzoli, 1991)

Erzen, Jale N., 'Architect of Profound Priorities and of the Spiritual', in *Re/Framing Louis Kahn*, ed. Müge Cengizkan (Istanbul: Pera Museum, 2017)

Frampton, Kenneth, *Studies in Tectonic Culture: The Poetics of Construction in Nineteenth and Twentieth Century Architecture*, ed. John Cava (Cambridge, MA: MIT Press, 1995)

Gargiani, Roberto, *Louis I. Kahn: Exposed Concrete and Hollow Stones, 1949–1959* (Lausanne and Oxford: EPFL Press/Routledge, 2014)

Giurgola, Romaldo, and Jaimini Mehta, *Louis I. Kahn: Architect* (Boulder, CO: Westview Press, 1975)

Goldhagen, Sarah Williams, *Louis Kahn's Situated Modernism* (New Haven, CT: Yale University Press, 2001)

Johnson, Nell E., ed., *Light is the Theme: Louis I. Kahn and the Kimbell Art Museum* (Fort Worth, TX: Kimbell Art Foundation, 1975)

Kahn, Louis I., *Louis Kahn: Conversations with Students*, ed. Dung Ngo, Architecture at Rice 26 (New York: Princeton Architectural Press, 1969)

——, *Louis Kahn: Essential Texts*, ed. Robert Twombly (New York: W. W. Norton & Co., 2003)

——, *Louis I. Kahn: Silence and Light* (Zurich: Park Books, 2013)

——, *Louis I. Kahn: Writings, Lectures, Interviews*, ed. Alessandra Latour (New York: Rizzoli, 1991)

——, *What Will Be Has Always Been: The Words of Louis I. Kahn*, ed. Richard Saul Wurman (New York: Access Press/Rizzoli, 1986)

Kries, Mateo, Jochen Eisenbrand and Stanislaus von Moos, eds, *Louis Kahn: The Power of Architecture* (Weil am Rhein: Vitra Design Museum, 2013)

Leslie, Thomas, *Louis I. Kahn: Building Art, Building Science* (New York: George Braziller, 2005)

Maniaque, Caroline, 'Essays on Residential Masterpieces: Louis I. Kahn. House, a House, Home', *GA Houses*, 44 (1994), pp. 10–33

——, *Louis I. Kahn, architecte* (Paris: Centre national de documentation pédagogique, 1992)

Marcus, George H., and William Whitaker, *The Houses of Louis Kahn* (New Haven, CT: Yale University Press, 2013)

Margolis, Joseph, *Toward a Metaphysics of Culture* (New York: Routledge, 2013)

——, *What, After All, Is a Work of Art?* (University Park, PA: Pennsylvania State University Press, 1999)

McCarter, Robert, *Louis I. Kahn* (London: Phaidon, 2005)

Prown, Jules David, and Karen E. Denavit, eds, *Louis I. Kahn in Conversation: Interviews with John W. Cook and Heinrich Klotz, 1969–70* (New Haven, CT: Yale University Press, 2014)

Ronner, Heinz, Sharad Jhaveri and Alessandro Vasella, eds, *Louis I. Kahn: Complete Works, 1935–74*, 2nd edn (Basel and Boston, MA: Birkhäuser, 1987)

Scully, Vincent Jr, *Louis I. Kahn* (New York: George Braziller, 1962)

Smith, G. E. Kidder, *Source Book of American Architecture* (New York: Princeton Architectural Press, 1996)

Solomon, Susan G., *Louis I. Kahn's Jewish Architecture: Mikveh Israel and the Midcentury American Synagogue* (Waltham, MA: Brandeis University Press, 2009)

Twombly, Robert, ed., *Louis I. Kahn: Essential Texts* (New York: W. W. Norton & Co., 2003)

Tyng, Alexandra, *Beginnings: Louis I. Kahn's Philosophy of Architecture* (New York: John Wiley & Sons, 1984)

Tyng, Anne Griswold, ed., *Louis Kahn to Anne Tyng: The Rome Letters, 1953–54* (New York: Rizzoli, 1997)

Wiseman, Carter, *Louis I. Kahn: Beyond Time and Style* (New York: W. W. Norton & Co., 2007)

Zucker, Paul, ed., *New Architecture and City Planning: A Symposium* (New York: Philosophical Library, 1944)

© 2021 Prestel Verlag
Munich • London • New York
A member of Penguin Random House
Verlagsgruppe GmbH
Neumarkter Straße 28, 81673 Munich

© for the texts by the Authors

Reprinted 2022

© for the images Cemal Emden, 2021, with the exception of the following: pp. 299 (bottom right), 300 (left, top right, bottom right), 301 (bottom), 302 (top left, bottom left, bottom right), 303 (top right, bottom right), 304 (top left, bottom left), 305 (left), 306 (top left), 313 (right), 315 (top left, right), 316 (right), courtesy of the Louis I. Kahn Collection, University of Pennsylvania and Pennsylvania Historical and Museum; pp. 299 (left) courtesy of the Marshall D. Meyers Collection, The Architectural Archives, University of Pennsylvania; 298 (bottom), 301 (top), 302 (top right), courtesy of the Library of Congress, Prints and Photographs Division, Washington, DC.

In respect to links in the book the Publisher expressly notes that no illegal content was discernible on the linked sites at the time the links were created. The Publisher has no influence at all over the current and future design, content or authorship of the linked sites. For this reason the Publisher expressly disassociates itself from all content on linked sites that has been altered since the link was created and assumes no liability for such content.

A CIP catalogue record for this book is available from the British Library.

Editorial direction
Anna Godfrey

Copy-editing
Aimee Selby

Assistant to Cemal Emden
Arzu Uludağ

With thanks to
Nafiz Akşehirlioğlu
Kazi Khaleed Ashraf
Özalp Birol
Bülent Gültekin
Süha Özkan
Zeynep Tözüm
Banu Uçak

Translation of the texts by
Caroline Maniaque
Zelda Moureu Vose

Art direction
Bülent Erkmen

Graphic design
Kerem Yaman, BEK

Pre-press
Barış Akkurt, BEK

Printing and binding
A4 Ofset
Matbaacılık San. ve Tic. A.Ş.

Printed in Istanbul

ISBN: 978-3-7913-8750-5

www.prestel.com

Front cover:
Indian Institute of Management,
Ahmedabad, India